Glamorous
LIVING

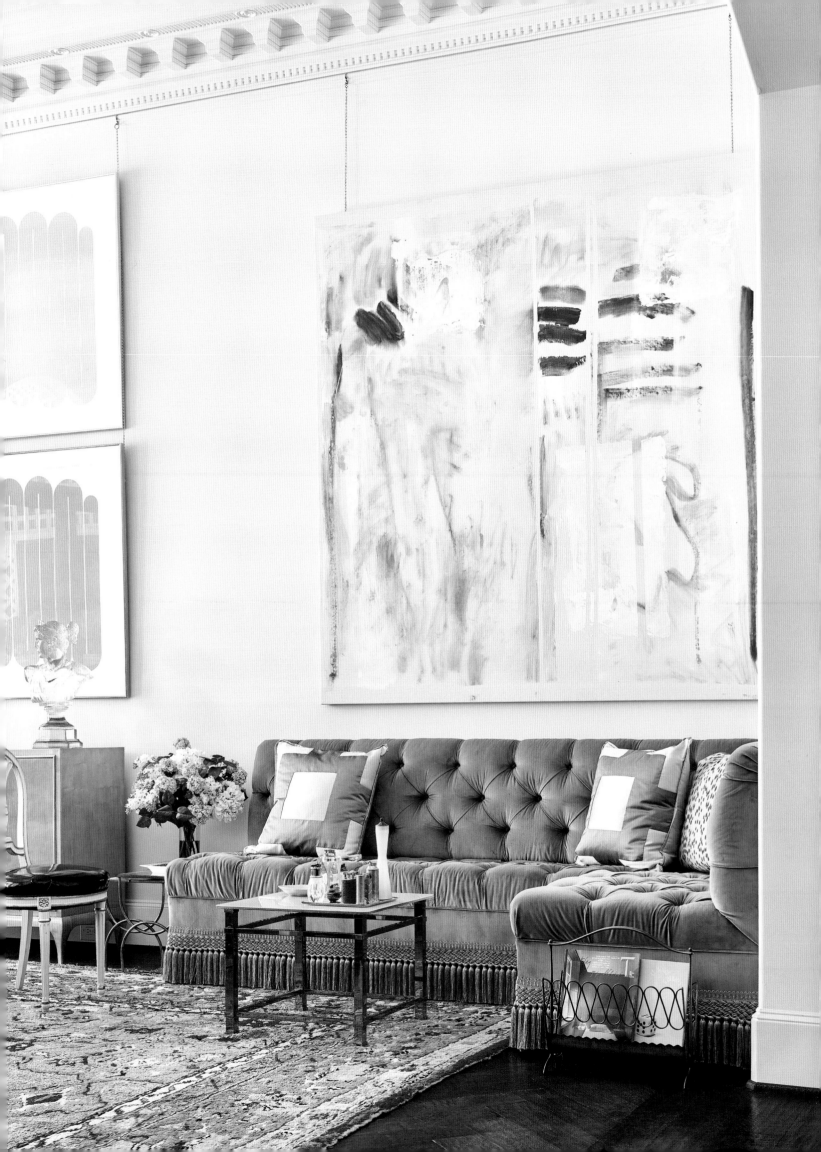

"Decorating is autobiography."
—GLORIA VANDERBILT

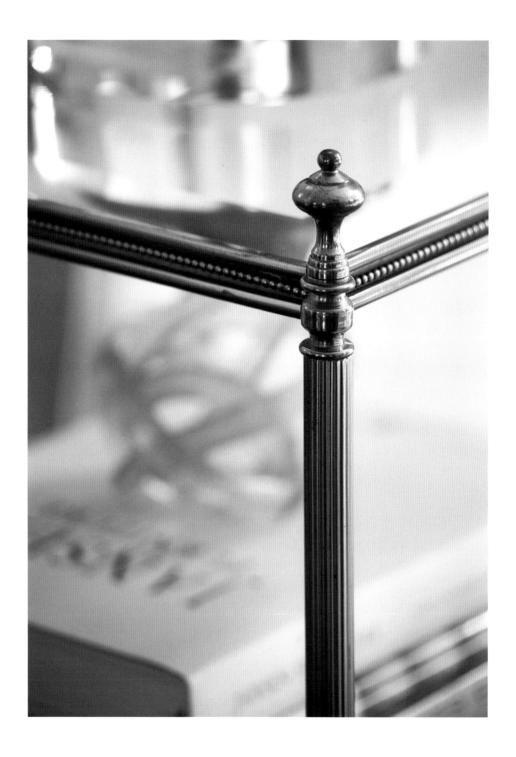

Previous page: Custom tufted banquette in blue green velvet by Kravet,
pattern Versailles, with heavy fringe by Samuel & Sons. Art by Leif Ritchey.

❋

Above: Corner detail of a French 1940s brass table, Louis XVI style.
Opposite: A cozy corner of a glamorous New York apartment.
The Milan Chair and Holden Credenza are from the Jan Showers Collection.

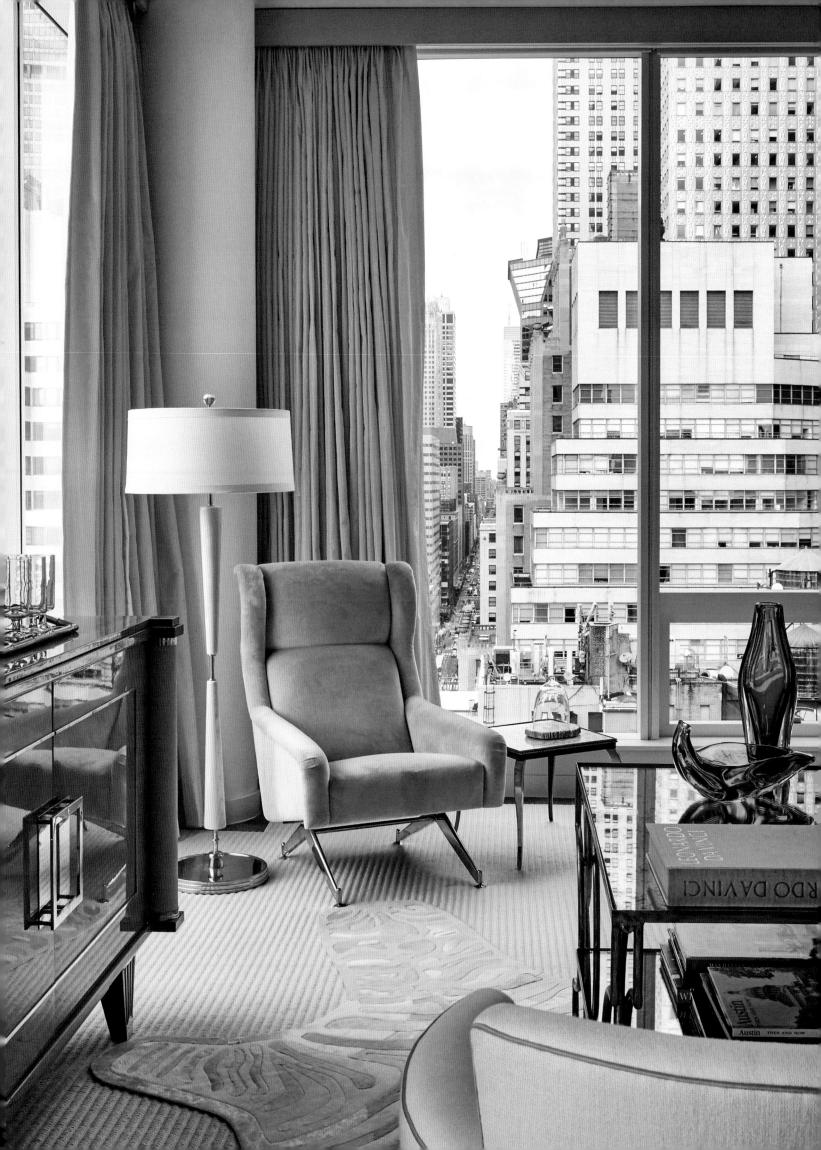

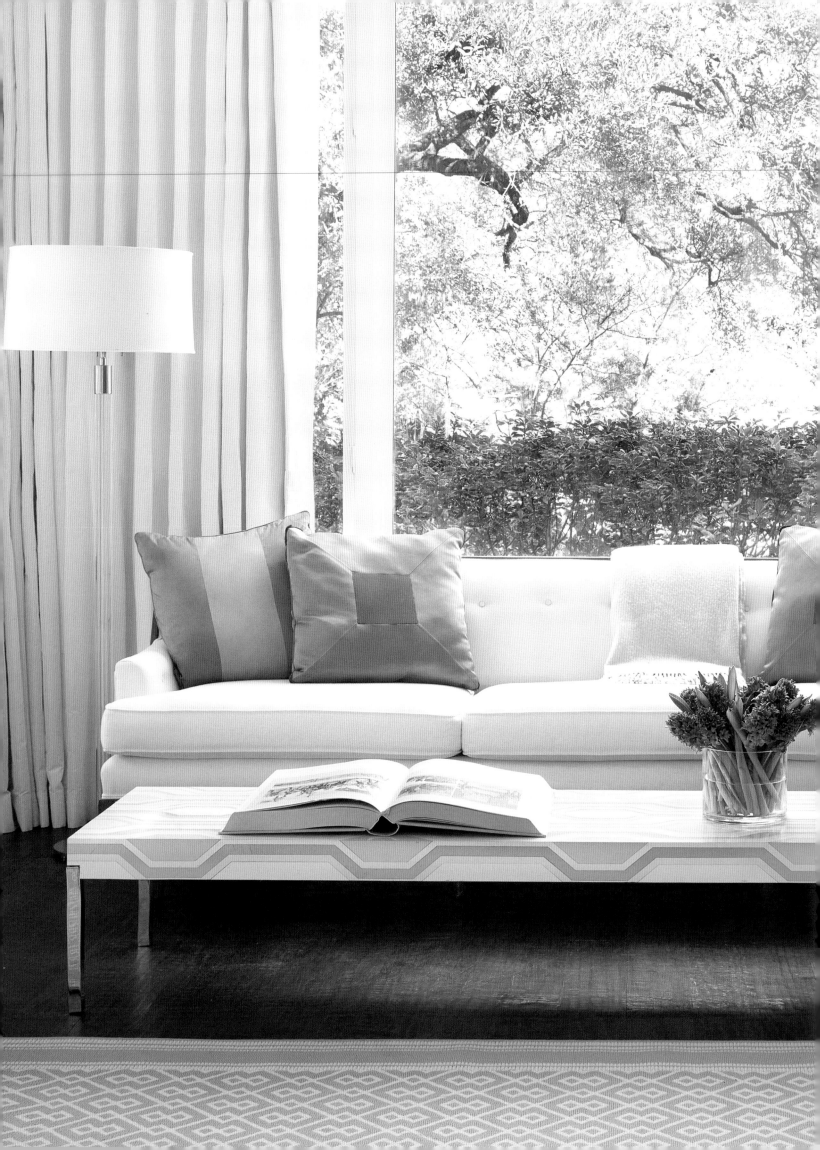

Glamorous Living is dedicated to
my own family and
to my family of warm and generous
clients through the years.

JAN SHOWERS

ABRAMS, NEW YORK

Contents

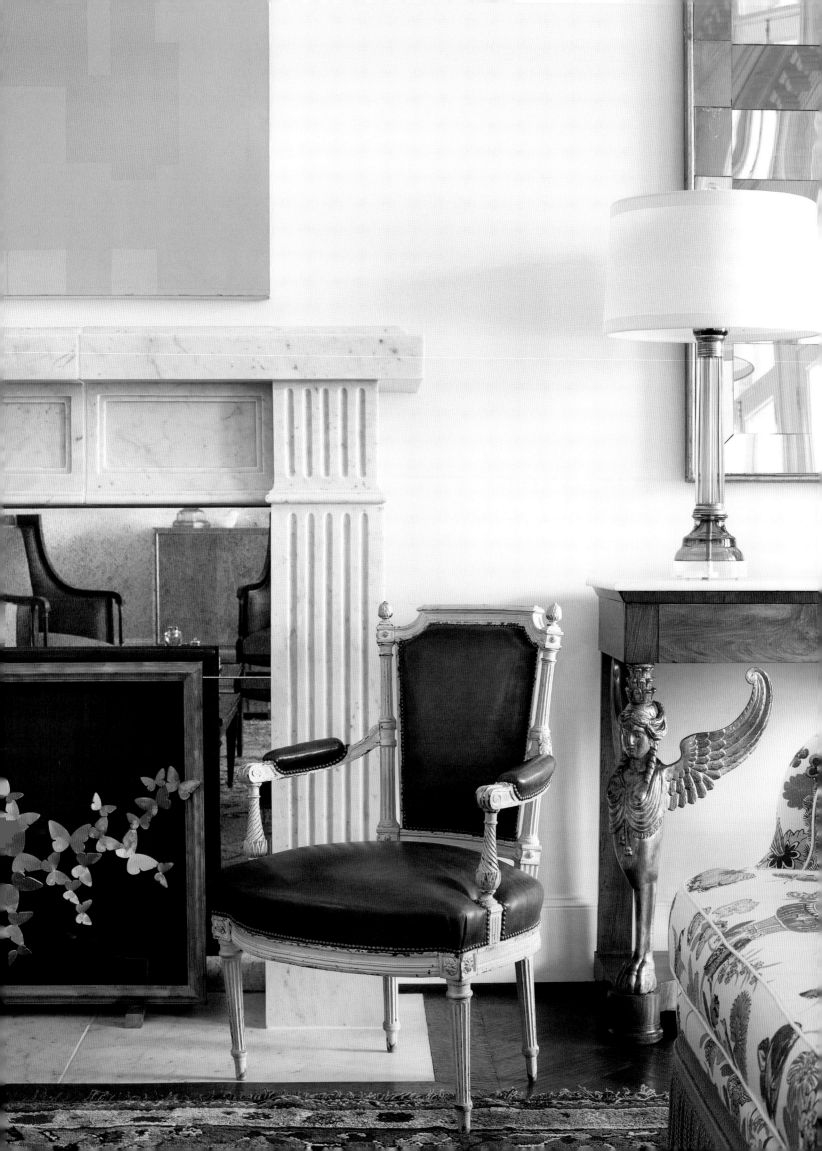

Foreword

I was on a plane, flipping through a magazine, when a design story caught my eye: a little bit of fringe, a lot of pastel, a bit of mirror, and loads of charm. I looked, and learned the decorator was someone named Jan Showers. Not being overly familiar with the world of American decorators, I was unaware that Jan was a star. I myself had grown up in England under the imposing eye of David Hicks, who was arguably the most influential interior designer of his generation—but perhaps I am biased, I am his daughter after all.

Rather presumptively, I contacted Jan out of the blue. And she, with typical Southern manners, not only replied but also gently explained that one of her three daughters had a house on Harbour Island—where I lived and raised my own tribe of children, and to where she was a regular visitor.

And so our friendship began, over a shared love for the Bahamas and a firm belief in family.

But my presumption knew no bounds, and I went on to ask if Jan would consider hosting my first-ever trunk show in her elegant show room in Dallas; generously, she agreed to do it.

In this beautiful book, Jan talks about her hopes for experiencing "a frisson of curiosity about what's to come." I had no idea what was to come from that first show, but it brought me the good fortune of meeting a family friend of the Showers' who went on to play a most pivotal part in my business.

Like the chapters seen in this book, the event itself was filled with Gracious Living, some Dream Time, and a lot of Finishing Touches. My favorite was not the attention to detail over the guest list or the good lighting Jan provided (both utterly essential), but her spirited sense of fun. A framed photograph of my father had been placed on the bar, beside the cocktails. "I wanted you to feel at home," said Jan. "Perfect placement," I replied. "My father was well known for his love of a good drink—in fact several good drinks."

May I suggest you now pour yourself a good drink and luxuriate in a little Glamorous Living.

—INDIA HICKS

LIVING *Like* THIS

Successful design is always personal. For me, glamorous living means engaging with the world in a certain way, bringing my own style and unique set of influences with me everywhere I go. Glamorous living never means glittery, baroque ostentation. It's about living with style and grace, creating environments for family and friends to be a part of your life while feeling their best.

Simple pleasures are the most glamorous. Cocktails with my husband at the end of the day. Lunch outside on a beautiful afternoon. Fried chicken, a simple salad, fresh flowers, a nap in an elegantly outfitted bed. It isn't about jetting off on over-the-top vacations. It's about setting the stage for lovely experiences and pausing to take pleasure in them.

In that sense, this book—my third—has been one of the most glamorous experiences of my life, as I've looked back over these projects and seen them with fresh eyes in all their variety and fun. Represented here are so many styles and looks, so many opportunities for growth and laughter—the treasure hunts and incredible discoveries that have defined my working life in the past decade as my clients and friends shared with me their unique points of view and the glamour of their lives.

—JAN SHOWERS

Clockwise, from top left: Jan and daughter Susanna in Maui, Hawaii, 1974; Susanna,
Jan, Jim, daughter Elizabeth, and friend in Acapulco, 1982; Jan and Susanna, Christmas 1968;
Jan and Jim in Paris, 1970; Rick Rogers, Jan, and Jim in Quebec City, 1975

Clockwise from top left:
Jan and Elizabeth, 1975; Jan
and Susanna in Vail, 1976; Susanna,
Jan, and Elizabeth in Mendocino,
California, 1983; Elizabeth, Jim, Jan,
and Susanna at home, 1997;
Elizabeth and Susanna with a new friend
in Vermont, summer 1980;
Susanna, Jan, and Elizabeth, 1997;
Jan in her showroom in
the Dallas Design District, 2002;
Jim c. 1976; Jim and Susanna
on his birthday, 1970

Clockwise from top left:
Jim and grandson Matthew in Hillsboro, Texas, Thanksgiving 2004; Jan and Jim entertaining at their Dallas townhouse, 2002; grandchildren Eliza and Ben with Jan, Thanksgiving 2004; Jan and Jim at an Aspen wedding, 2003; Matthew, Jan, and Ben, the Soniat House Hotel, New Orleans, 2012; Matthew, Ben, Palmer, Eliza, Susanna, Jan, Jim, and Elizabeth, Christmas 2006; Jan and Eliza, Thanksgiving 2004

Following spread: Our Dallas townhouse on Turtle Creek, Dallas.

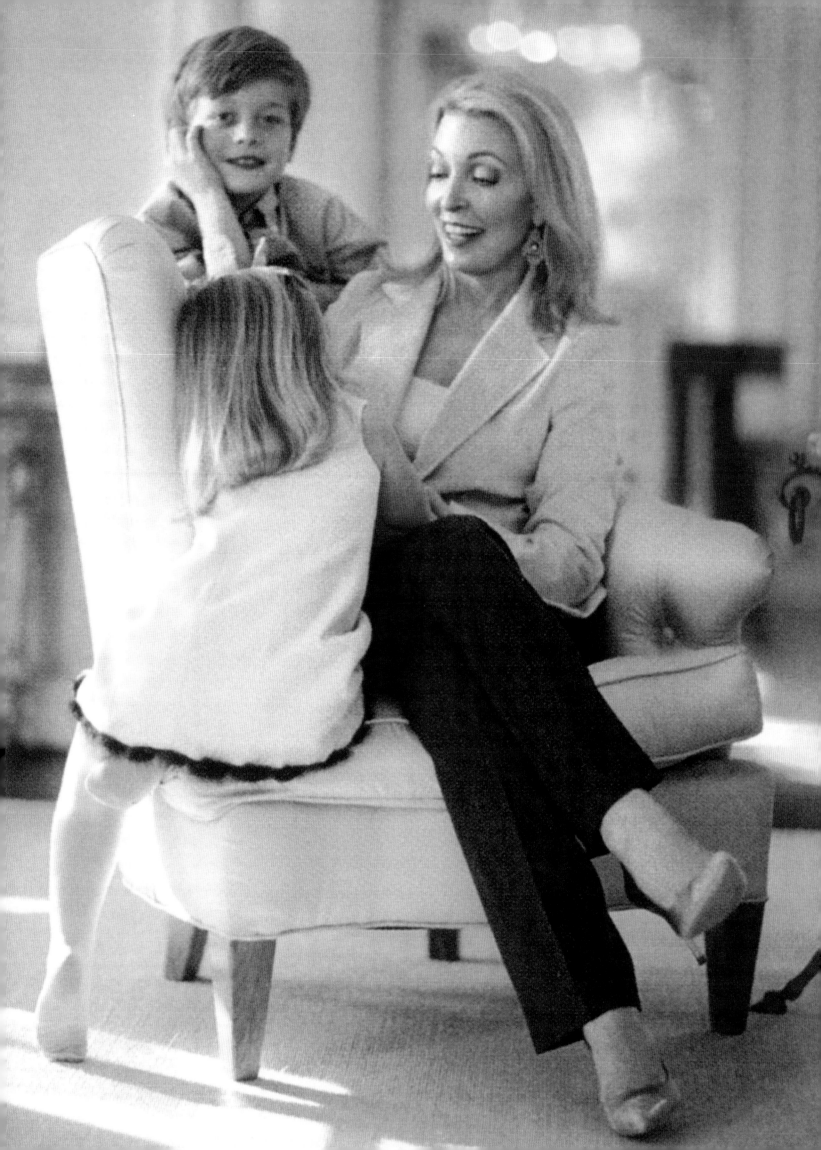

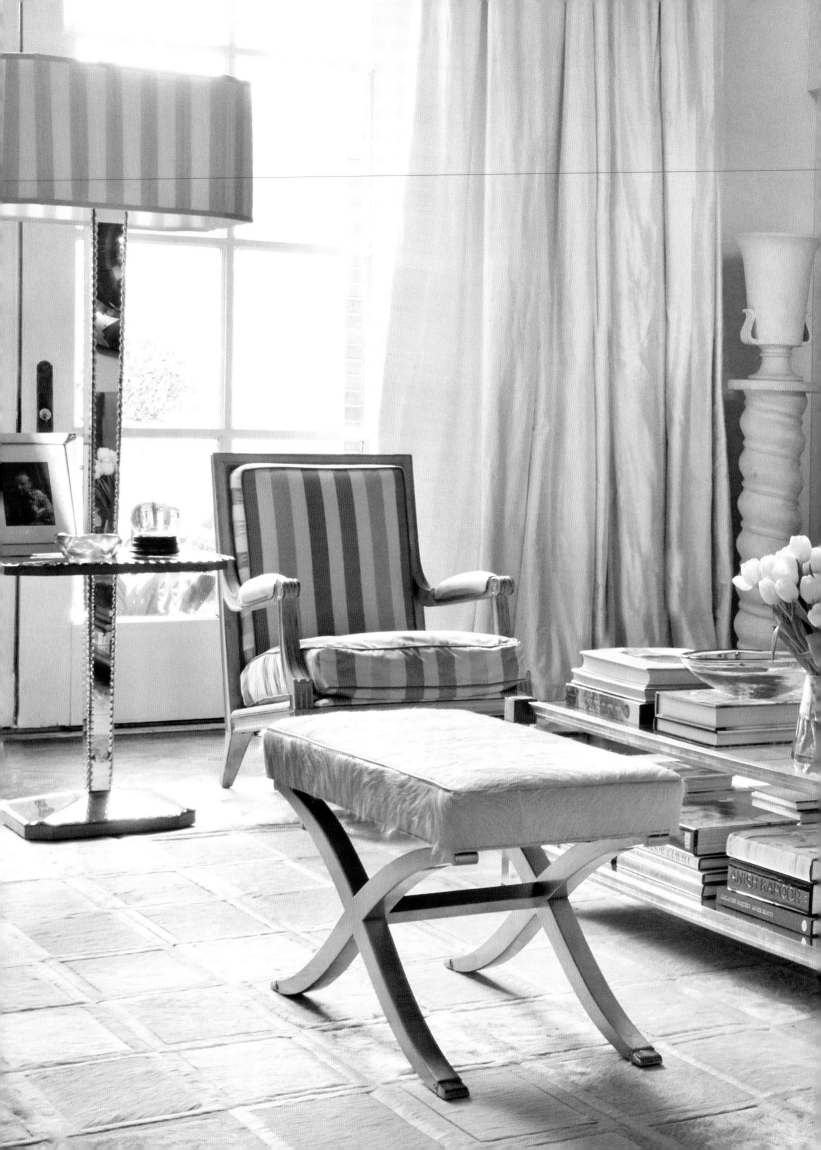

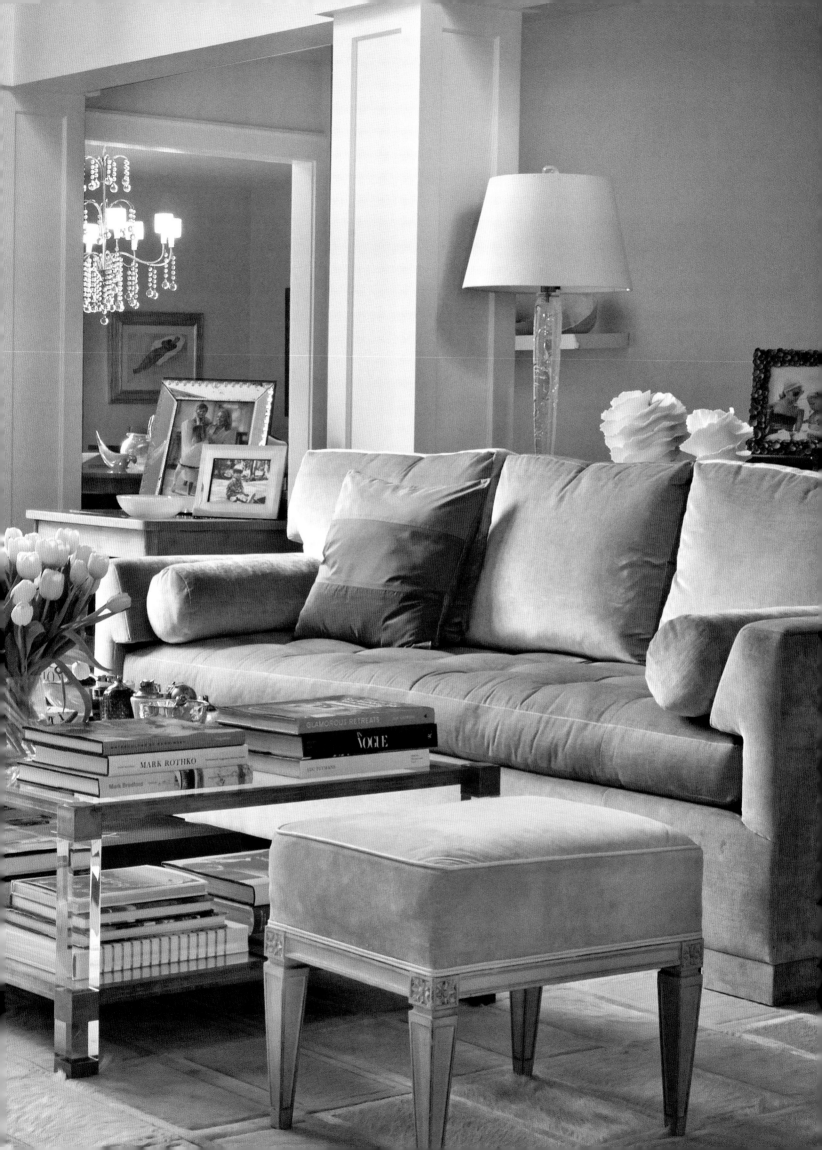

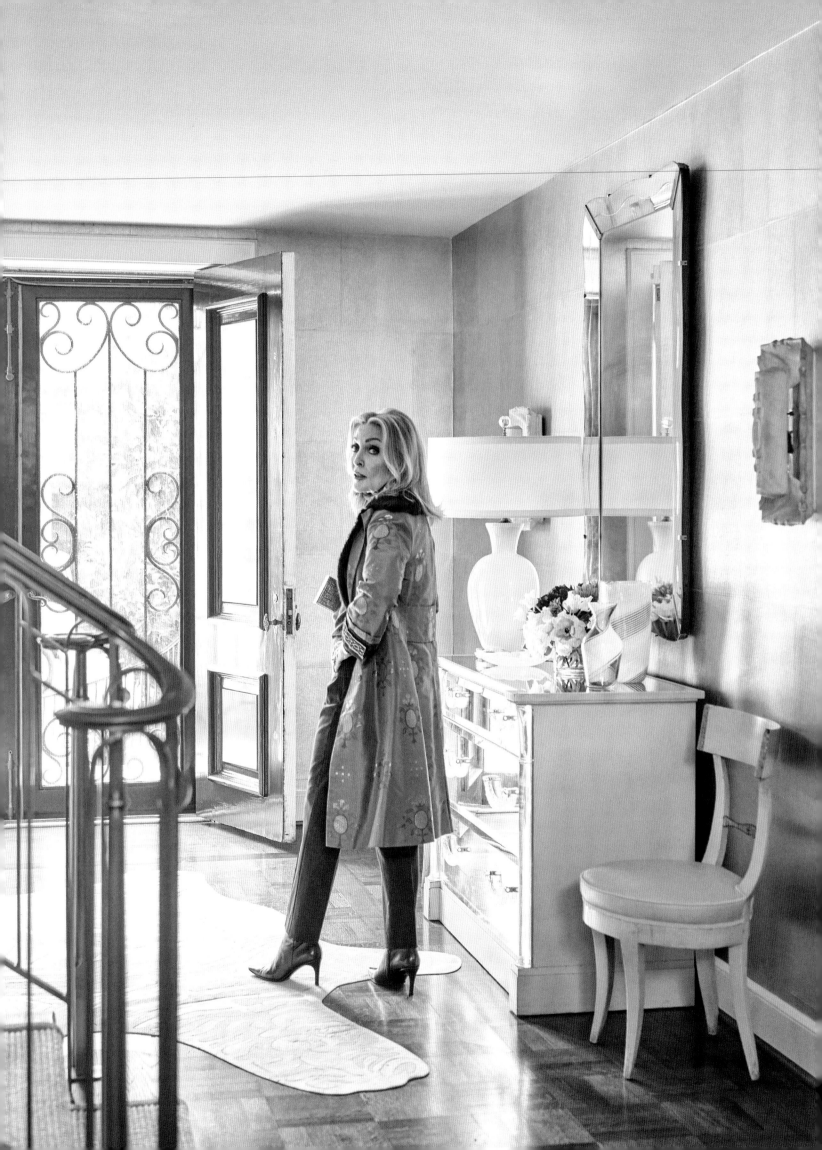

First IMPRESSIONS

W hen I enter a house, I expect to be greeted above all by a feeling. Certainly, one hopes to experience a frisson of curiosity about what's to come, but any entry I design is more than a preview. Every space must make its own statement. Entries also afford a fun opportunity to play against type. I love walking into a traditional house and being surprised by a mid-century vintage chandelier.

Some clients are reluctant to showcase great furnishings or works of art in their entry halls, reserving such pieces for living spaces where people spend more time. I don't believe in saving the best of anything for a special occasion, least of all in decorating the rooms through which all guests will pass at least twice. It's wonderful to walk into a house and discover right away an unexpected painting, sculpture, or photograph. Great art generates excitement and makes all who enter interested to see what lies beyond.

Mirrors in entries are practically essential, and not just because of the beautiful quality they create, but also because they are convenient for checking one's appearance upon entering or leaving for the day.

Typically, entry halls lead to powder rooms, and they're just as important when it comes to establishing a first impression. In my designs, I tend toward powder rooms in one of two styles: romantic or dramatic. If it's drama I'm after, I'll use dark-colored high-gloss or lacquered walls. The richness and depth it creates truly can't be duplicated. Wallpaper is always the best way to create a romantic powder room.

As in every room, nothing is more glamorous than adding a personal touch. In our country house powder room, I have a charming photograph of my granddaughter at five years old dressed in one of my coats and a pair of my high heels beside an image of me when I was the same age in my mother's heels.

Dallas townhouse entry hall. Syrie Maugham 1930s commode, eighteenth-century
Italian chairs, unusual lemon yellow 1940s Seguso lamp.

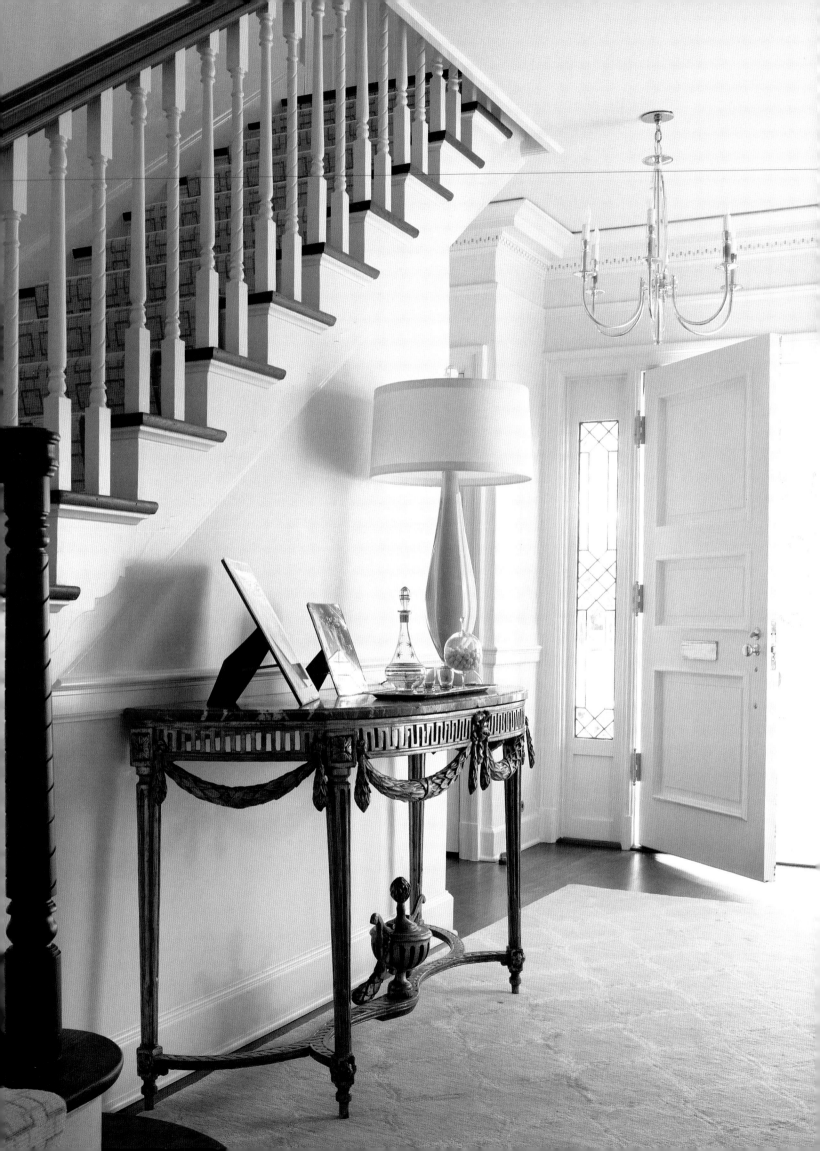

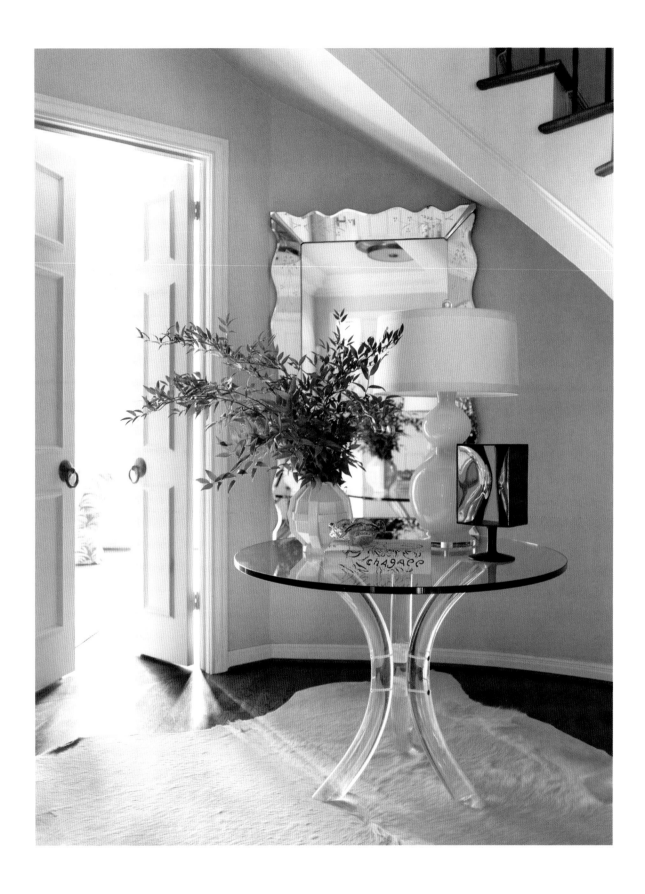

Opposite: Late-eighteenth-century gilded French console and 1950s
Murano lamp in historic Austin house. *Above*: A modern table
from the 1960s sits under a curved staircase with a #4 Venetian Series Lamp,
from the Jan Showers Collection, in a Houston house on Buffalo Bayou.

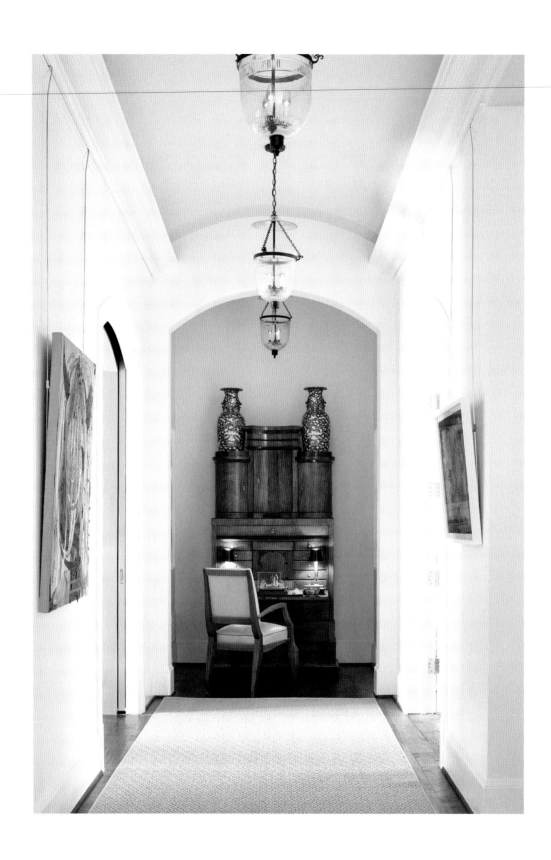

Above: Gallery in Preston Hollow, Dallas, house, with an architectural remodel by Dallas architect J. Wilson Fuqua, including a Biedermeier secretary and Chinese export urns; ceiling painted Skylight by Farrow & Ball. *Opposite*: Entry hall looking into dining room of Preston Hollow house with Louis–XV style carved console with original marble top and Napoleon III water-gilt mirror with Dutch delft tulip vases. Left of the doorway is an antique French mahogany demilune. The art is by Matt Connors.

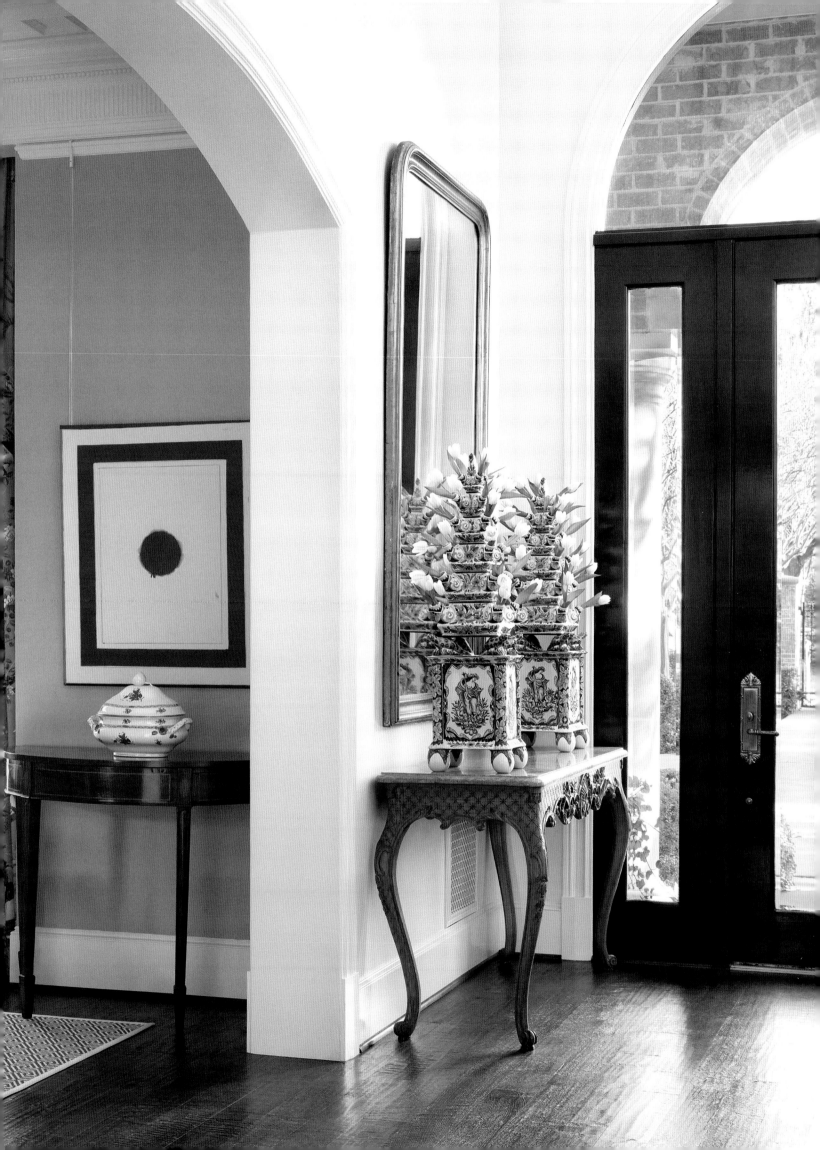

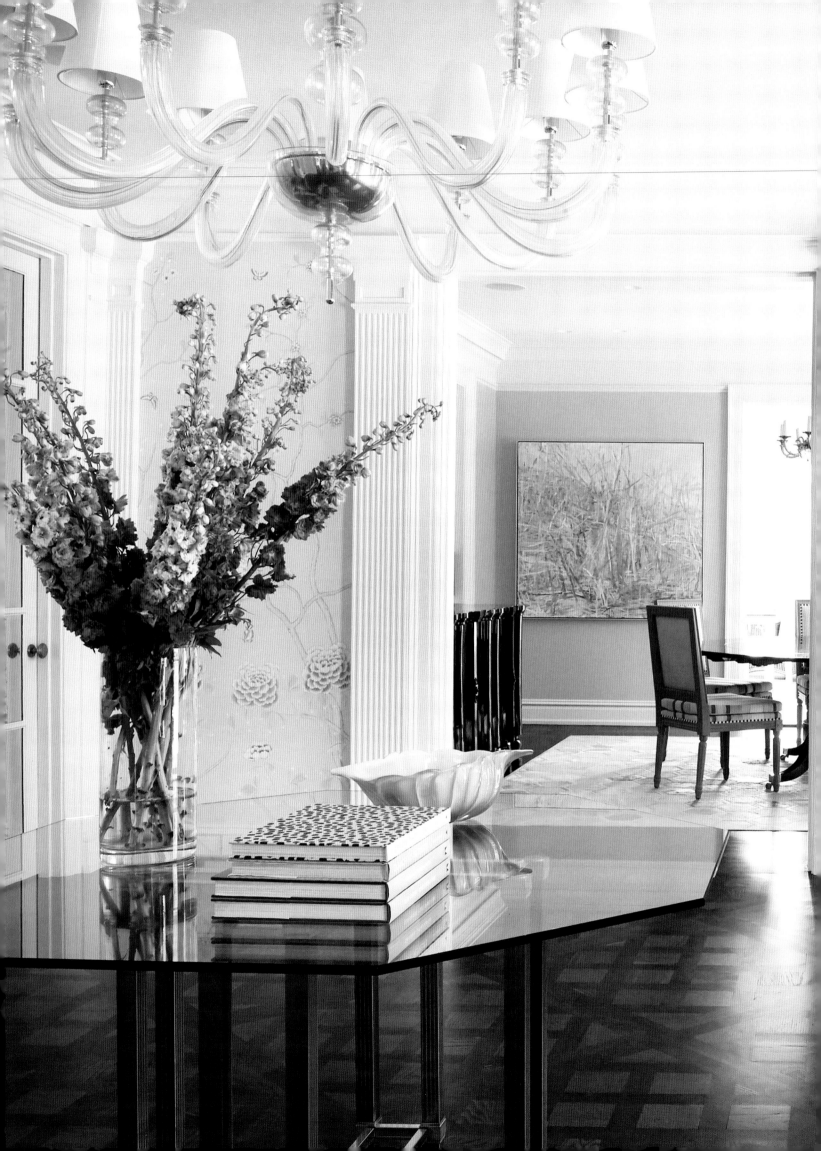

Left: Large entry hall with walnut-and-oak parquet custom floors in historic 1915 Hal Thomson house, Highland Park, Dallas; updated by Dallas architect Ralph Duesing. The generous entry hall has custom hand-painted de Gournay wallpaper, vintage Louis XVI–style painted consoles, and a gold Barovier Murano chandelier. *Below*: A pair of faux-bamboo painted chairs nestle into the curved stairway.

※

Following spread: (*left*) Curved stairway carpeted in the Continental style in Martin Patrick Evan custom carpet. Stair retainers by Stark. (*right*) Maison Charles gilded lamp with turquoise glass and an Accolay bowl.

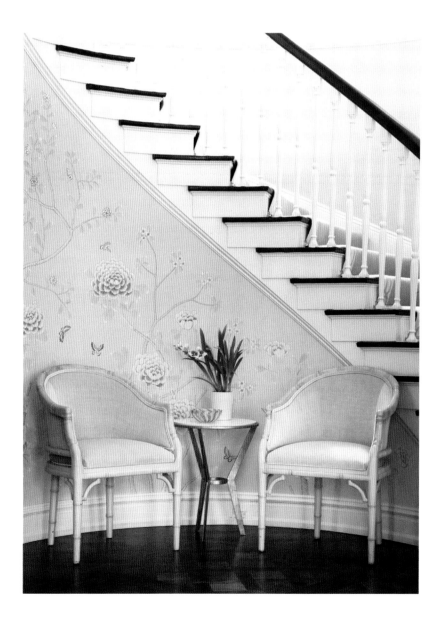

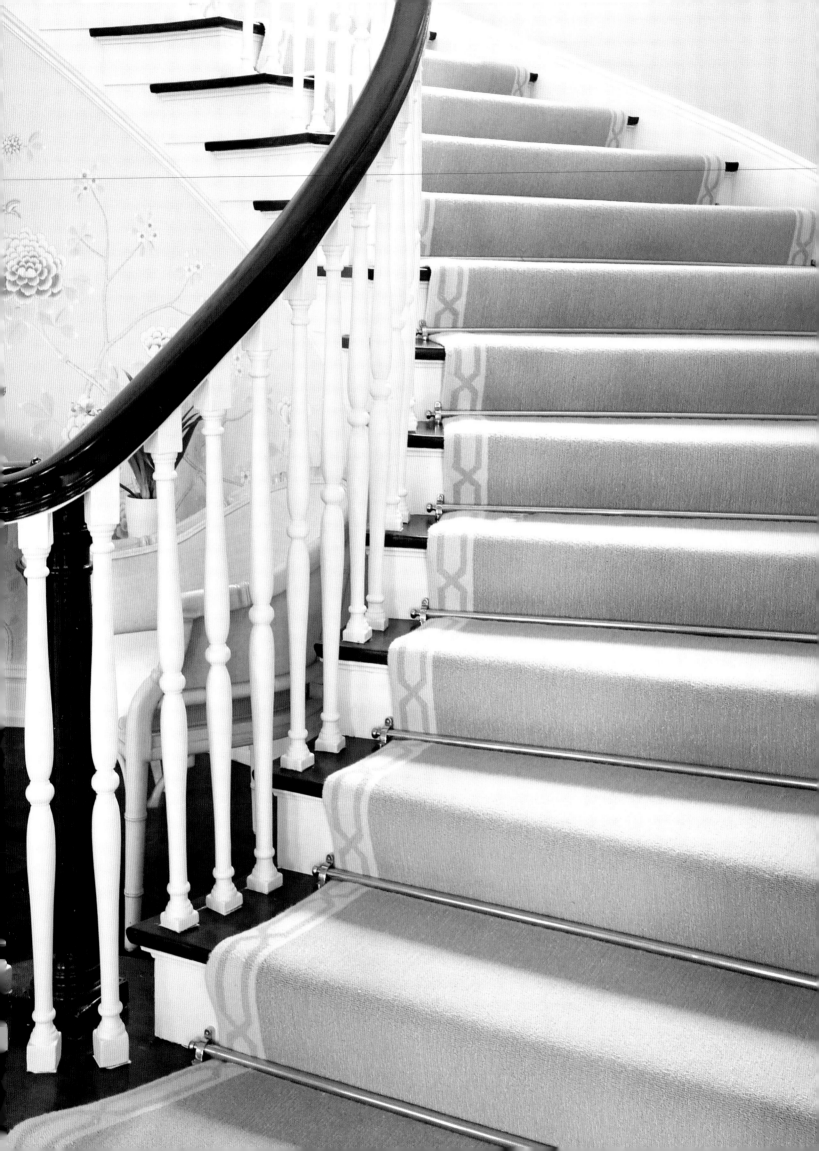

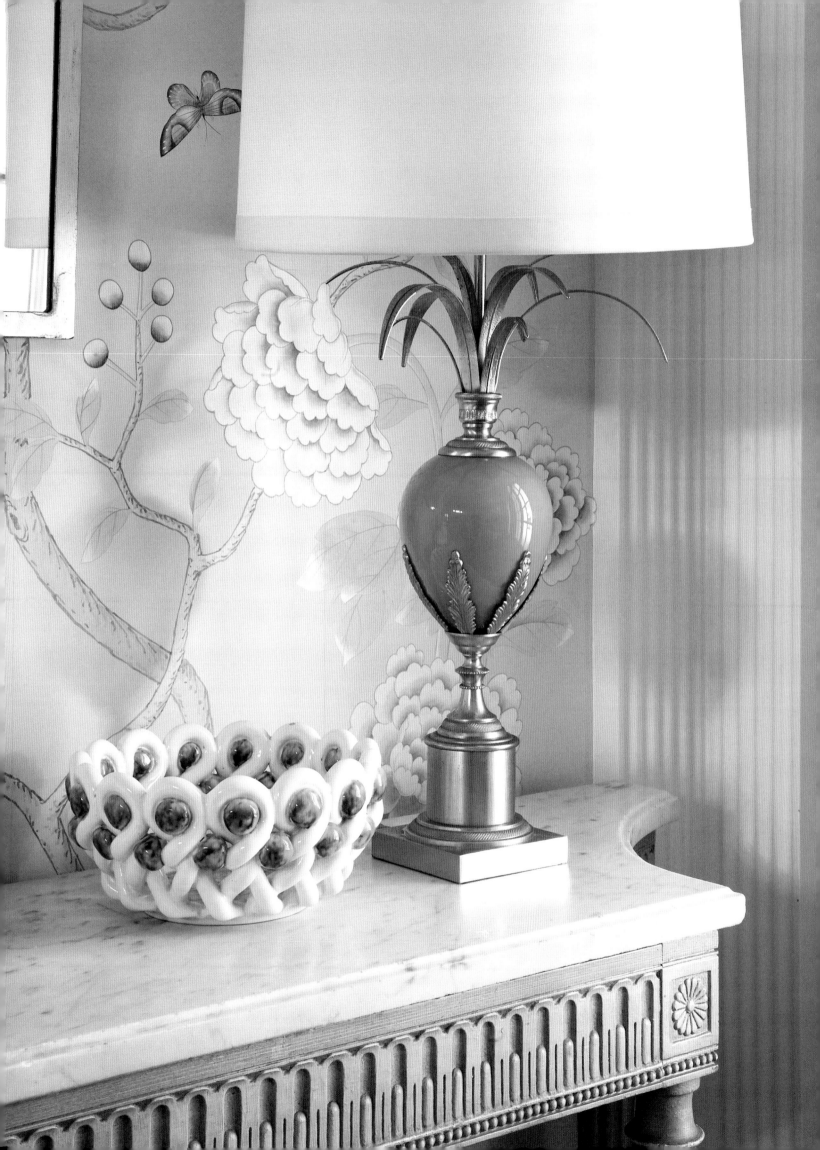

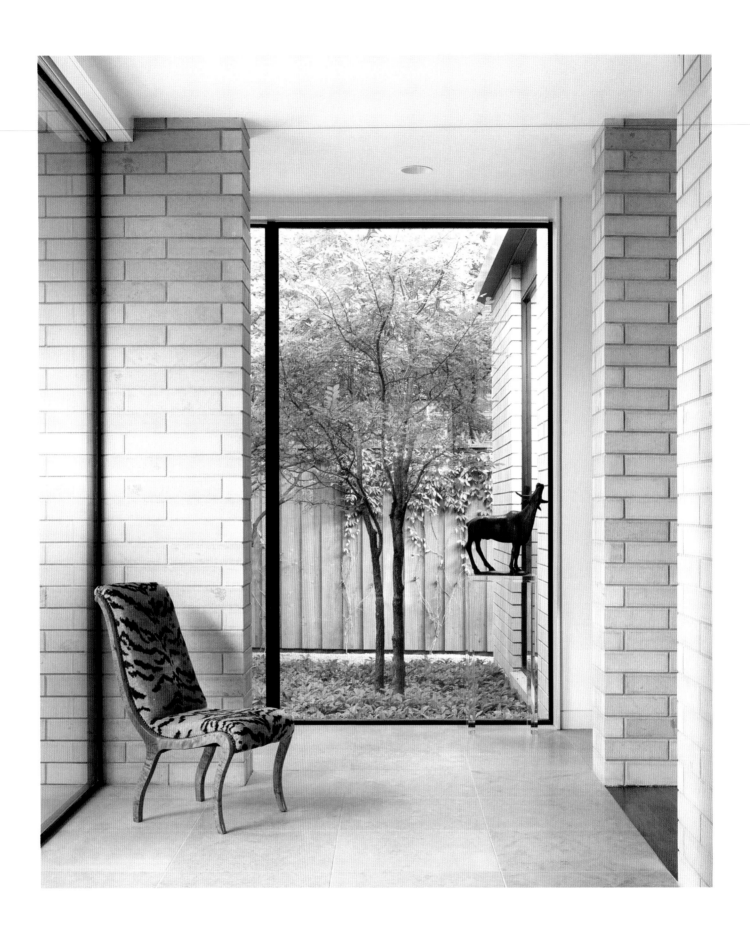

Above: A view of the side garden with antique sculpture and antique
Biedermier chair with Tiger Velvet by Brunschwig & Fils.
Opposite: Entry to a modern house in Dallas's Bluffview neighborhood.
Artwork by Celia Rogge, *London Reflections*, antique carved chest.

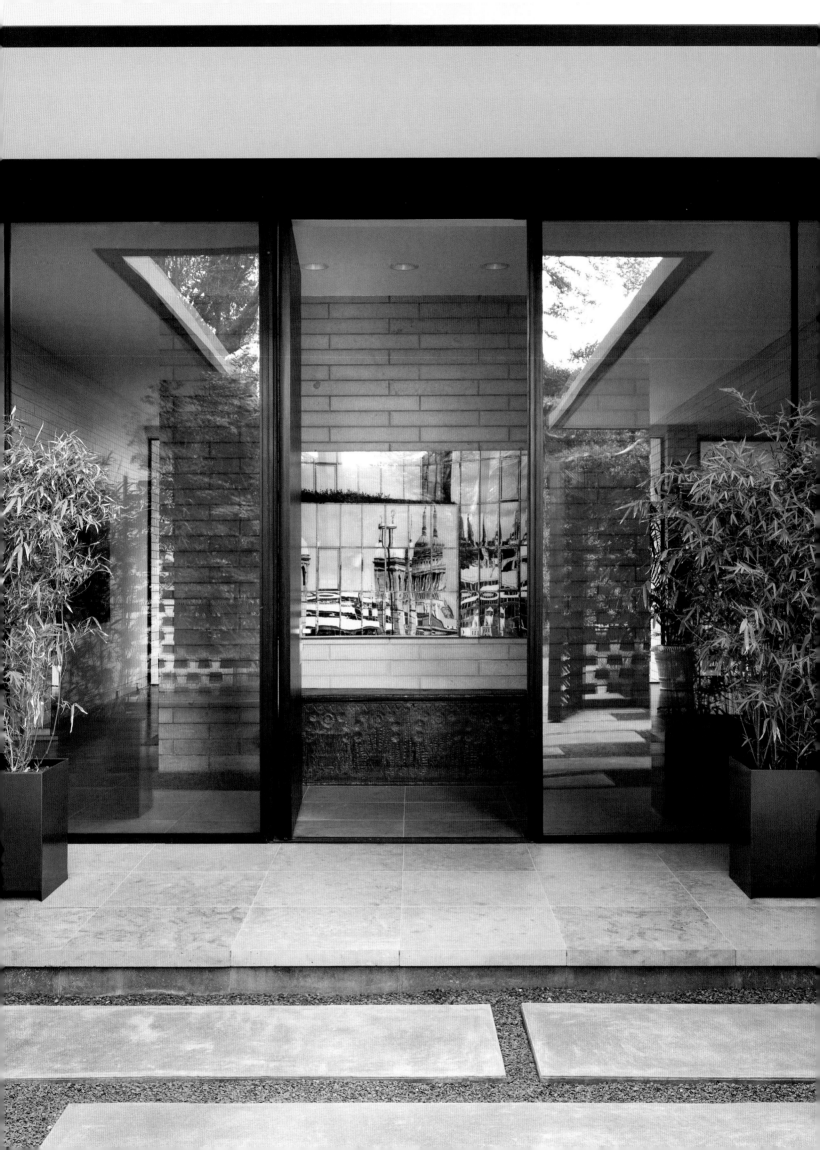

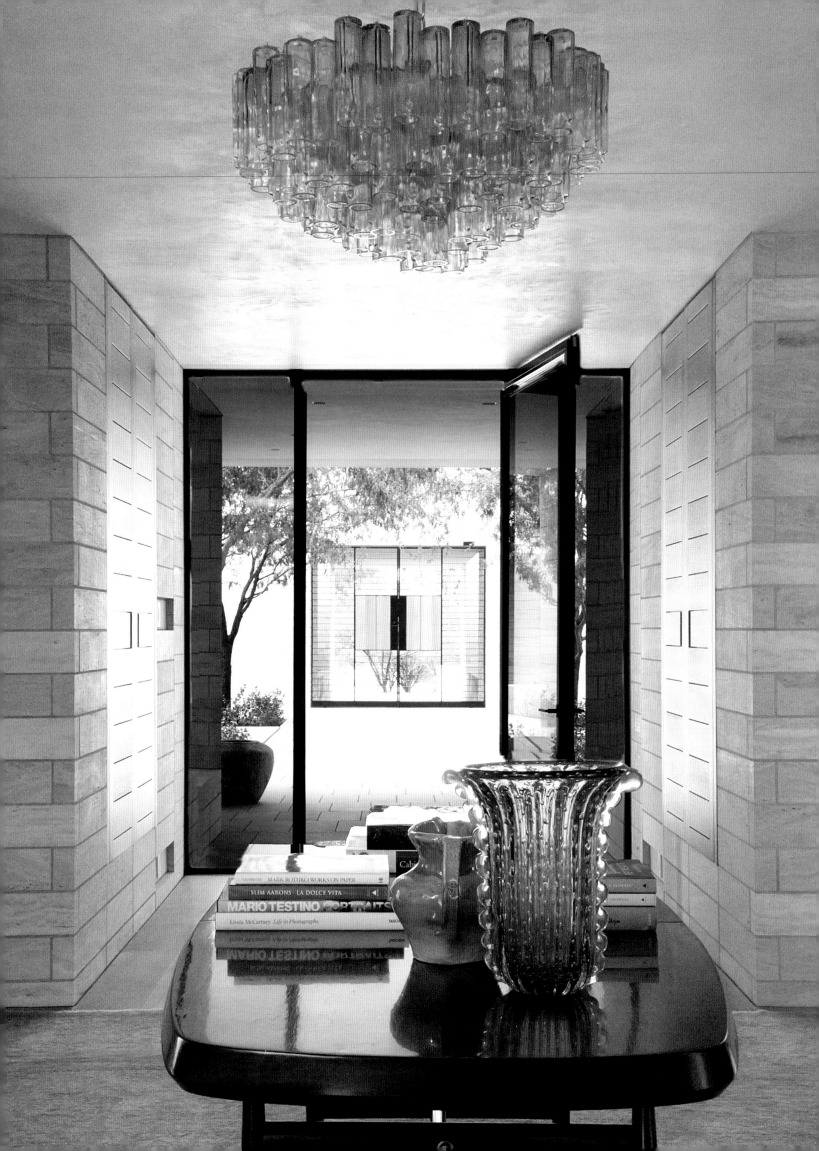

"I don't believe in saving the best of anything
for a special occasion."

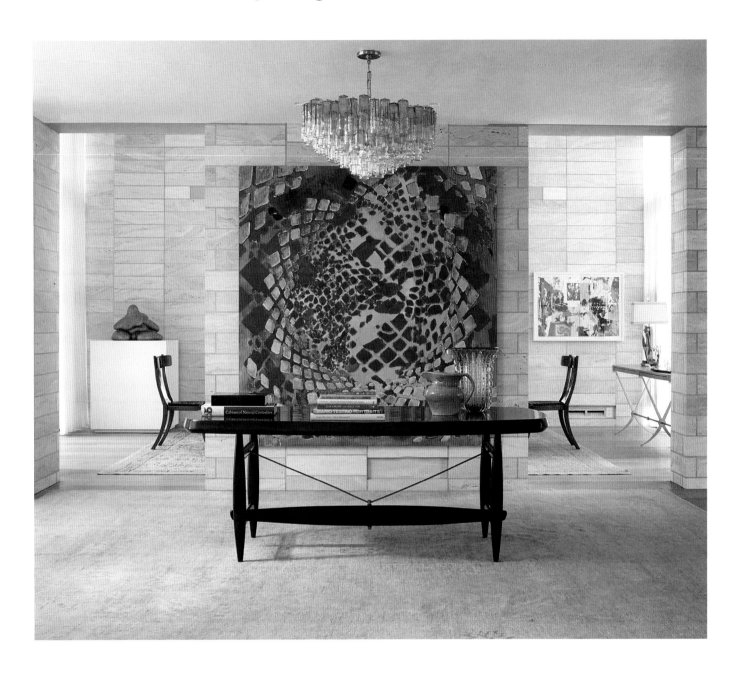

Opposite: Views to the outdoors are throughout this house, which was designed
by architect Marwan Al-Sayed. *Above*: Entry in Paradise Valley, Arizona. Venini chandelier,
c. 1950, rosewood table by Sergio Rodrigues, antique Oushak rug, art by Terry Winters.

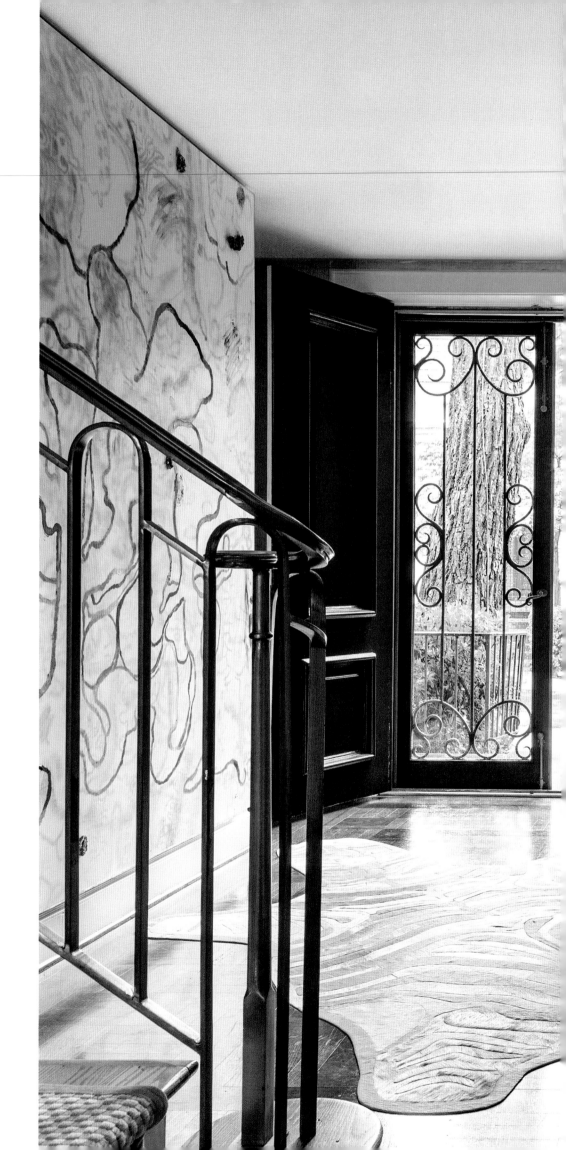

Entry in our Dallas townhouse
with a large painting by Michael
Williams and white zebra rug
by Kyle Bunting. At the time this
image was taken, I still had a
custom mirrored commode here.

36

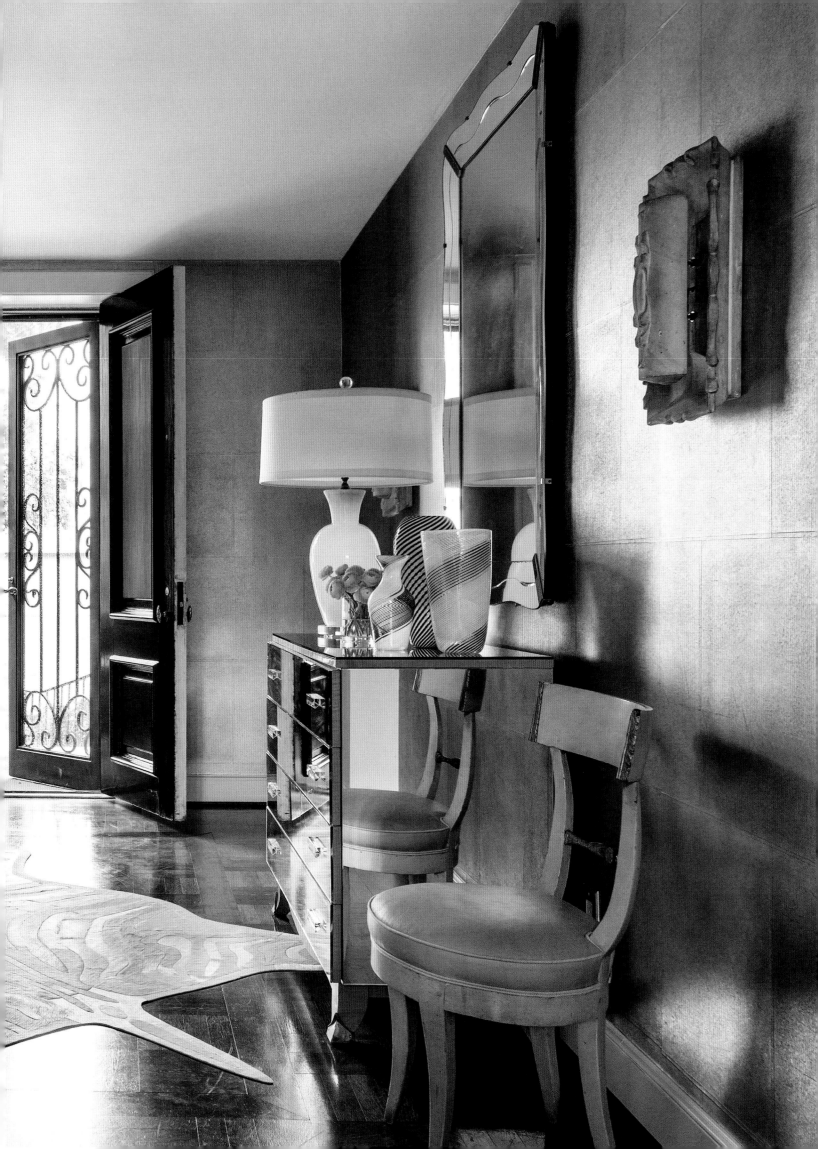

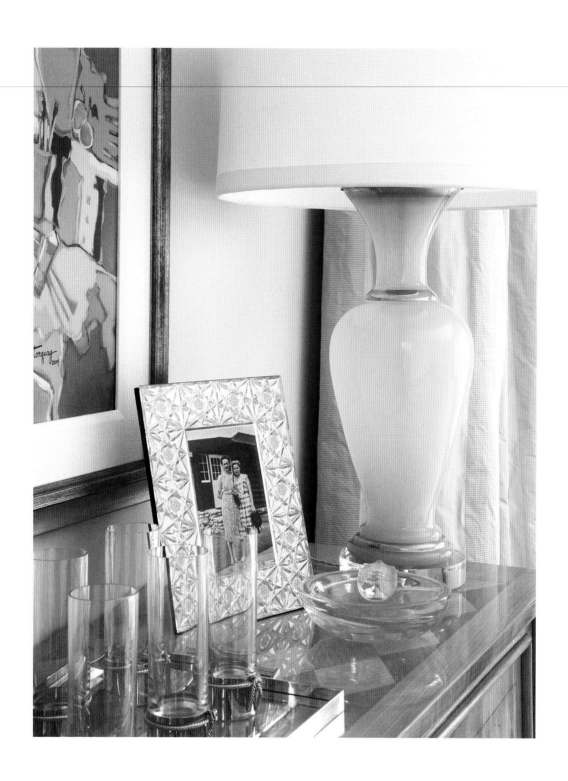

Above: An unusual, opalescent moonglow-colored vintage Murano lamp lights a hallway.
Opposite: The entry to my country house, built in 1938 and designed by Goodwin
& Tatum. A late-eighteenth-century painted-and-gilded console with a faux marble top
holds a pair of wooden column lamps with box space shades and beaded fringe.

Following spread: (*left*) A narrow entry in a Belgravia, London, townhouse with a
custom console and mirror. (*right*) The entry in a luxurious apartment in the
Mansion Residences on Turtle Creek in Dallas. The glass wall sculpture is by Christophe
Gaignon, the center table is the Oliver from the Jan Showers Collection,
and the chandelier is Murano from the 1960s.

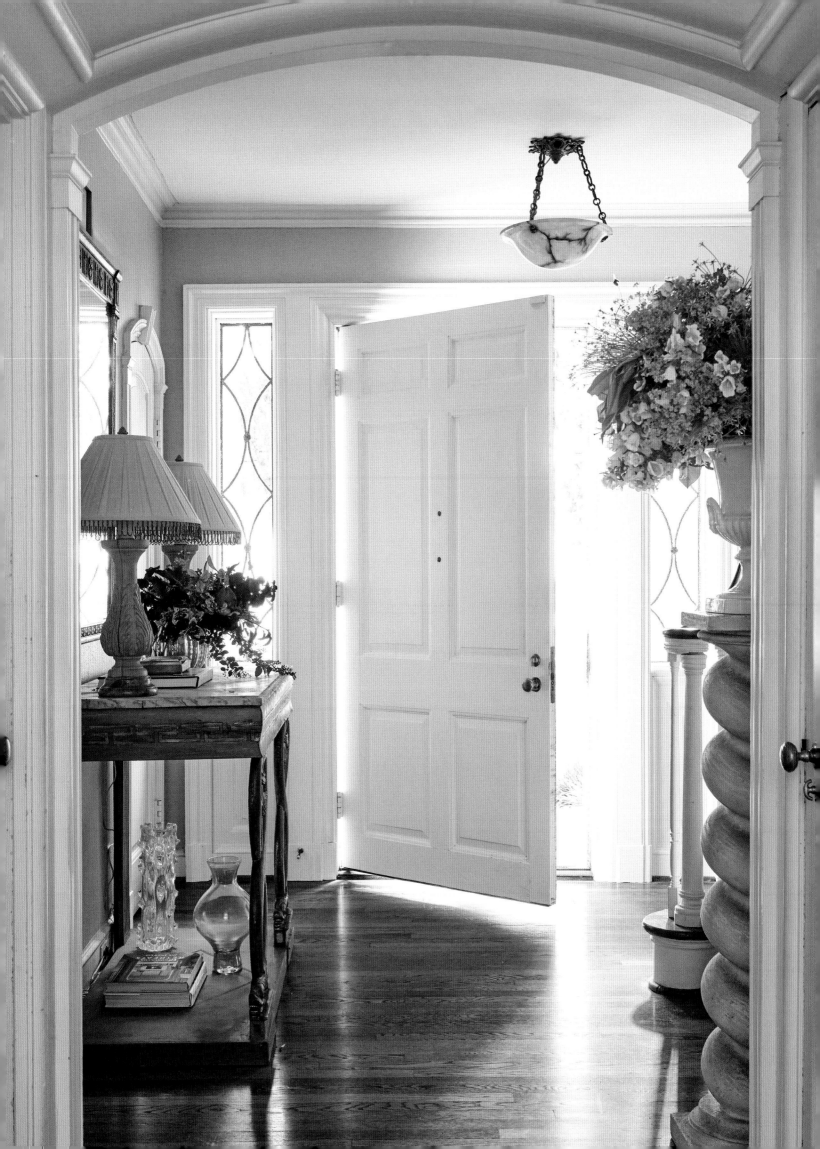

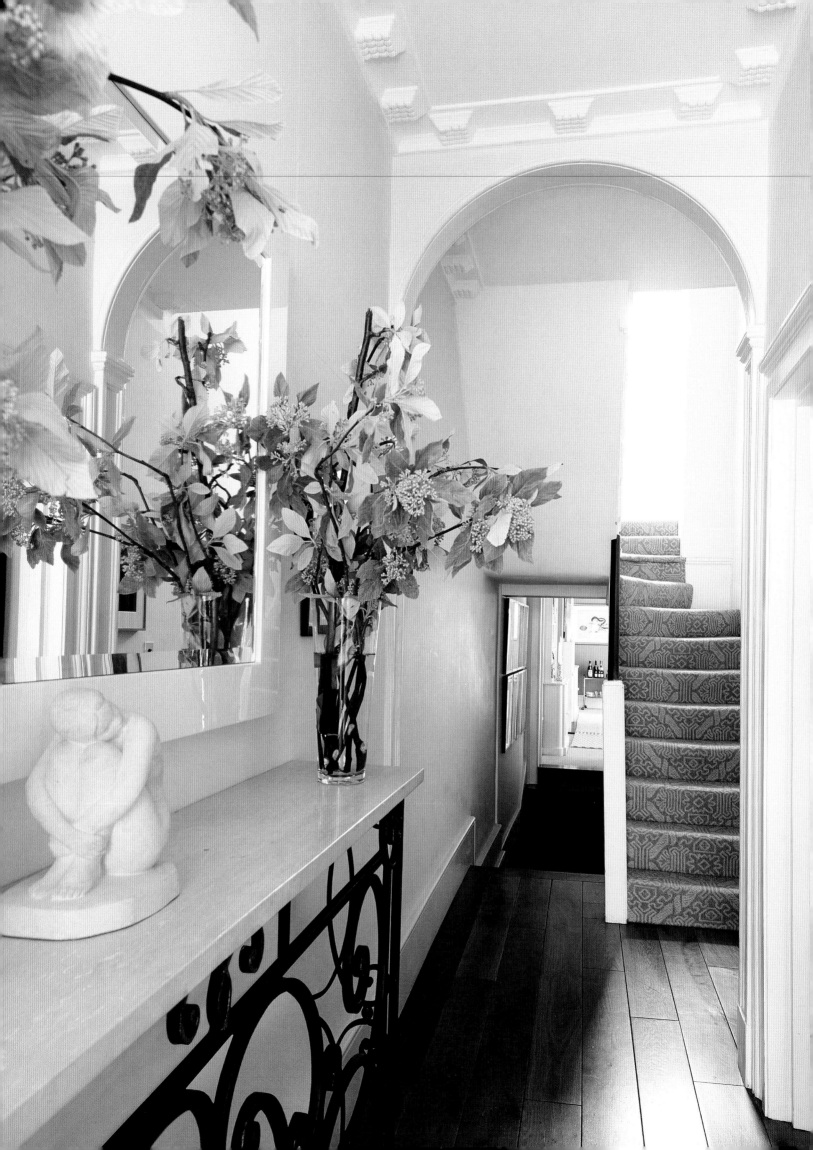

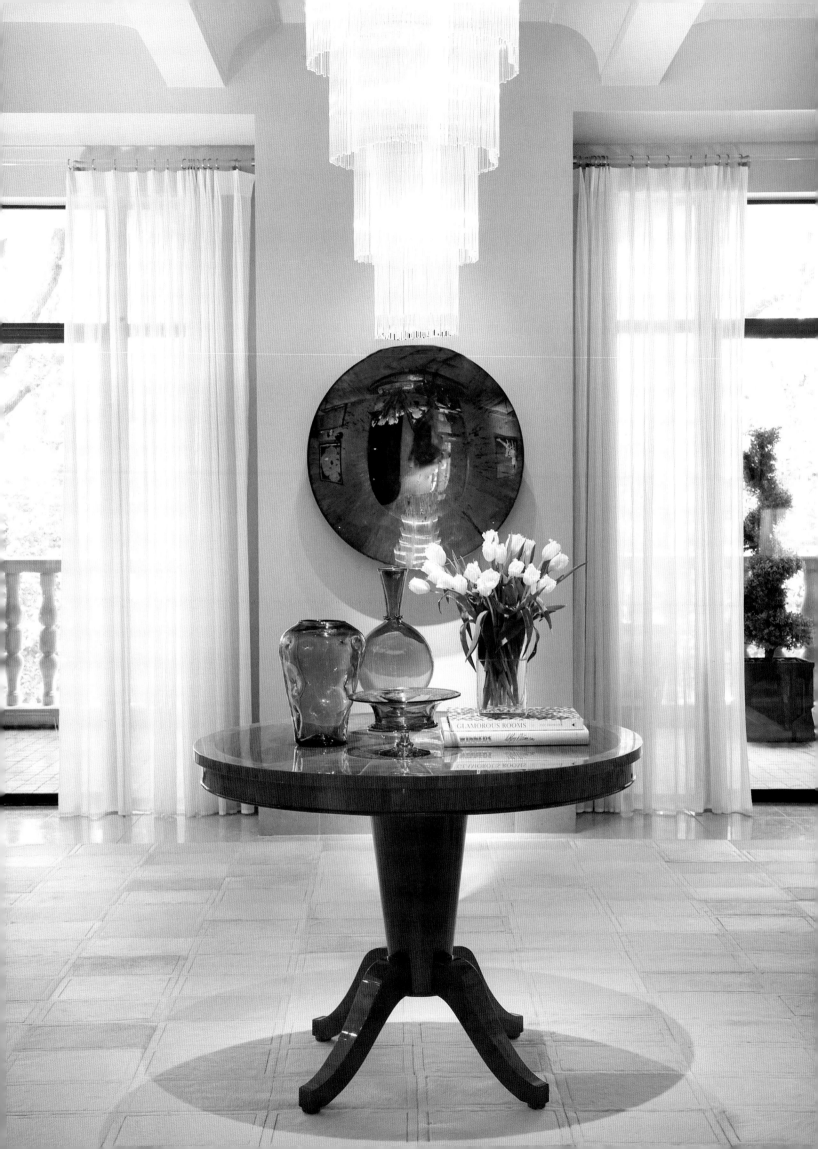

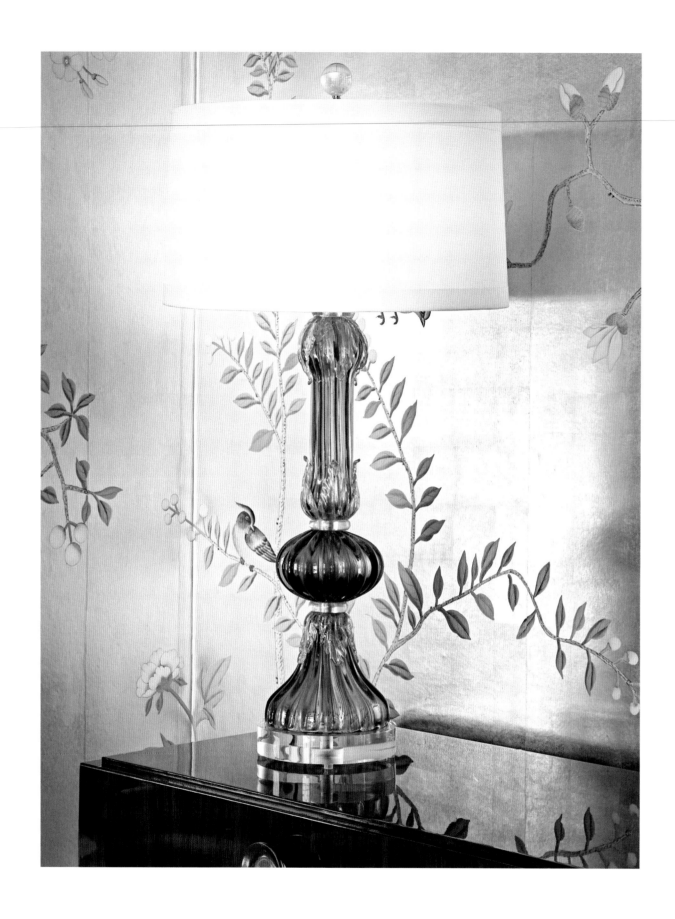

Above: A wonderful acid green Murano lamp with 22-karat gold accents sits in front
of custom white-gold hand-painted wallpaper by de Gournay. *Opposite*: A custom
demilune—inspired by a French piece from the 1940s, in hand-tooled leather, aged mirror,
and merisier—makes a statement below the round Murano mirror with an
parrot green glass frame, also from the 1940s.

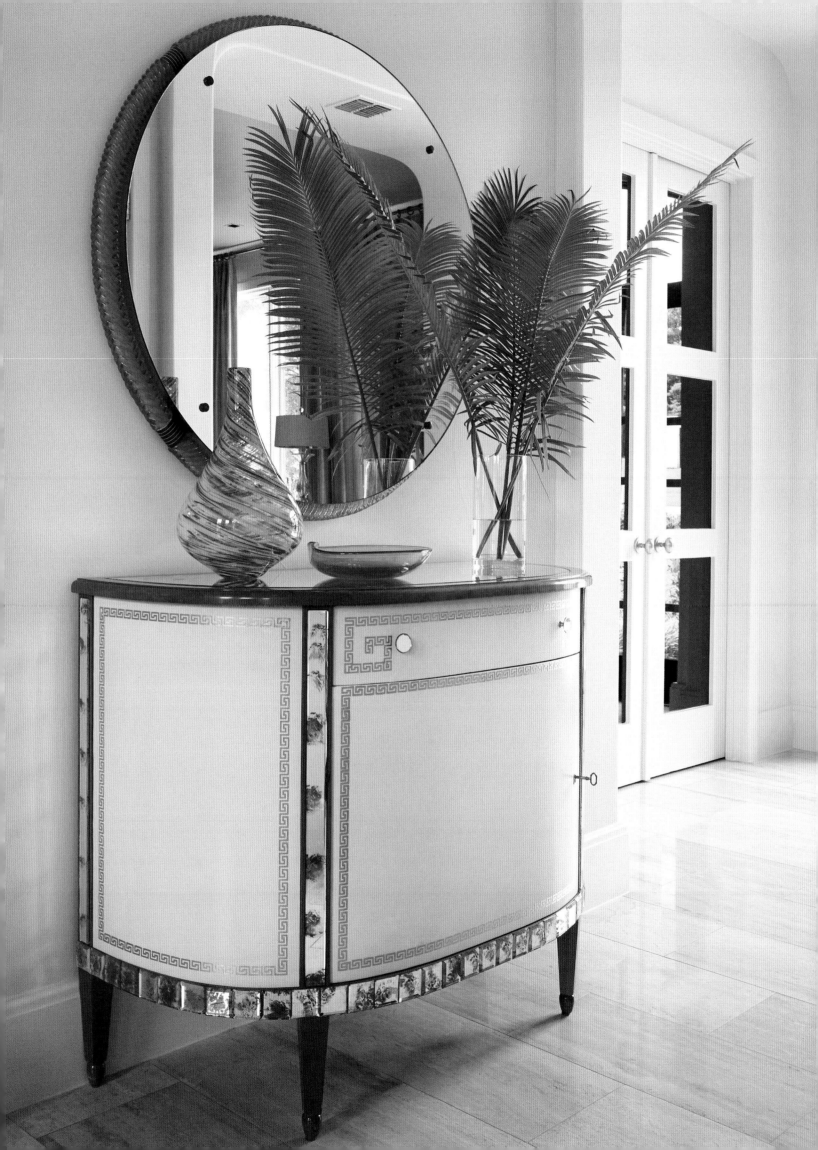

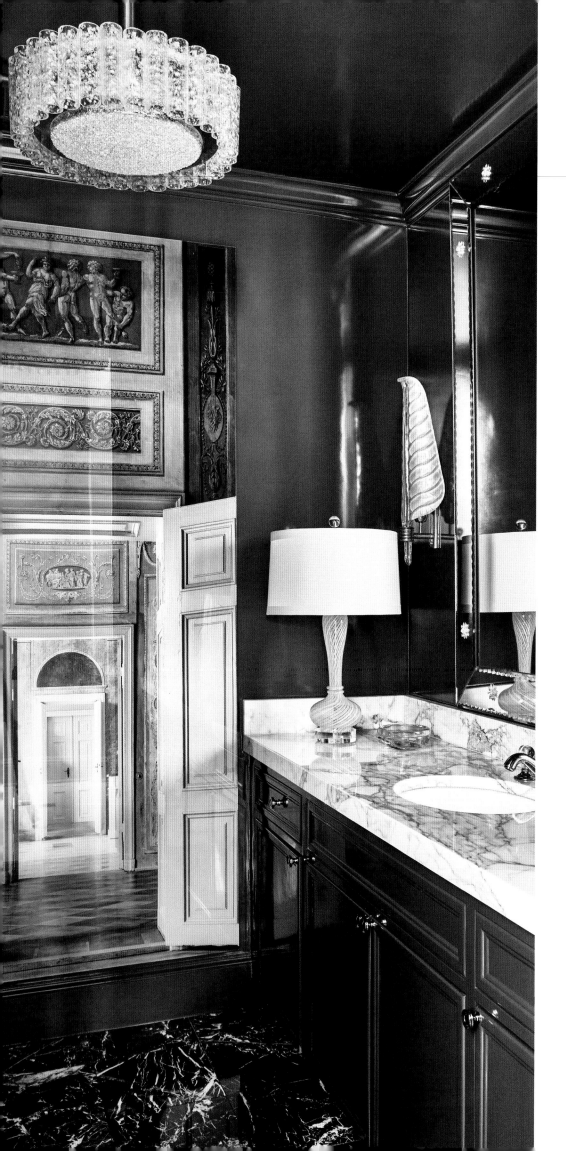

Left: A narrow powder room, lacquered in Hague Blue by Farrow & Ball in high gloss, is impressive with its stunning Murano chandelier from the 1950s, pale green Murano lamp and gold Murano-glass leaf sconces from the 1940s, and art by Celia Rogge. *Opposite*: Custom de Gournay white-gold-leaf hand-painted wallpaper with a French etched mirror from the 1930s on an onyx wall.

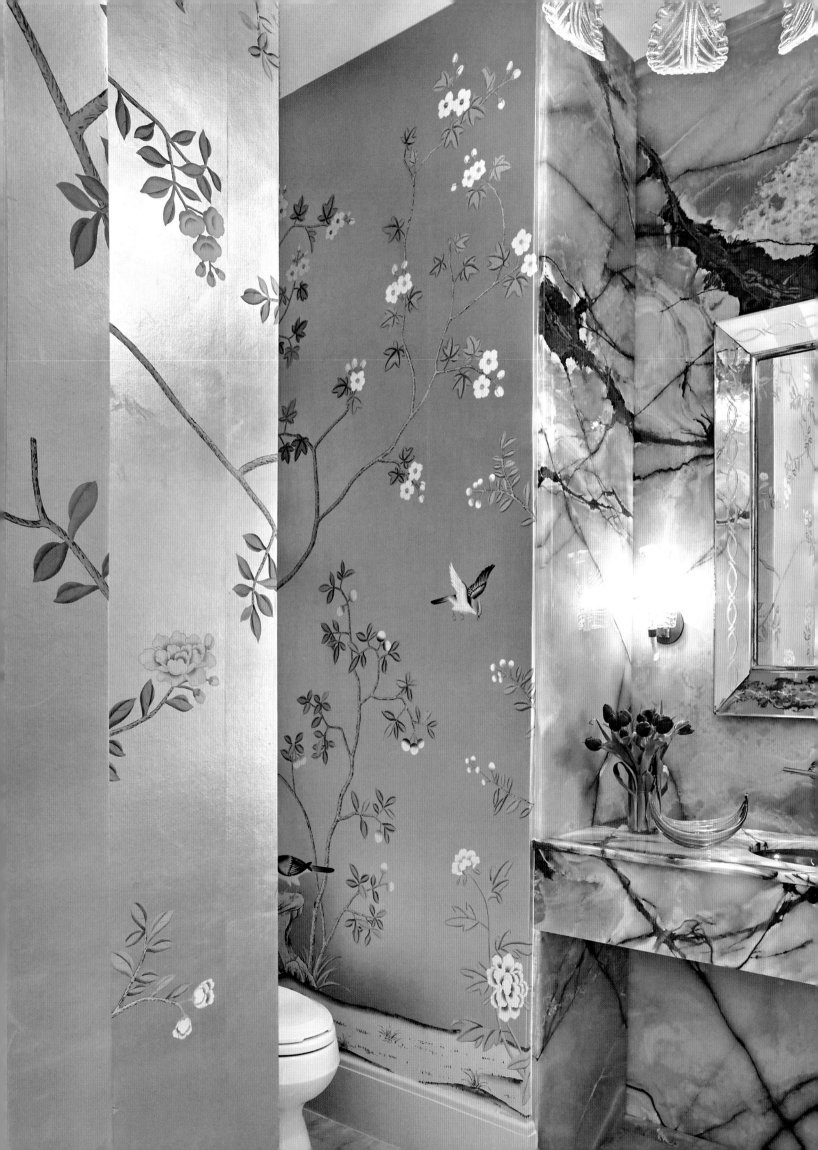

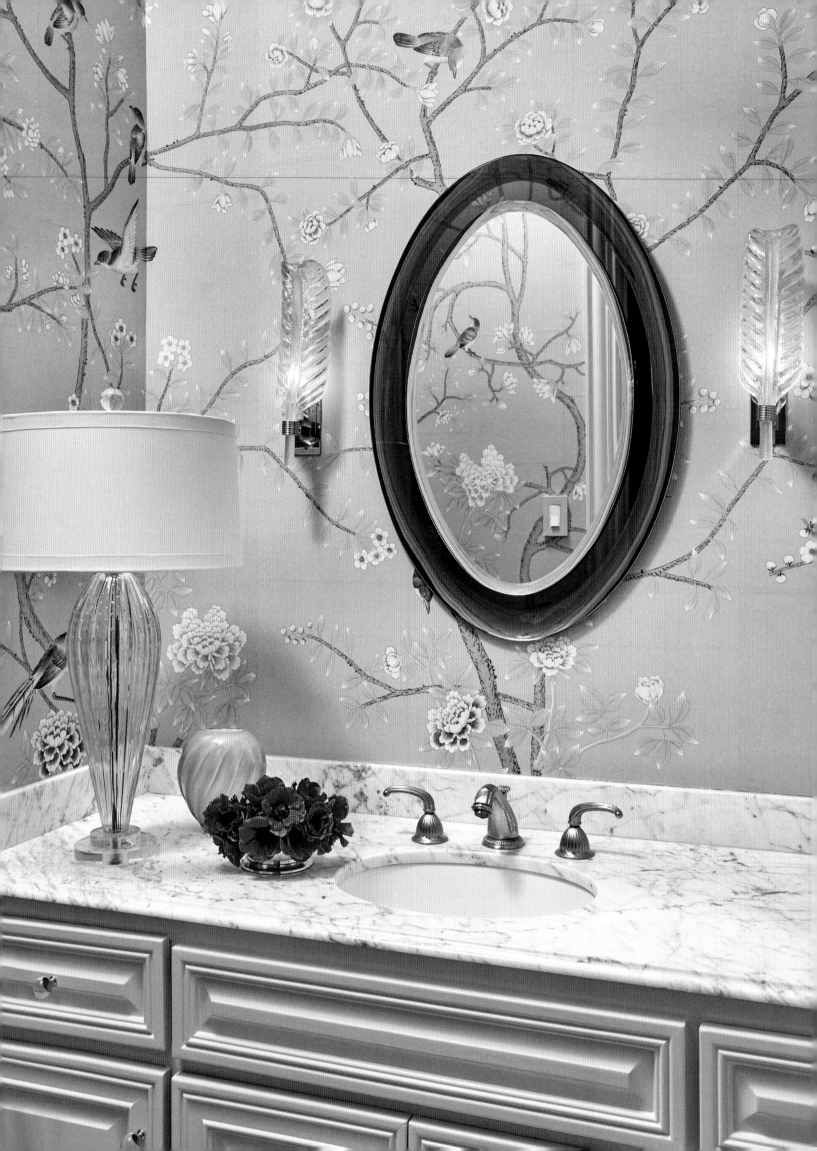

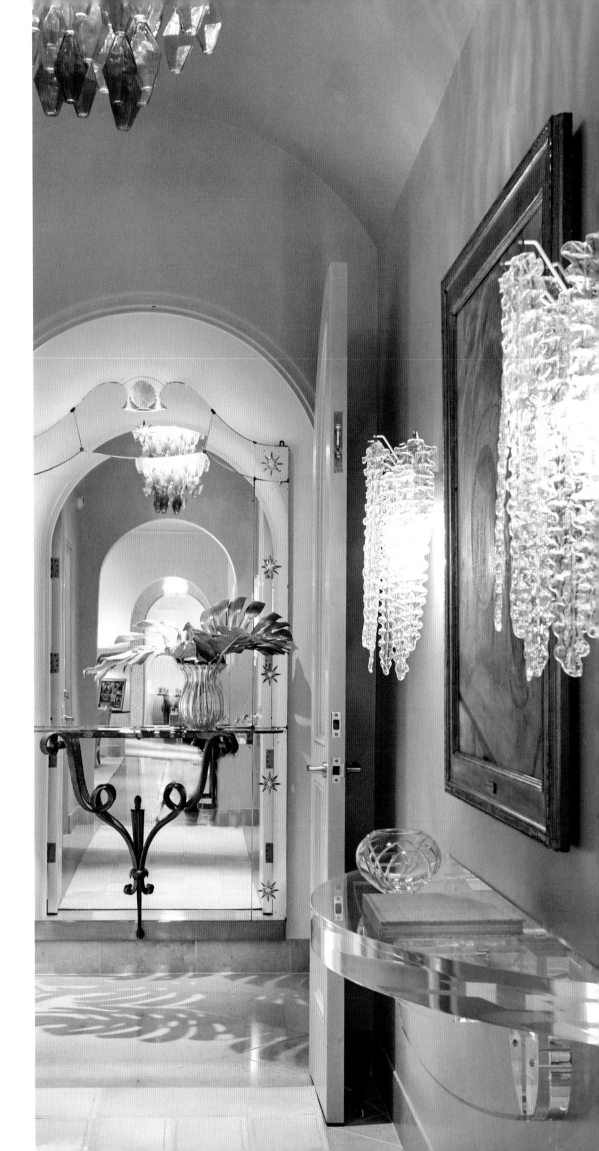

Opposite: A small powder room is turned into a jewel box with custom de Gournay wallpaper in Gentleman's Pink, a mirror by FontanaArte, and a lime-green Murano lamp. *Right*: An überglam hallway to a lady's bedroom with "icicle" Murano sconces and a wonderful etched Italian hall mirror, c. 1940, reflecting the gallery.

Gracious LIVING

My philosophy is that every room of the house should be equally comfortable and inviting. I don't believe in spaces that are sacred or reserved for use only when entertaining. For that reason I tend to avoid the term "formal living," which can perpetuate a sense of foreboding about a part of the house I would like to see people use much more liberally.

In living rooms, especially, my aim is the creation of visual complexity, a blend of textures and styles. Rooms centered on achieving a sense of sameness—same colors, same era, same texture or fabric—are almost always unwelcoming and, frankly, passé. If the pillows match the drapery, which matches the rug, which matches the wall color, it's going to feel formulaic. Period.

I love when my clients have collections, all the more so when they're passionate about them, but I can't bear displaying them in fusty glass cabinets where people seldom stop to enjoy them. Surround yourself with the things you love. Place them on the surfaces around you. Let them create depth and complexity in your environment.

No decorative item creates a greater sense of depth than books. People tend to reserve bookcases for use in a library or study, but I love to see them in public rooms. When I walk into a house with no books, I immediately wonder about the people who live there. If you have a variety of books at arm's length on tables as well as bookcases, you know one could never be bored. I love when a book catches a guest's eye and they begin paging through it.

As often as possible, I opt for large coffee tables with room to display collections and books in addition to providing ample space for drinks and hors d'oeuvres. A beautiful coffee table has the potential to be any room's little black dress.

Your living room will likely be the most glamorous room in your house, but the real glamour comes from living in these rooms with comfort and confidence.

Jan and Jim, post–dinner party, relaxing in the living room of their country house on a Napoleon III sofa. Matisse drawings flank the Napoleon III gilded mirror.

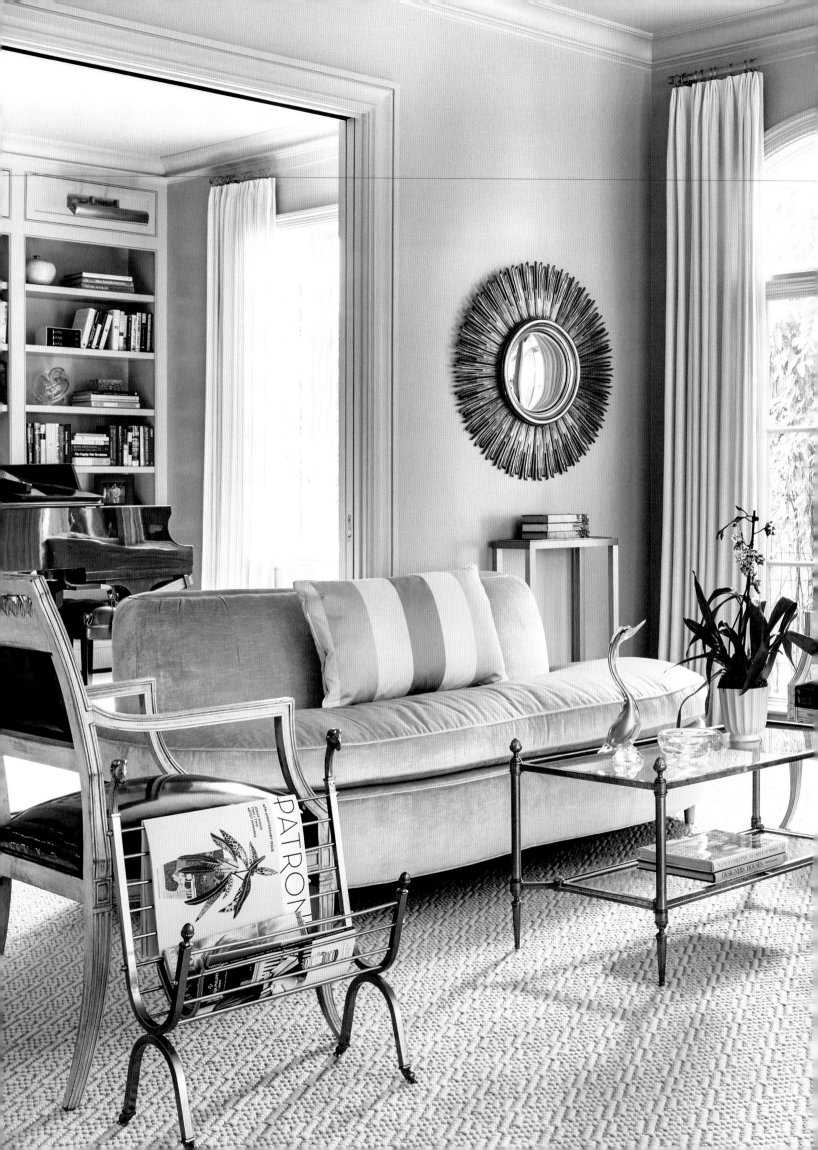

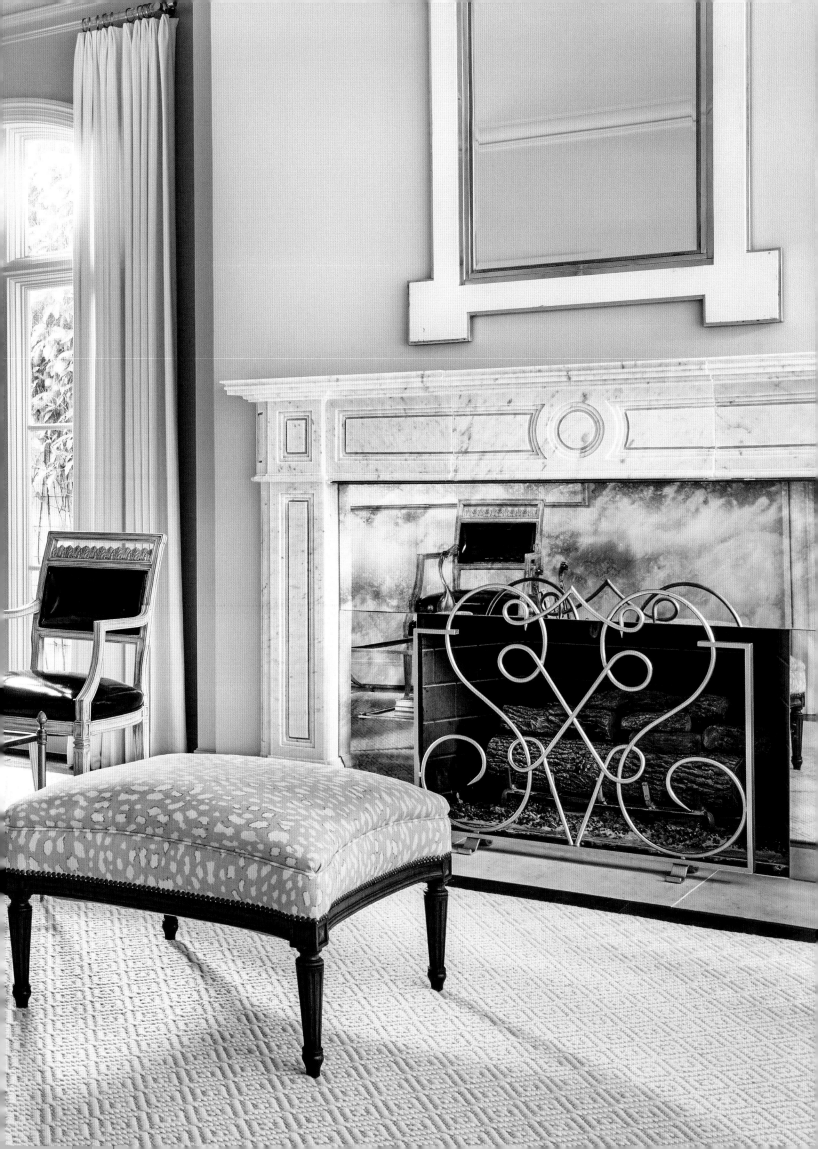

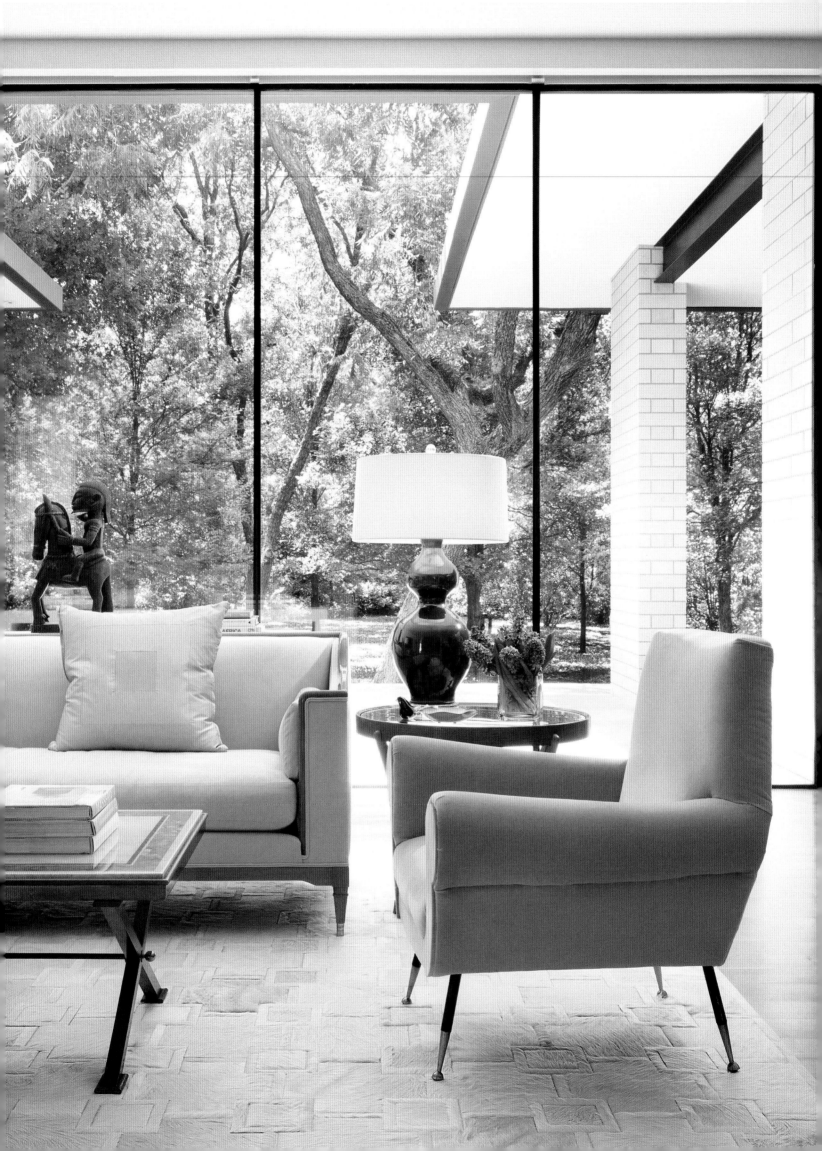

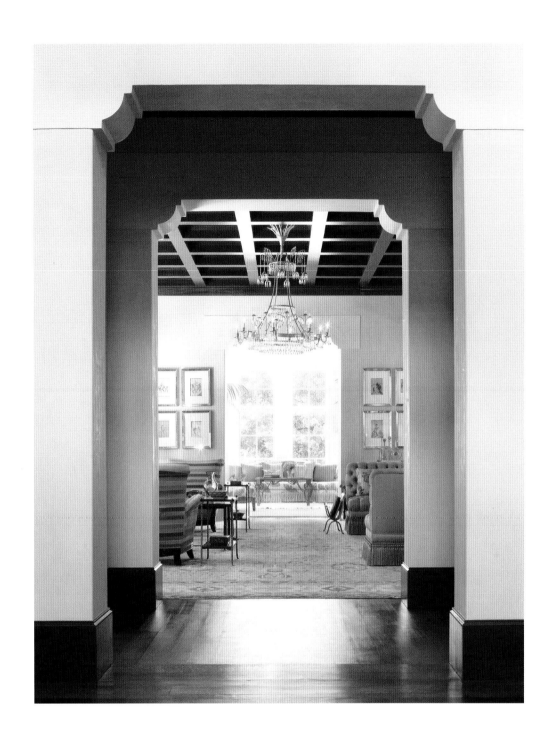

Previous spread: Seating area of a glamorous living room in Highland Park, Dallas, with a custom Kravet Riviera banquette, a 1940s French brass, nickel, and glass cocktail table, and a nineteenth-century French Louis XVI–style ottoman upholstered in Lynx Dot by Kravet Couture. Fire screen is a custom design by Jan Showers & Associates; the rug is by Stark. The mirror over the custom-designed marble mantel is from the 1960s, designed by Alain Delon, best known as a French actor and movie star.

✳

Opposite: A corner of a living room in a modern Bluffview, Dallas, house with an Italian chair from the 1960s and a Maison Jansen bronze coffee table with a highly glazed faux marble top sitting atop Glamorous, a Kyle Bunting rug by Jan Showers. The lamp is by Paul Schneider Ceramics. *Above*: Enfilades from entry to living room to solarium in a Preston Hollow, Dallas, house. A stunning nineteenth-century Swedish chandelier hangs in the living room.

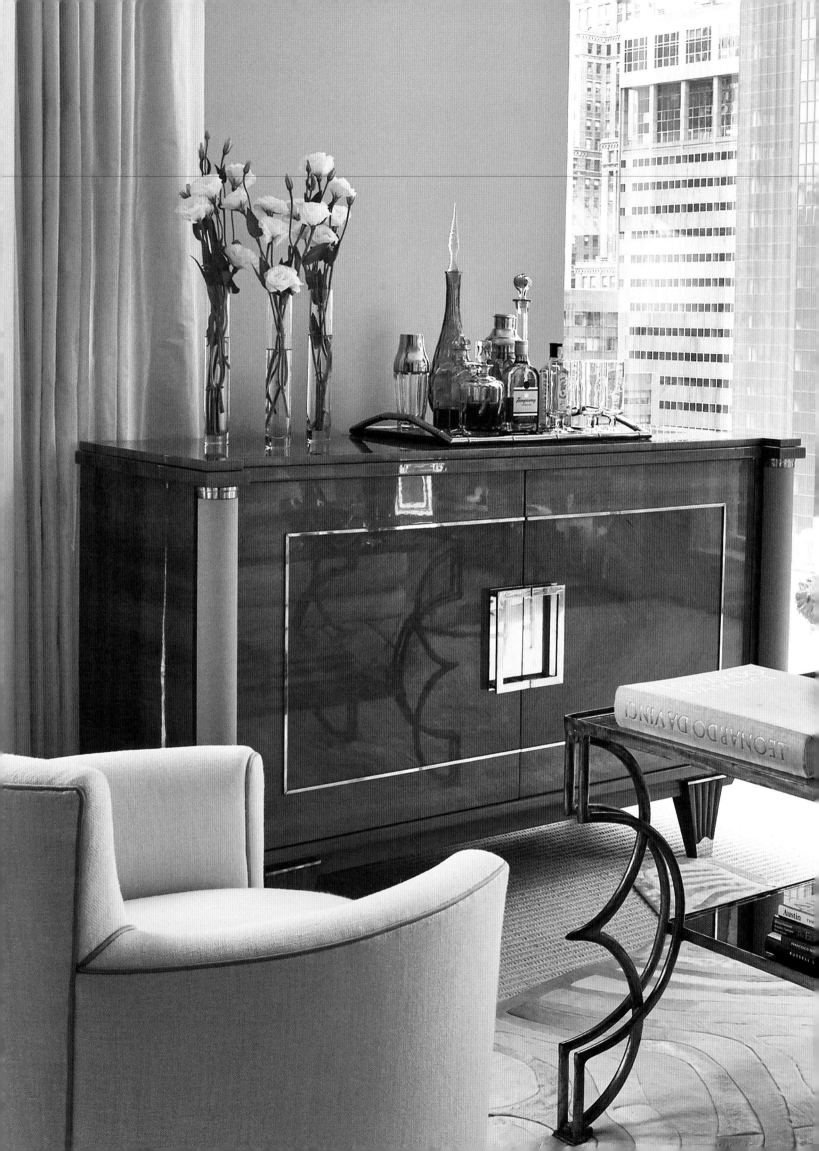

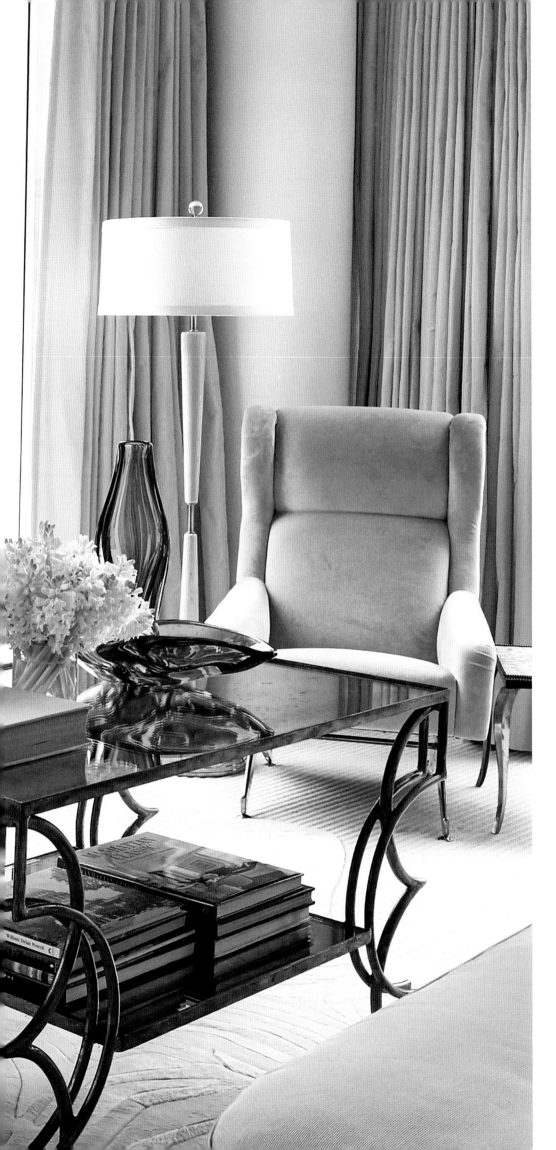

A New York apartment filled with pieces from the Jan Showers Collection. *From the left in foreground*: the Daphne Chair, the Holden Credenza, the Sabine Coffee Table, the Milan Floor Lamp, and the Milan Chair. The white zebra rug is by Kyle Bunting.

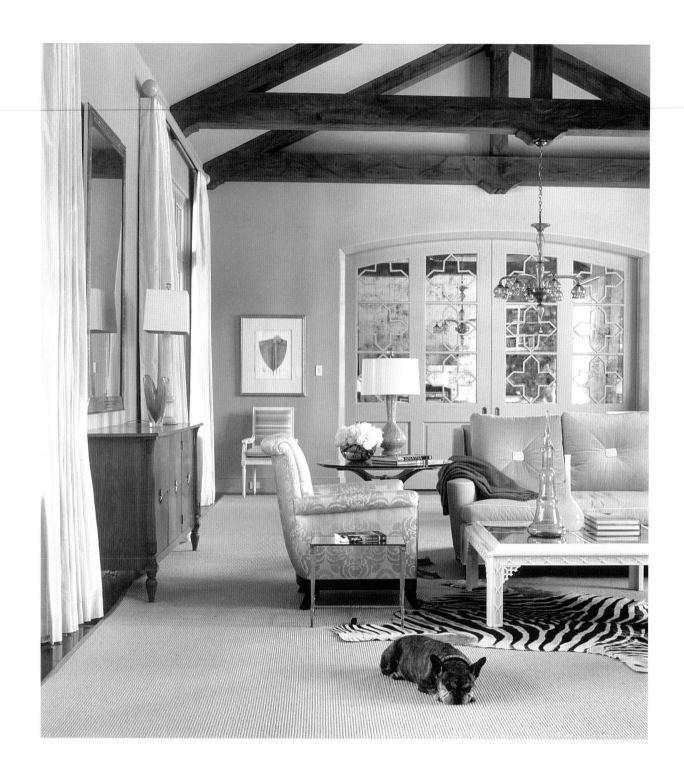

Above: The living room of a glamorous French country house in Tulsa with Hollywood
Regency accents and the owner's French bulldog. *Opposite*: The second-floor reception
room in a Belgravia townhouse in London with wonderful vintage finds from the owner.
The art is by Fiona Rae and the rug by the Rug Company. Commode with parchment detail
to left by Suzanne Guiguichon with lamp by Maison Charles. Marnie Chair, custom
pillows, and Villa Sofa from the Jan Showers Collection.

Following spread: Another view of the second-floor reception room in Belgravia with
a pair of Italian Zanuso chairs and a Warhol edition over the mantel with a
Lucian Freud edition to the left. The owner has a wonderful eye and found the monumental
brass bird sculptures in Paris.

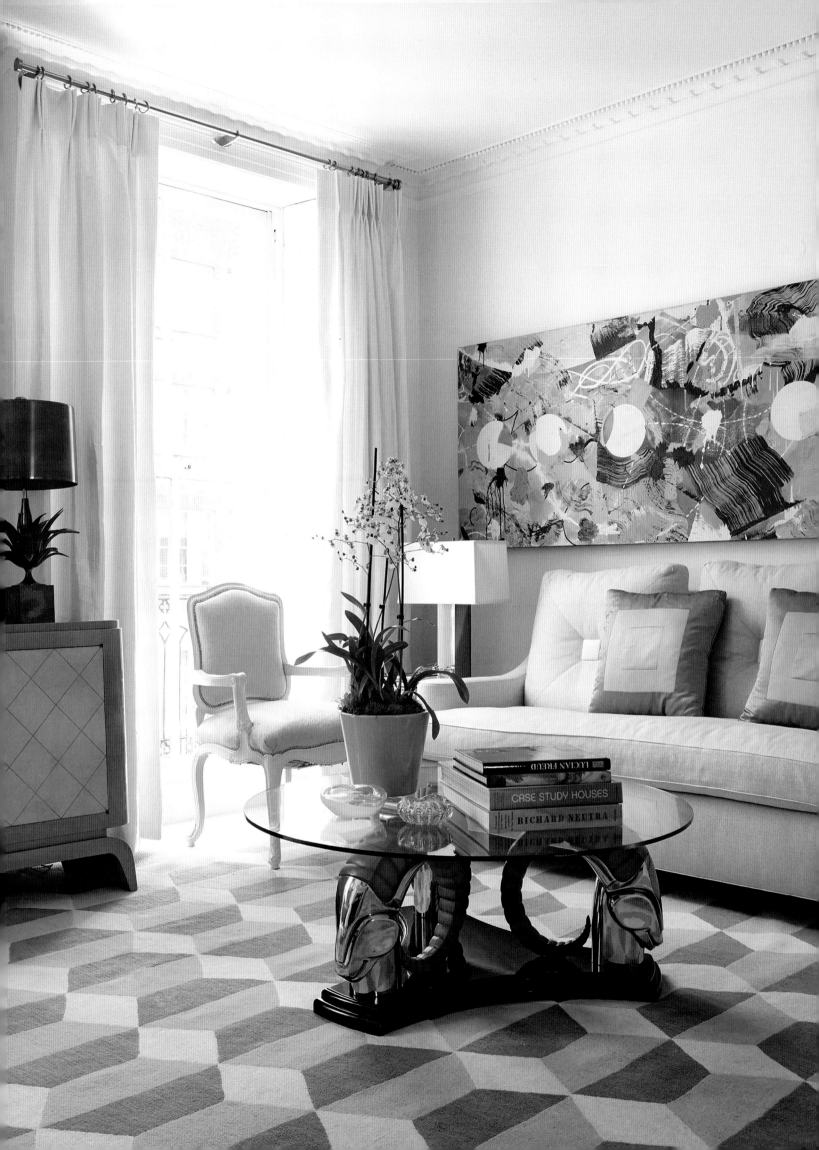

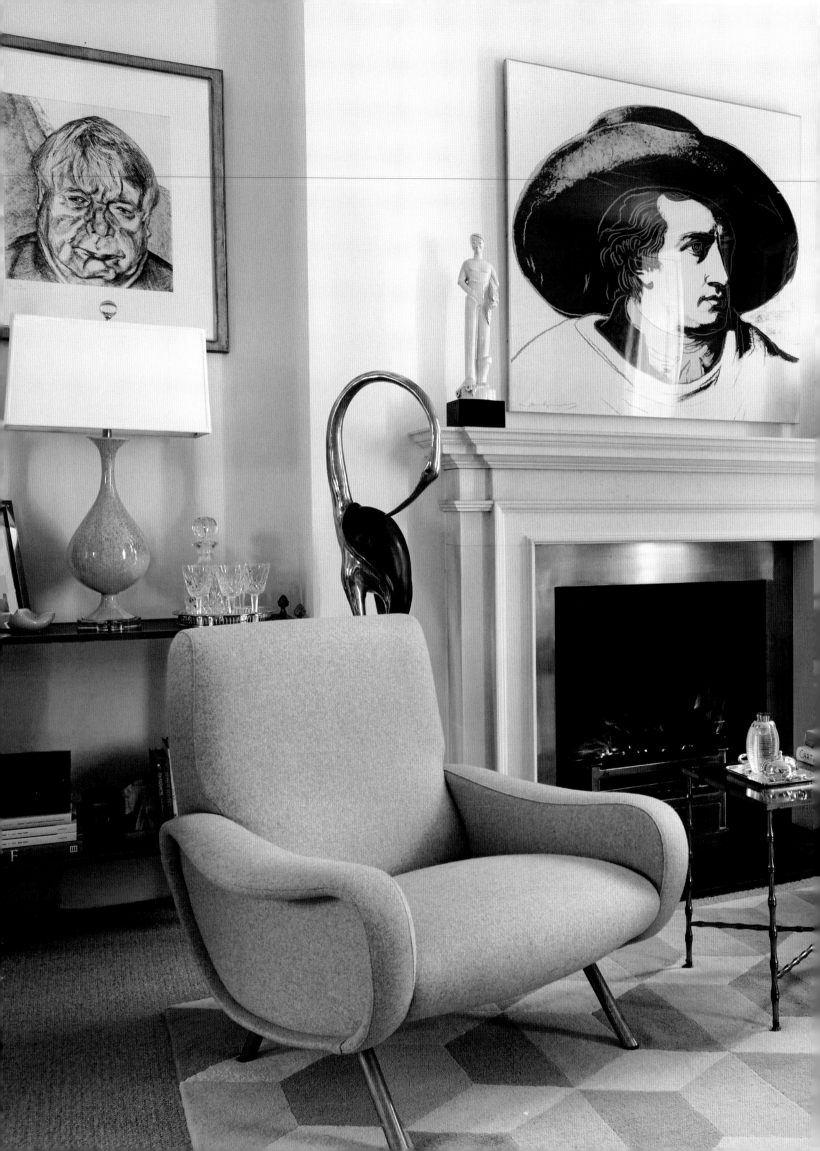

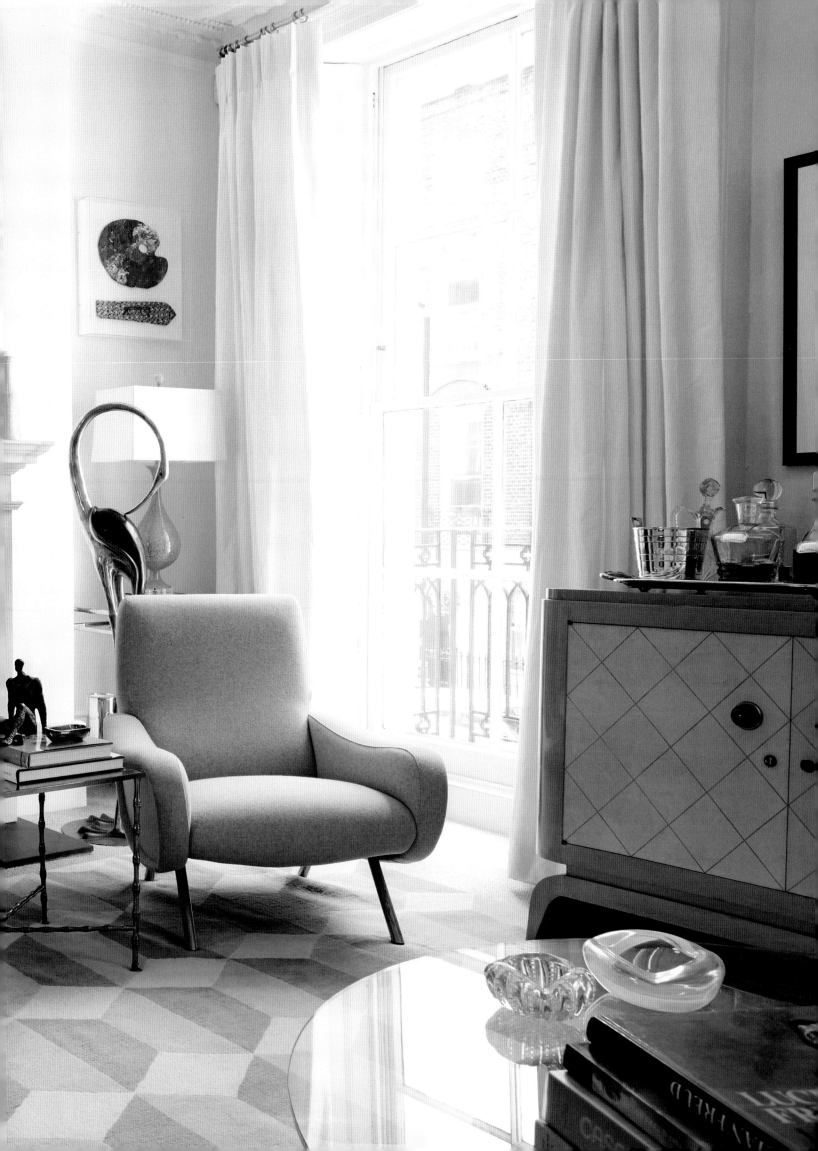

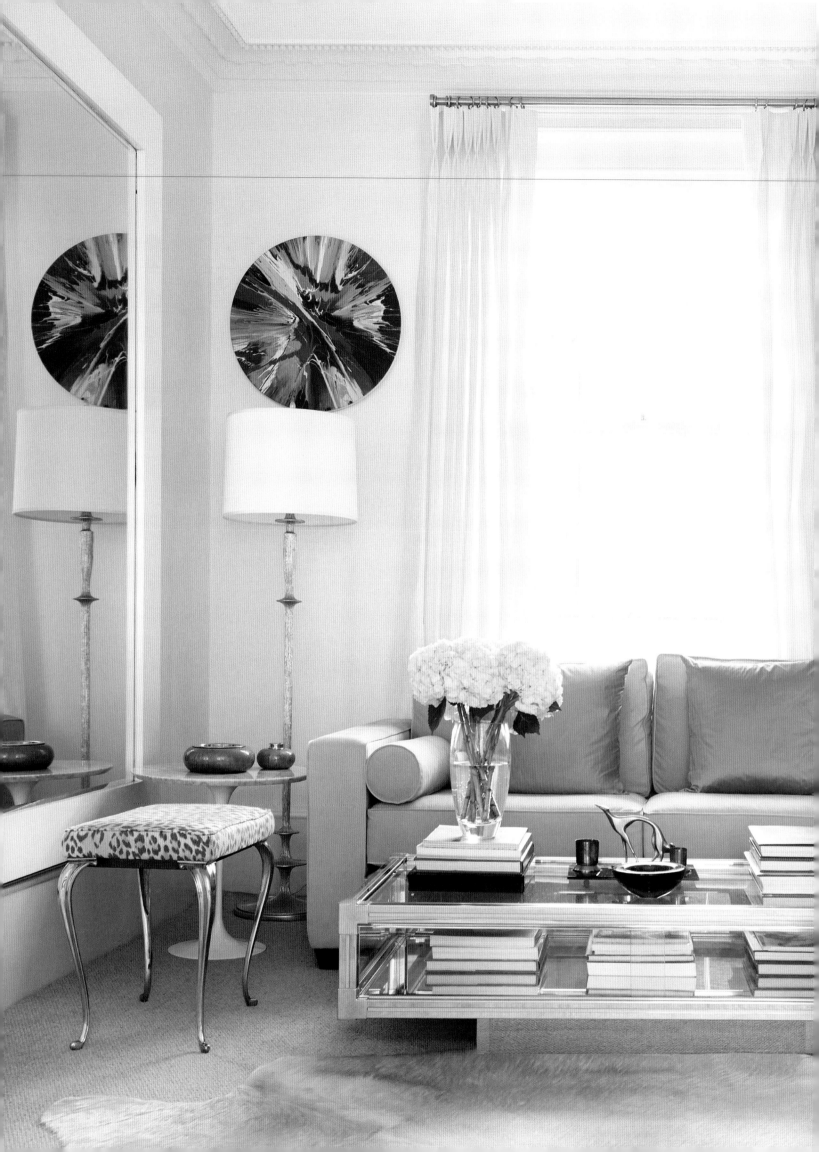

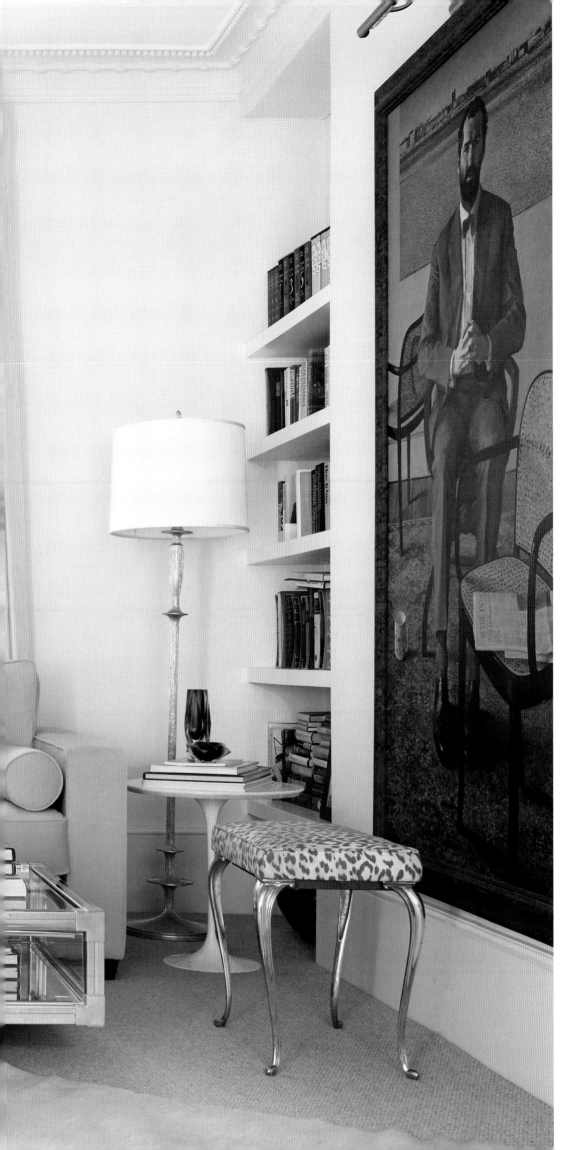

A cozy corner of the Belgravia
townhouse, great for two
to four people for drinks or
for overflow with a large group.
The "floating" coffee table
from the 1960s is one of my
favorites. A Damien Hirst
"Spin" painting is to the left of
the window, and a portrait
of the owner is on the right.

*"Surround yourself with the
things you love."*

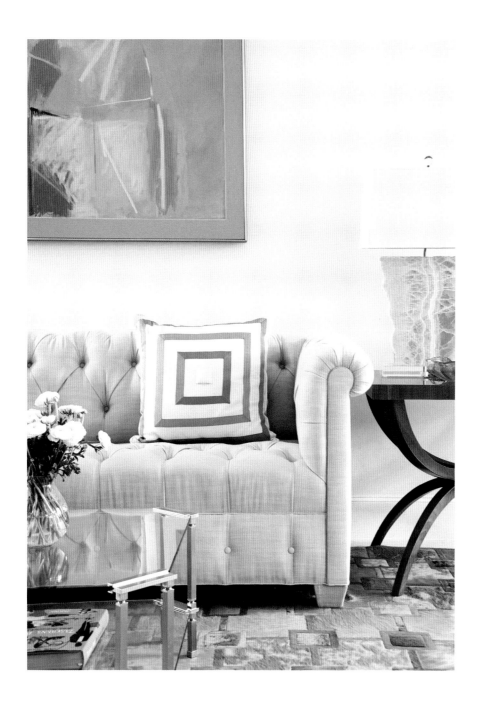

Above: A quiet corner in a living room in Highland Park, Dallas. A blue linen
Chesterfield Sofa with custom Dividend pillow by Jan Showers & Associates. The table
to the right is the Alfred from the Jan Showers Collection with a custom mineral lamp.
All are sitting on a Glamorous rug by Kyle Bunting. *Opposite*: Another view of the living
room in our Dallas townhouse with custom designed bookcases, an eighteenth-century
limestone mantel, a custom Murano chandelier made for the townhouse, and a Harrison
Coffee Table from the Jan Showers Collection in the foreground. Art by Freeman
and Lowe. Custom fire screen and surround designed by Jan Showers.

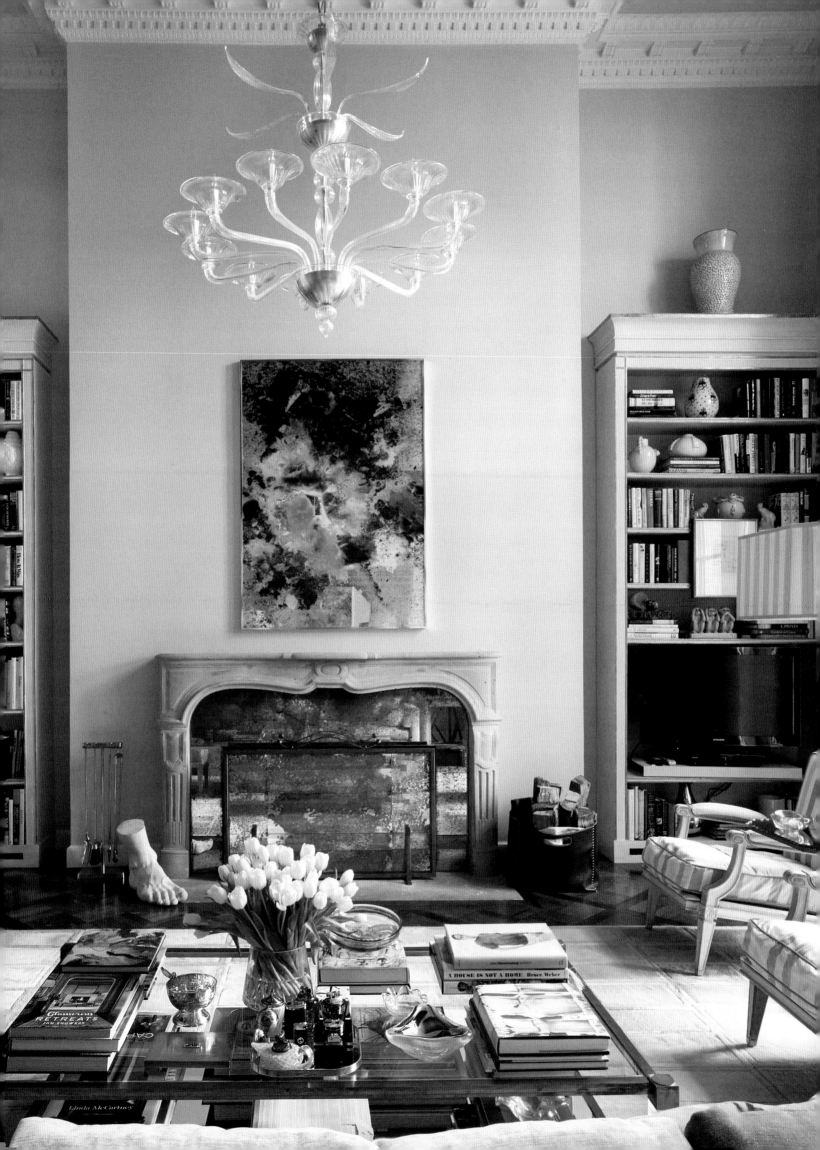

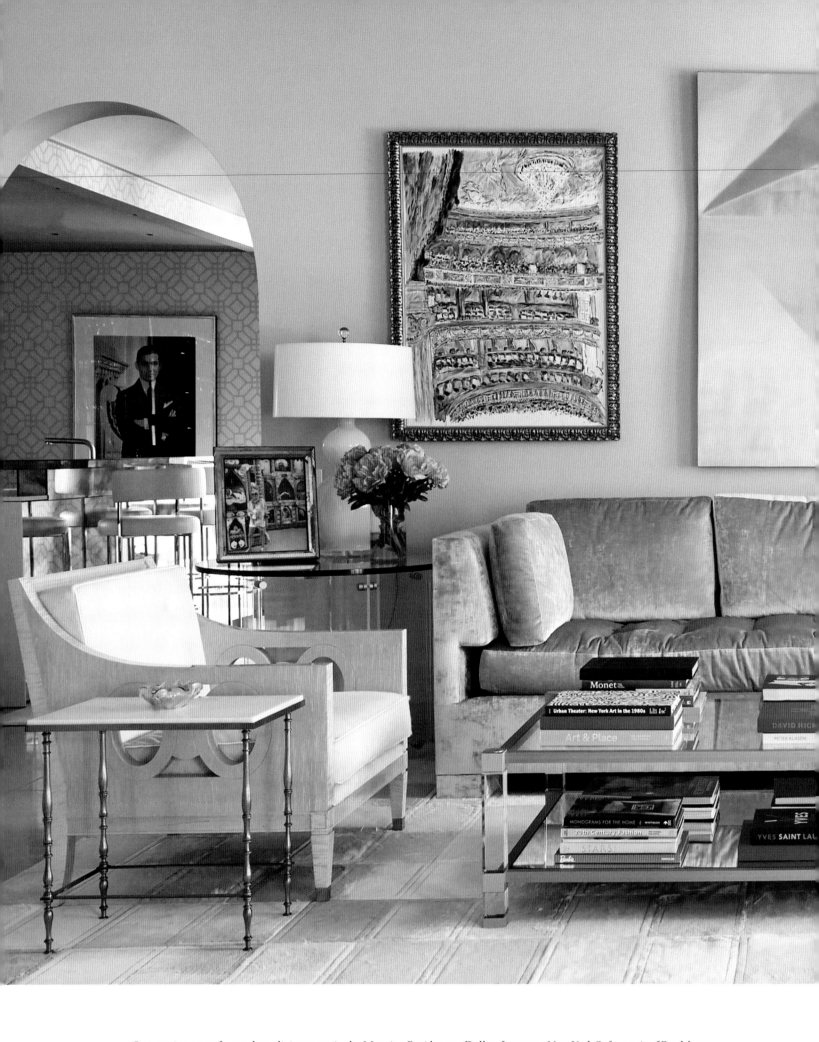

One seating area of a very large living room in the Mansion Residences, Dallas, features a New York Sofa, a pair of Bradshaw Chairs, a Harrison Coffee Table, and a Milan Floor Lamp, all from the Jan Showers Collection. Art by owner.

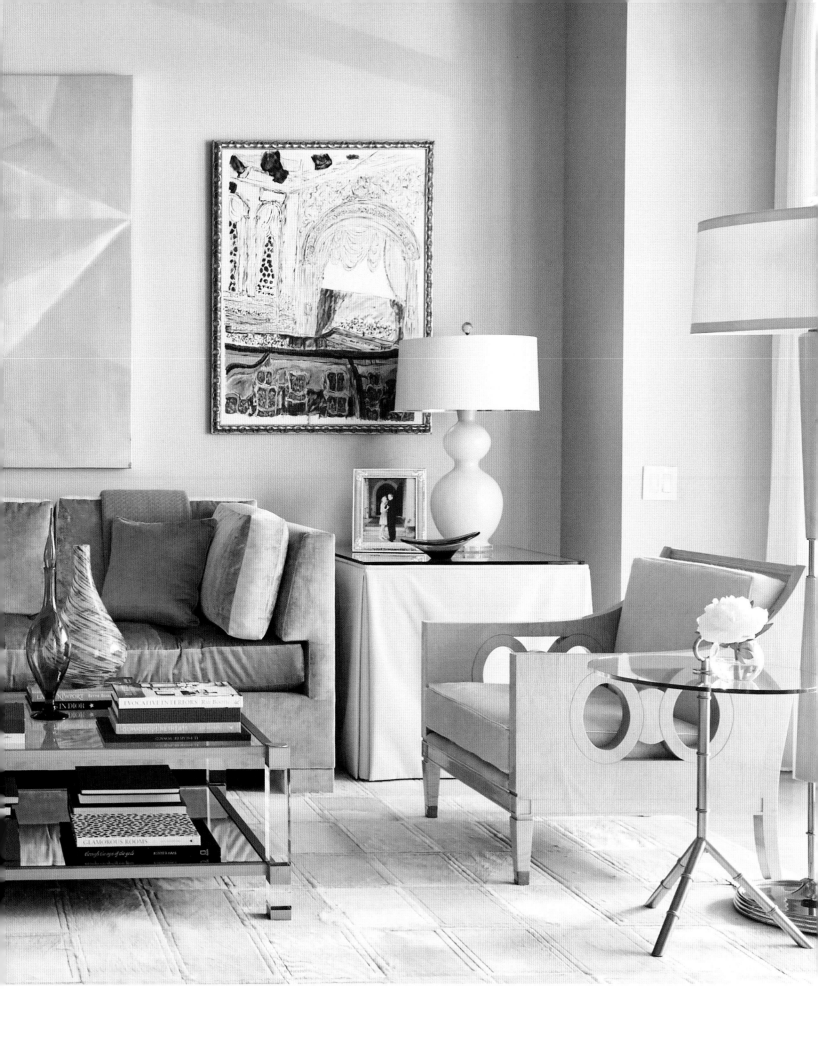

The opposite end of the living room on the preceding page, with a vintage mirrored cocktail table, a pair of vintage Italian Gio Ponti chairs, and a pair of golden Marbro Murano glass lamps.

✳

Following spread:
A very chic living room in Preston Hollow, Dallas, with an antique Persian rug, vintage French brass, a mirror-and-glass coffee table, a handsome pair of André Arbus fauteuils from the 1940s, and custom bookcases by Jan Showers & Associates. Art by Greg Miller.

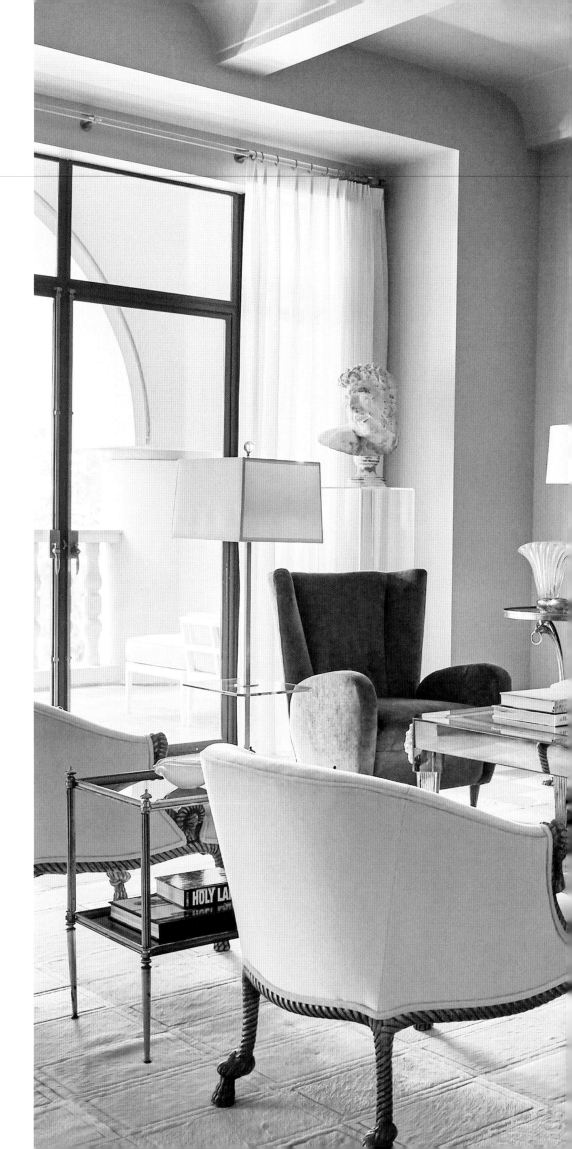

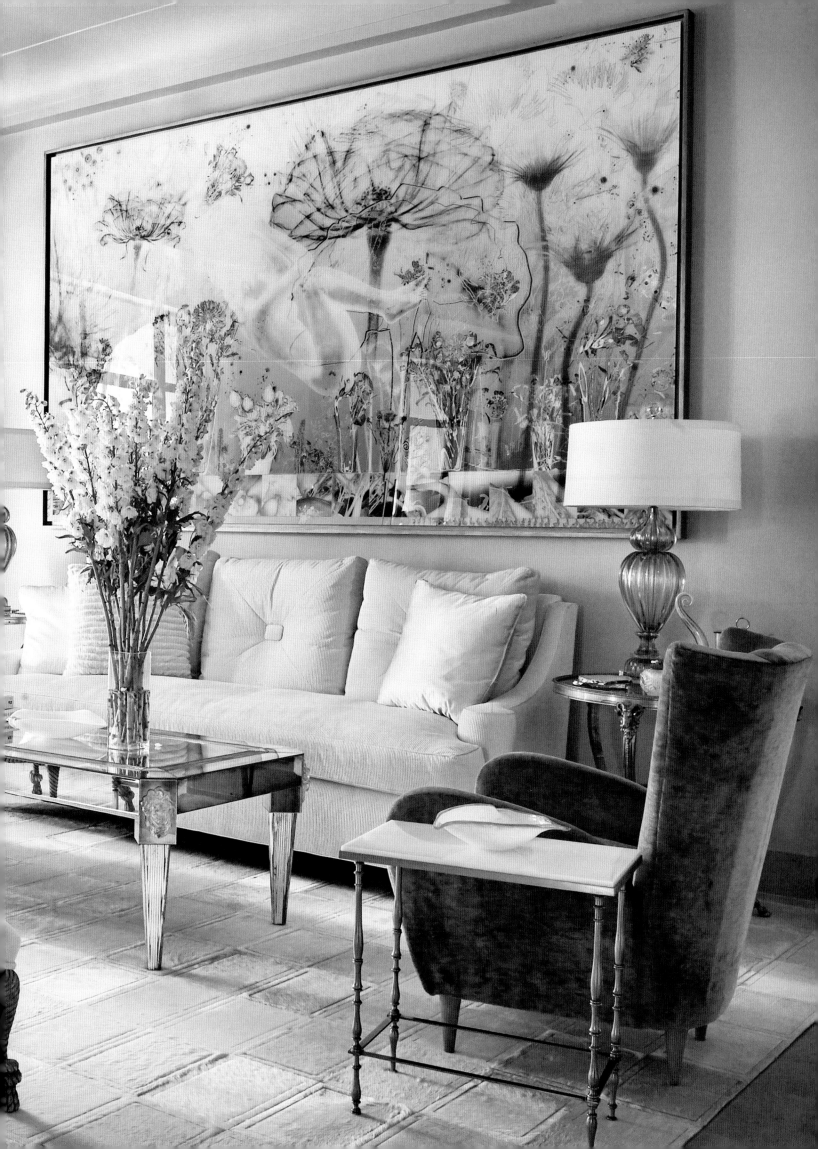

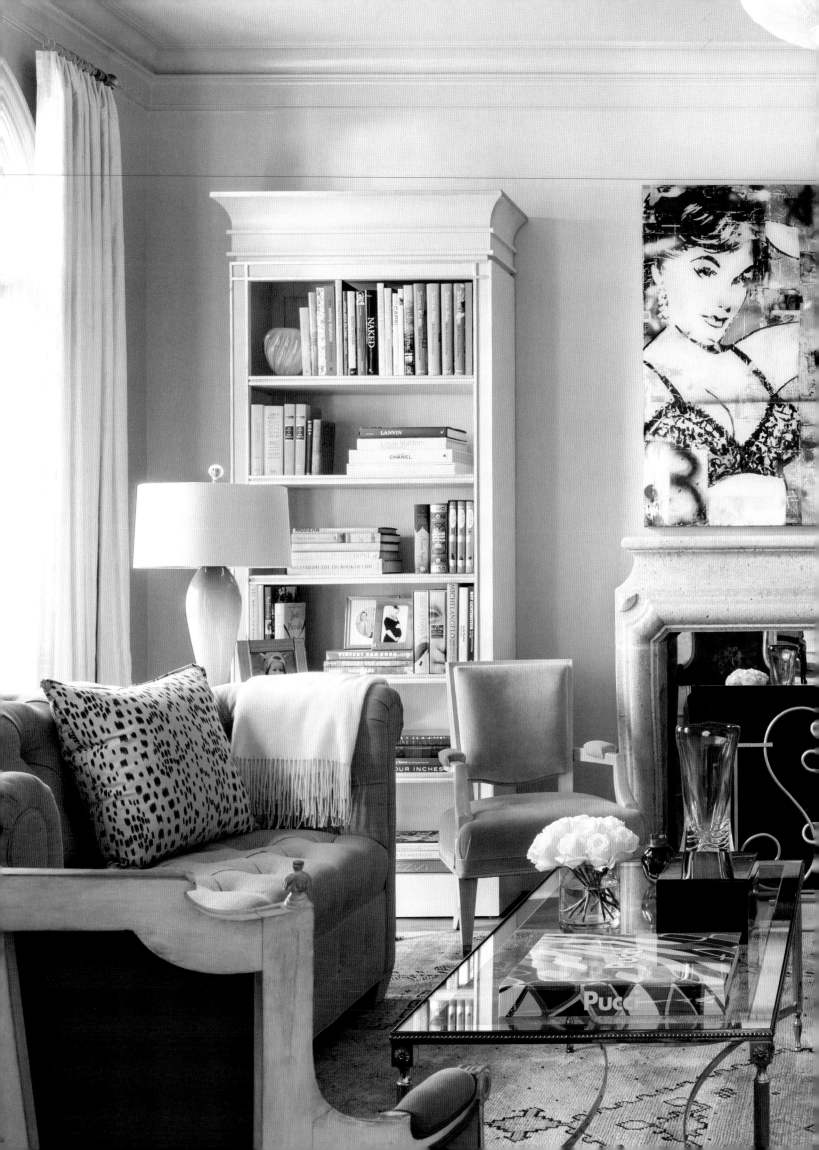

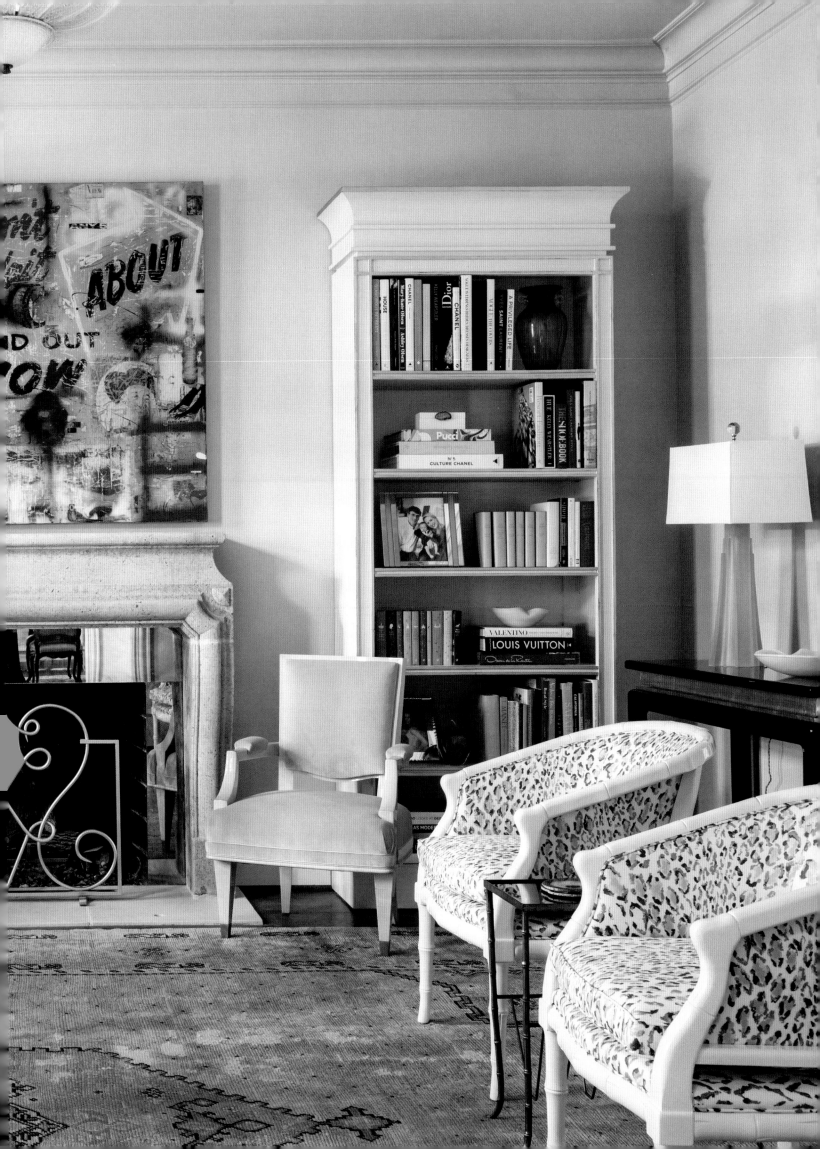

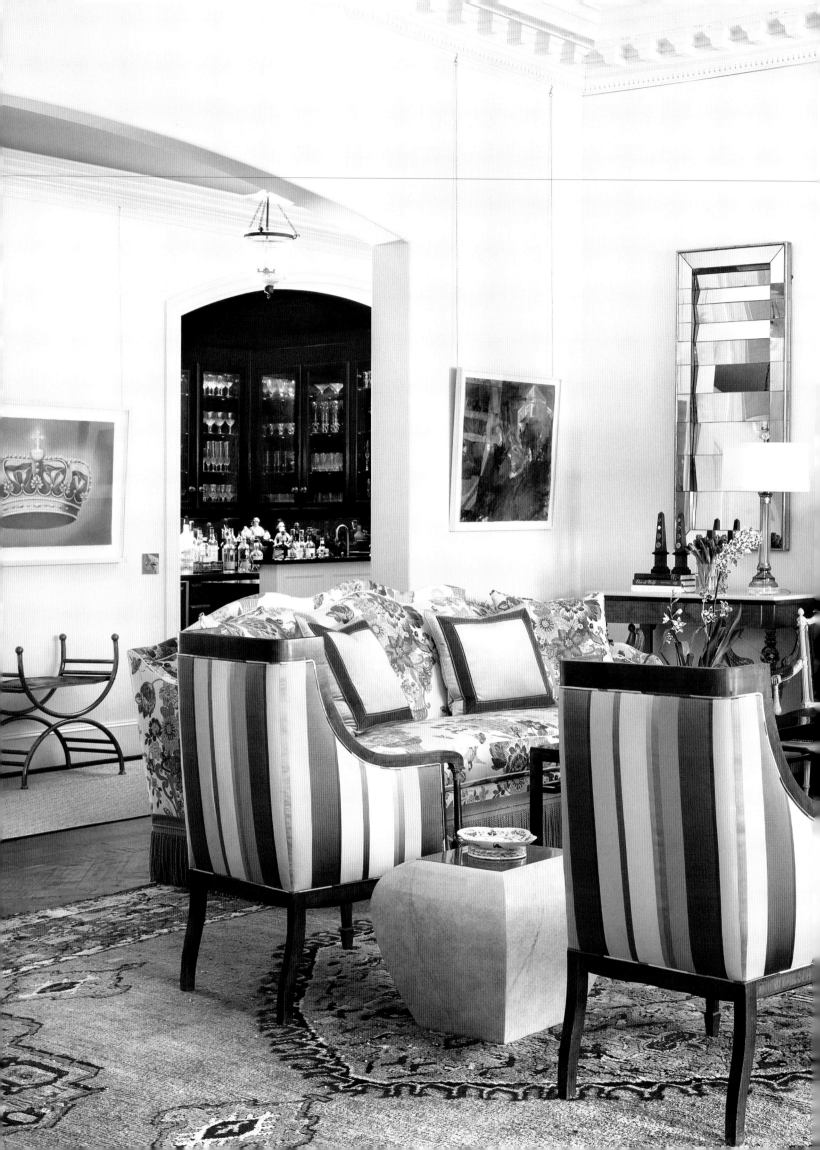

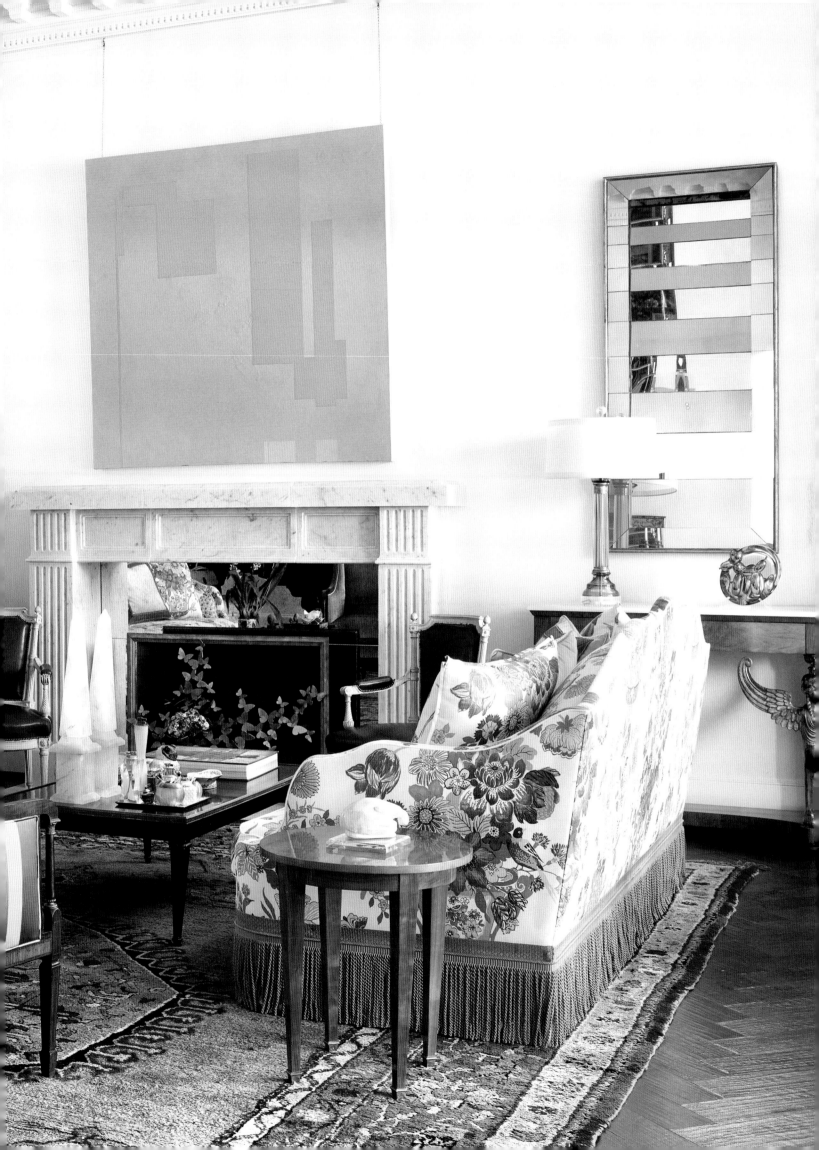

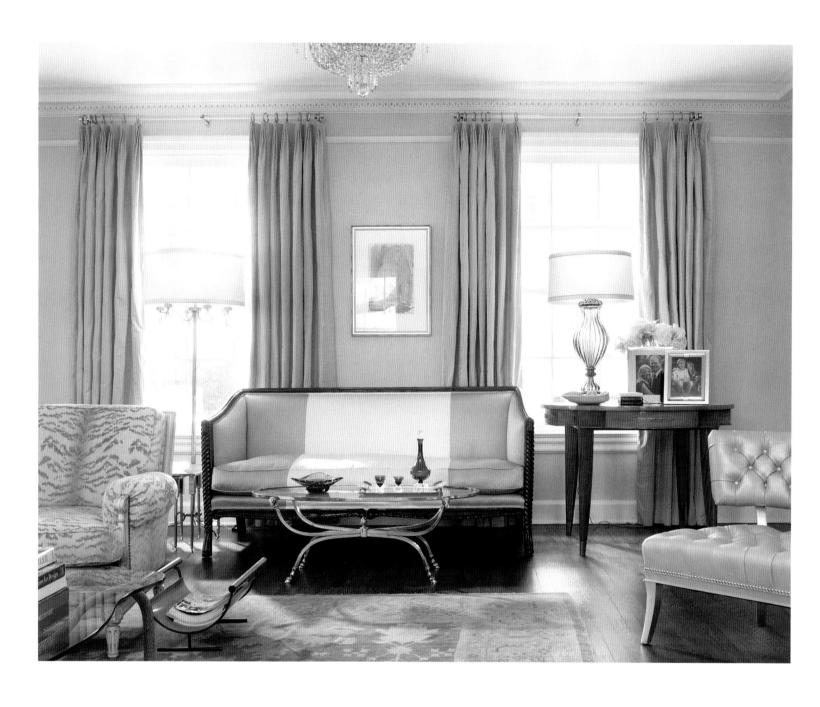

Previous spread: A wonderfully eclectic living room in a Preston Hollow house in Dallas.
Nineteenth-century Persian rug, Maison Jansen coffee table, Serge Roche mirrors,
nineteenth-century French consoles with gilded winged figures, Marbro Murano lamps,
c. 1950, and custom sofas upholstered in Schumacher Lansdale Bouquet.
Art above the fireplace by Pete Jourdan.

✳

Above: A vintage settee and a Maison Jansen coffee table sit at the end of a large
living room, creating a wonderful place for a tête-à-tête. A Marbro lamp sits atop a fabulous
1940s French merisier table with brass decoration and fittings. The floor lamp is also
vintage French from the 1940s in silver plate. *Opposite*: On the other side of the room, a
vintage Lucite-and-brass drink cart is flanked by a pair of large Louis XVI–style chairs.
The lamp on the cart is the Chiseled Lamp from the Jan Showers Collection. All the other
glass on the cart is Murano from the 1940s.

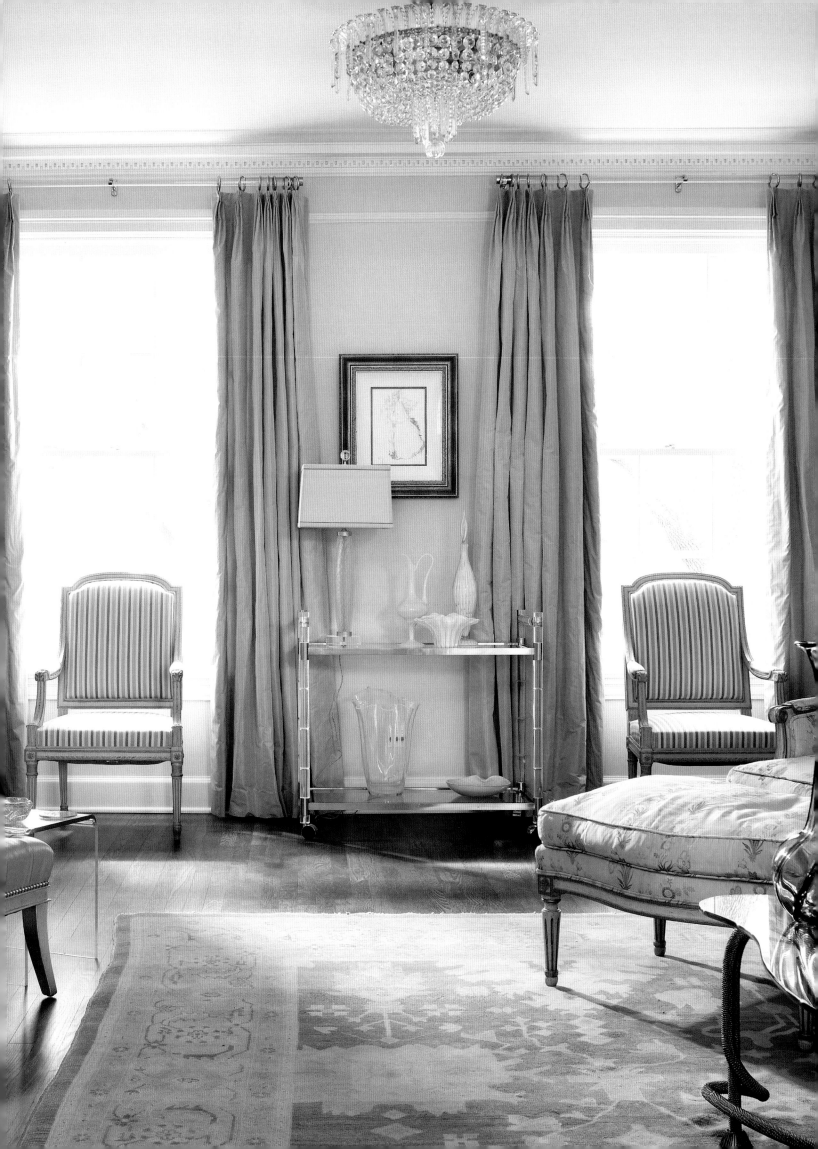

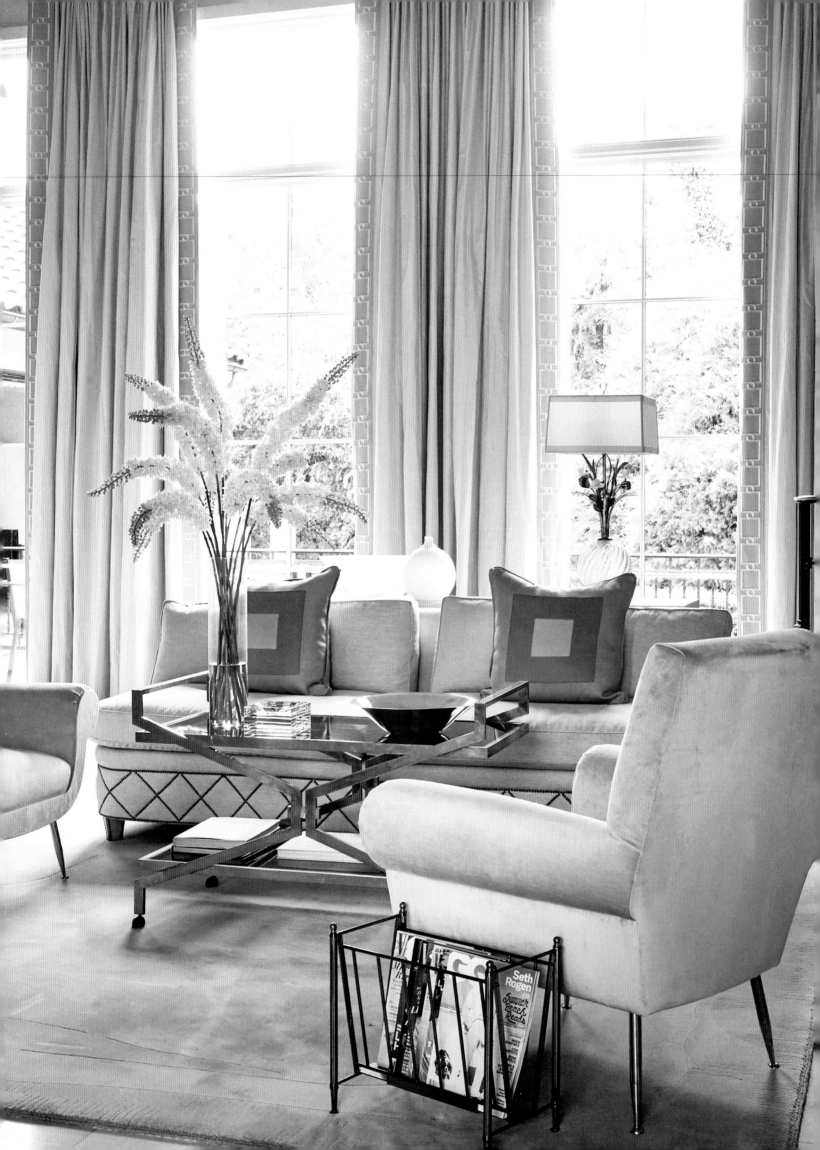

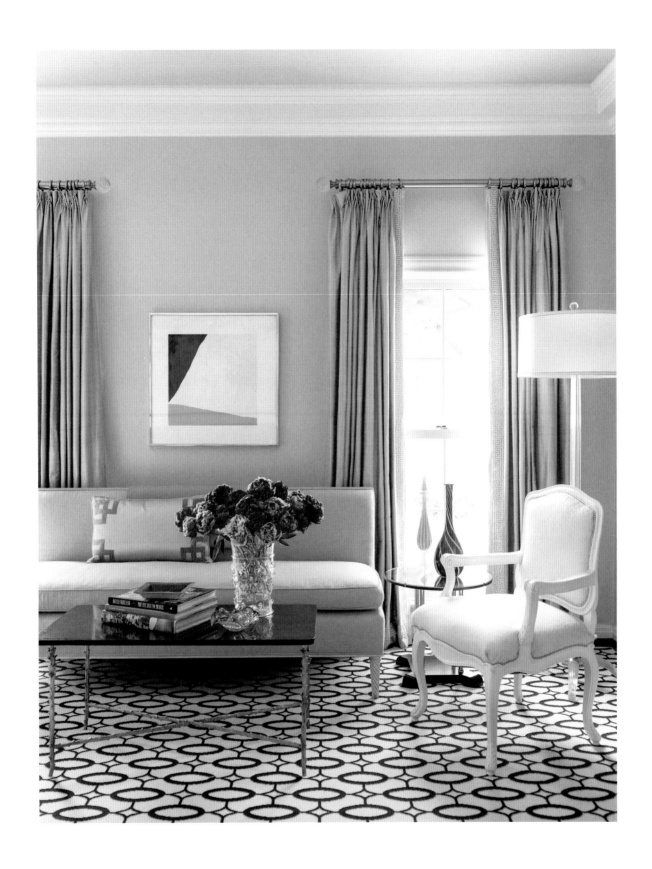

Opposite: A seating area in a living room meant for conversation. The tea table from
the 1970s is one of my all-time favorites and was found in Paris. The banquette is the Palazzo
from the Jan Showers Collection. The custom-made chairs are Italian inspired.
Above: The Palm Beach Banquette and Marnie Dining Chair from the Jan Showers Collection
create an intimate area for visiting over coffee or a drink in the evening. The coffee
table is by Baguès with palm leaf legs in gold plate and the original black marble top.
The rug is Ellipse by Stark in chocolate.

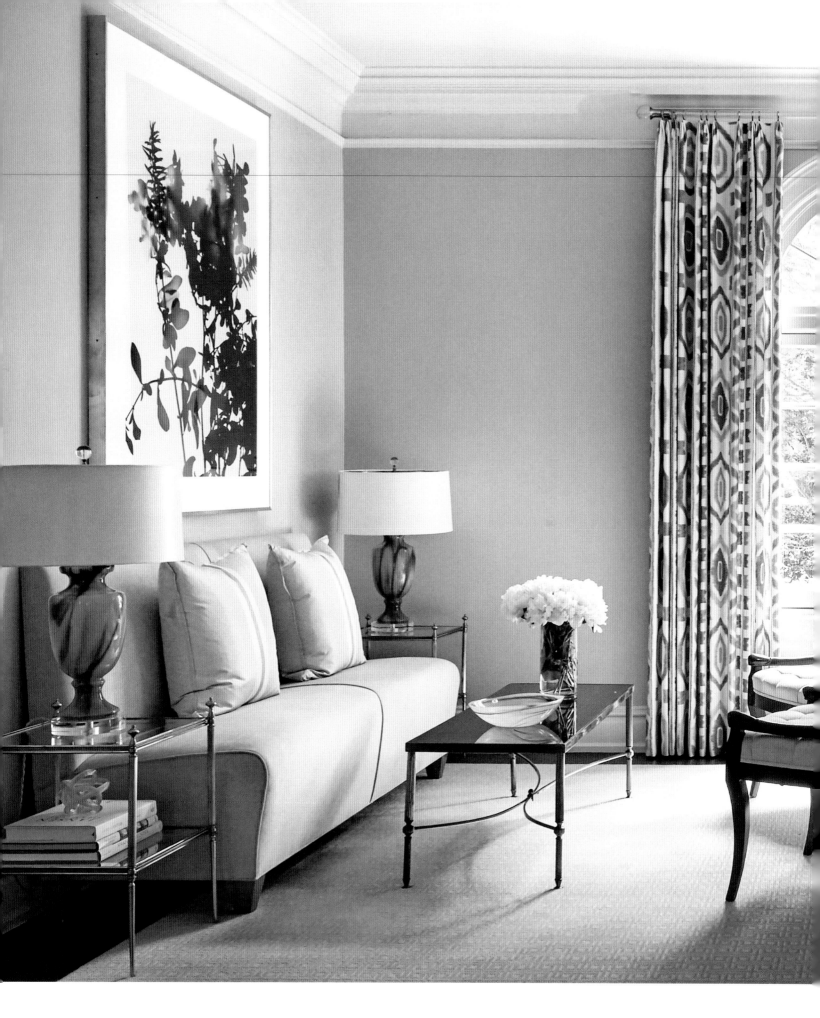

One side of a large living room in a historic Hal Thomson house in Highland Park, Dallas, with a lovely pair of brass-and-glass Louis XVI–style tables and a coffee table in bronze with an opaline top—all vintage from the 1940s—and the Paris Banquette from the Jan Showers Collection. The floor lamp to the right of the piano is the Capri from the Jan Showers Collection. Art by James Welling.

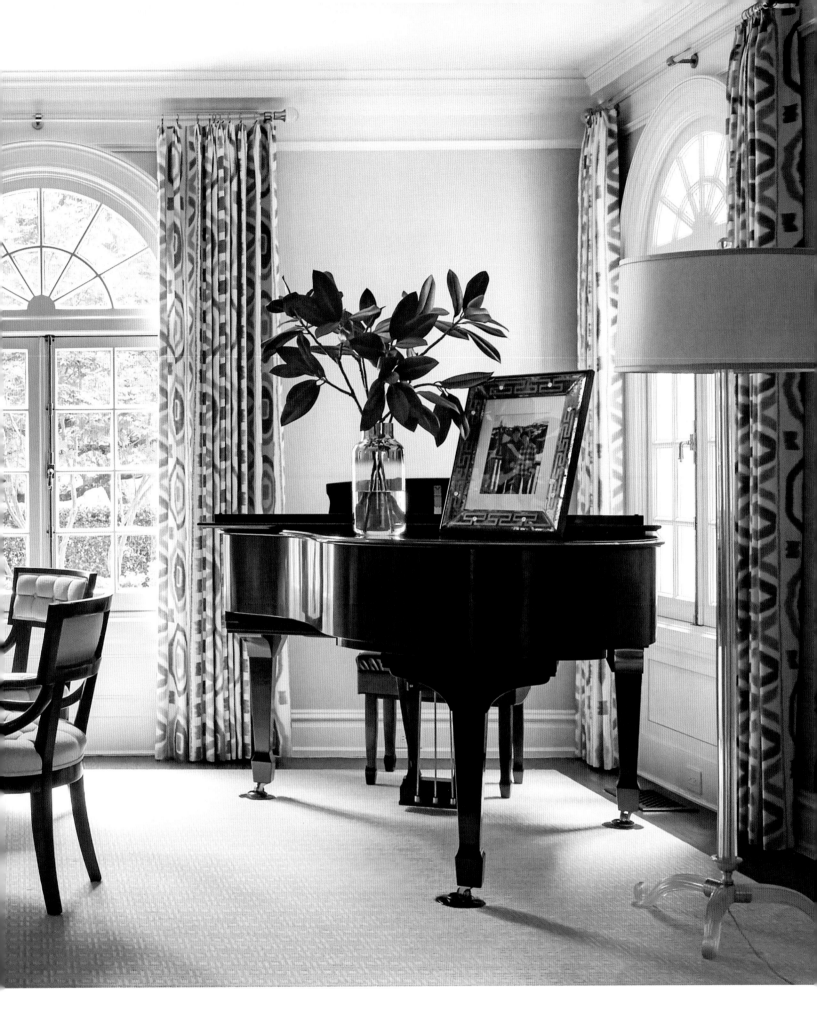

The opposite side of the living room on the previous spread. Antique French stools, lamps by Paul Schneider Ceramics, a custom Chesterfield Sofa by Jan Showers & Associates, and a custom tea table in gold-leafed steel. Art by Toby Ziegler.

✳

Following spread: This room is a perfect example of what good art does for any space. The antique Oushak rug and wonderful vintage furniture add the warmth the room absolutely needs. Art (from left) *Untitled*, 1985, by Robert Therrien; *Untitled*, by Chiyu Uemae; *Grass Number 1*, 2010, by Zhang Huan; and sculpture *Dark Blue Figure*, 2000, by John Mason.

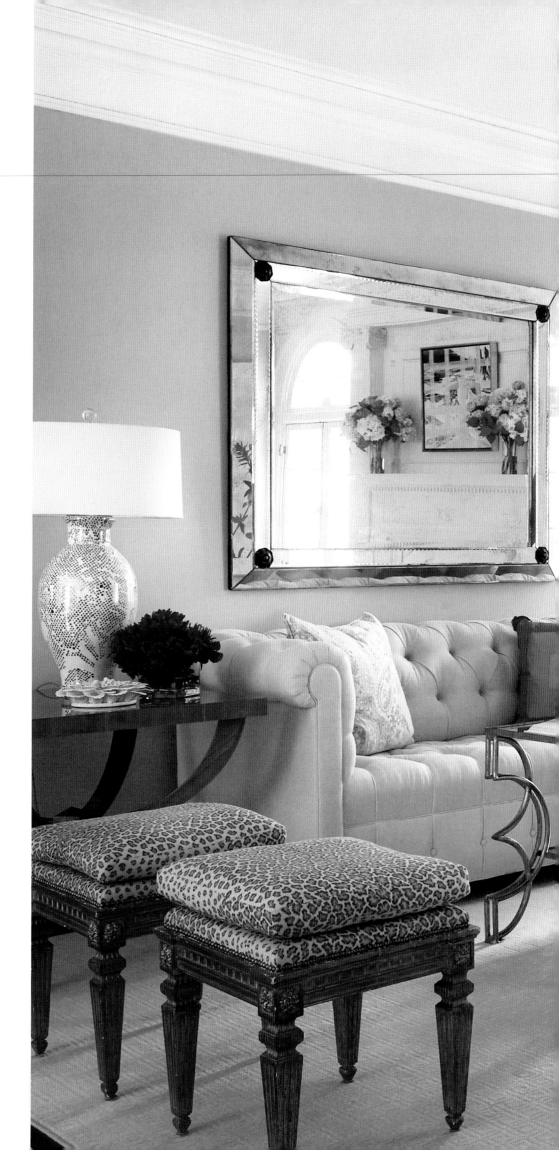

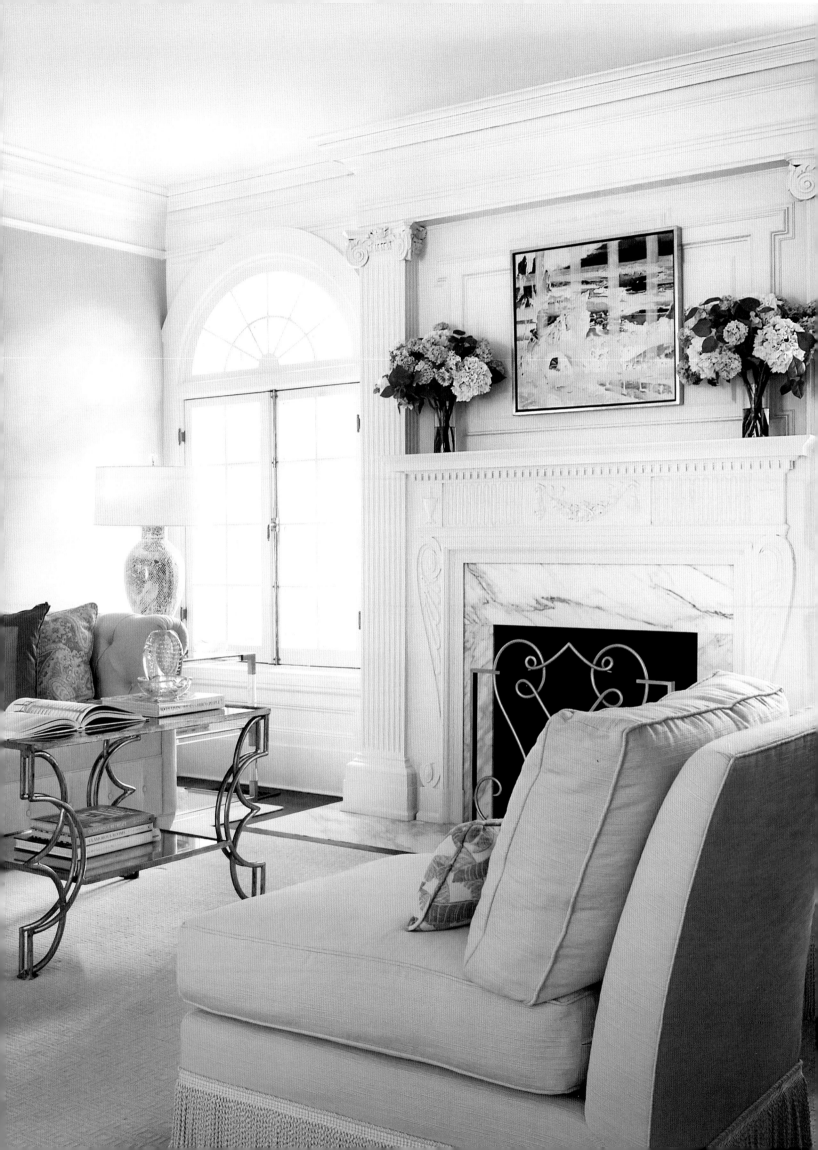

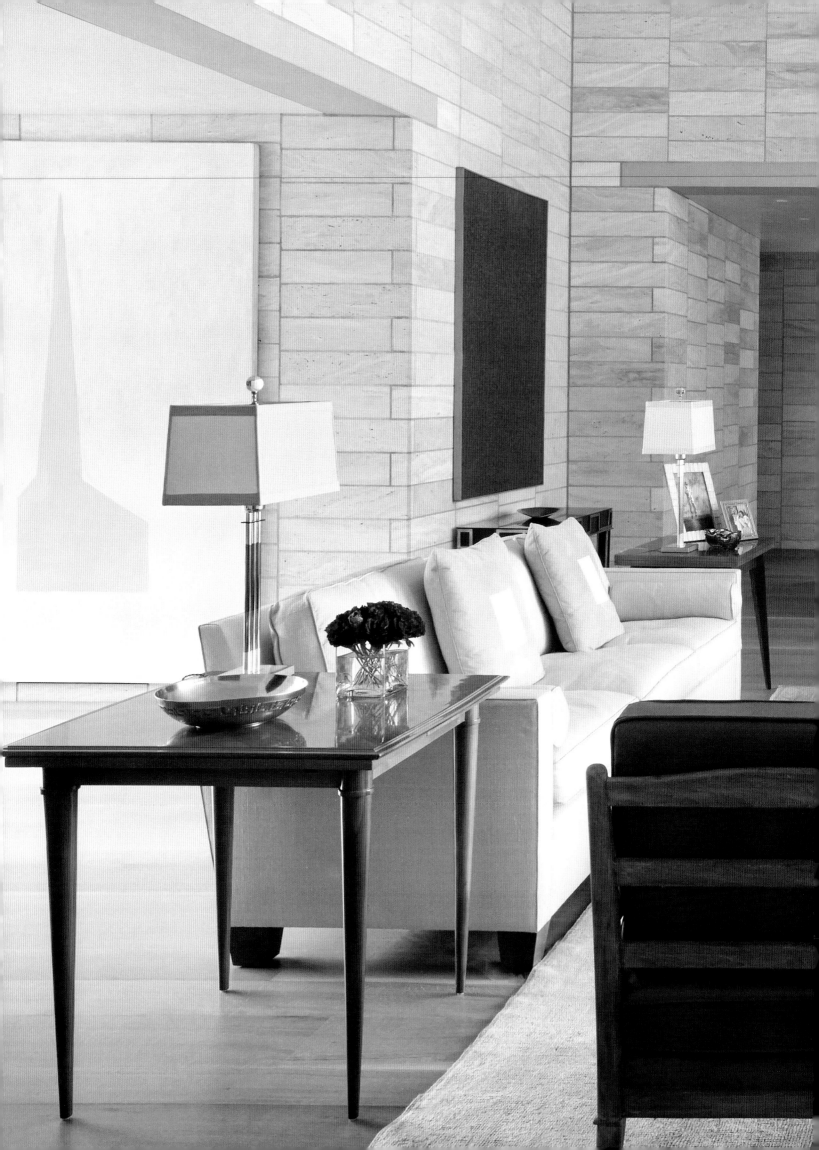

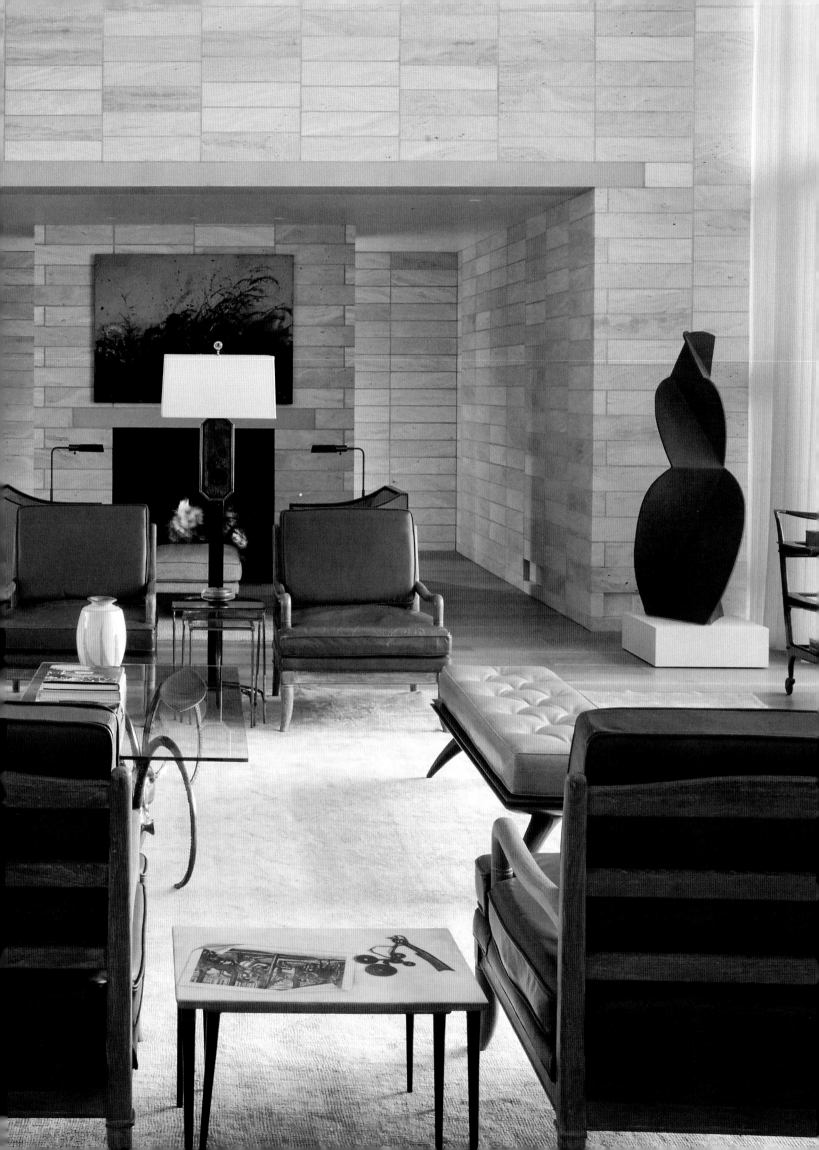

Above: Detail of a Louis XVI Chair from the Jan Showers Collection. *Opposite*: A quiet corner of our country house living room with a pair of vintage Louis XVI–style chairs in their original fabric from the 1940s and a screen, hand painted by my mother, Margaret Anne Smith, and my aunt, Jane Noland, in the late 1960s.

Following spread: Our living room looks into the dining room in our country house, featuring a pair of Louis XV-style chairs upholstered in a chinoiserie designed by Charlotte Moss for Fabricut, a late-nineteenth-century iron gueridon with original marble top, a Napoleon III gilded table to the left of the door, and one of a pair of commodes in the manner of André Arbus to the right. The chair in the foreground is in the Directoire style with gilded accents. The chandelier in the dining room was designed by André Arbus for Barovier in the 1940s. The pair of cased Murano lamps are from the 1950s.

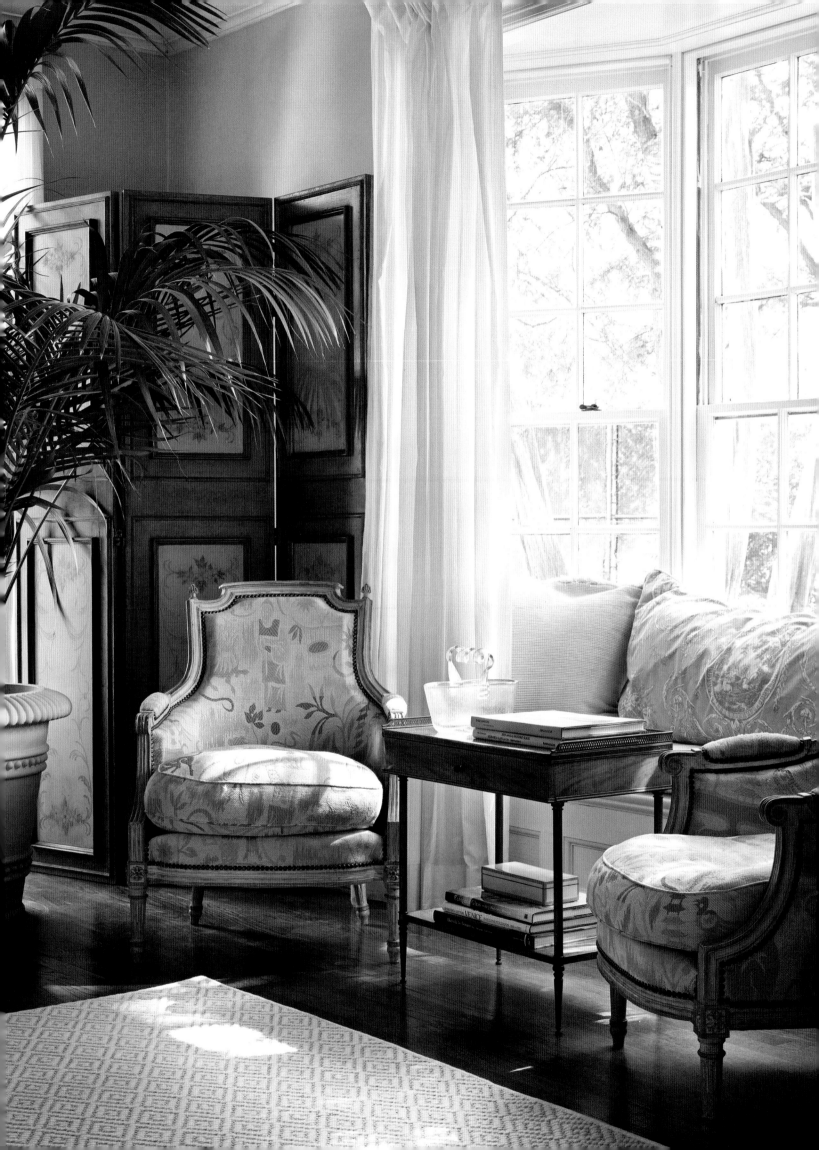

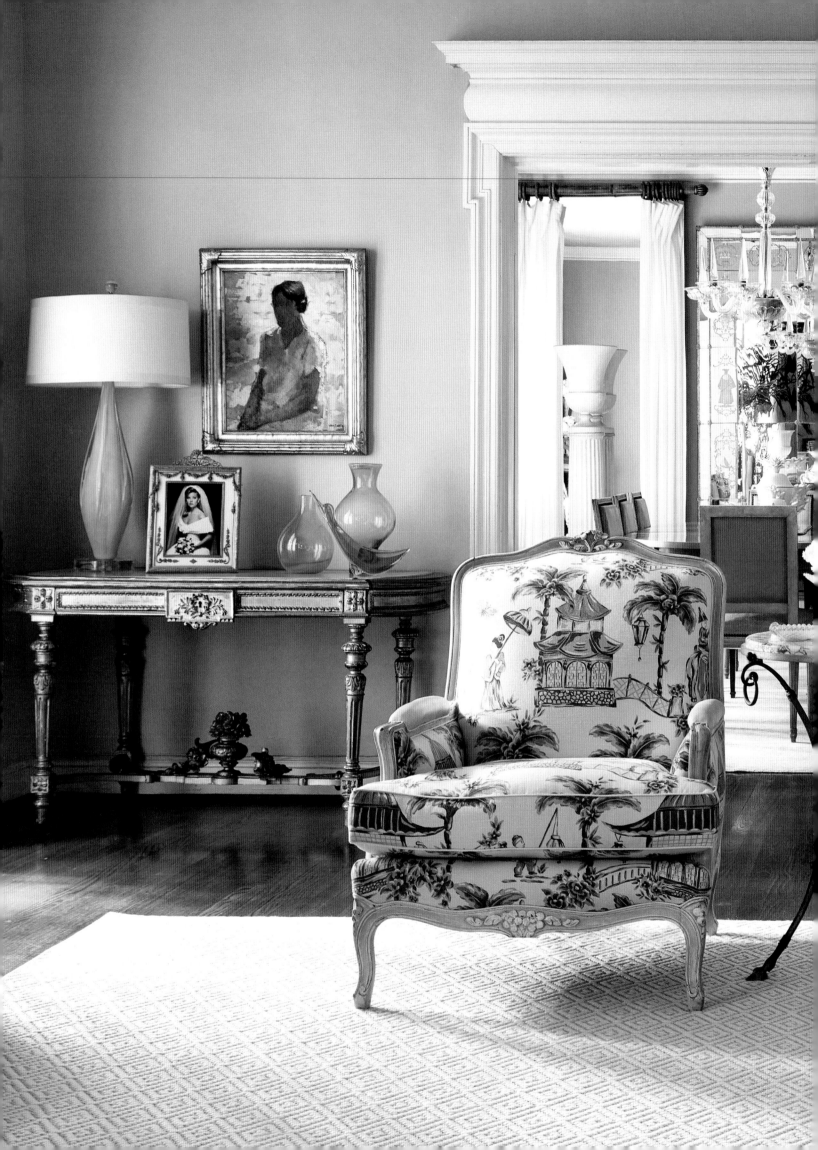

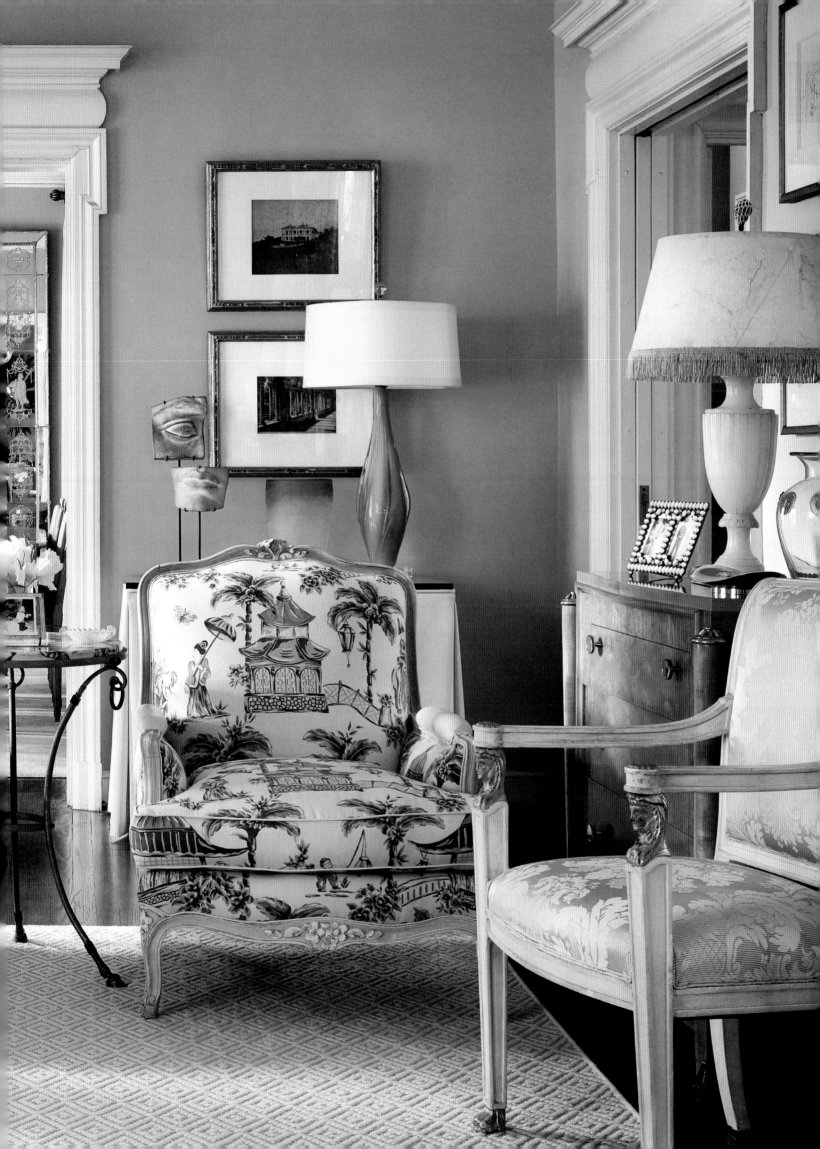

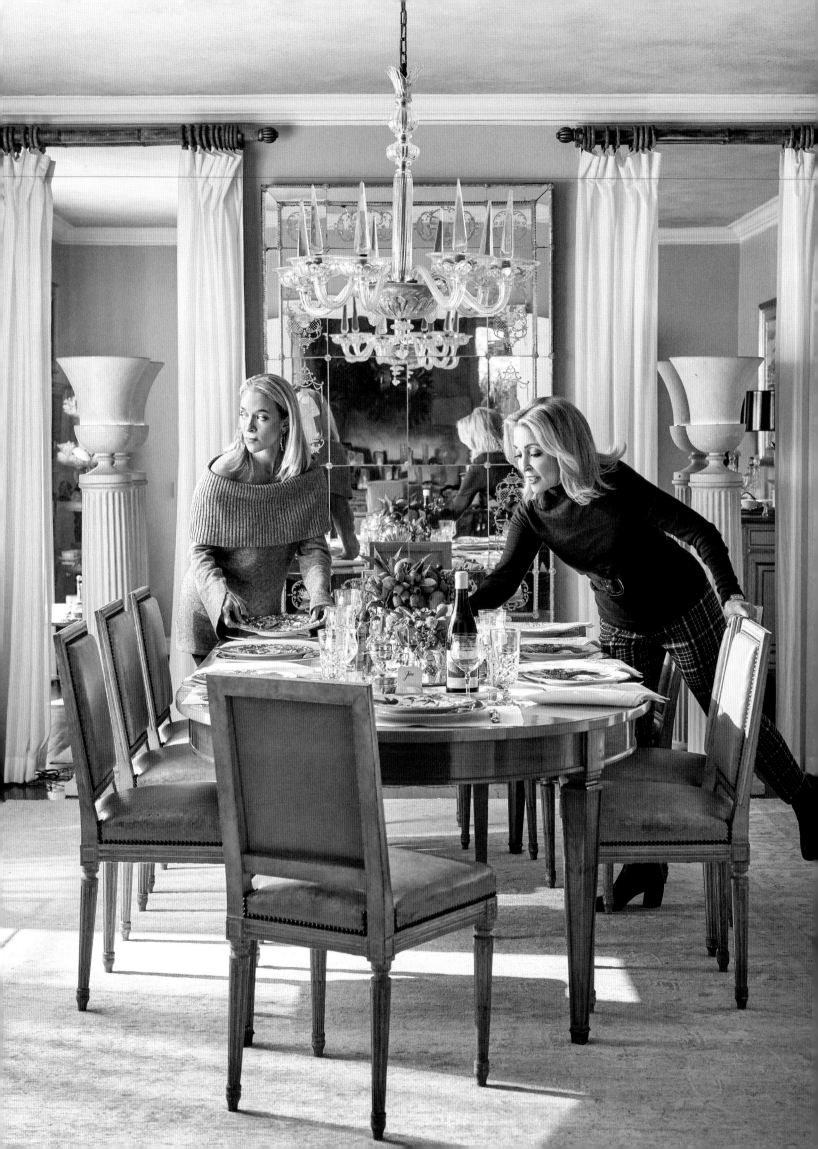

DINING *at* HOME

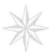

T hinking back over my life, I have so many memories that originate around dining tables and the conversations I've had at them. I've met unexpected characters and made lasting friendships in the dining rooms of my friends. There's a kind of magic about dining rooms, a spell we fall under when we sit down in a beautifully decorated room and share a long evening together. Whether it's an intimate dinner with a loved one or a grand party, you know it's been a success when, even after dessert and coffee have been served, everyone feels reluctant to rise from the table and proceed to the evening's next phase.

As with formal living spaces, people tend to treat their dining rooms as if they're sacred territories. I do everything I can to ensure that my clients feel as at home in their formal dining rooms as in any other room of the house.

Lighting a dining table is like lighting a stage. You must achieve a warm, dramatic glow that makes you and your guests look their best. Invariably it starts with a chandelier and candlelight. Scenes in movies set at dining tables always attract me, the way the light plays off the varied surfaces: champagne flutes, wine glasses, silverware, and interesting centerpieces. Nowhere in your home will you find such a dense concentration of unusual and exquisite objects.

A beautifully decorated dining room can make any meal feel elevated and special. You're truly living glamorously when you don't wait for a special occasion to use your dining room, but instead make an ordinary lunch or dinner into an occasion by virtue of the beauty of your environment. A grilled cheese sandwich and tomato soup on beautiful china with fine linen is, for me, what glamorous living is all about.

Elizabeth and Jan setting the table for Thanksgiving for the family, who gather at
their country house for Thanksgiving and Easter.

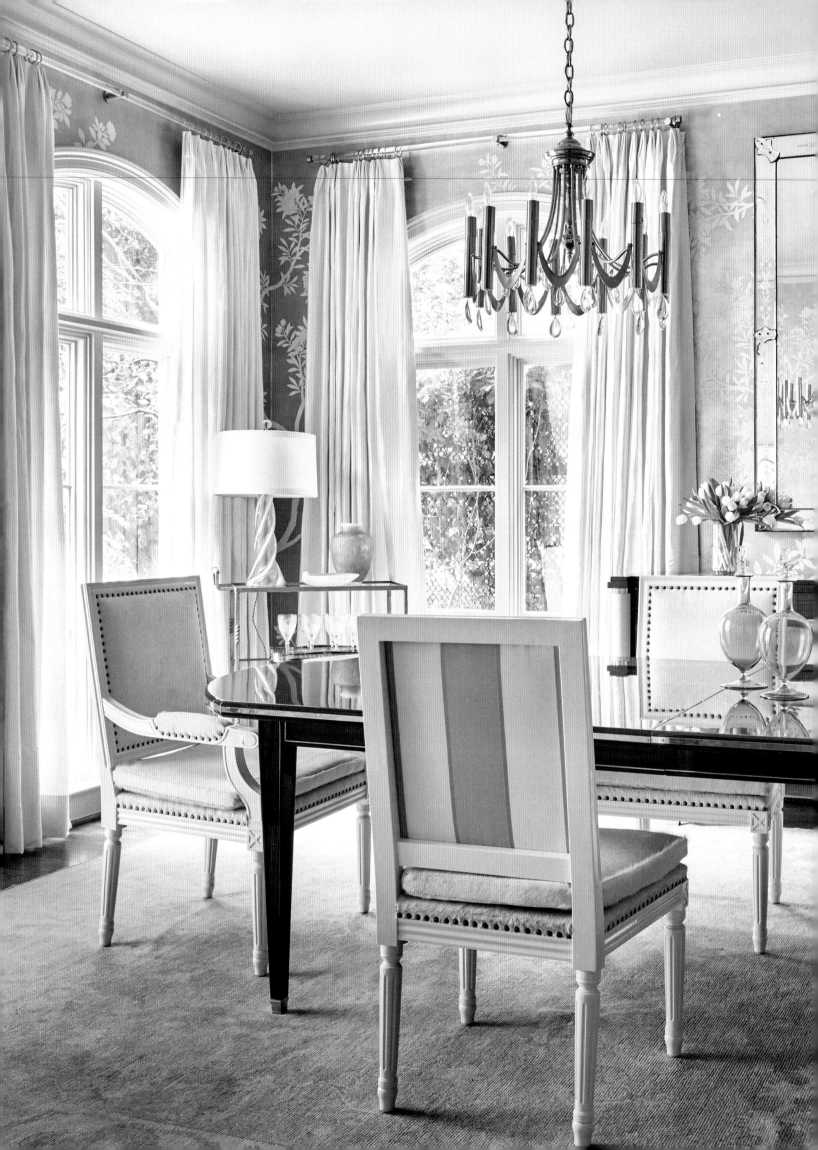

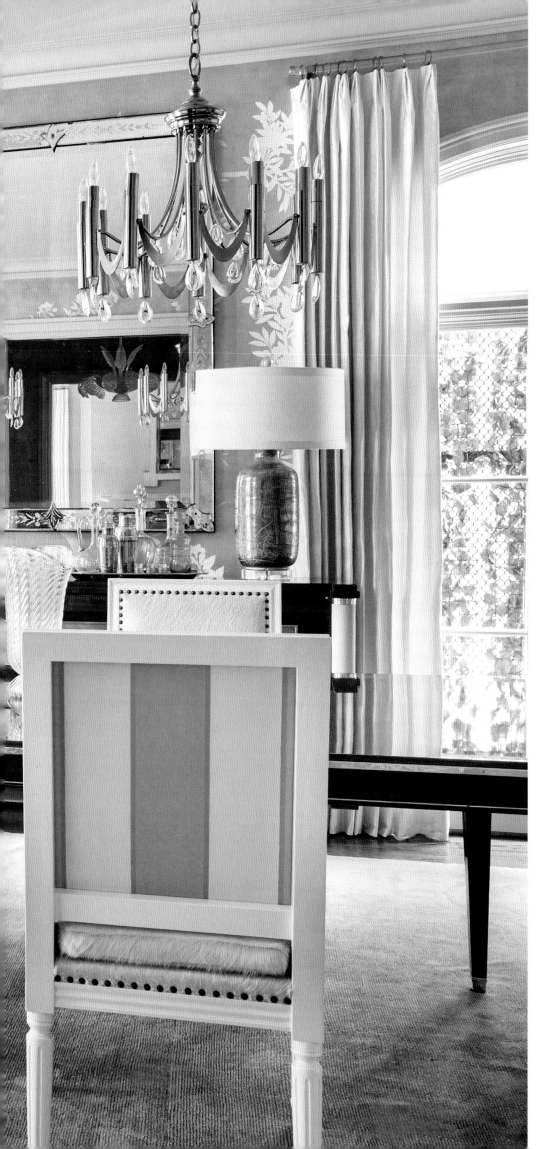

A lovely dining room wallpapered in hand-painted warm silver leaf by Gracie. The pair of silver-and-crystal chandeliers were purchased in Paris for this dining room. The rug is a low-contrast Oushak in a luscious blue tone on tone. The French mahogany dining table is the Zara Dining Table designed by Zara Taitt, senior designer at Jan Showers & Associates. Chairs are the Antibes, also from the Jan Showers Collection. The mirror is Venetian from the 1940s, and the lamp on the buffet is Marbro from the 1950s.

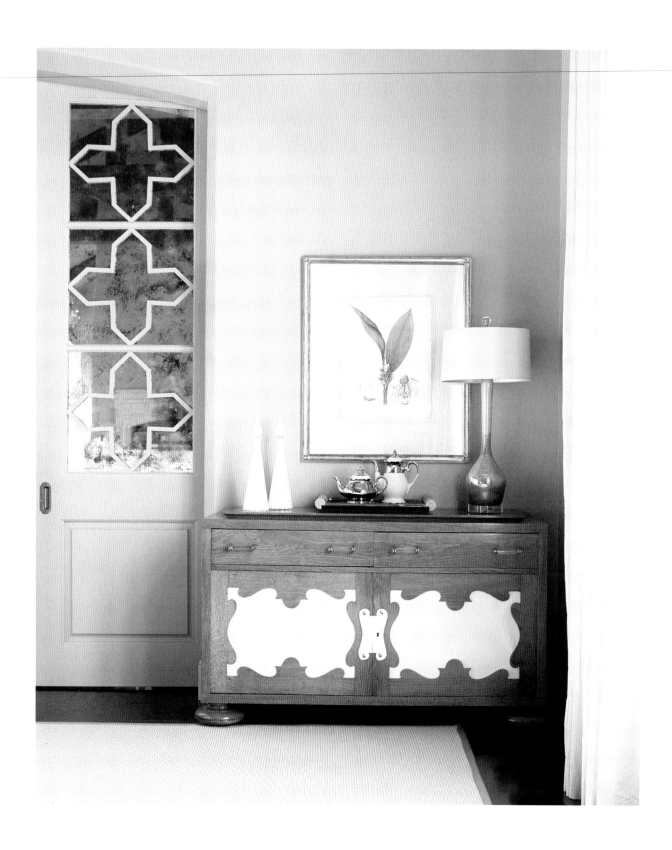

Above: An unusual French credenza from the 1940s fills a corner of a dining room; the insets are parchment. *Opposite*: Benjamin Moore Hale Navy creates a moody and secluded dining room. The chandelier is late-nineteenth-century French. The chairs are Louis XVI style upholstered in leather. The floor lamp is 1940s French in crystal, the rug is an Oushak, and the table is the Oliver from the Jan Showers Collection. All the glass on the table is vintage.

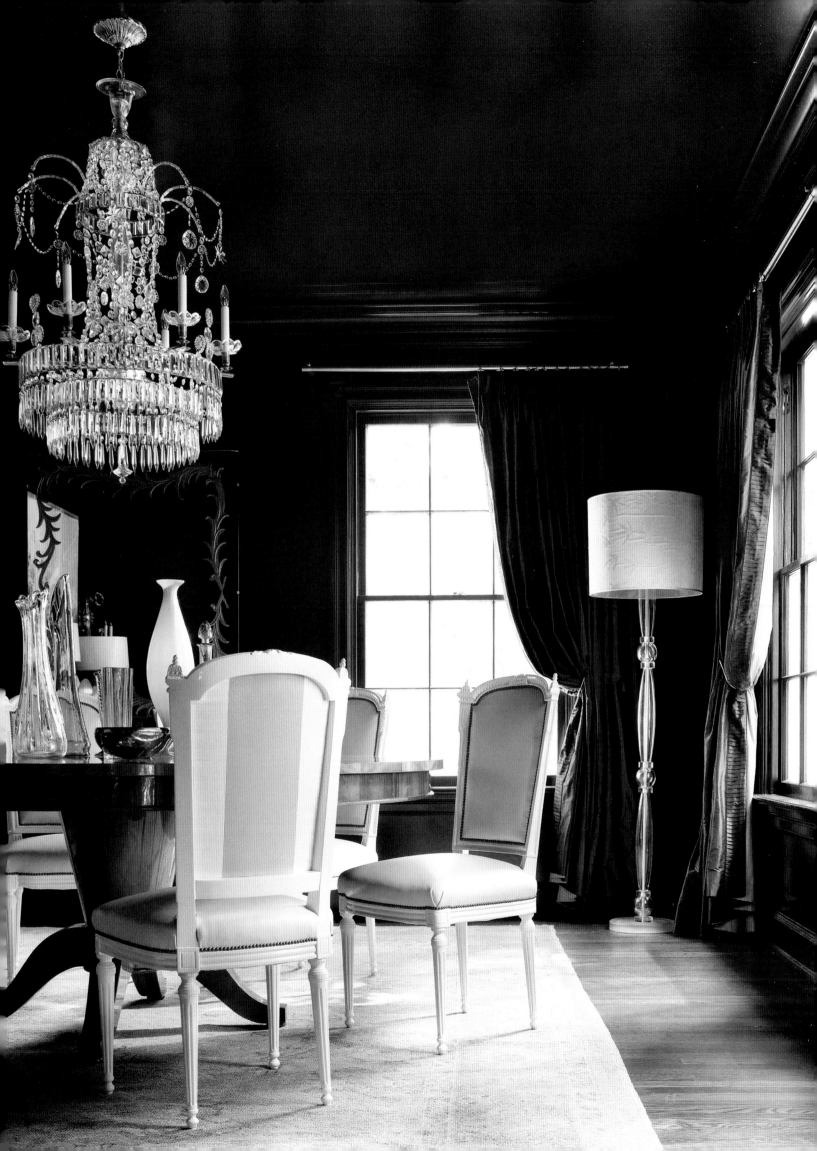

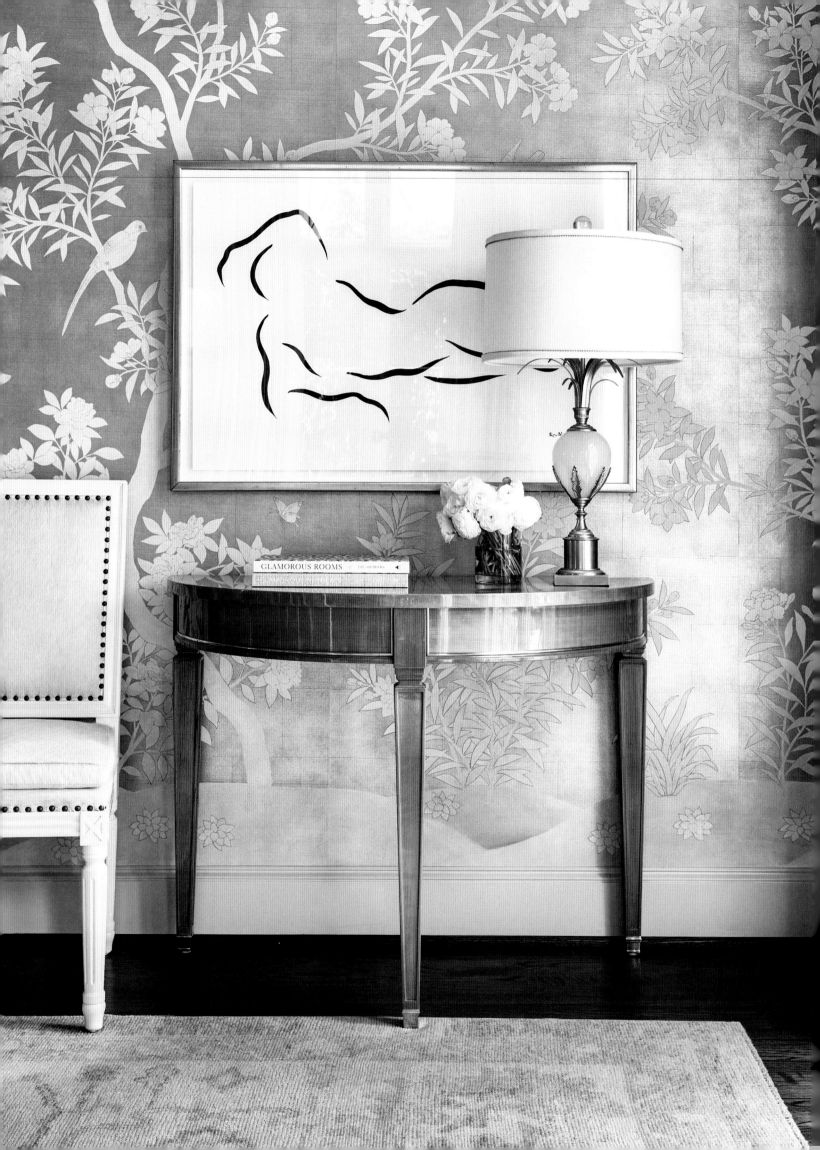

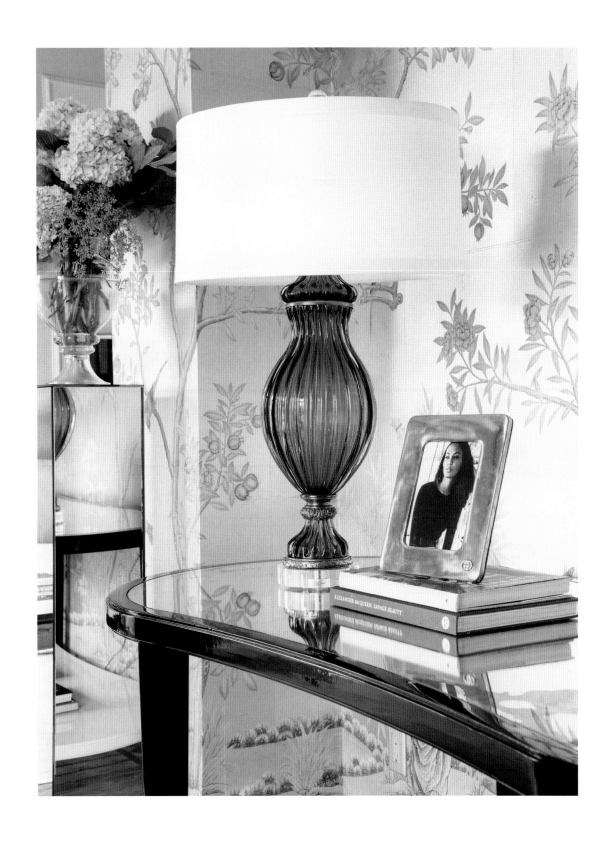

Opposite: A line drawing by Don Bodine and one of a pair of merisier demilunes with a
Maison Charles lamp in gold-plated metal and opaline glass. Gracie wallpaper.
Above: A Marbro Murano lamp from the 1950s sits atop a vintage mirrored and ebonized
console, surrounded by hand-painted warm silver leaf Gracie wallpaper.

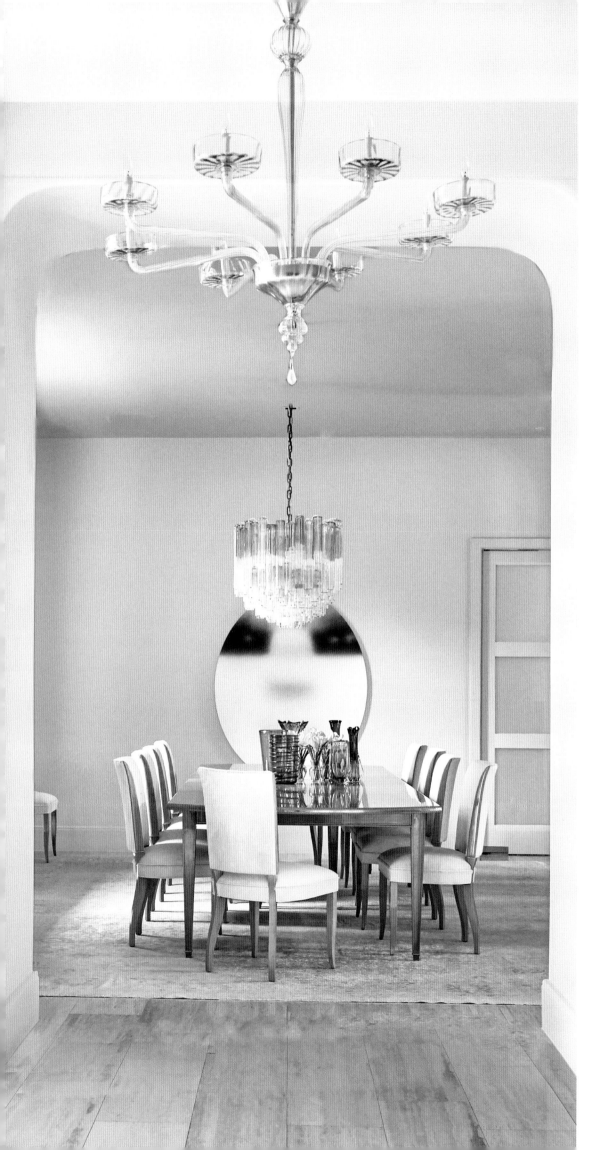

Left: A large dining room in a modern house that can seat fourteen people with a Zara Dining Table and Lulu Dining Chairs from the Jan Showers Collection. A Venini chandelier lights the dining table. The pale-green Murano chandelier in the entry, leading into the dining room, is a vintage one from the 1950s, found in Murano. Art by Todd Hebert. *Opposite*: A traditional dining room in a historic house by Hal Thompson in Dallas's Highland Park neighborhood. The table is a custom table, and the chairs are in the Louis XVI style. The chandelier is from Julie Neill Designs of New Orleans, and the rug is Moonglow by Jan Showers for Kyle Bunting.

"Lighting a dining table is like lighting a stage."

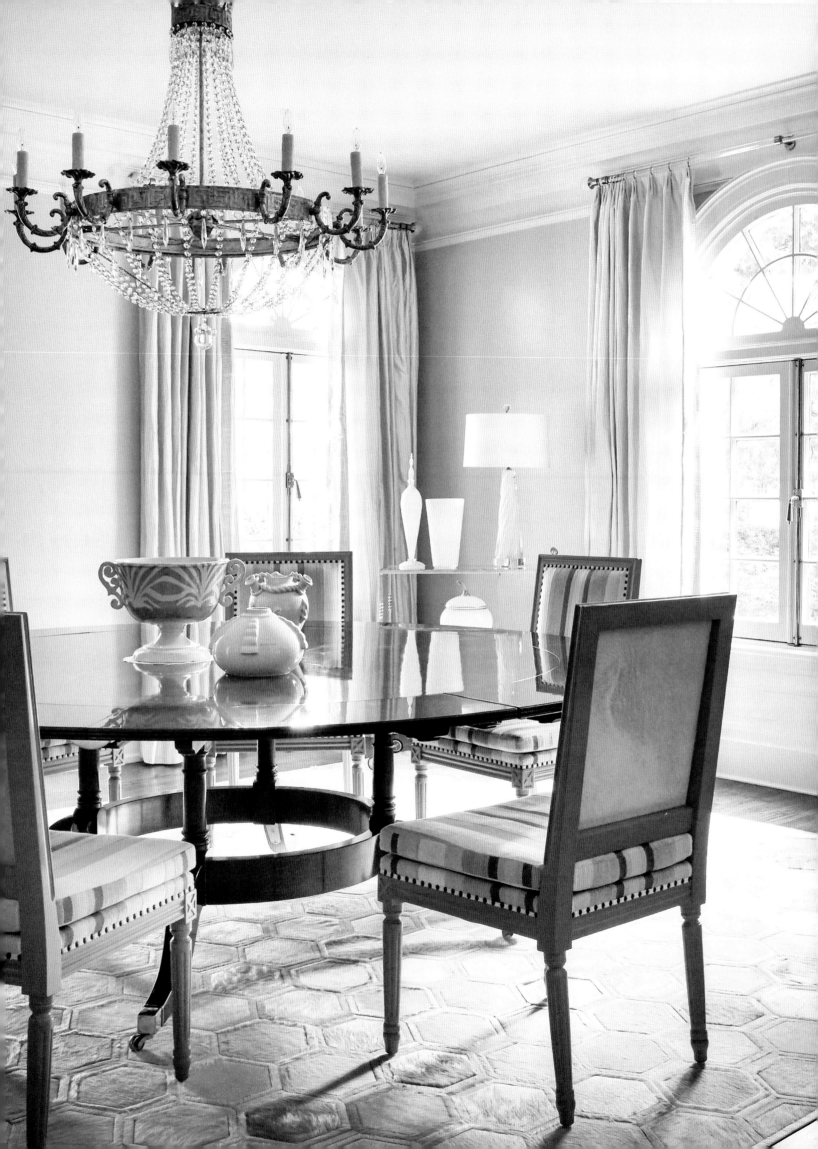

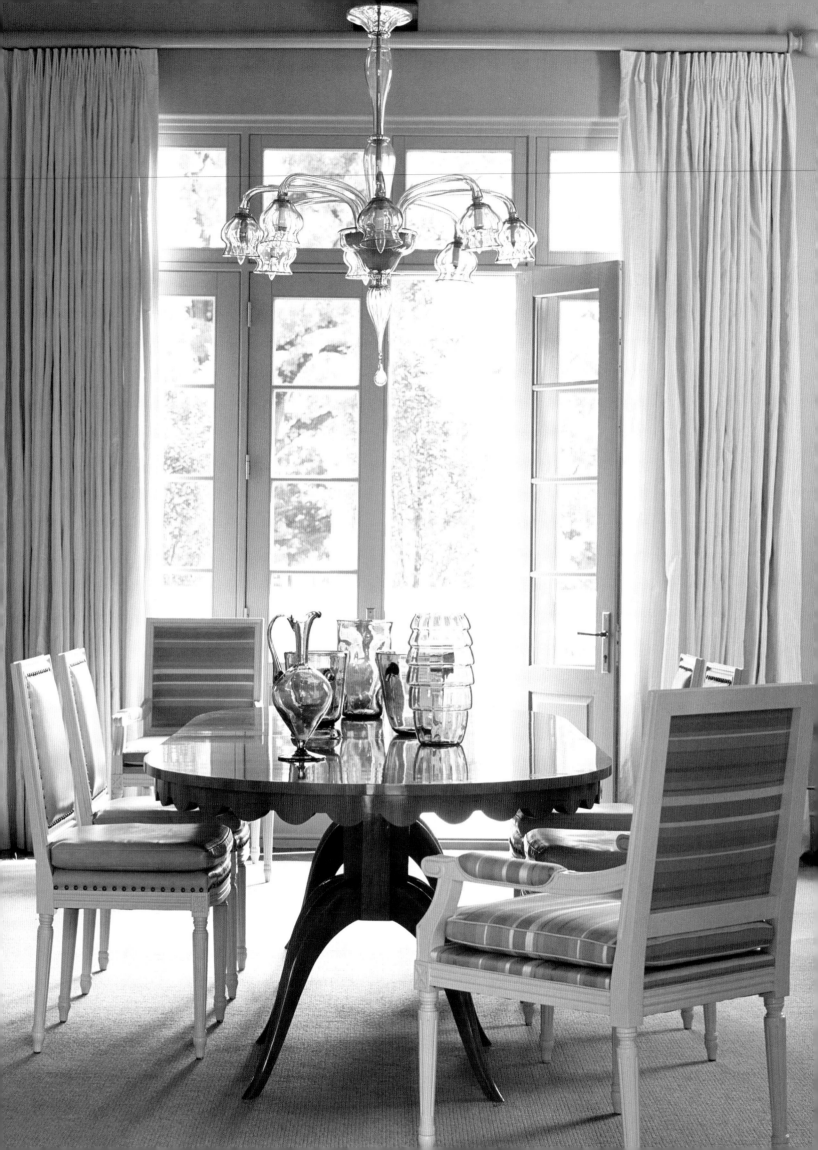

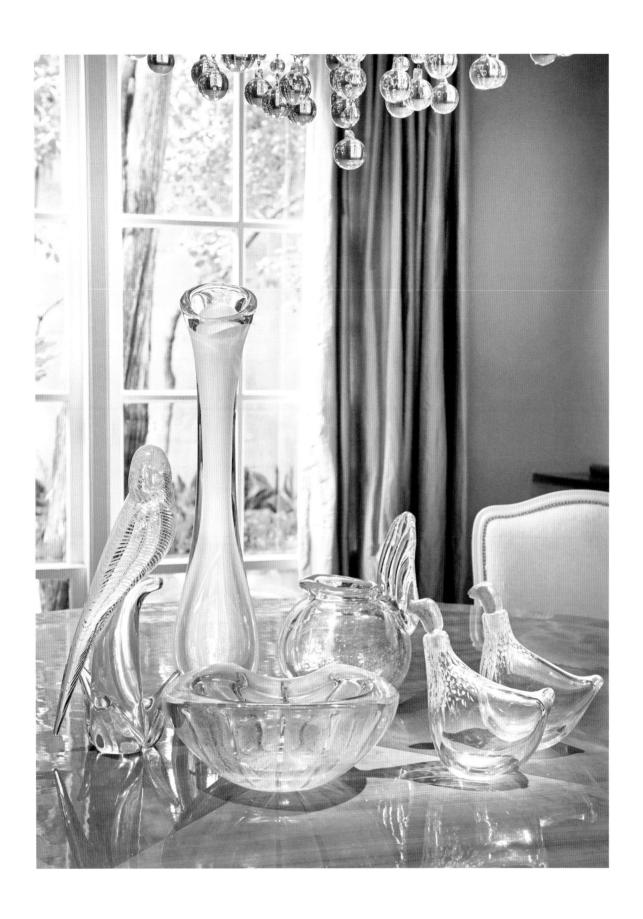

Opposite: A dining area at the end of a long living room with an unusual vintage
Murano fumé chandelier and a wonderful collection of green Empoli glass atop a Lombard
Dining Table by the Jan Showers Collection in merisier. *Above*: A collection of
chartreuse Murano and German glass adorns a round dining table in our Dallas townhouse.

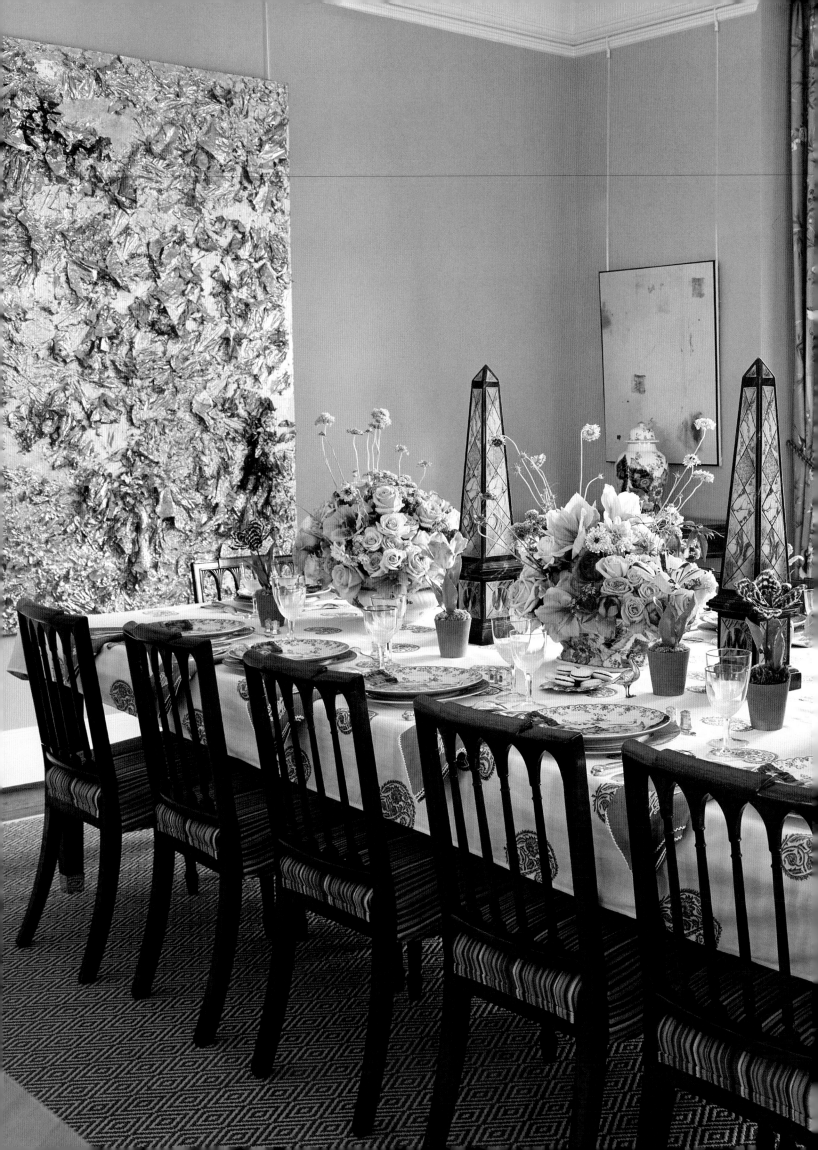

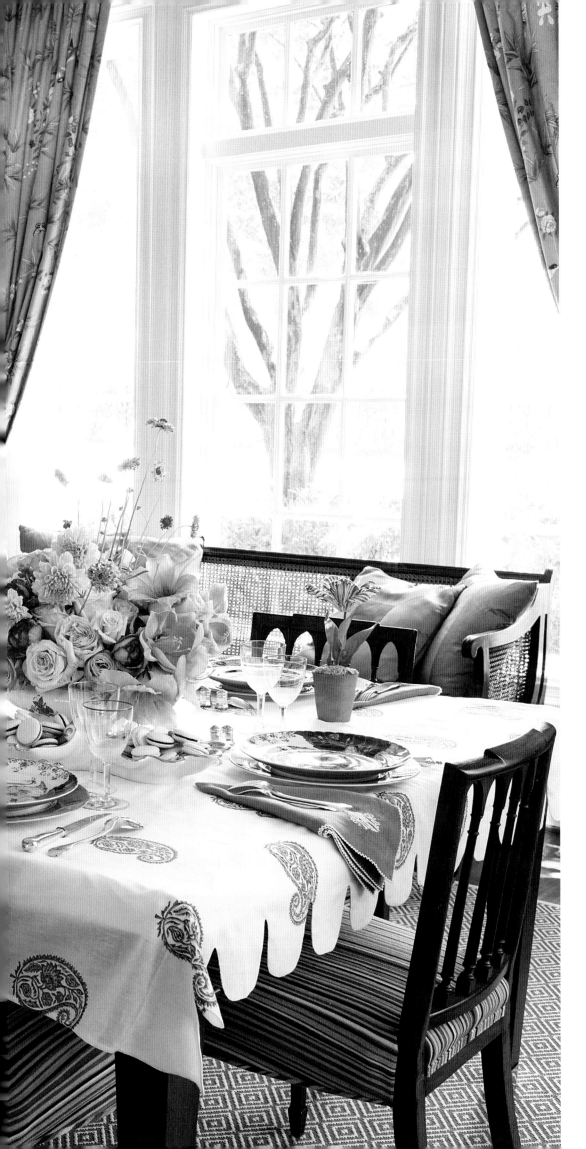

A dining room in a Dallas estate with a large set of George III mahogany chairs and a custom dining table that will seat fourteen people. Drapery fabric is Brighton Pavilion from F. Schumacher. The walls are lacquered with Persian Melon by Benjamin Moore, and the large foil painting is by Tam Van Tran. Flowers and styling by Jimmie Henslee.

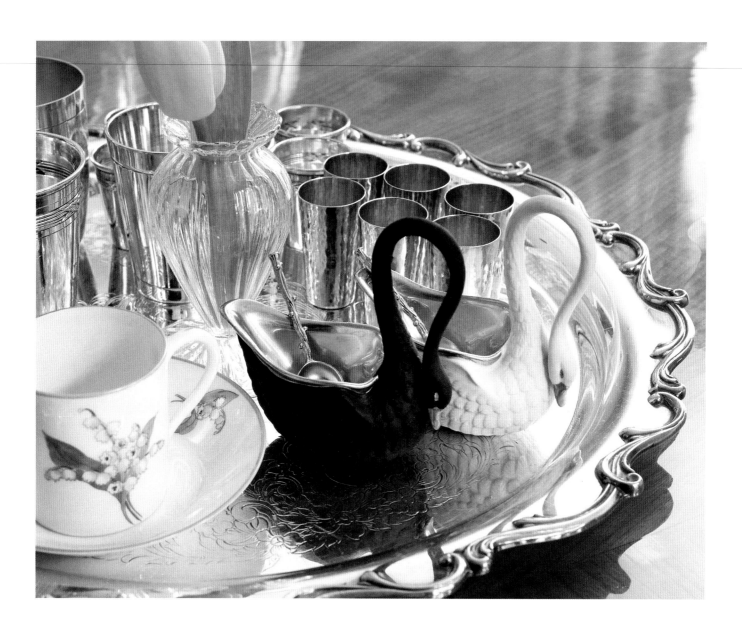

Above: A collection of silver and china that I love—everything is vintage except the swan salt and pepper containers by L'Objet. *Opposite*: One of my favorite color combinations, yellow and gray, creates a warm and welcoming dining room. The table is vintage from France, c. 1940, the chandelier was custom-made for this room in Murano, and the chairs are the Coco Dining Chairs from the Jan Showers Collection. Art between windows by Alexander Calder.

✳

Following spread: A dining area in front of a well-hidden kitchen. A double-tiered Murano chandelier hangs over a custom-made, 1950s French–style merisier table with custom sabots. The comfortable and stylish dining chairs are by John Boone. All the glass on the table is vintage Murano.

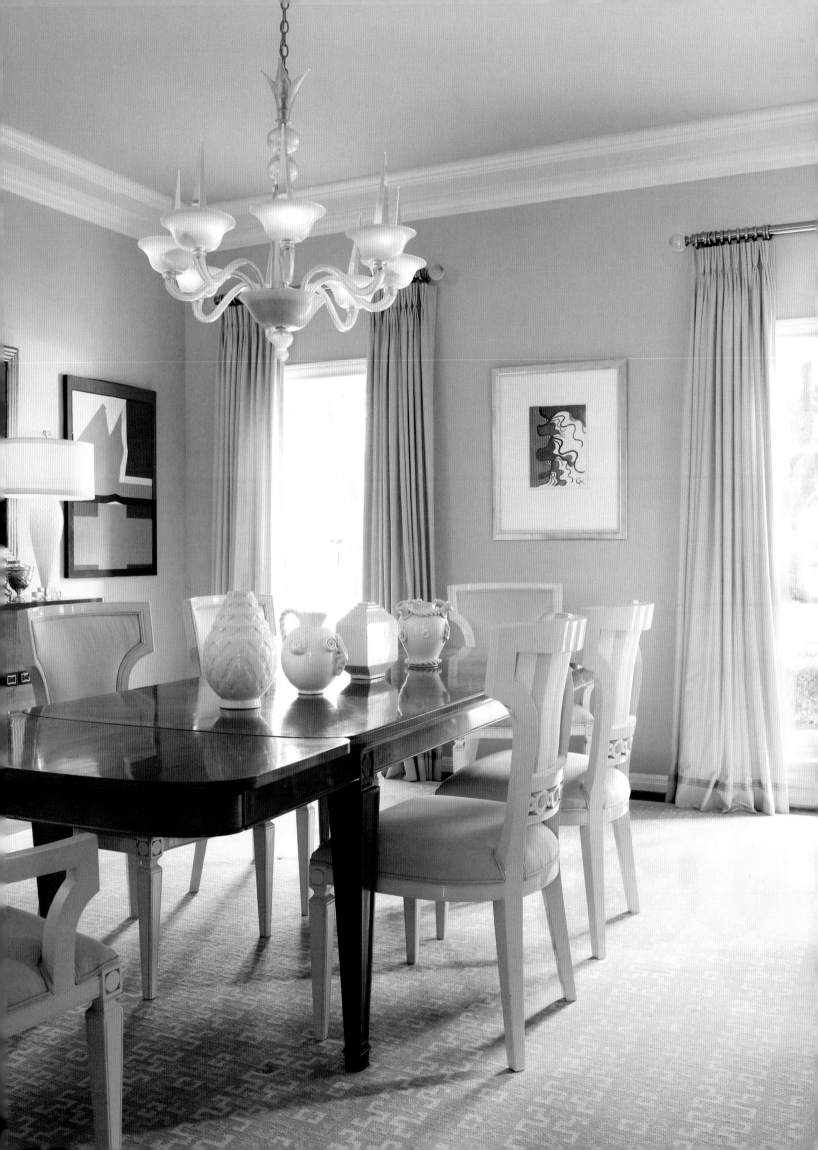

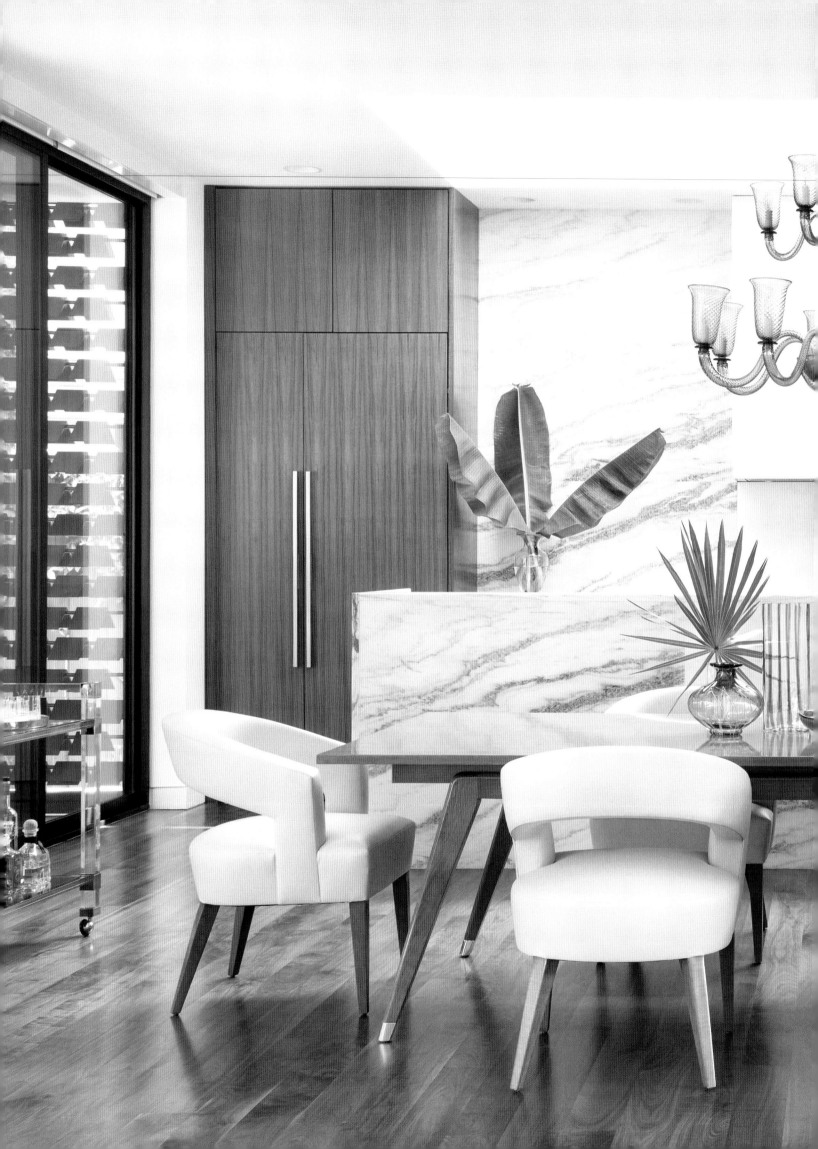

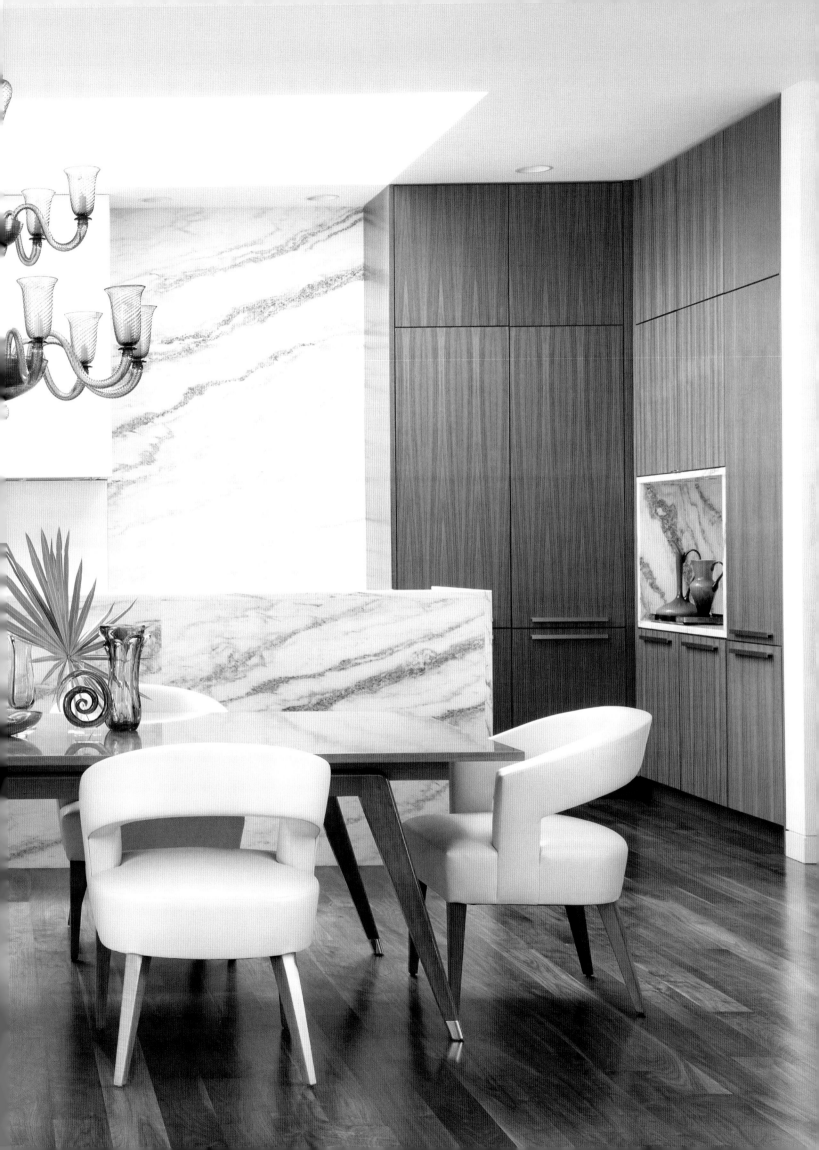

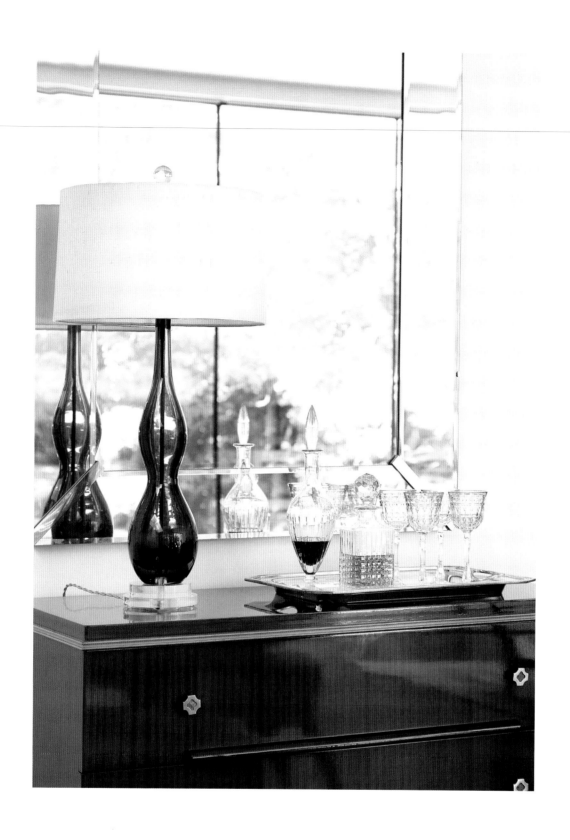

Above: A Swedish commode holds a stunning vintage Murano lamp in aubergine and a tray for after-dinner drinks. *Opposite*: A square room makes for a cozy dining experience with a round dining table. The sideboard is a very typical 1940s French merisier piece, derivative of the Directoire period in France. The lamps are Hollywood Regency from the 1960s, the chairs are the Marnie Chairs from the Jan Showers Collection, and the chandelier is a glass-and-brass Murano from the 1970s. The paint is Florida Keys by Benjamin Moore.

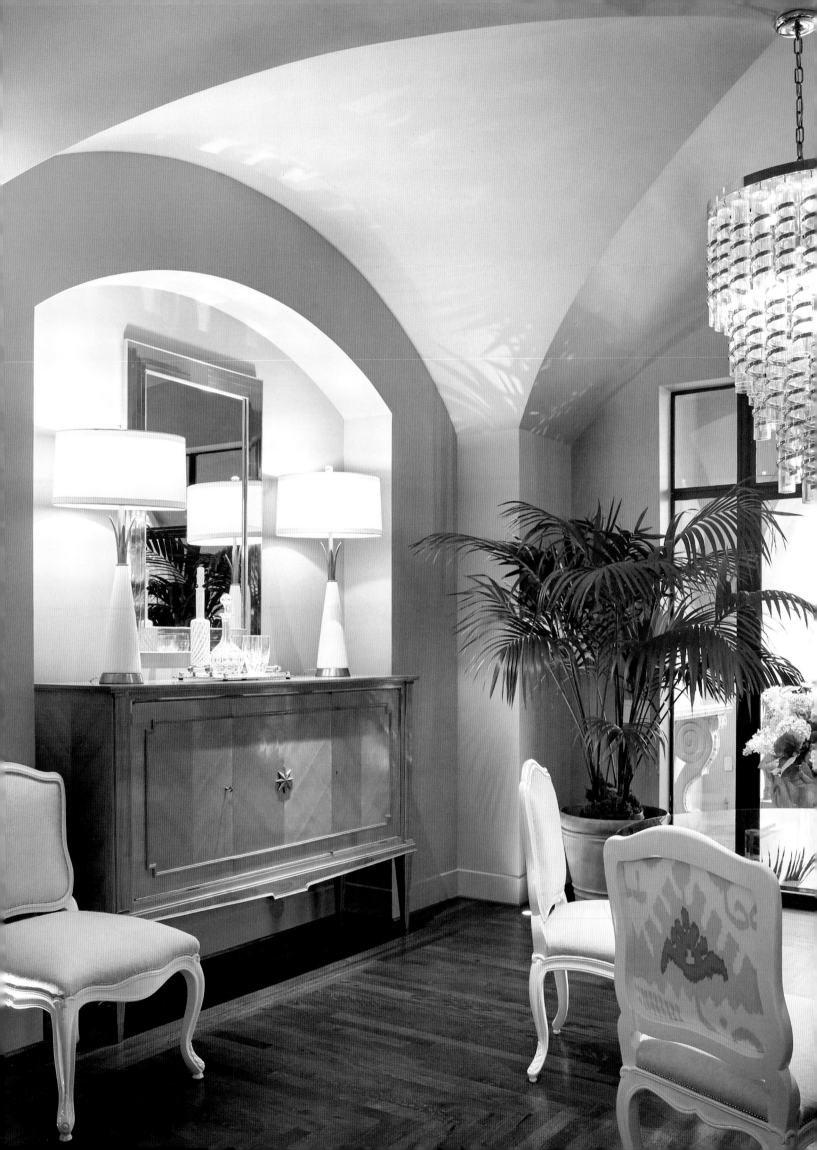

An austere yet warm dining room in a modern house in Paradise Valley, Arizona, with Robsjohn Gibbings dining chairs, a vintage mahogany table from the 1950s, a French sideboard, and a handsome sculptural bronze chandelier by Peter Van Heeck, c. 1970. Painting to the left in the hallway is by Lee Ufan.

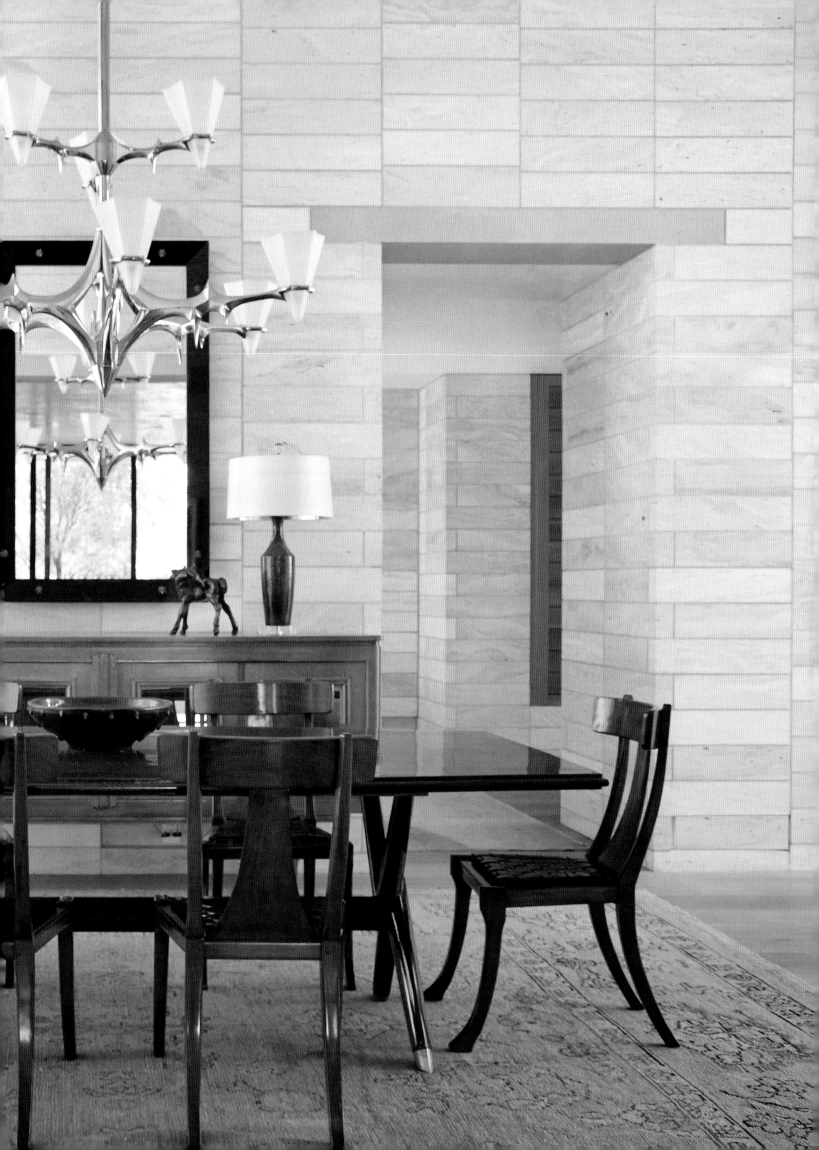

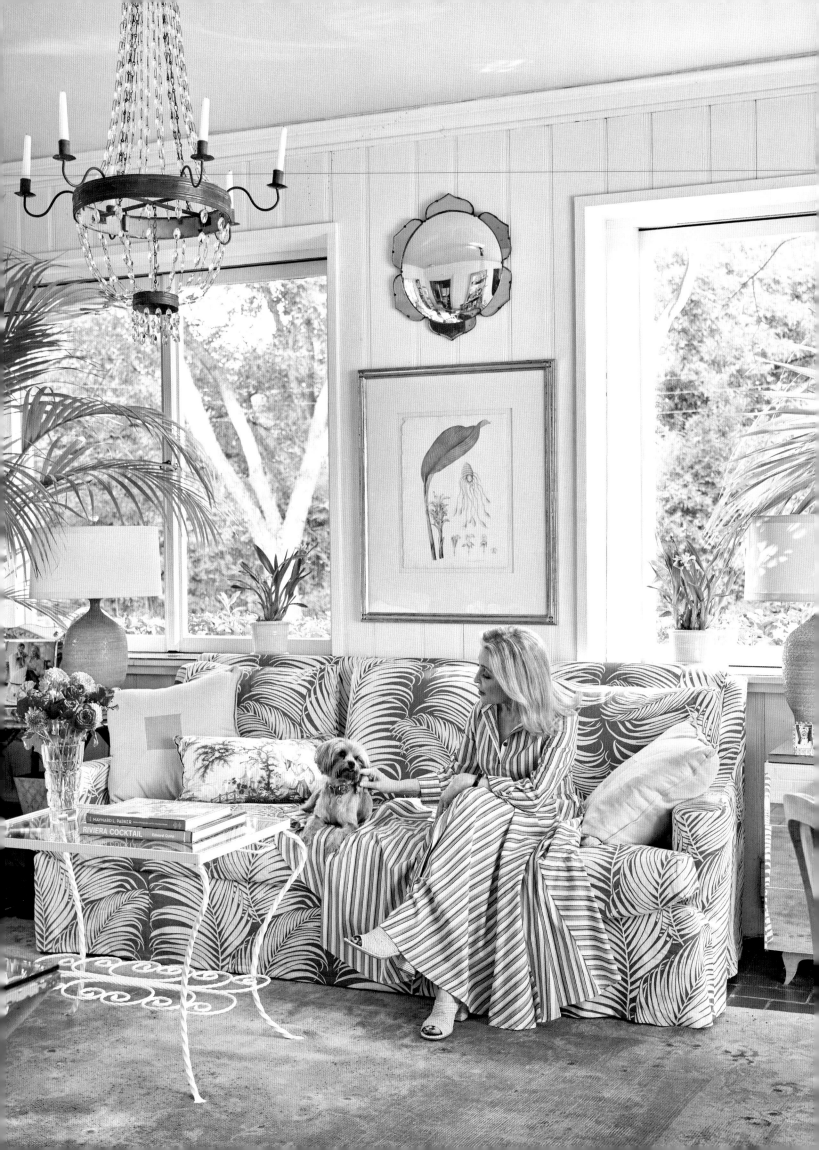

Easy LIVING

When I'm home with Jim at our country house, I inevitably find myself drawn to one of two rooms: our sunroom or our library—both of which embody my idea of easy living. The intimate, wood-paneled library is warm and inviting. The window-lined sunroom has a casual dining table and a deep, cozy sofa and chairs. I have passed many hours in these rooms with my feet up, a throw over me, and my dogs beside me, while I watch movies, read, or listen to music, usually in a caftan with no makeup.

Over the years I've traveled to Europe many times for my antiques and vintage showroom. The French, English, and Italians have an extremely relaxed style in their day-to-day lives that I admire, especially in the way they use their dining and living spaces. I share their preference for things that feel old and have histories. No matter how tastefully a room is decorated, nothing will make it feel more inviting than antiques and vintage pieces, which instantly create depth, sophistication, and comfort.

Kitchens, once utilitarian and hidden behind doors, have become the center of casual living in many homes. There is a special intimacy to kitchens. Good friends and family know they can walk in and serve themselves a glass of water or go behind your bar and mix themselves a drink.

Though far more prevalent today than ever before, there have always been good kitchen design companies who put together distinctive kitchens. My mother had a St. Charles kitchen in the 1950s, when they were popular. Since then, there have been many kitchen companies. At the present time, I prefer Christopher Peacock for traditional homes and Bulthaup or Poliform for more modern interiors. They're brilliantly designed and well worth the investment.

Many of the houses I design have bars and lounges where people can gather. They are always fun spaces to decorate because, like casual living rooms and kitchens, I know they'll be well used, and people will enjoy their time there. Which is the whole point, of course—relaxing together, feeling comfortable and at ease with the people you love.

Sis, Jan's Silky Terrier, and Jan relaxing in the sunroom of her country house.

*"Nothing makes a room
feel more inviting than antiques
and vintage pieces."*

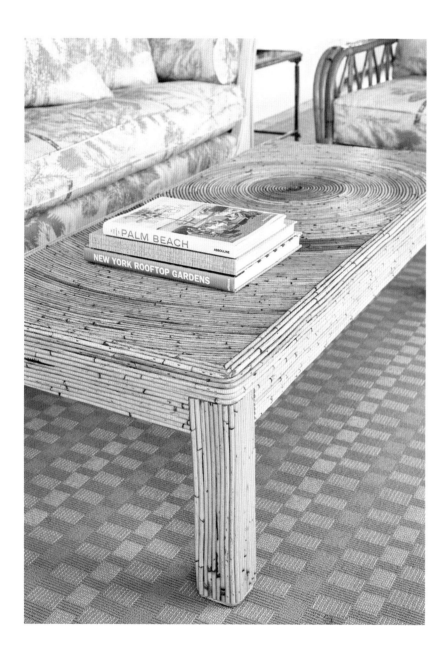

Right: A long, narrow sunroom overlooks the pool. Wallpaper by
Carleton V Boca Grand; furnishings are vintage, including
a split-bamboo coffee table by Crespi, bamboo chairs, and a Palm Beach
painted sofa from the 1950s, with a Slim Aarons photograph above.
Fabric is Bahamas by Manuel Canovas.

Following spread: Upholstering all furniture in the
same fabric is very typical of Palm Beach.

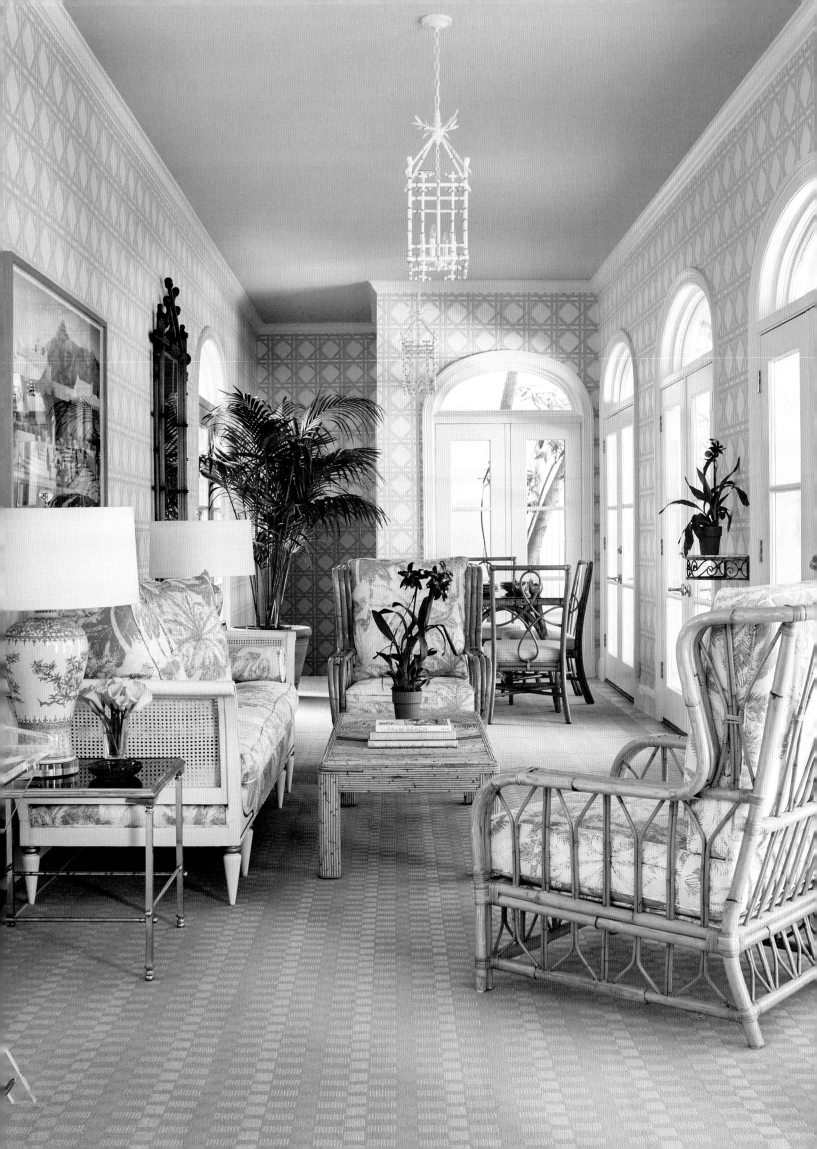

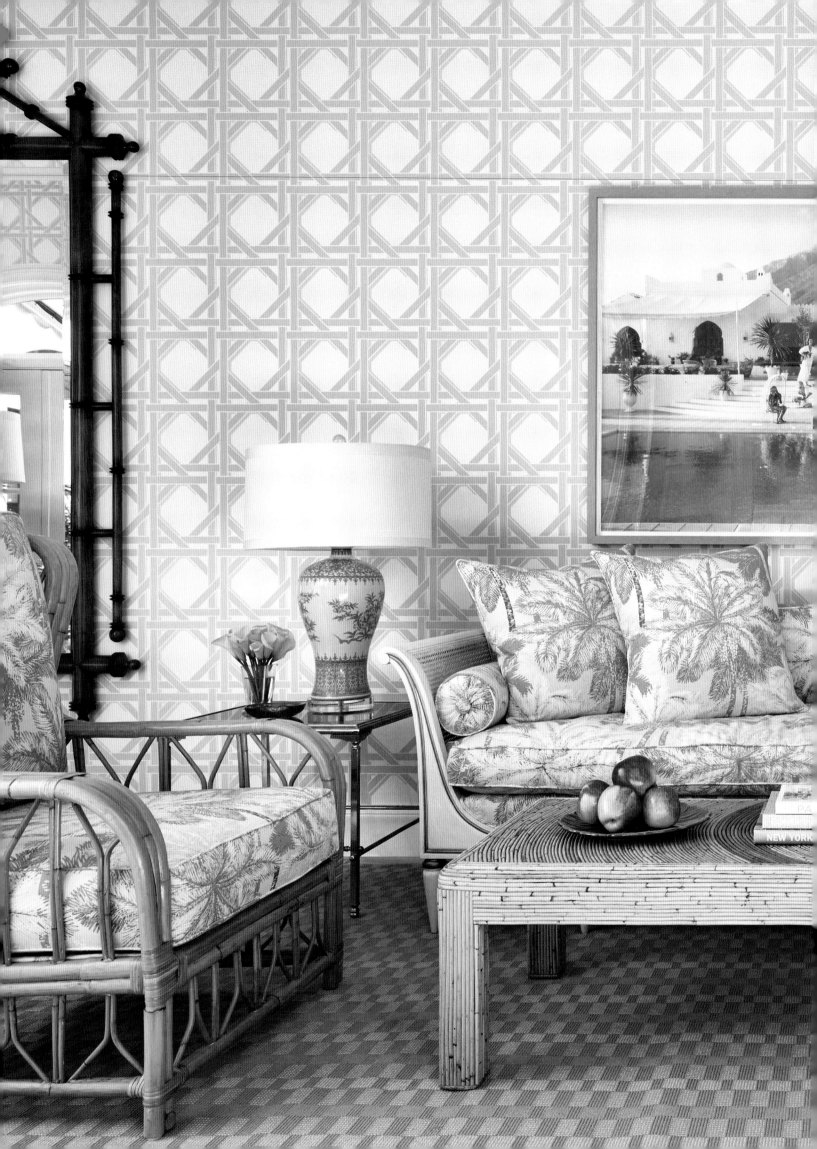

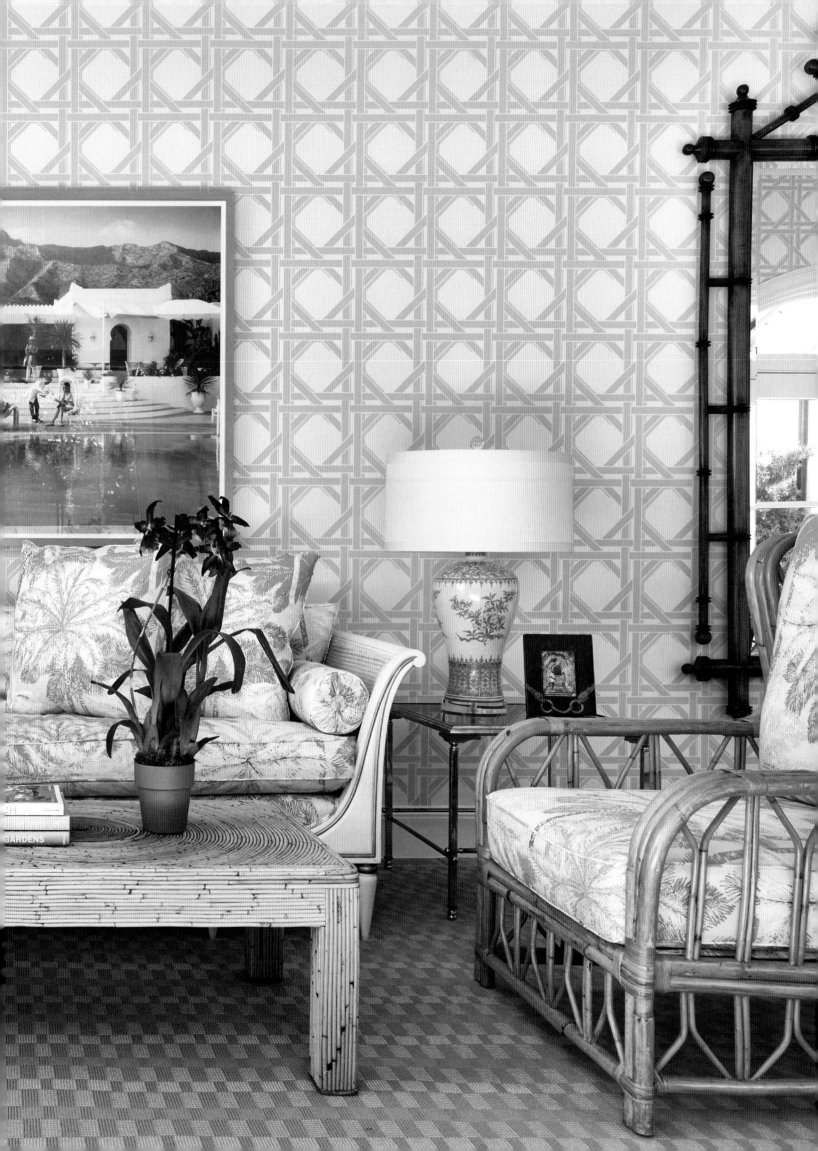

Below: The Paris Chair from the Jan Showers Collection in the library of
our country house sits by a 1940s French flip-top card table. Lamp by Paul Schneider
Ceramics. *Opposite*: Another view of the library with all vintage furniture
purchased on many trips to Paris when buying for my showroom. The art is by
Ellsworth Kelly, from his collection of plant and botanical drawings.
I love the rug by Stark.

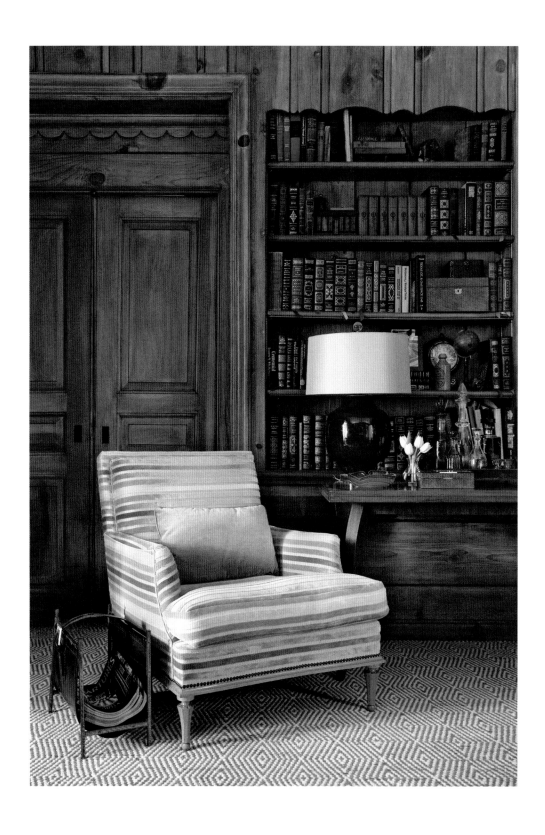

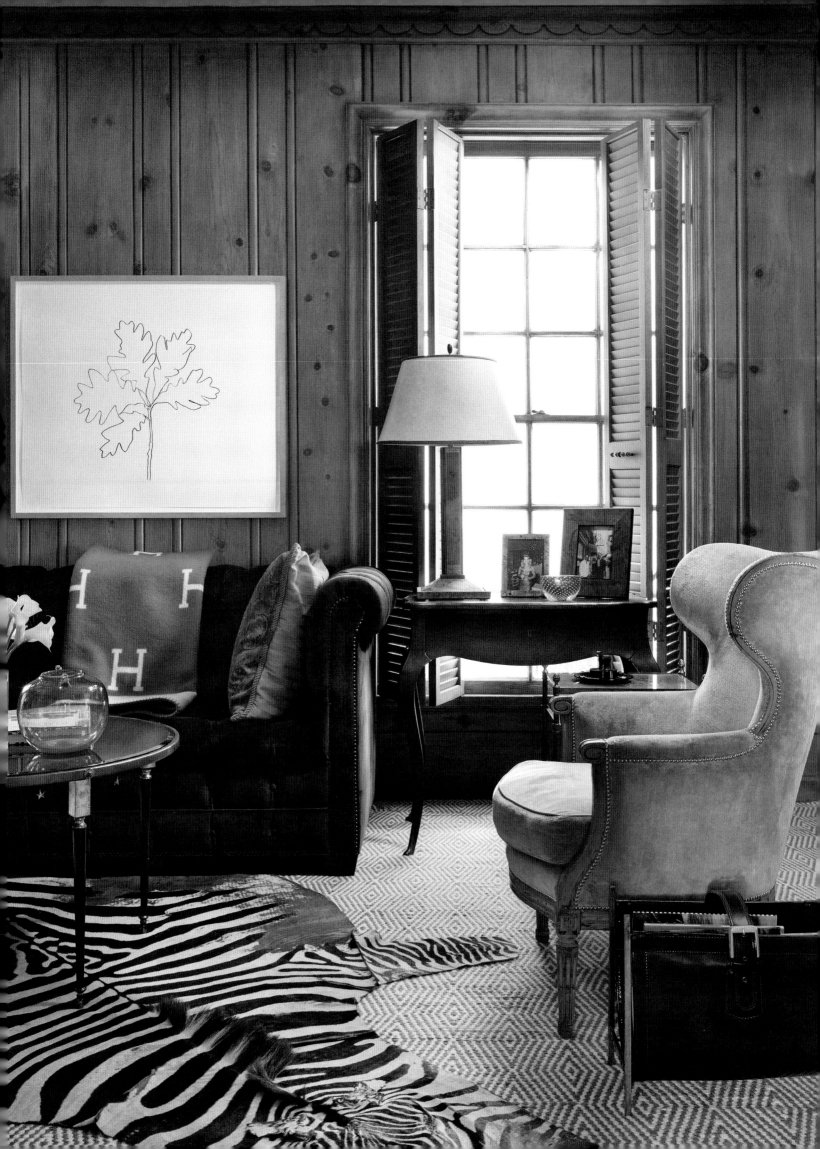

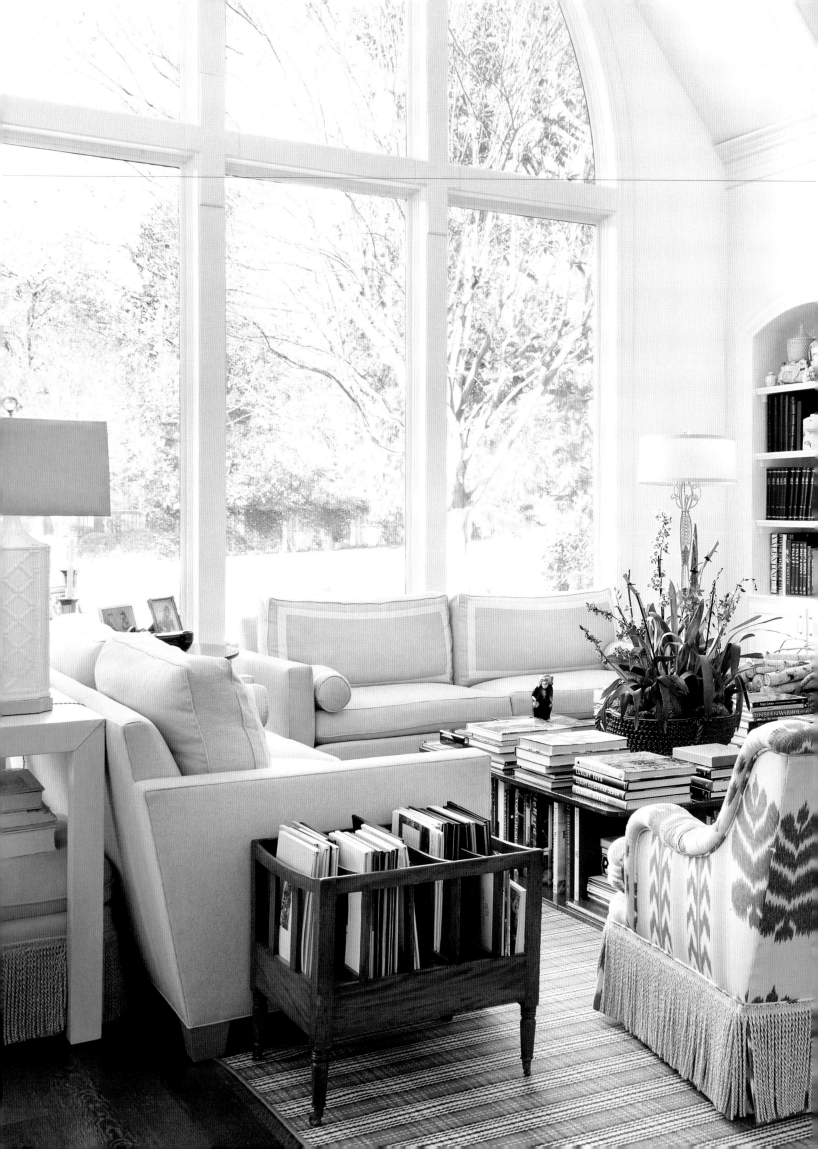

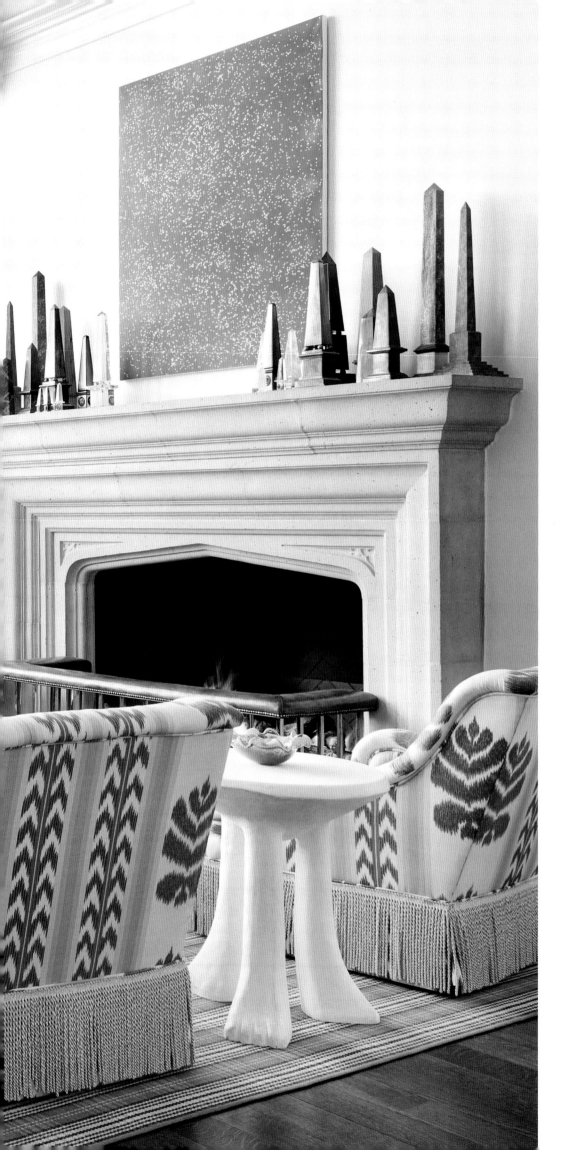

The family room in a large estate in Preston Hollow, Dallas, features a fabulous coffee table from Yves St. Laurent's atelier in Paris, a John Dickinson table, and the owner's wonderful collection of obelisks on the mantel. The lamps are Hollywood Regency, and the fabric on the lounge chairs is Chenonceaux by Brunschwig & Fils. Art is by Scott Reeder.

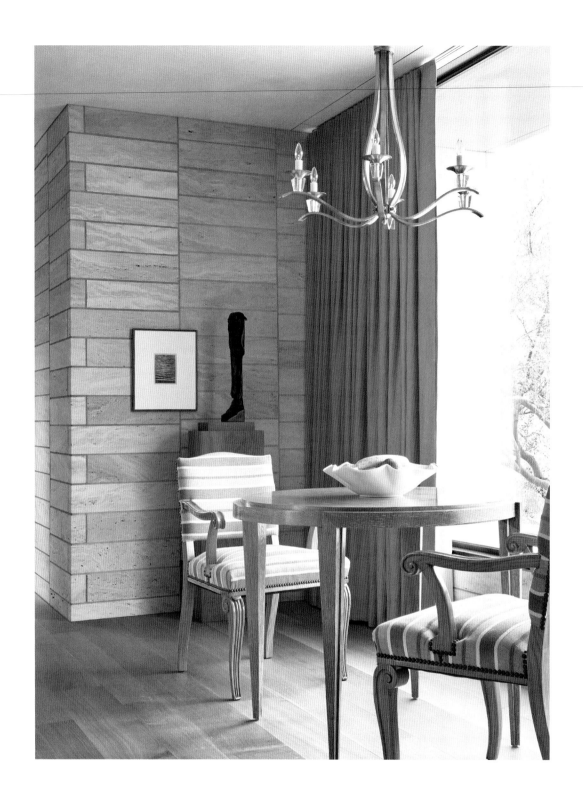

Above: A cozy dining area for two in a lovely guest house in Paradise Valley, Arizona.
Opposite: An inviting sectional with a double-trayed coffee table from the
1970s and a pair of gilded-and-mirrored French tables from the 1950s create a lovely
space for watching TV. The lamps are vintage Murano from the 1940s.

❋

Following spread: A custom Bulthaup kitchen in oak with a pair of unexpected,
magnificent Murano chandeliers, c. 1950. Art to left is *Untitled*, 1995, by Sol LeWitt.

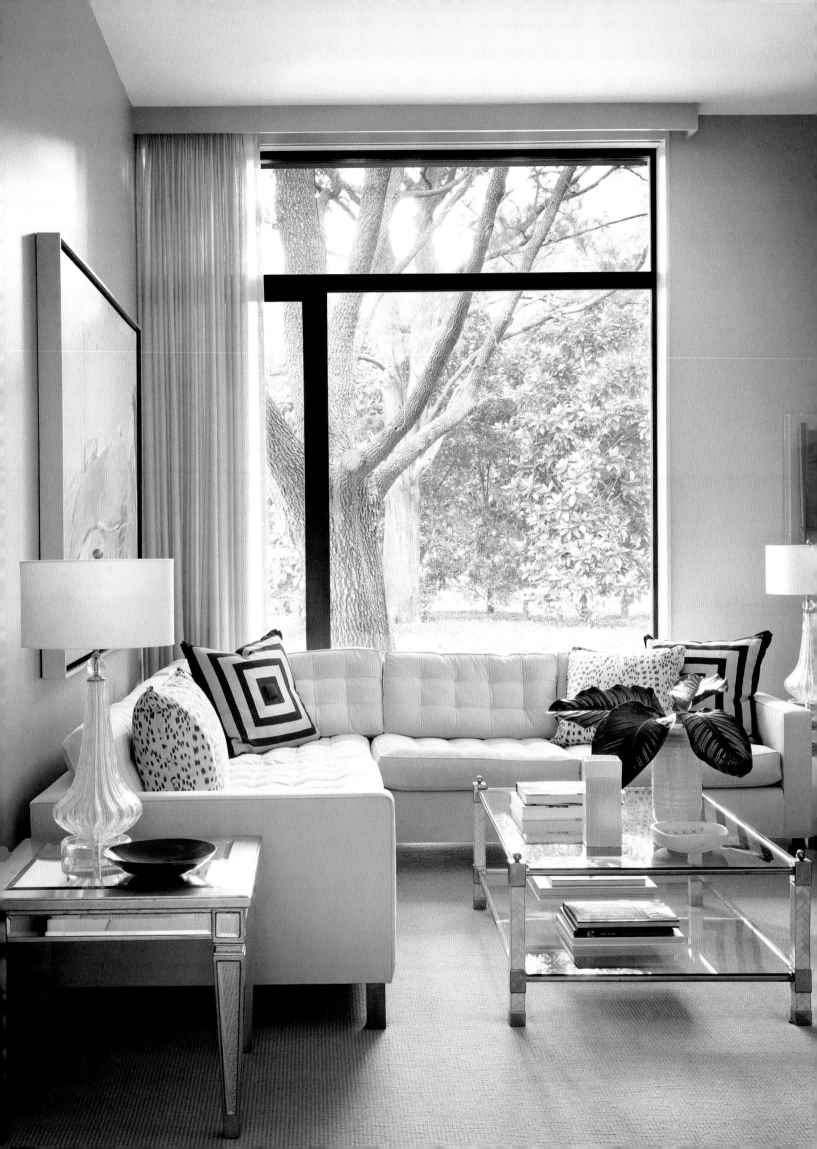

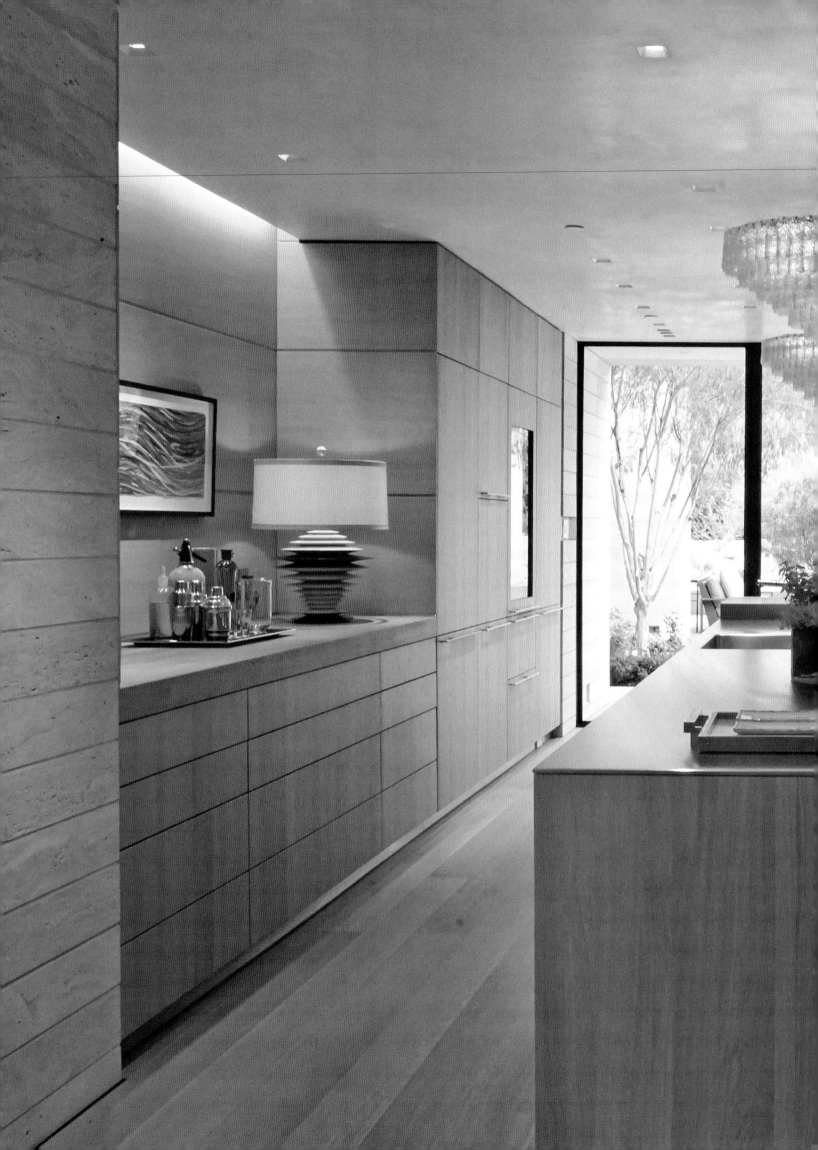

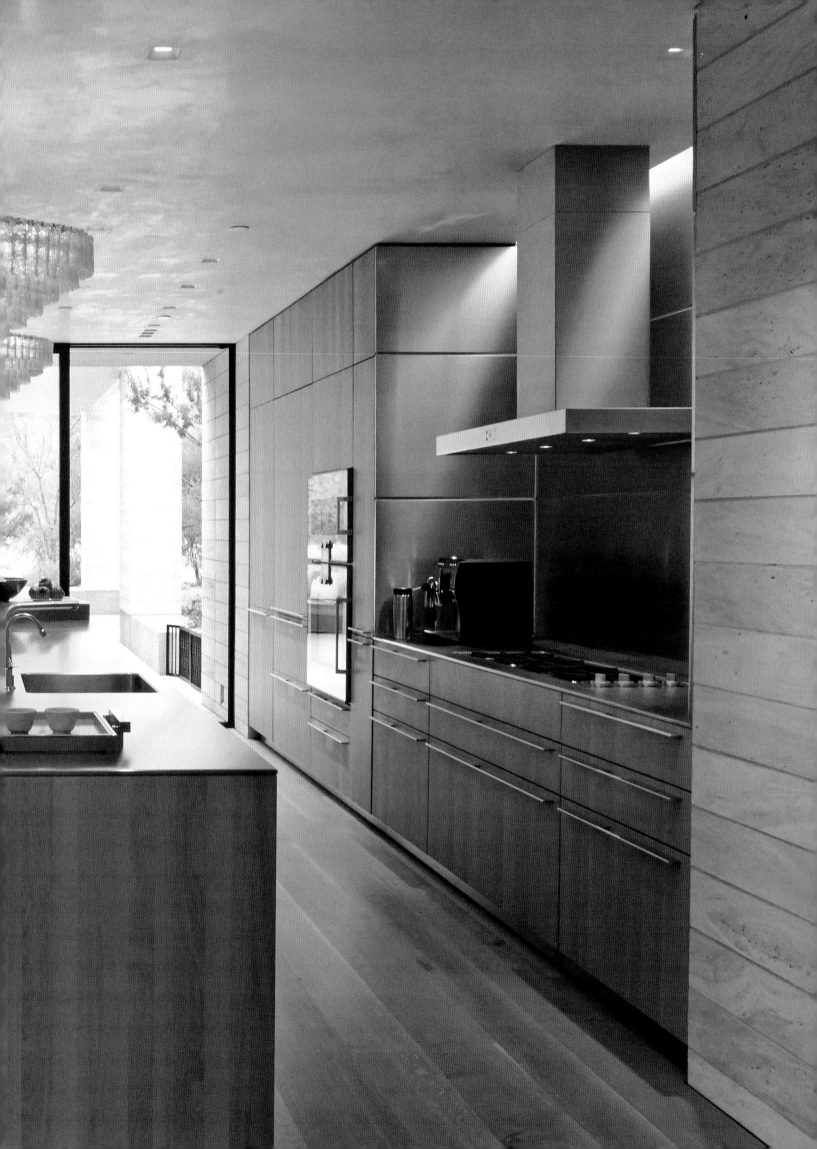

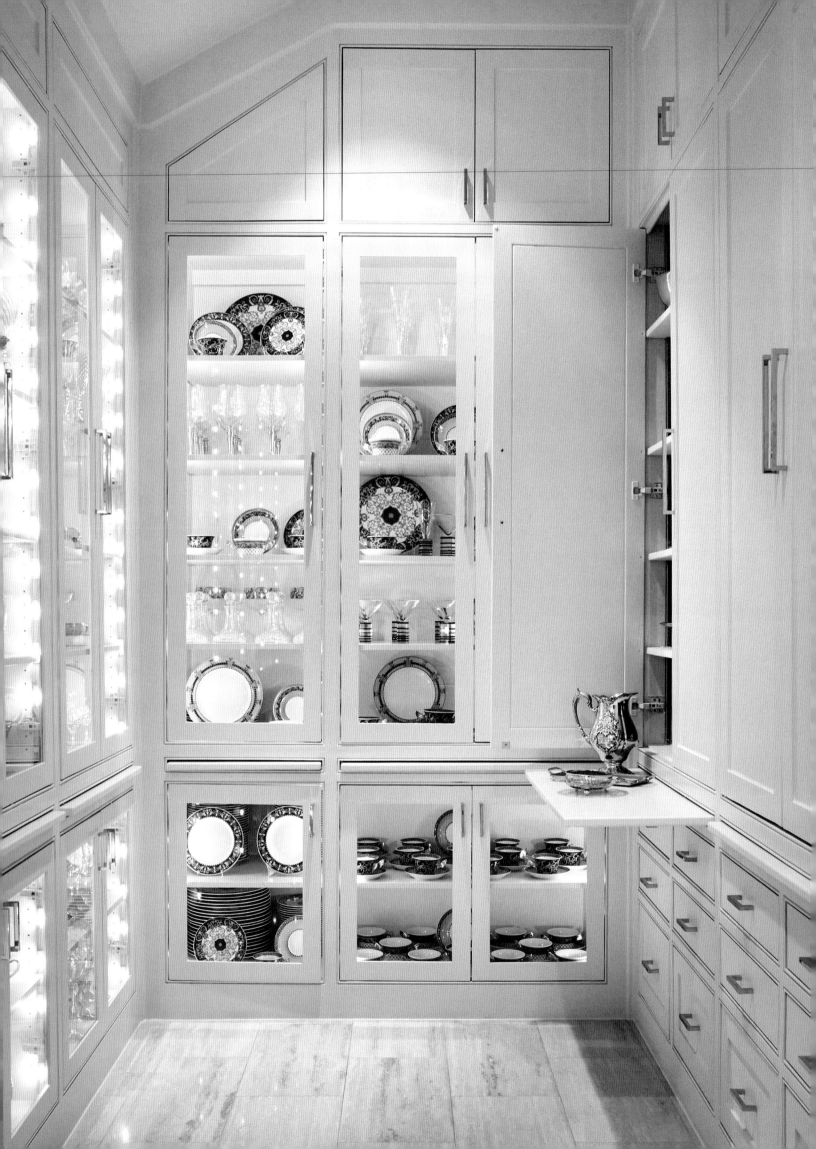

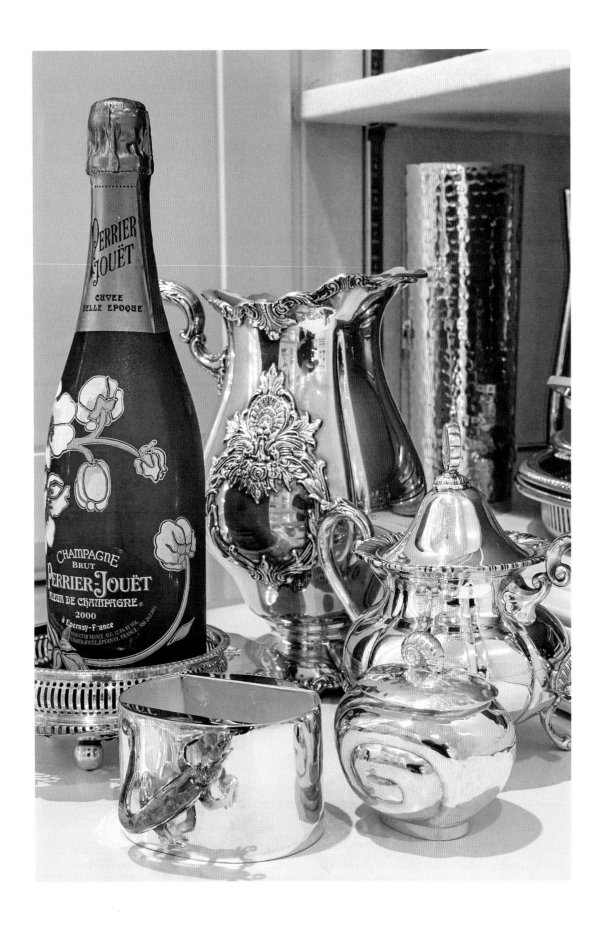

Opposite: One end of a china and crystal room in a Dallas house. *Above*: A detail of the owner's wonderful silver serving pieces she uses regularly for entertaining.

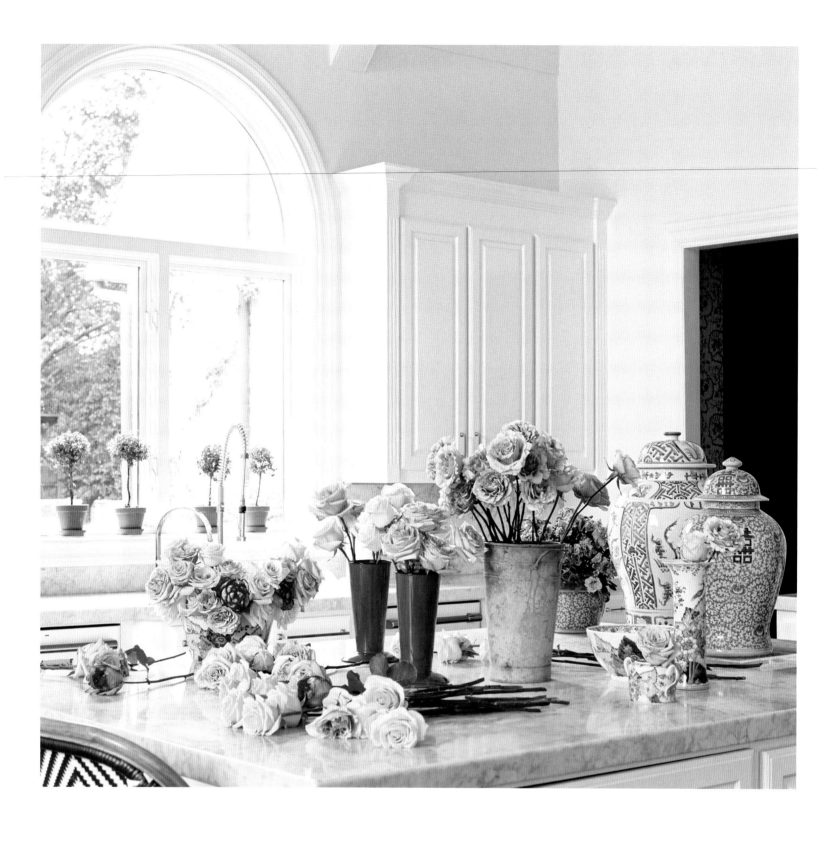

Above: The owner of this house loves to entertain and arrange flowers on the
large island in this bright and happy kitchen. *Opposite*: The china room, between
the dining room and the kitchen, with the owner's many collections of
china and silver. The paint is Stiffkey Blue by Farrow & Ball in high-gloss.

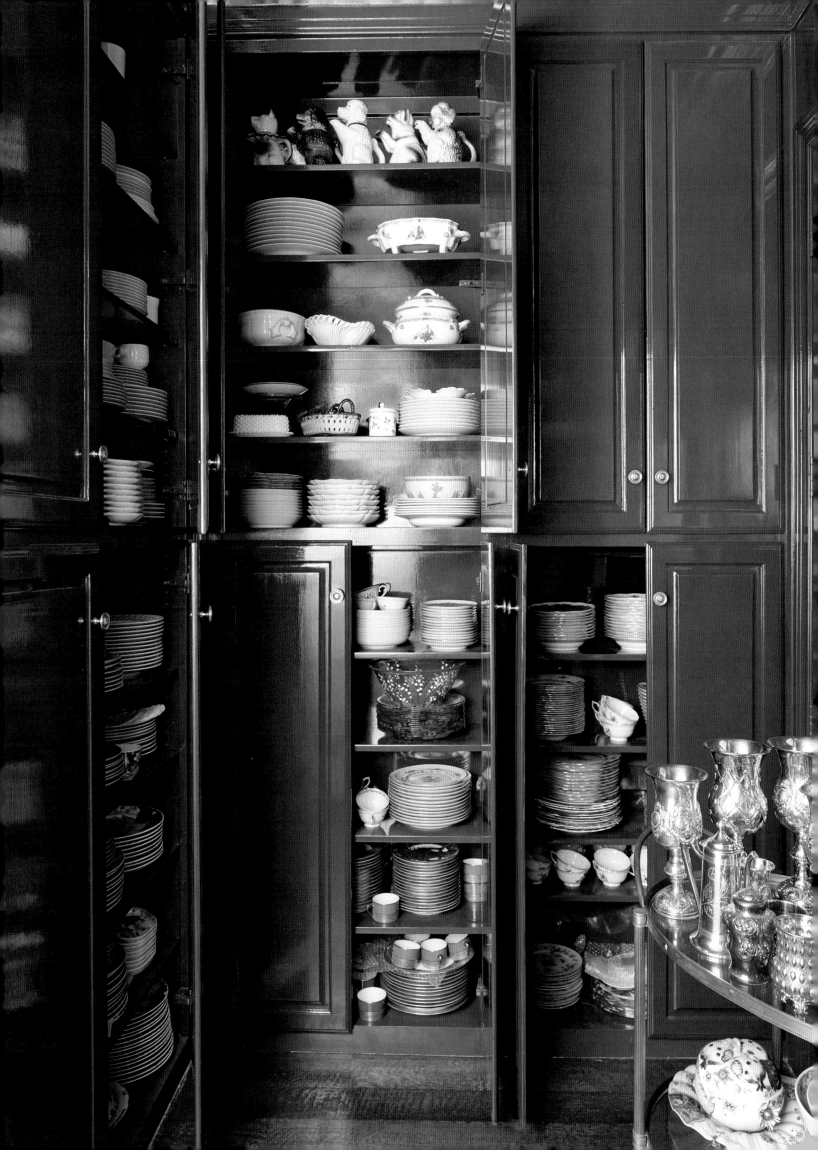

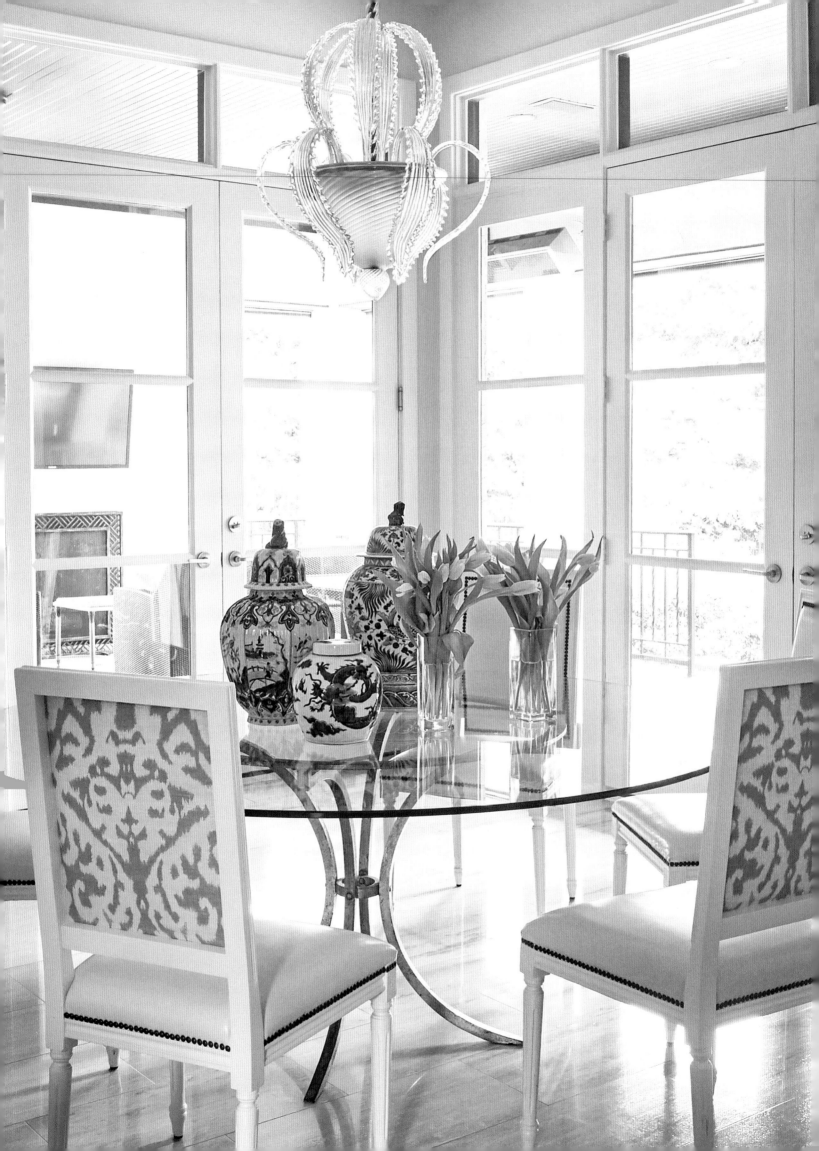

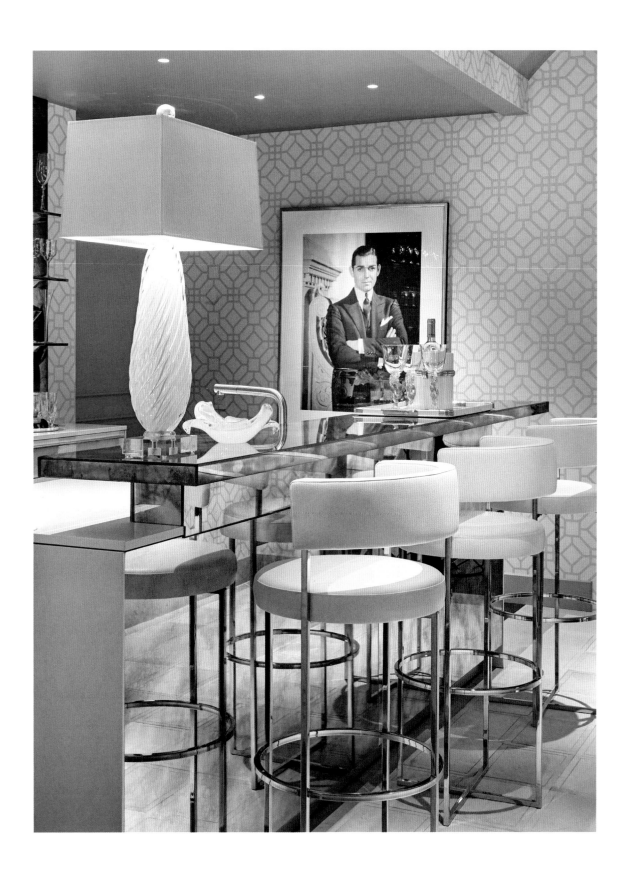

Opposite: Louis XVI–style chairs surround a glass-top table with a custom gold-leaf base.
A Murano chandelier from the 1940s lights the room. Blue-and-white delft porcelain
complements the golden tones in the fabric on the chairs by Bergamo. *Above*: A one-of-a-kind
vintage Murano lamp in opalescent yellow sits atop a mirrored bar. Wallpaper
by Sanderson. Clark Gable, one of the owner's favorite film stars, presides over the bar.

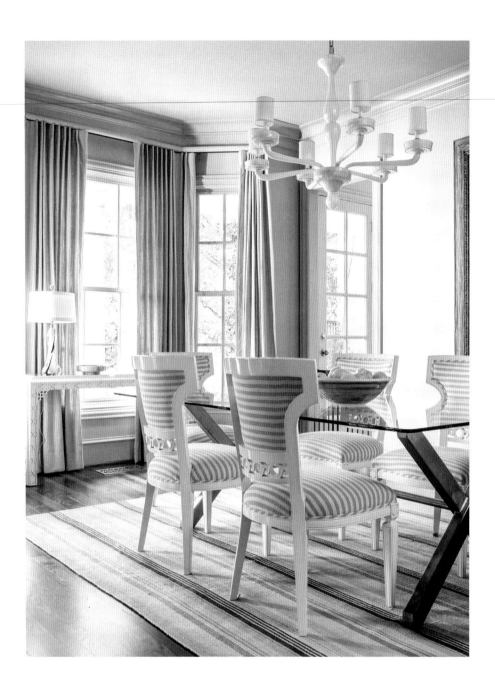

Above: A cozy breakfast area with Katherine Rally fabric on Coco Dining Chairs, a custom glass-top dining table, and an Elizabeth Chandelier from the Jan Showers Collection in Murano glass. *Opposite*: The solarium in an early-twentieth-century house in Dallas's Old Highland Park is now the family's casual dining room, with chairs for reading and lounging. The chandelier is a Chinese Tole bamboo lantern by Jasper, the table is vintage, and the wallcovering is by Phillip Jeffries.

※

Following spread: A chocolate-brown bar with custom banquettes in ivory-tufted leather is perfect for entertaining in this historic house. A pair of Wallis Tea Tables by the Jan Showers Collection add another touch of glamour to the room. Paint is Mink by Benjamin Moore in a high gloss. Aged mirrored panels by Malloy Glass, Dallas. Chandelier by Rejuvenation.

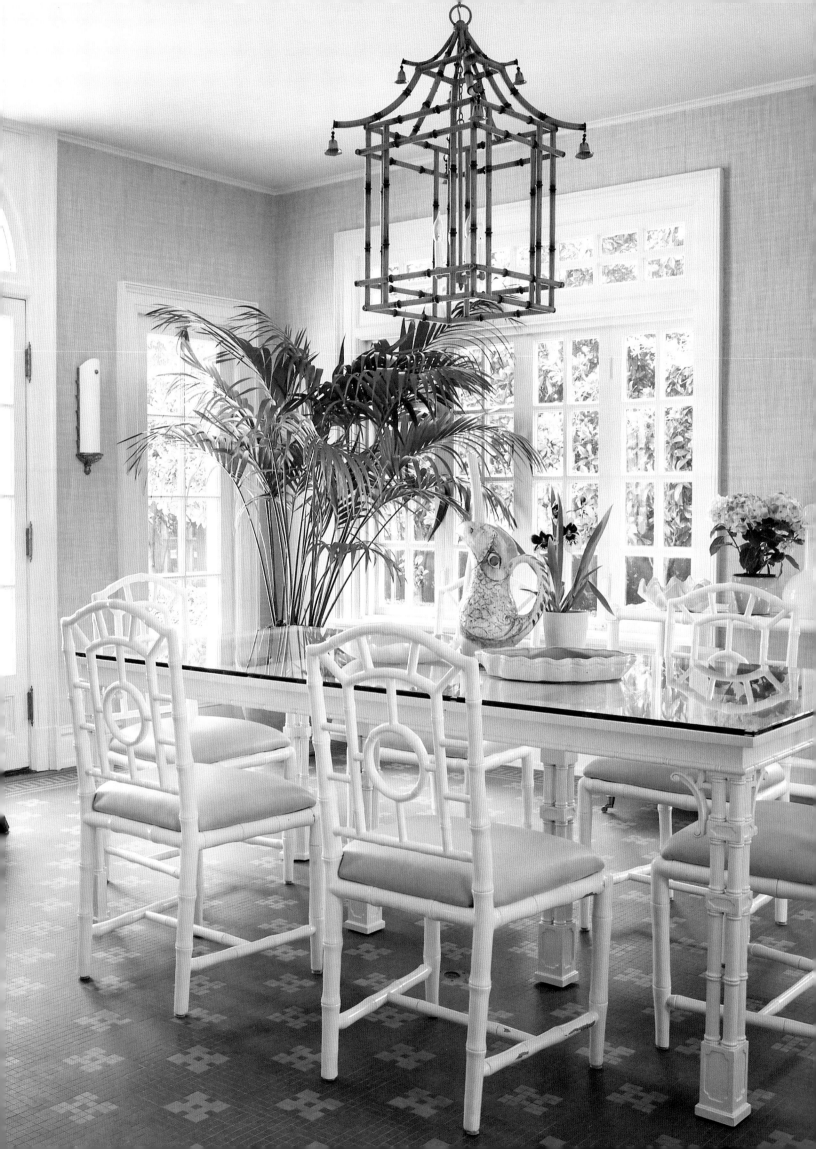

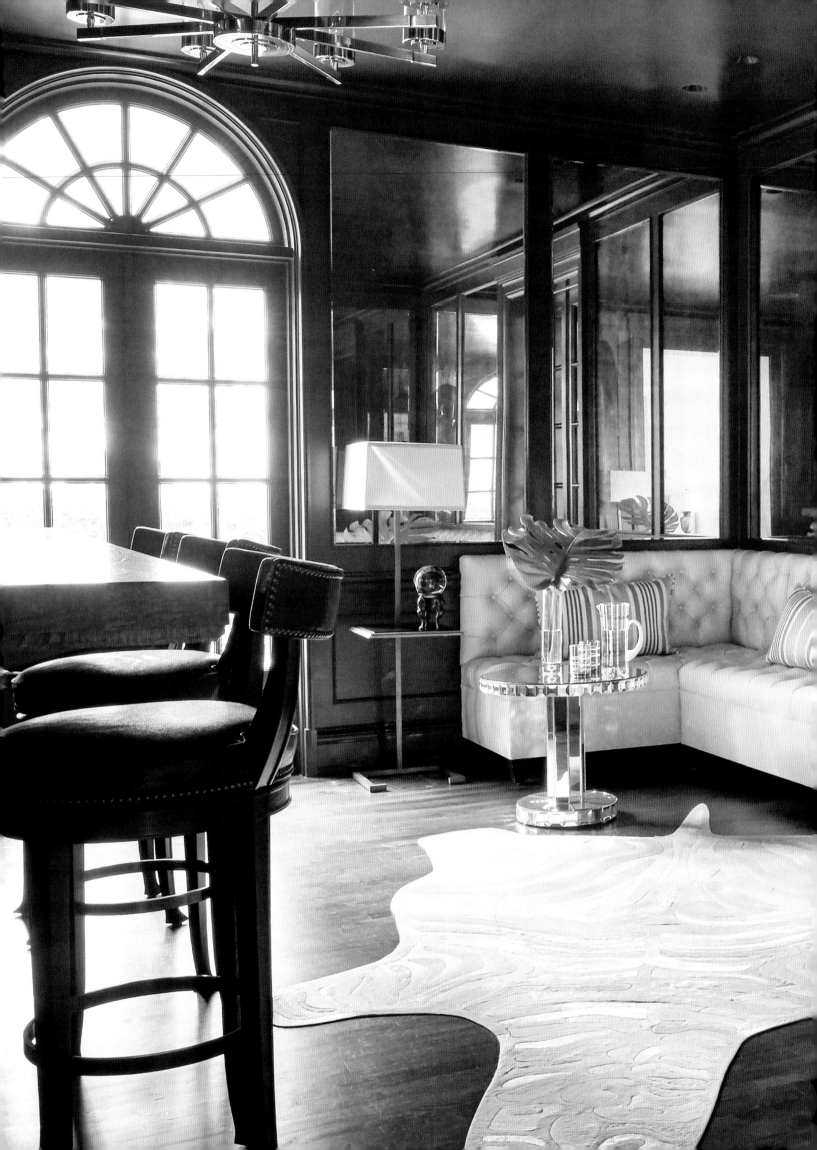

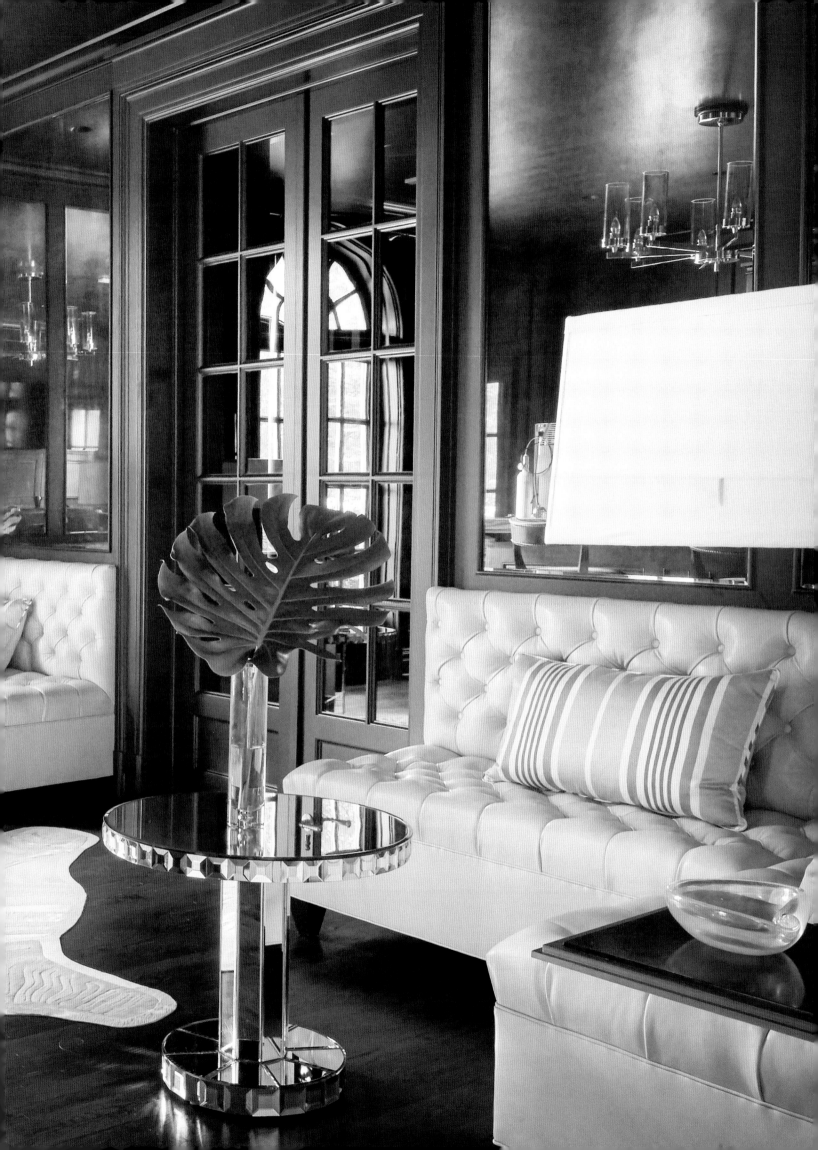

Dream TIME

Many of my clients say they never use their bedrooms for anything but sleep. Experts confirm this is the best way to get a good night of rest, but I am quite the opposite. When I need to relax or am not feeling my best, my bedroom is the first place I go at any time of the day or evening. I love to read and write in my bedroom. I must admit I even work from bed, though never at night. I also buck popular wisdom by watching TV in my bedroom. At the end of a long and busy day, there is nothing more relaxing than watching a favorite film in my bedroom.

We've all heard someone describe a bedroom they admire as "like a hotel room." This could never be a compliment from my point of view. Like design in every other room of your house, it's only successful when it's personal—when every corner contains an element that means something to you, when your personality can be felt throughout.

I love personal photos in bedrooms, but I prefer snapshots over portraits. Beside my own bed, I have favorite images of my mother and father; Jim; and one of my best friends and me when we were early teenagers. I see them every night before I go to sleep and when I wake in the mornings. Other items on my bedside table include a round wooden box with an inlaid shell that Jim gave me when we were in St. Barth's on my birthday with a note that is special to me. One of my favorite clocks found in Paris (I collect them) sits on my table as well, along with a couple of objects that have brought me luck. Anyone who knows me would know the moment they entered the room that it could only belong to me. Though everything about it suggests comfort and retreat, it could never be mistaken for a hotel room.

Nothing like breakfast in bed in our Dallas townhouse—my favorite bed.

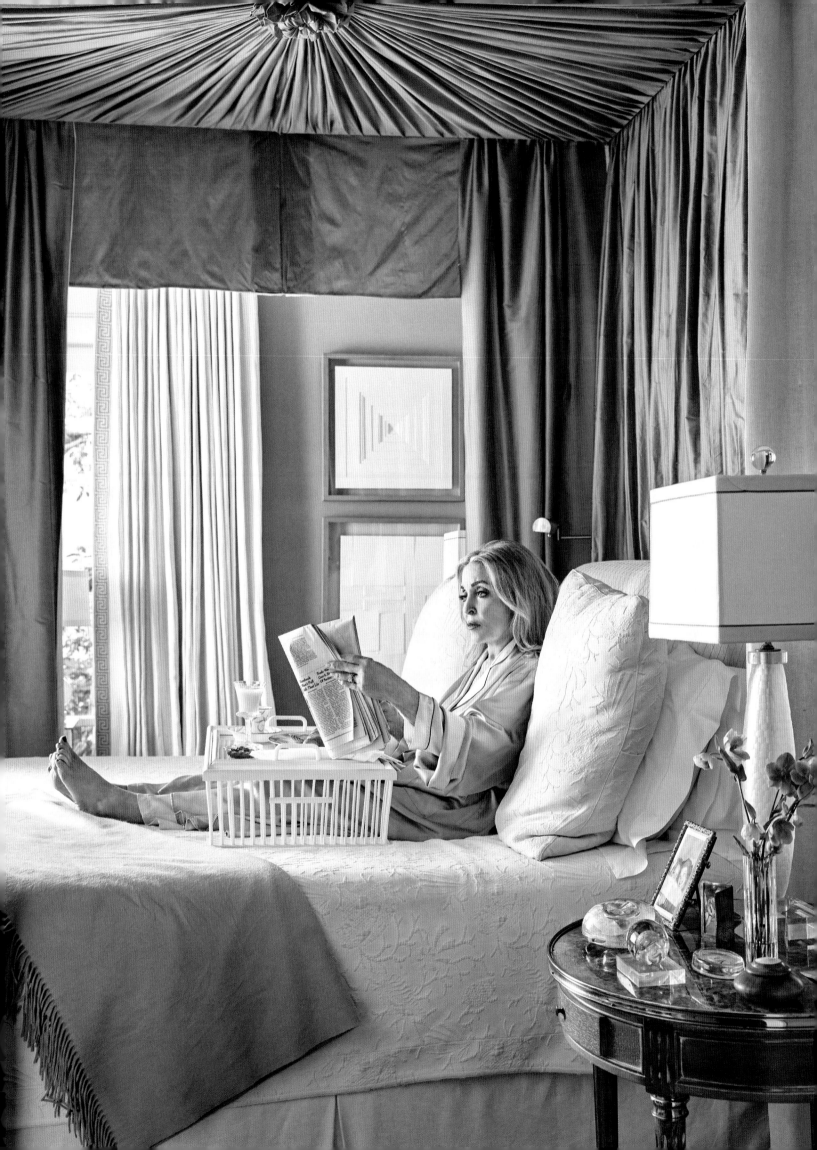

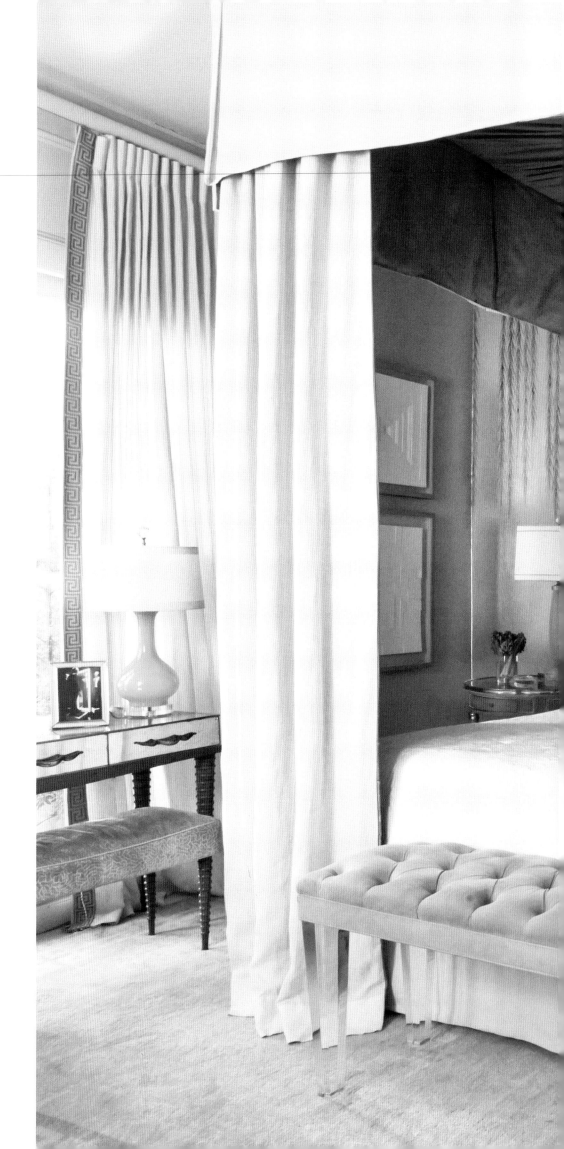

"Glamour and comfort are not mutually exclusive."

De Gournay Weeping Willow wallpaper hangs over the bed lined in my favorite green silk. The Mercer Bench in a pale chartreuse suede floats at the end of the bed. The sky-blue rug is one I designed for Moattar, and the dressing table and bench are vintage, found years ago on the French Riviera. The pair of bouillotte tables in a warm, cerused oak were found in Paris and are from the 1940s. Lamps are the Chiseled Lamps from the Jan Showers Collection.

✳

Following spread: An upstairs bedroom overlooks the gardens of our country house. The bed is upholstered with Flamands by Kravet Couture, and finished with a Jaipur Feather throw from Kravet Couture, all in Blush. A Louis XVI–style antique bench upholstered in raffia sits at the end of the bed. Books and bookcases add to the warmth of this room. Walls are Donald Kaufman #13. The butler's tray is French from the late 1930s.

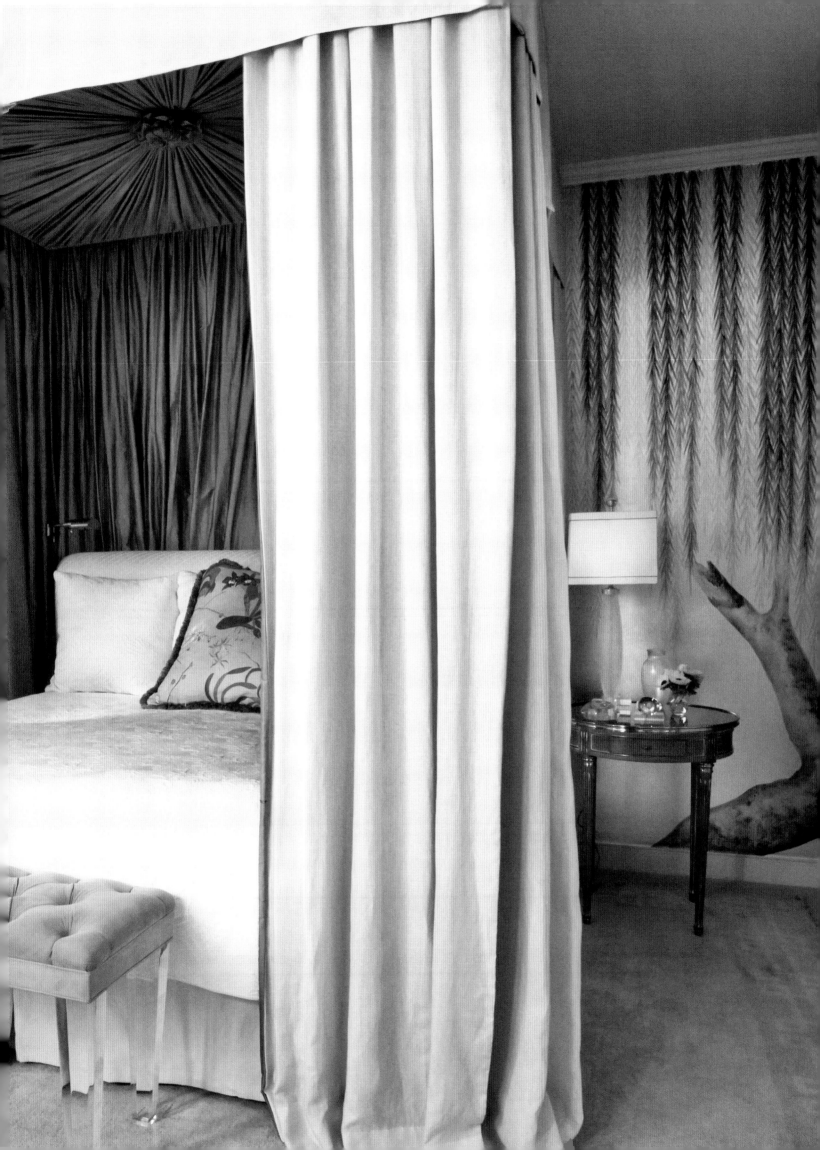

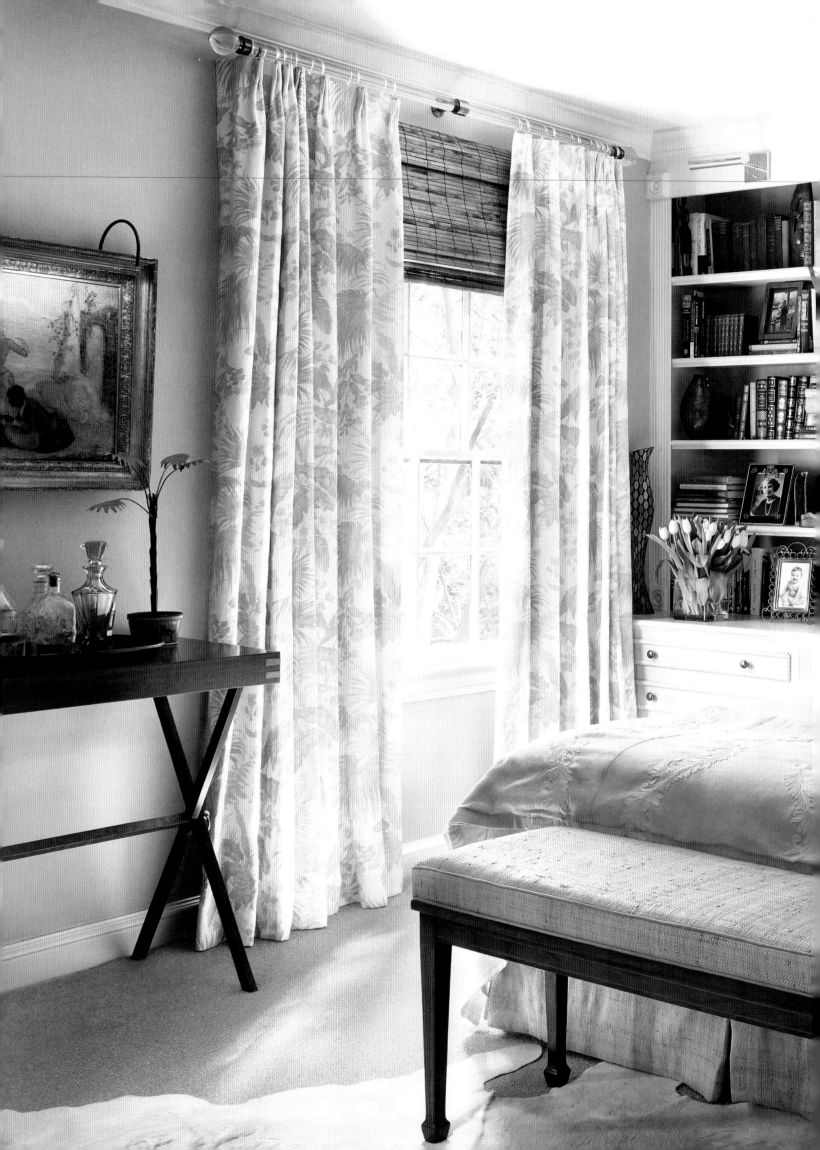

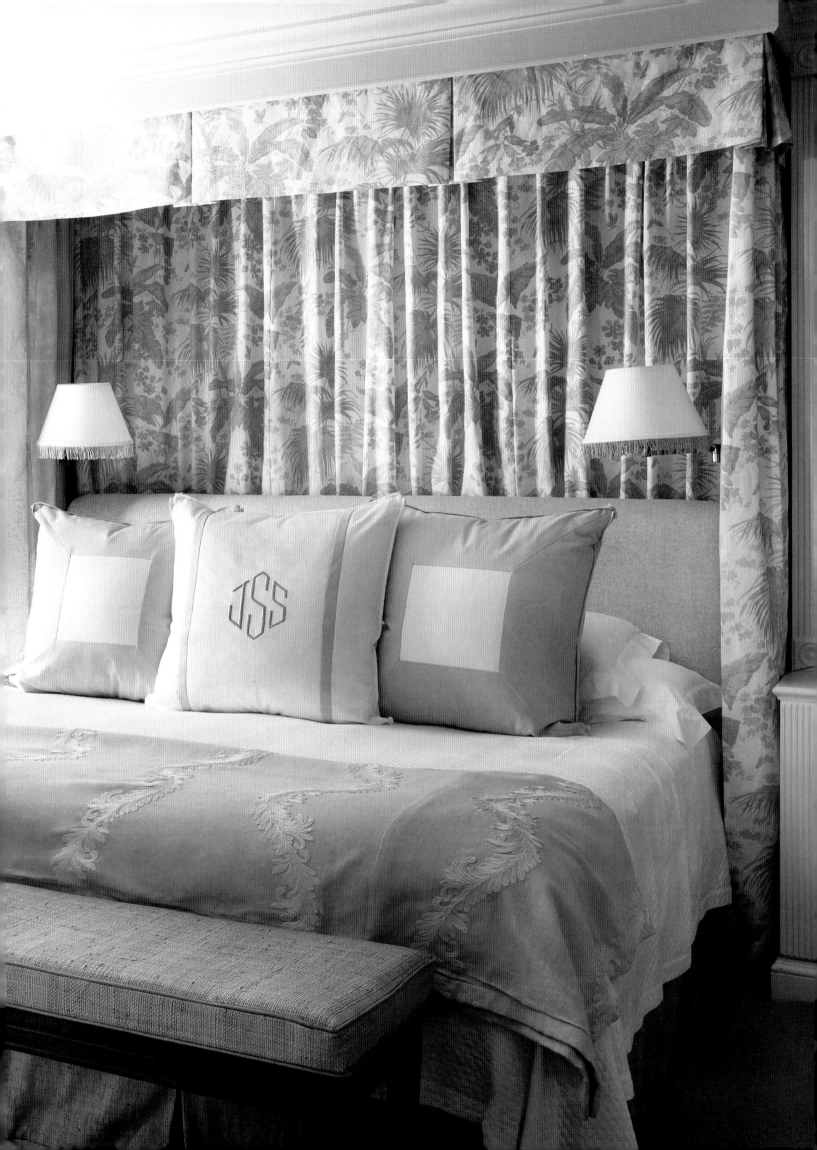

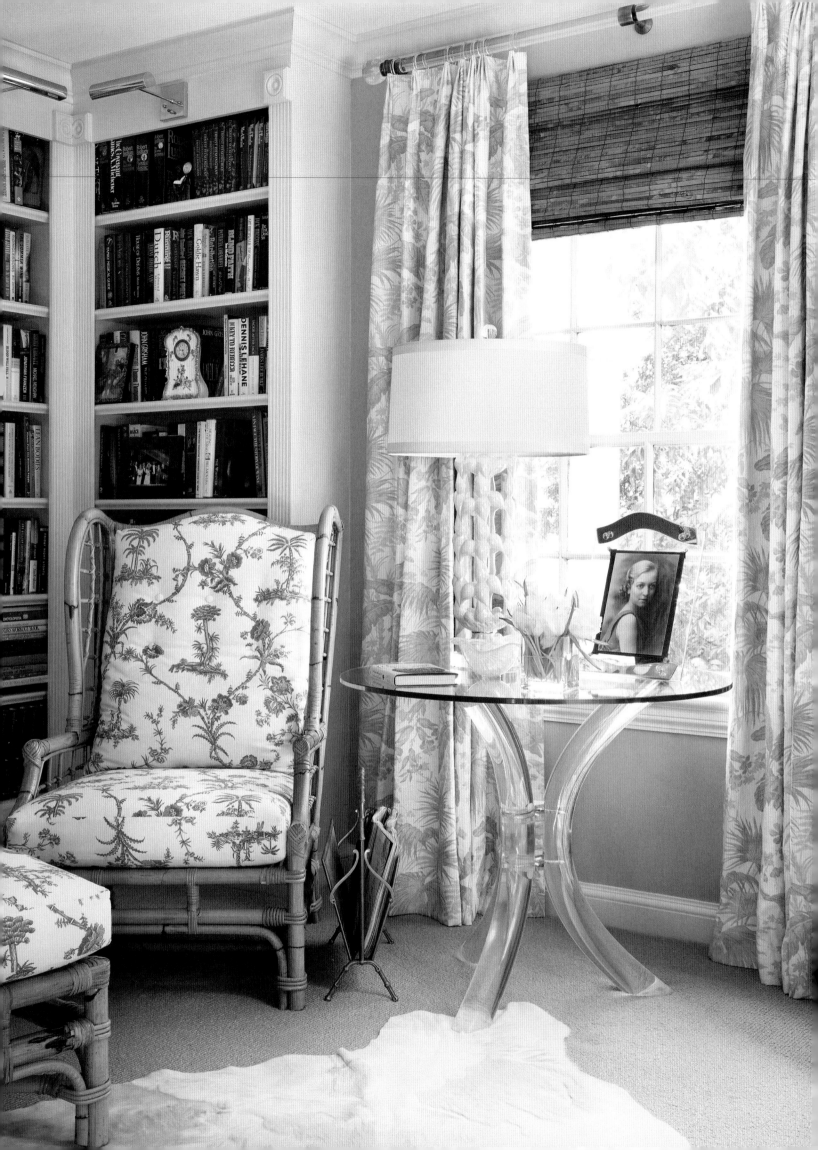

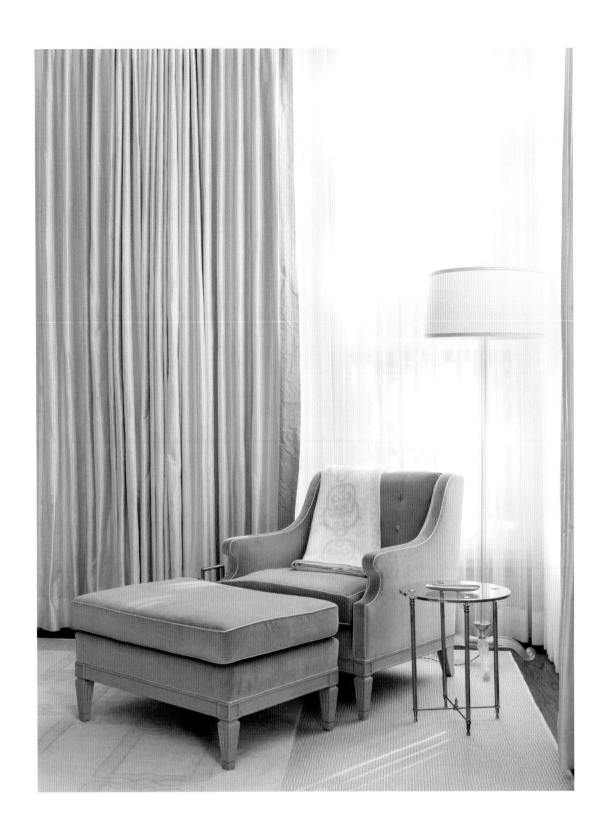

Opposite: A private corner for reading and relaxing. The modern Lucite-base table
pairs nicely with a vintage split-bamboo chair and an unusual iridescent ceramic
lamp by Marbro. The drapery fabric is Flamands by Kravet Couture, and the chair fabric
is West Indies Toile by Brunschwig & Fils. It's easy to mix prints that are one color and
of a different repeat or scale. The matchstick blinds add a more masculine element.
Above: A blush velvet chair and ottoman with cerused oak, Louis XVI–style base highlight
the corner of a master bedroom, which also includes a Jan Showers Collection Capri
Floor Lamp in gold Murano glass, and a French glass-and-brass 1950s table. The embroidered
throw is by Holland & Sherry. Chair and ottoman are in Kravet Versailles.

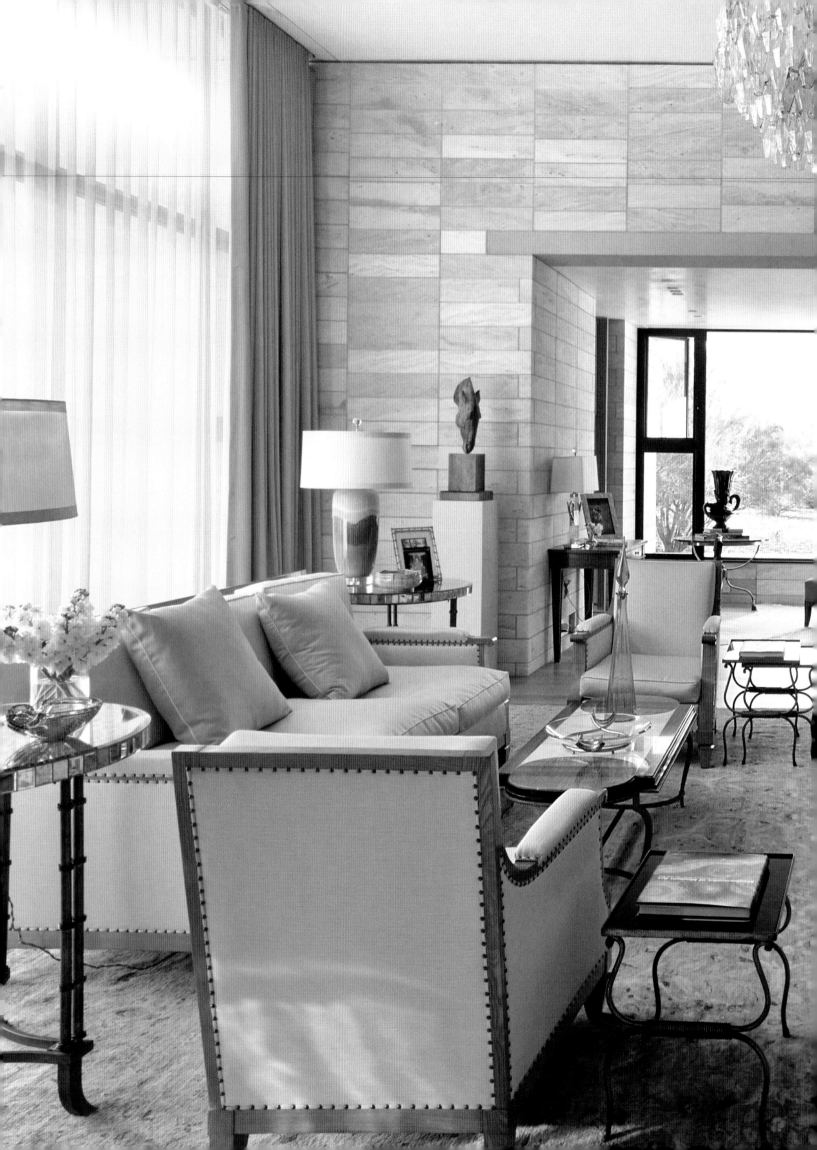

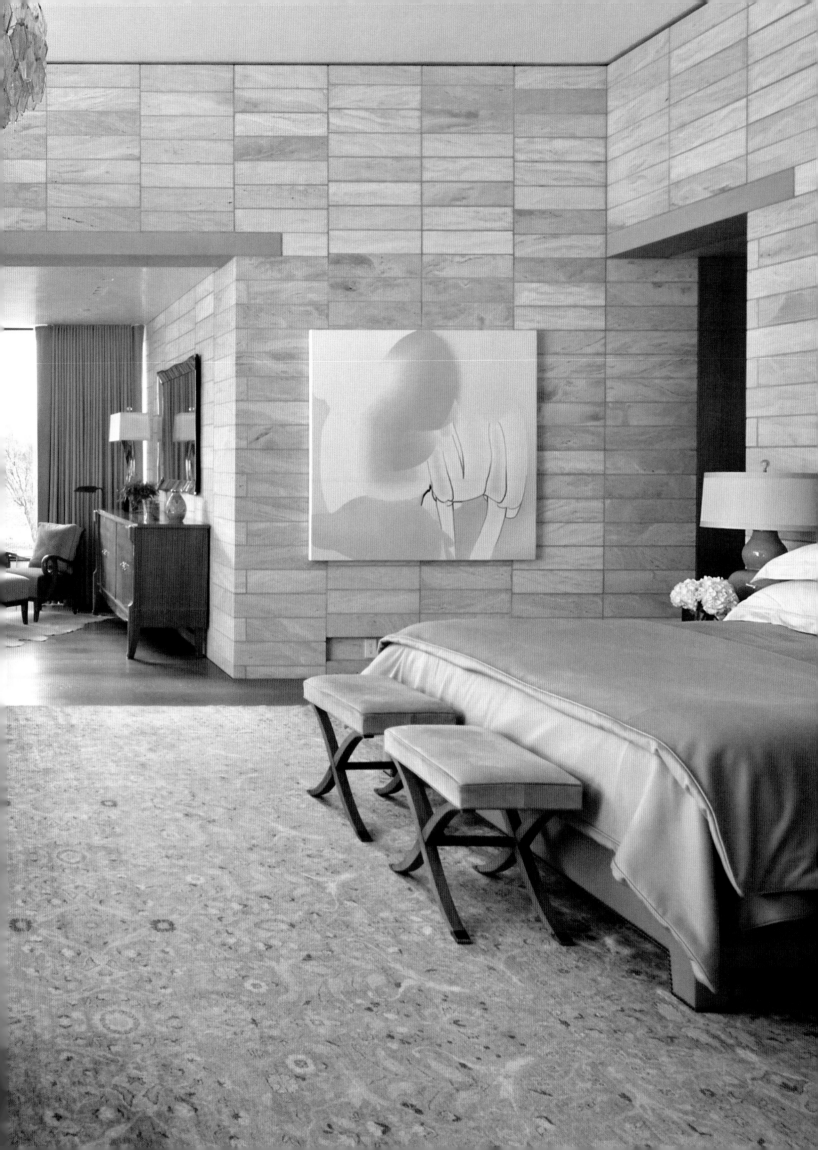

Previous spread: This luxurious master bedroom with a large sitting area feels cozy even with the stone walls because of the rug and all the sumptuous fabrics upholstering the vintage furniture. For a different view and a quiet place to read, there is a smaller sitting area with a chair and ottoman by Jean Royère. The merisier credenza is French from the 1940s. The sofa and matching chairs are in the style of André Arbus. A Venini chandelier from the 1958 World's Fair hangs in the center of the room. Art is *Untitled*, 2008, by Andy Collins.

Below: A Jan Showers Collection Carleton Chair with reverse French welt sits in the corner of this glamorous bedroom on a Kyle Bunting rug. *Opposite*: The bed is hung with a soft lavender velvet lined with off-white silk over a square-tufted headboard with a lushly quilted bed cover and pillows. The night commode, by Kittinger, and the bench in the Louis XVI style are both vintage pieces. The soleil mirror is vintage and one of a pair over each commode. The rug is by Kyle Bunting. The chandelier is Austrian from the 1930s.

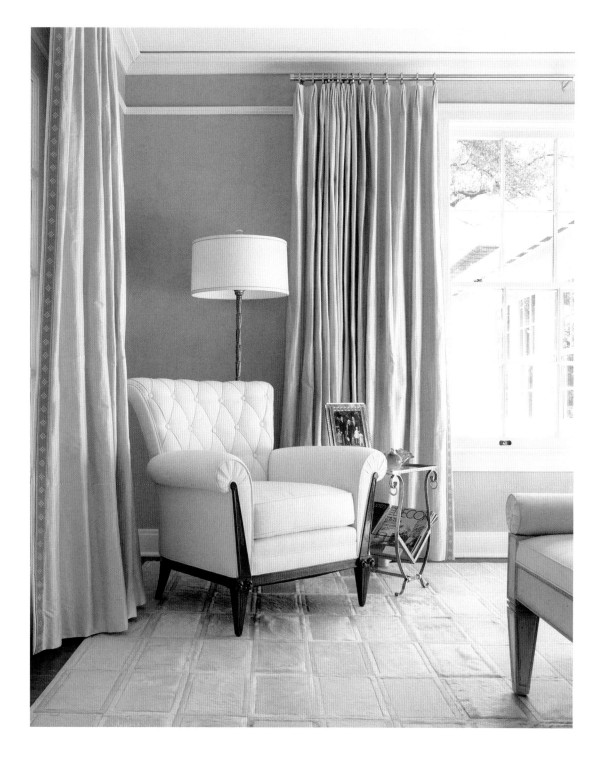

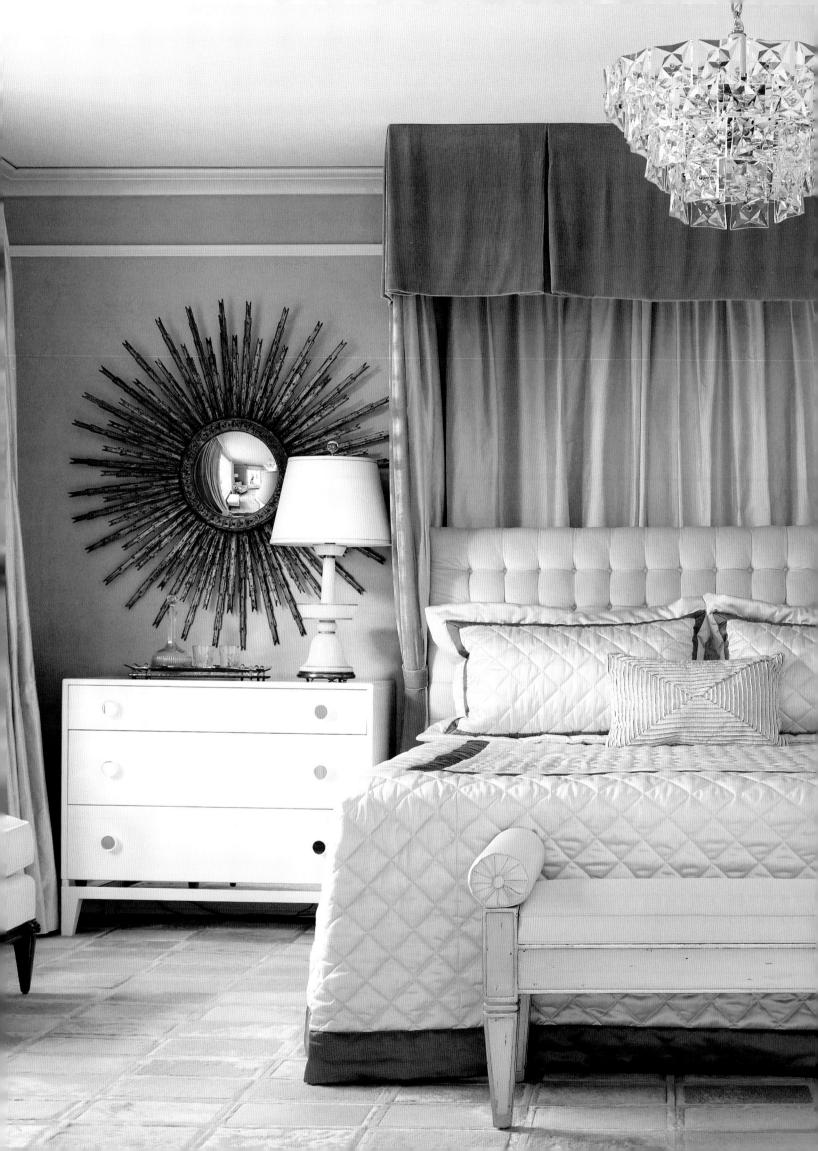

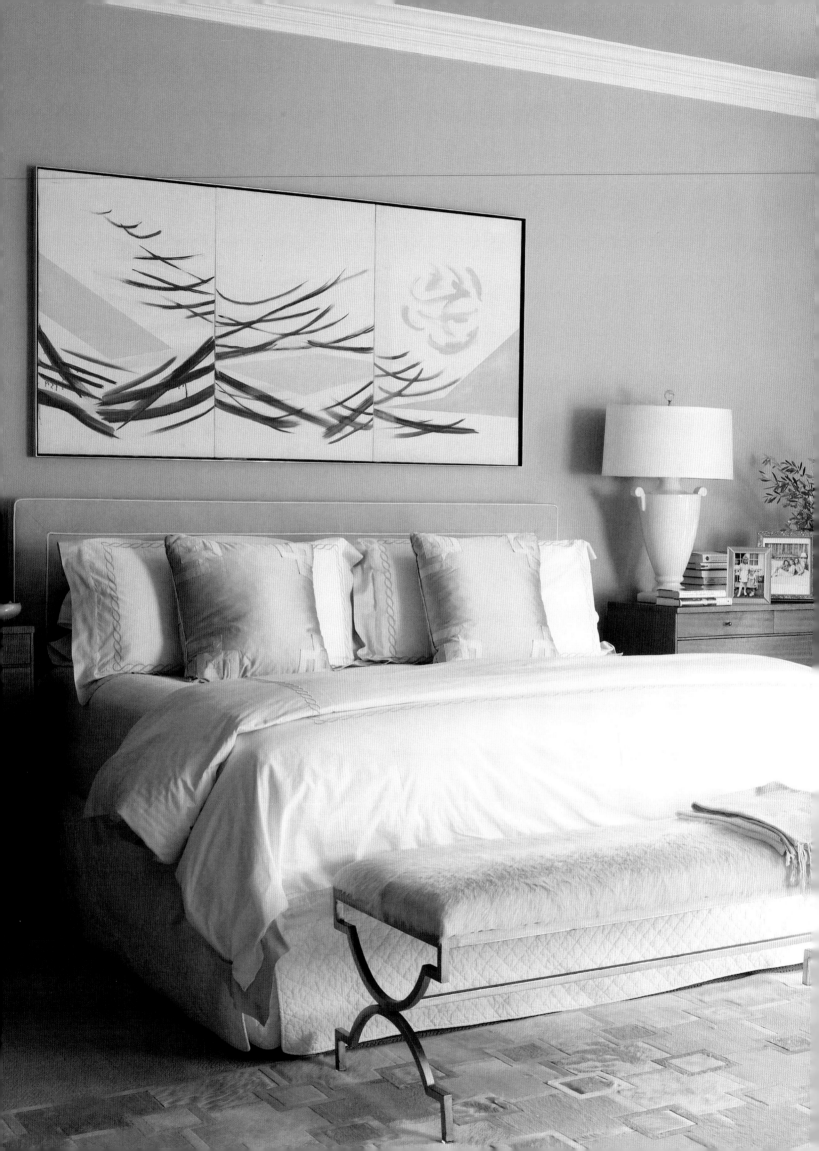

A master bedroom in Houston is painted in Sea Haze, a cool gray-green by Benjamin Moore. The gold leaf bench is the Sarah Bench from the Jan Showers Collection, upholstered in white cowhide. Paul McCobb commodes flank the bed. Art over the bed is by Marc Moldawer. The rug is Glamorous by Jan Showers for Kyle Bunting.

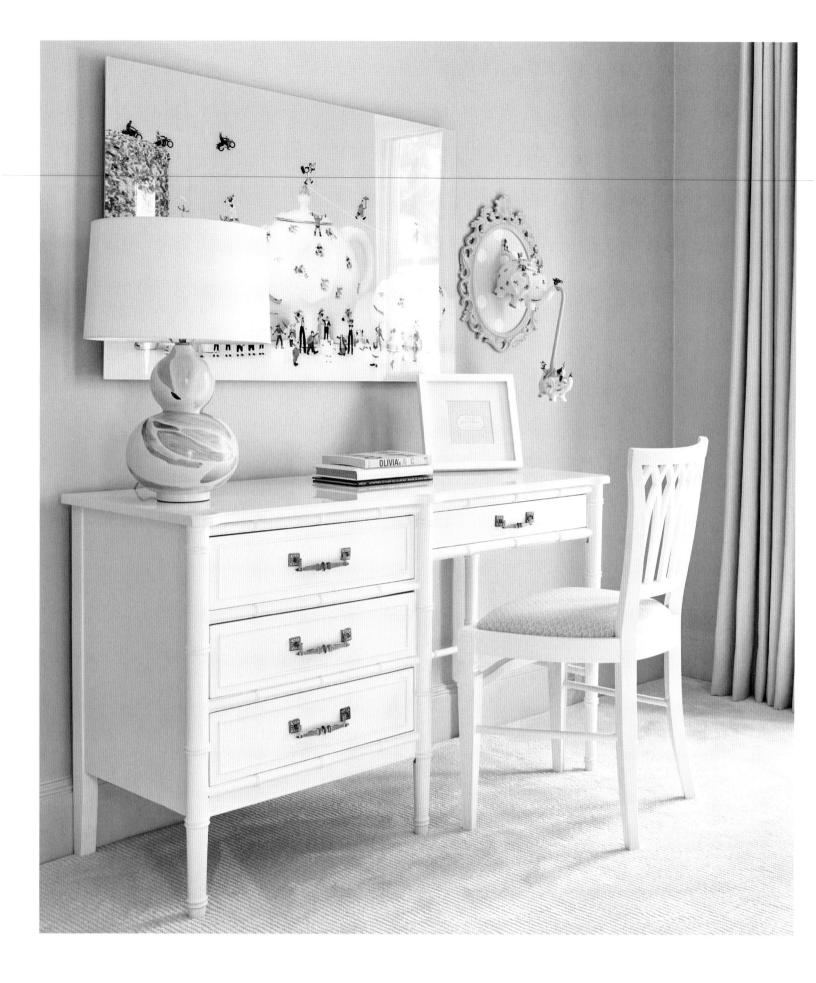

Above: A vintage faux-bamboo desk and chair in a young girl's room. Walls painted Odessa Pink by Benjamin Moore. *Opposite*: The other side of the bedroom, with a faux-bamboo four-poster bed and a Mercer Bench by the Jan Showers Collection floating at the end of the bed. The wallpaper on the ceiling is Cole & Sons and is called Stars.

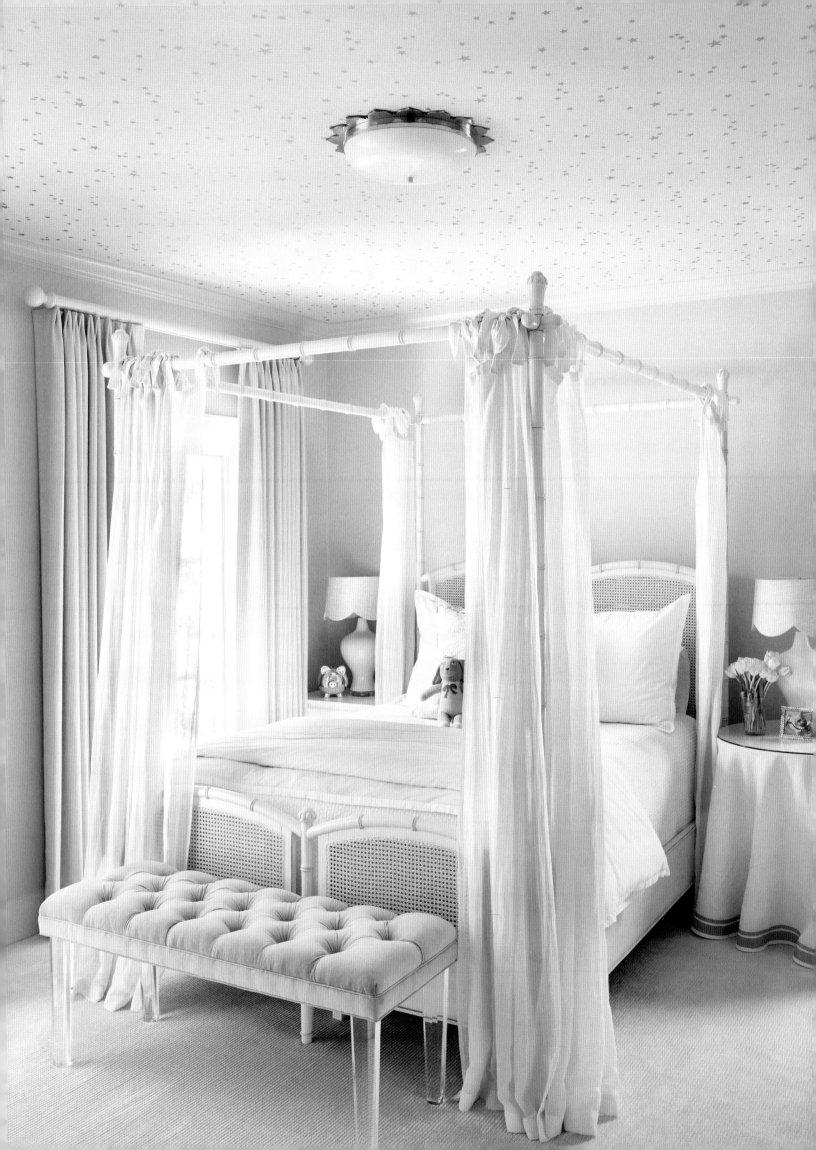

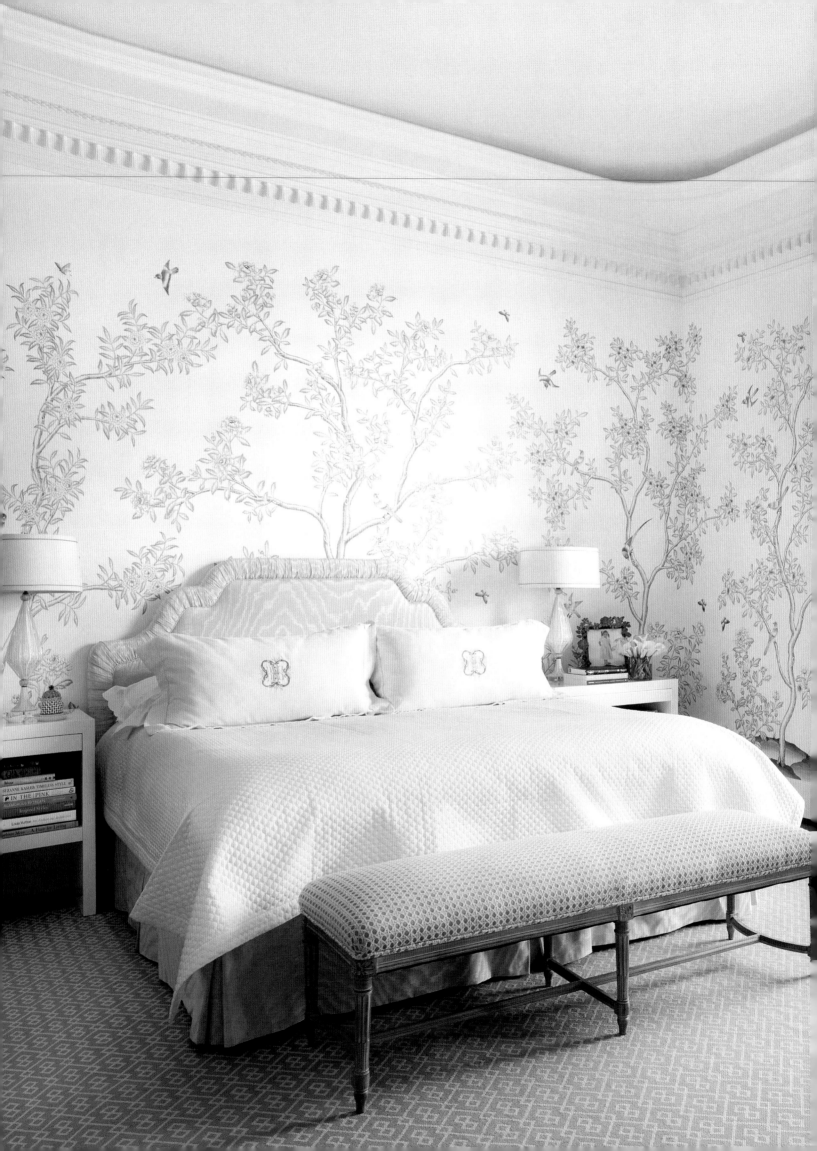

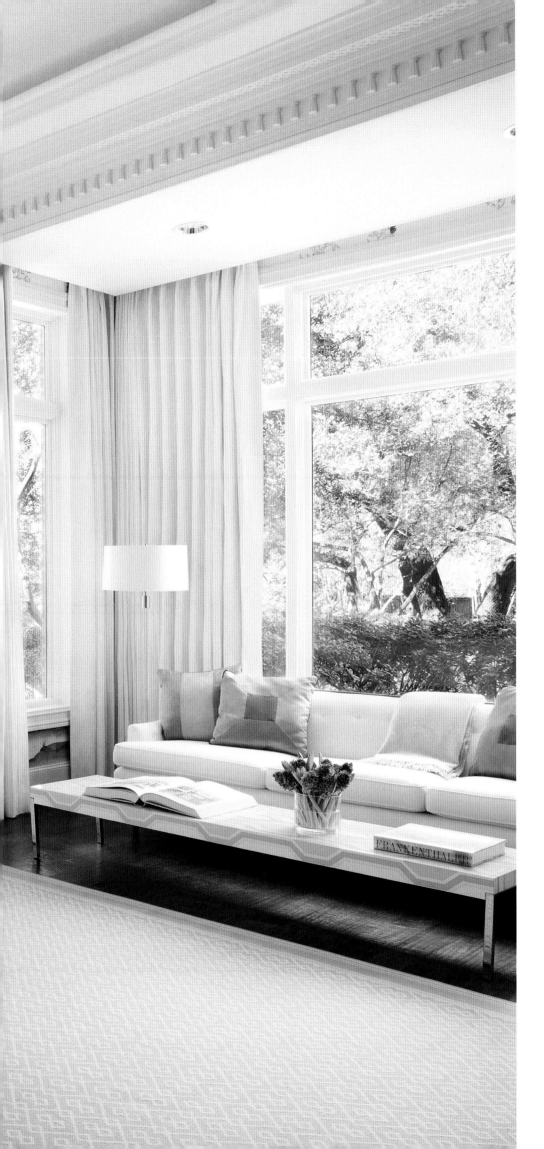

A favorite bedroom in a
Preston Hollow estate in Dallas
with custom, hand-painted
Gracie wallpaper and vintage
Murano lamps from the 1940s
flanking the bed. The sofa
is from the 1970s, given to the
owner by her mother, and
the coffee table is modern, done
in inlaid mica with metal
legs. Hinson floor lamps. Rug by
Stark in a soft blue and white.

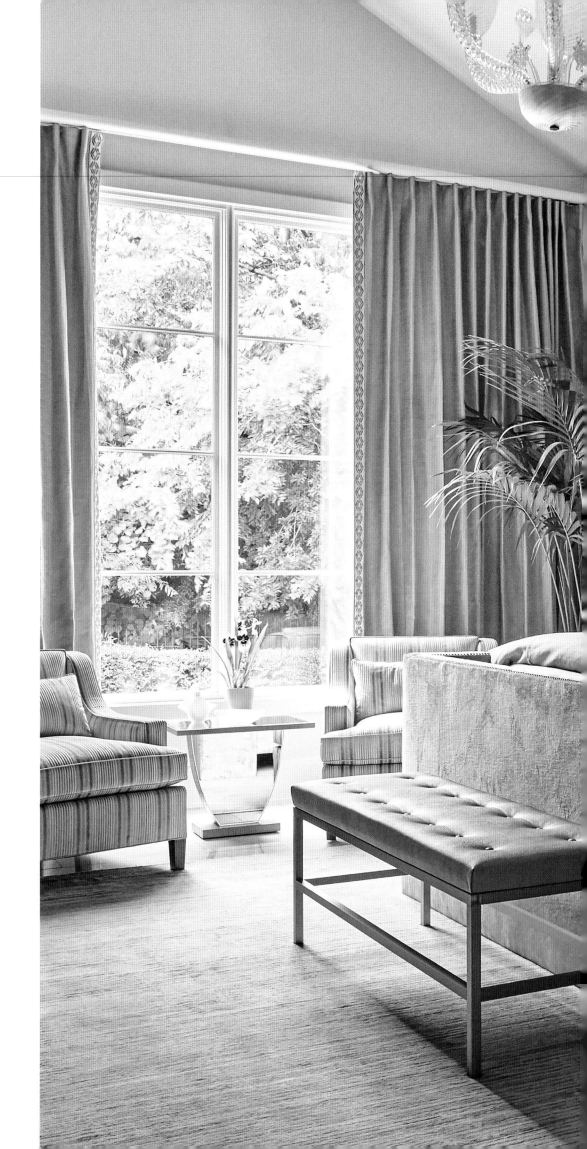

I love this room because
of the color combination of
acid green and blue. The
night tables are Jan Showers
Collection Laurette Custom
Tables with vintage Marbro
green lamps, and the bed is
upholstered in Glant velvet.
A Lindsay Bench from the Jan
Showers Collection sits at
the end of the bed, and a vintage
French eglomise mirror
hangs above the headboard.
The rug is custom by Stark.

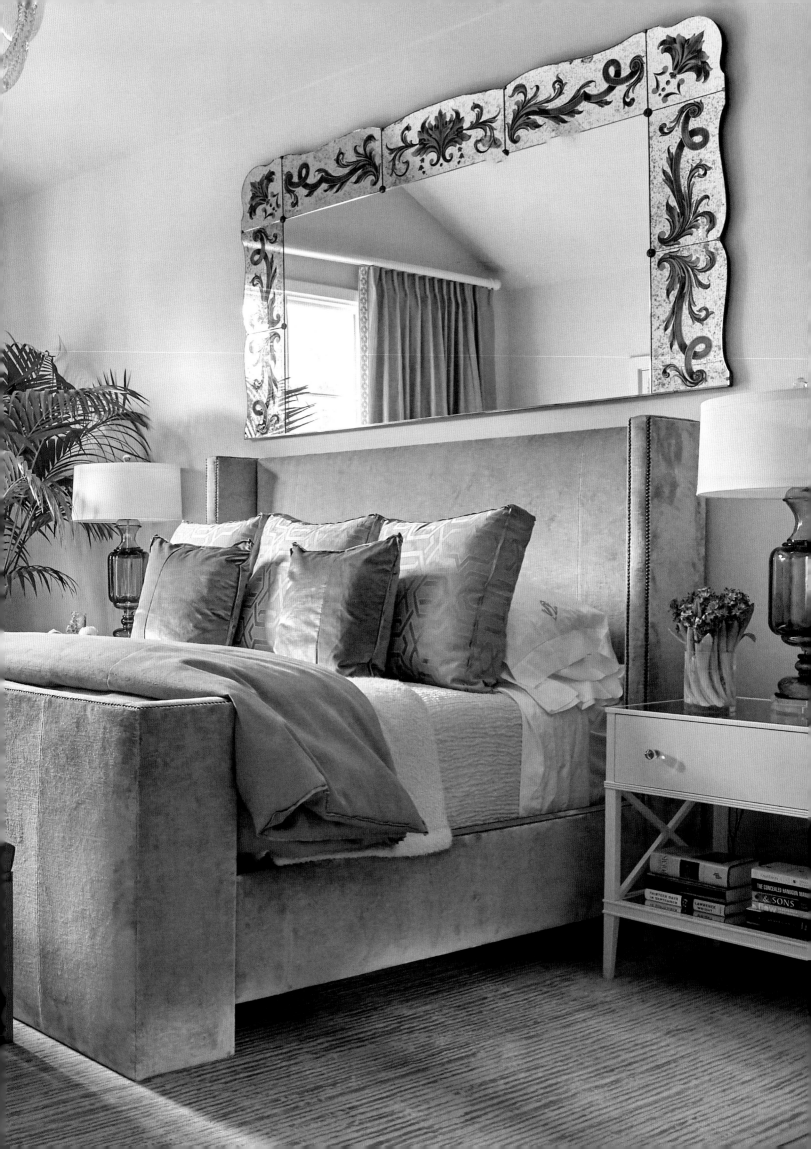

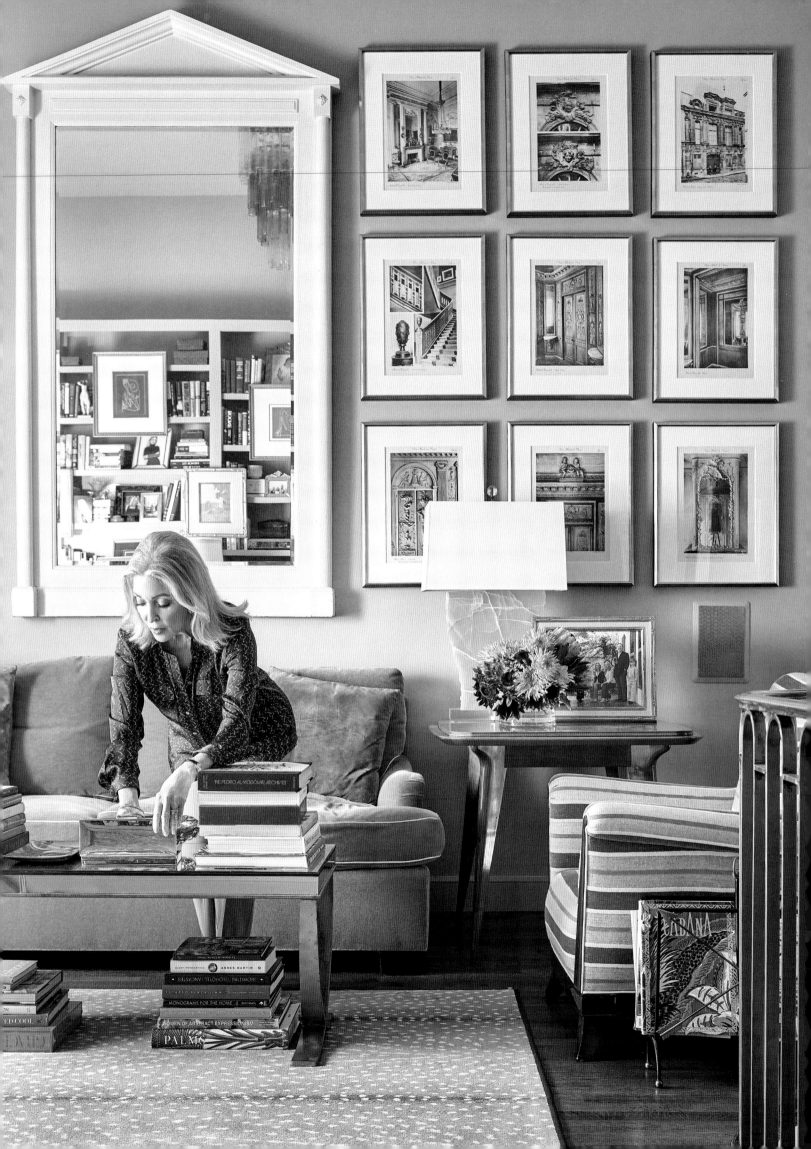

A Room OF ONE'S OWN

Everyone needs a refuge from the rest of the world, a place where they can escape from the pressures of daily living. Often it's not a room per se but a corner of the bedroom or living room. I love to sit quietly and write notes to friends and family at a desk in my daughter's old bedroom. Though it's open to the rest of the house, I can feel quite secluded when sitting behind my desk in the upstairs study in our town house. It's even better, of course, to have a room of one's own. Many of my clients have home offices or studies where they work away from the office or pursue personal projects.

In rooms such as this, I think it's best to surround oneself with special collections—not necessarily precious or valuable ones—but talismans of trips and experiences that evoke emotion and inspiration. Of course, personal photos should be a part of any private space—it's the ideal place for them. I have a bookcase in my study that is filled with books but also with meaningful objects and photos. It functions almost like an enormous bulletin board that reminds me of what fascinates and excites me, things to look forward to, and events from my history I want to remember. Just when I think I can't possibly fit one more thing on those shelves, I find a place.

Dressing tables serve much the same purpose, whether part of a large closet or set apart in their own room. Dressing rooms make wonderful places to get away. In our country house, my private room has a dressing table, a lovely chair and ottoman, a desk, and a daybed for napping. Hidden behind a decorative screen is a printer/copier for more practical matters. This is truly my room and I love it. Just walking into it makes me feel happy and content. The windows overlook the terrace, the gardens in the back of the house, the pool, and the tennis court. I think my room has the best views in our house.

My office at home in our Dallas townhouse—it's one of my favorite places to write, read, and just have a peaceful moment.

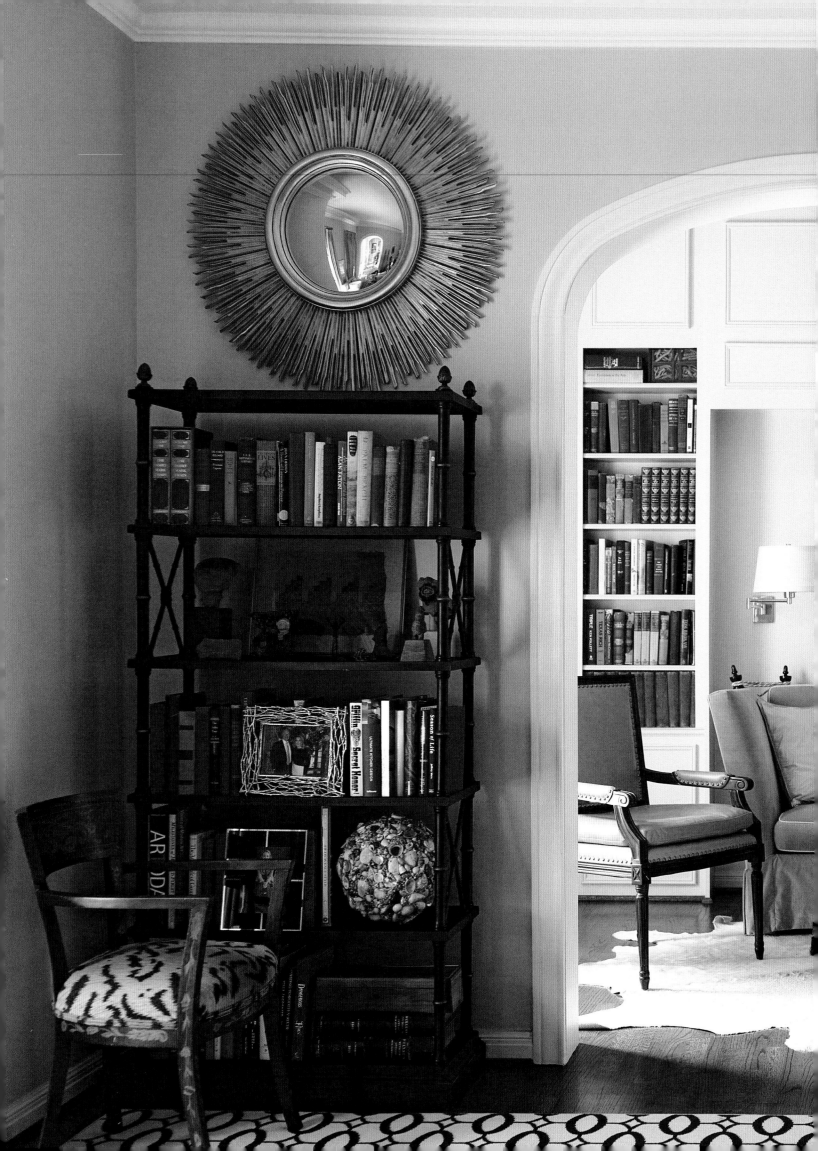

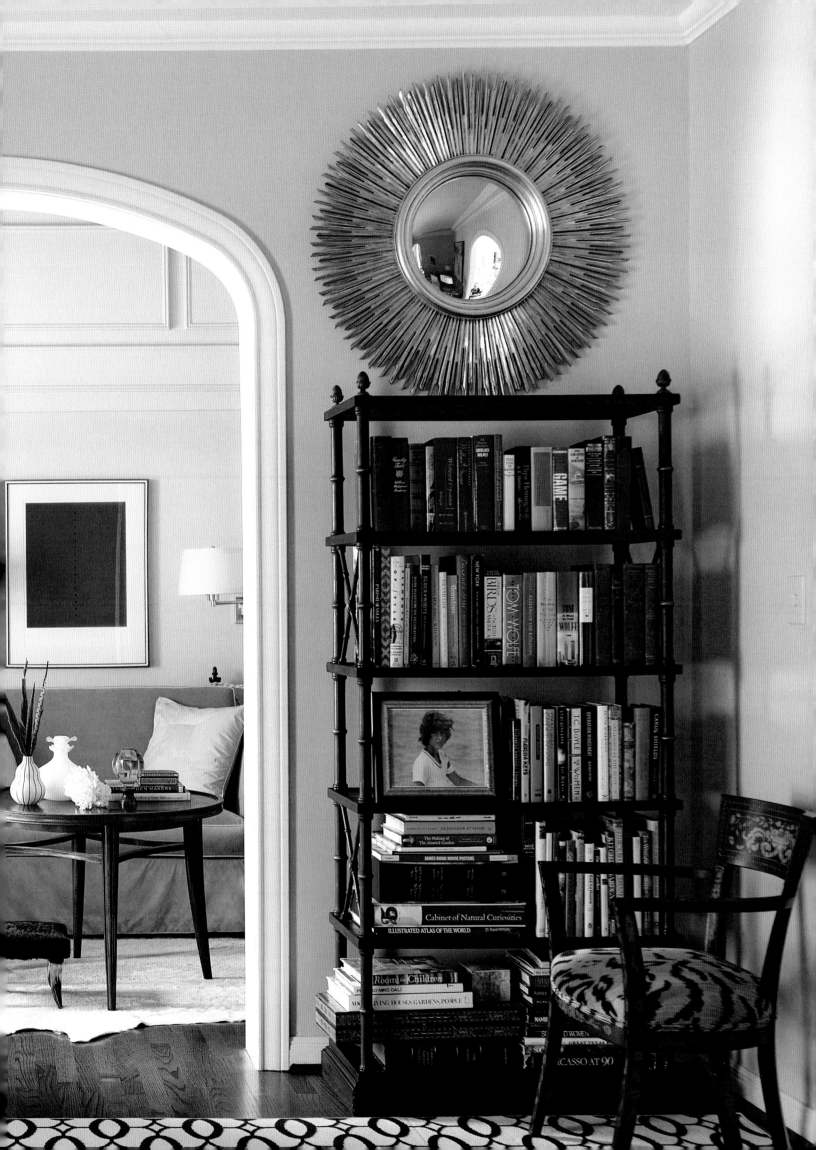

Previous spread: Looking into a library from the living room in a Houston house on Buffalo Bayou. Ebonized faux-bamboo étagères flank the opening to the library with antique Dutch marquetry chairs in front and gold leaf soleil mirrors above. A velvet Knole settee flanked by bookcases and an unusual French tea table with a pair of Antibes Chairs from the Jan Showers Collection complete the seating area. Art by Lucio Fontana.

✳

Below: A quiet corner in a lady's private space includes the Charlyn chair from Kravet, fabric by Nancy Corzine, and a vintage French gold-leafed iron coffee table with one of my favorite items to make any room have that lived-in look—a vintage magazine rack. Art by Megan Abdallah. *Opposite:* A wonderful library across from a master bedroom that makes this a lovely private space. The paneling is painted Wythe Blue by Benjamin Moore in a high gloss. The Louis XV–style chairs were found by the owner in Paris and have their original acid green leather upholstery. The chairs flanking the sofa are another Paris find from the late 1930s, and the gold-leaf coffee table also came from Paris, c. 1940. Drapery fabric is Le Lac by Brunschwig & Fils. Vintage green ceramic lamps with brass accents from the 1960s. Art by Billy Childish.

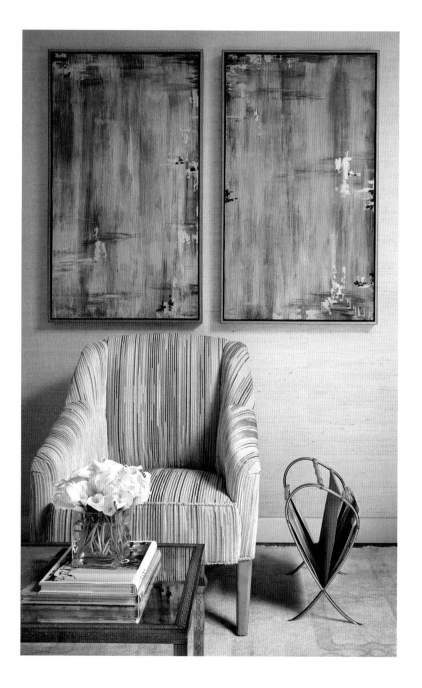

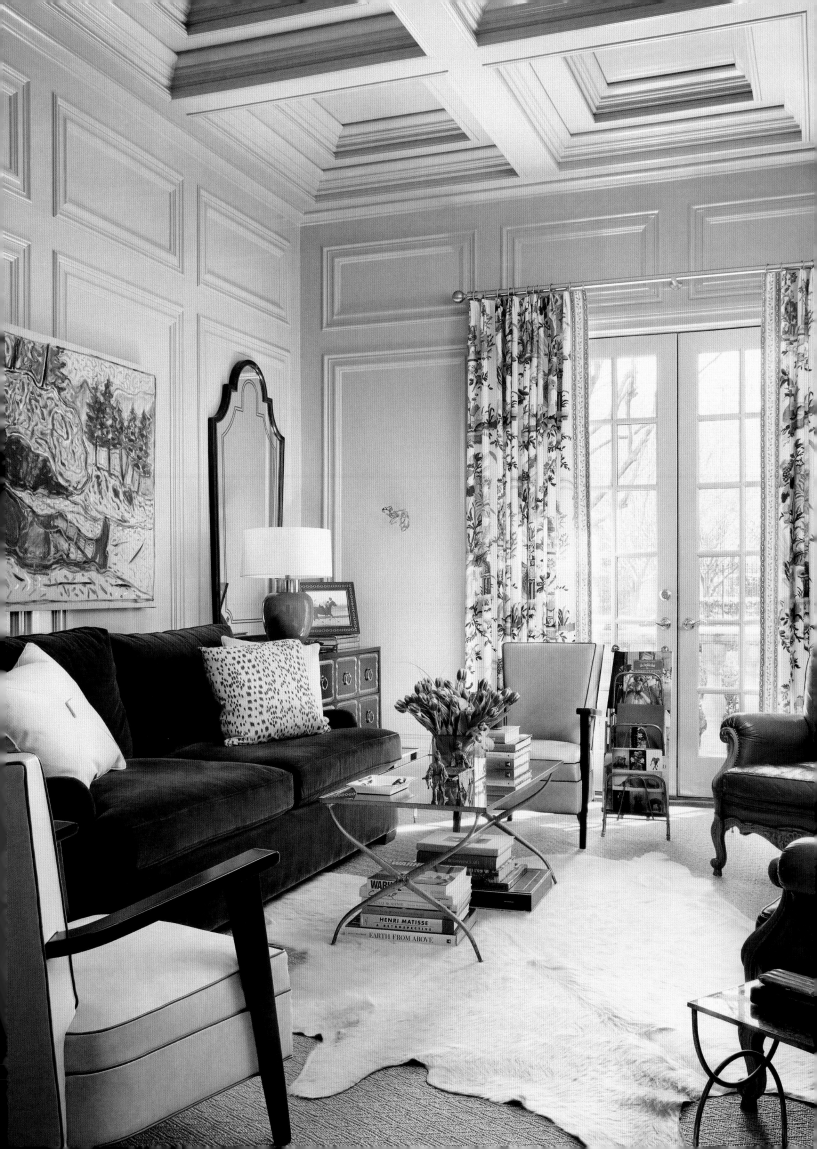

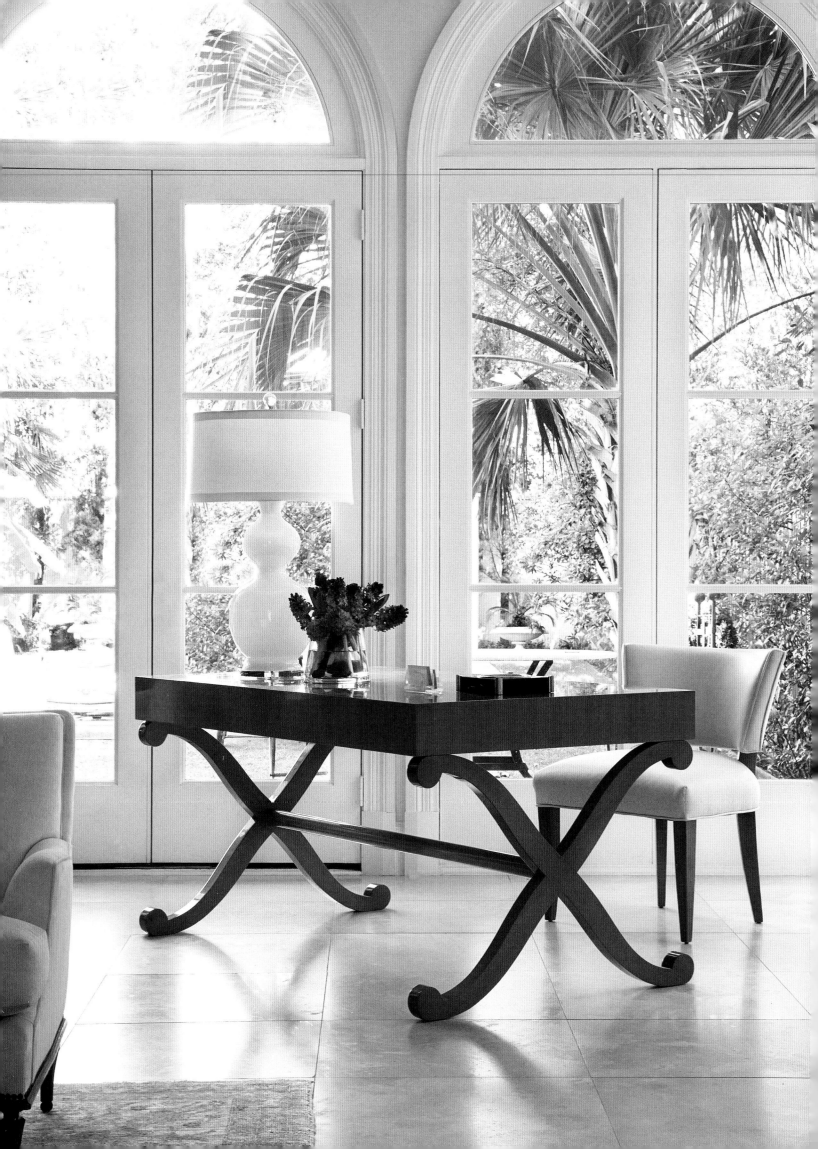

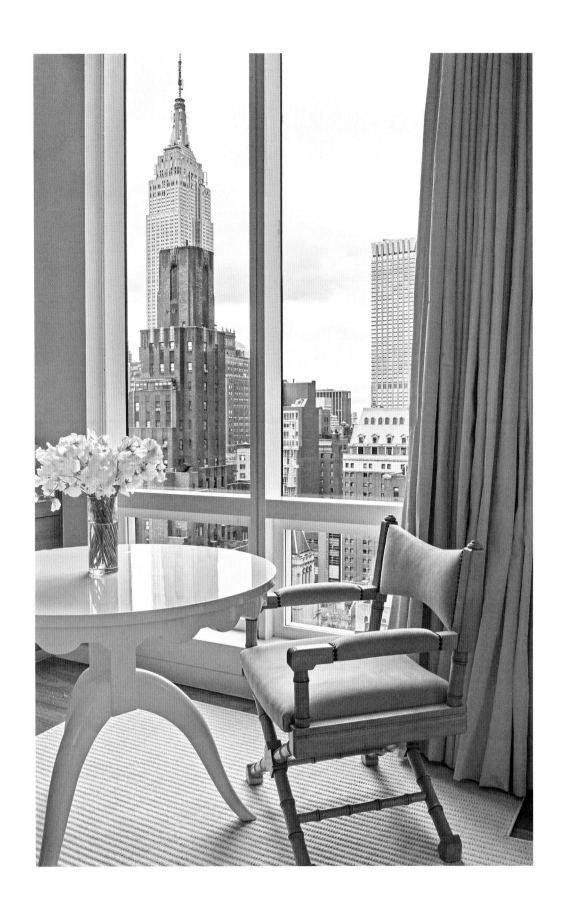

Opposite: A Plaza Desk in a corner of a large living room creates a quiet spot for writing
notes or working on a laptop in this house inspired by a house on the
Cote d'Azur. *Above*: A corner in a New York apartment overlooking the Empire State
Building creates a wonderful place for dining à deux with vintage director's chairs
upholstered in suede and the custom Lombard Table from the Jan Showers Collection.

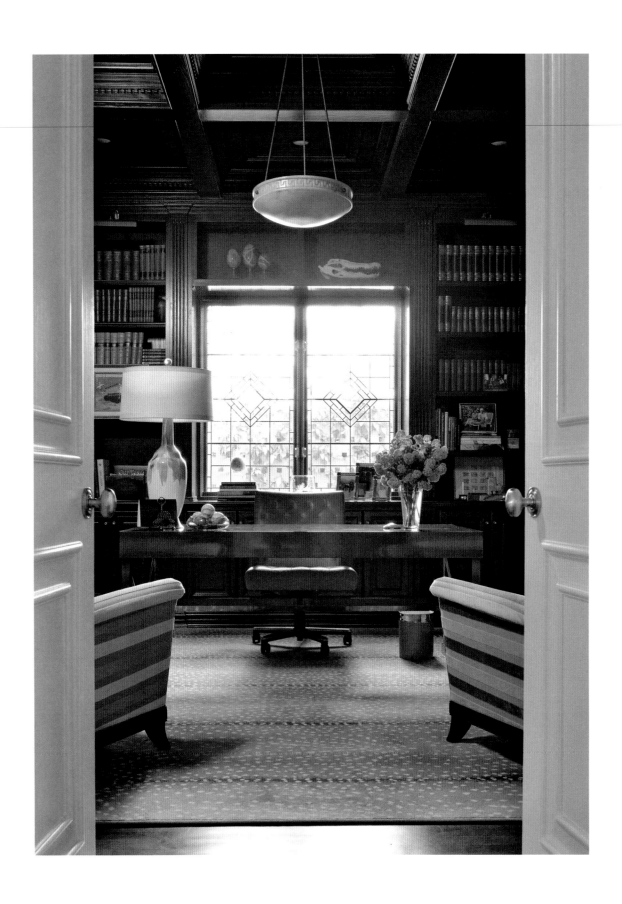

Above: A man's study off the main hallway of a house in Highland Park, Dallas, with an oversized desk, A. Rudin desk chair, a pair of Jan Showers Collection Rothschild Chairs, and a large vintage alabaster chandelier. Rug by Stark. Paint is Hale Navy by Benjamin Moore. *Opposite*: A well-equipped bar with wonderful vintage and antique barware collected by the owner. Paint is Essex Green in high gloss by Benjamin Moore.

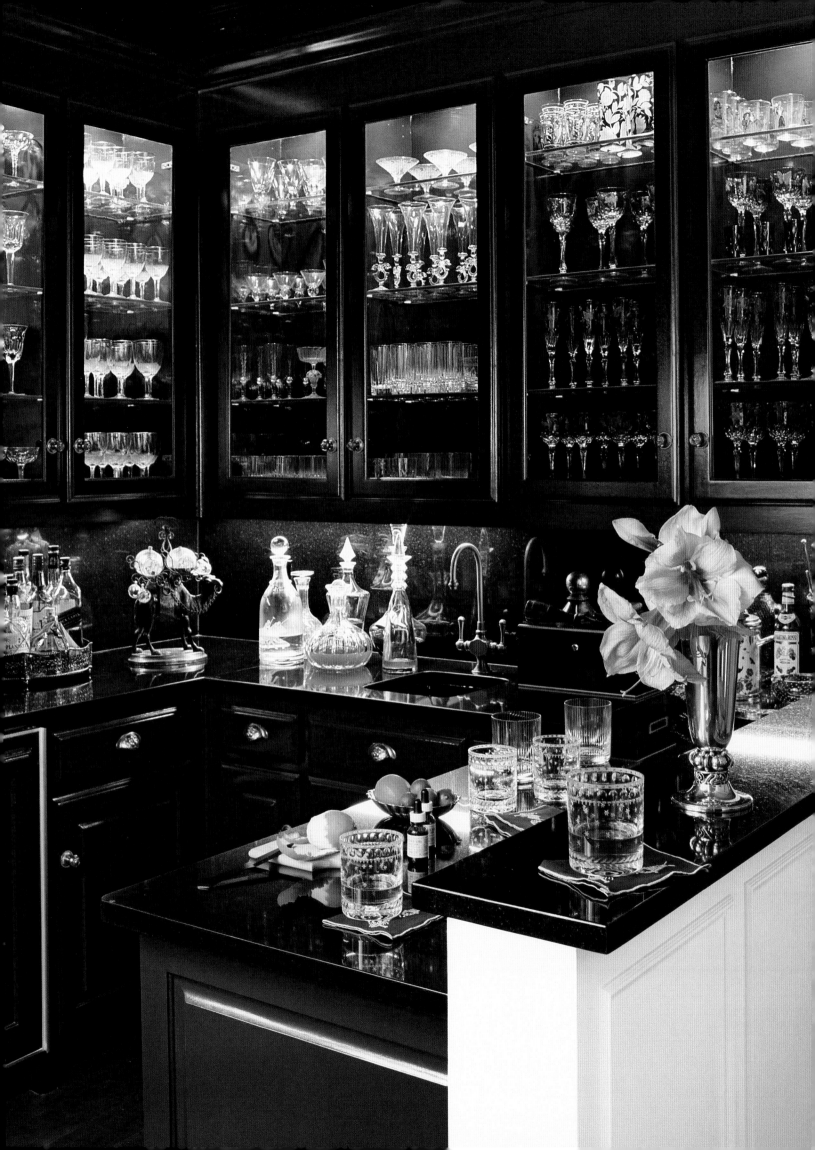

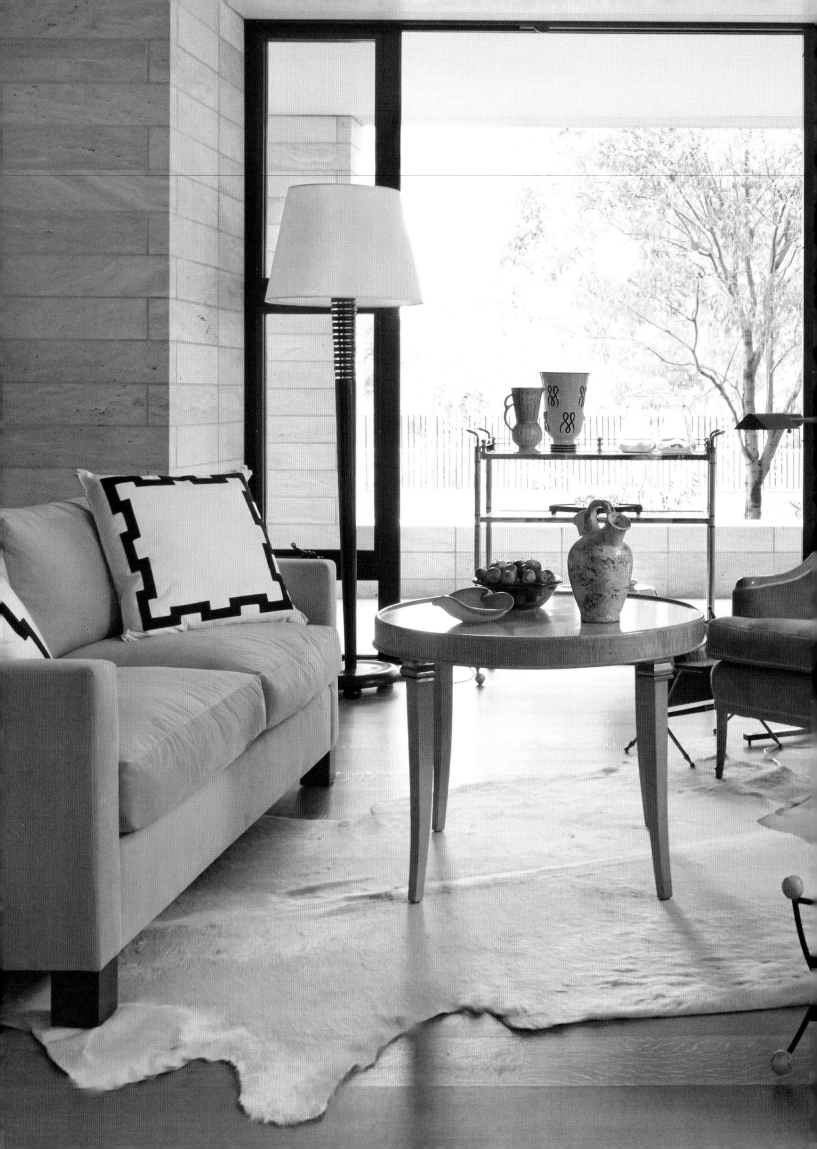

A small seating area just off the kitchen in this stunning Paradise Valley, Arizona, house. A Jacques Adnet tea table in sycamore and an Émile-Jacques Ruhlmann chair, c. 1930, add character to the grouping.

A handsome dressing room
with custom-made wardrobe
and vintage brass X-base
lamps leads into a luxurious
master bath. The pair of
chandeliers are Venini from
the 1950s, and the merisier
and mirrored dressing table
were custom-made for this
room. Hand-painted ceramic
lamps are by Marbro with
original brass bases. Rug is by
Kyle Bunting.

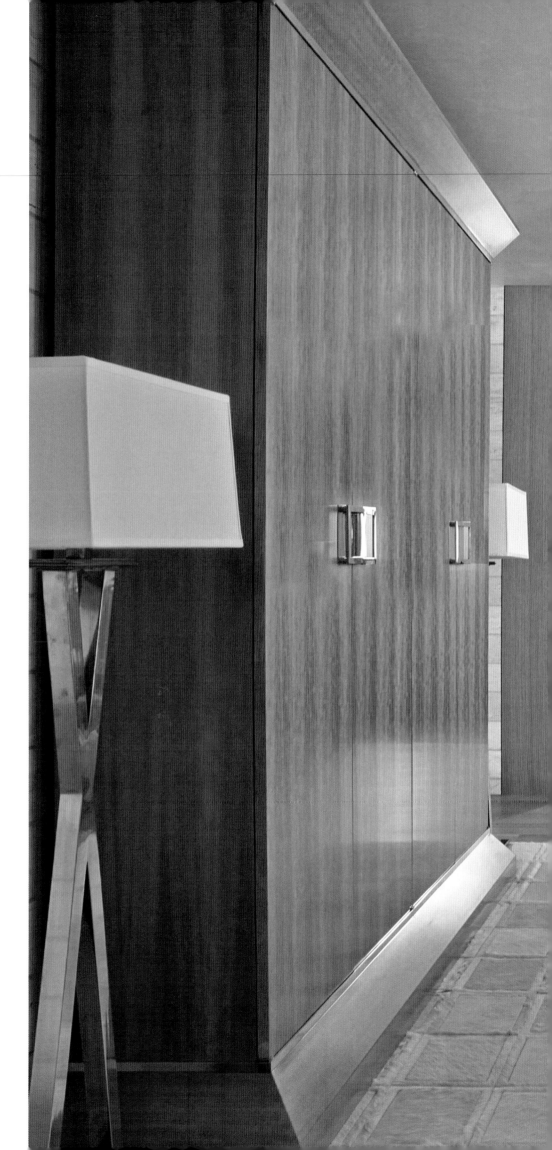

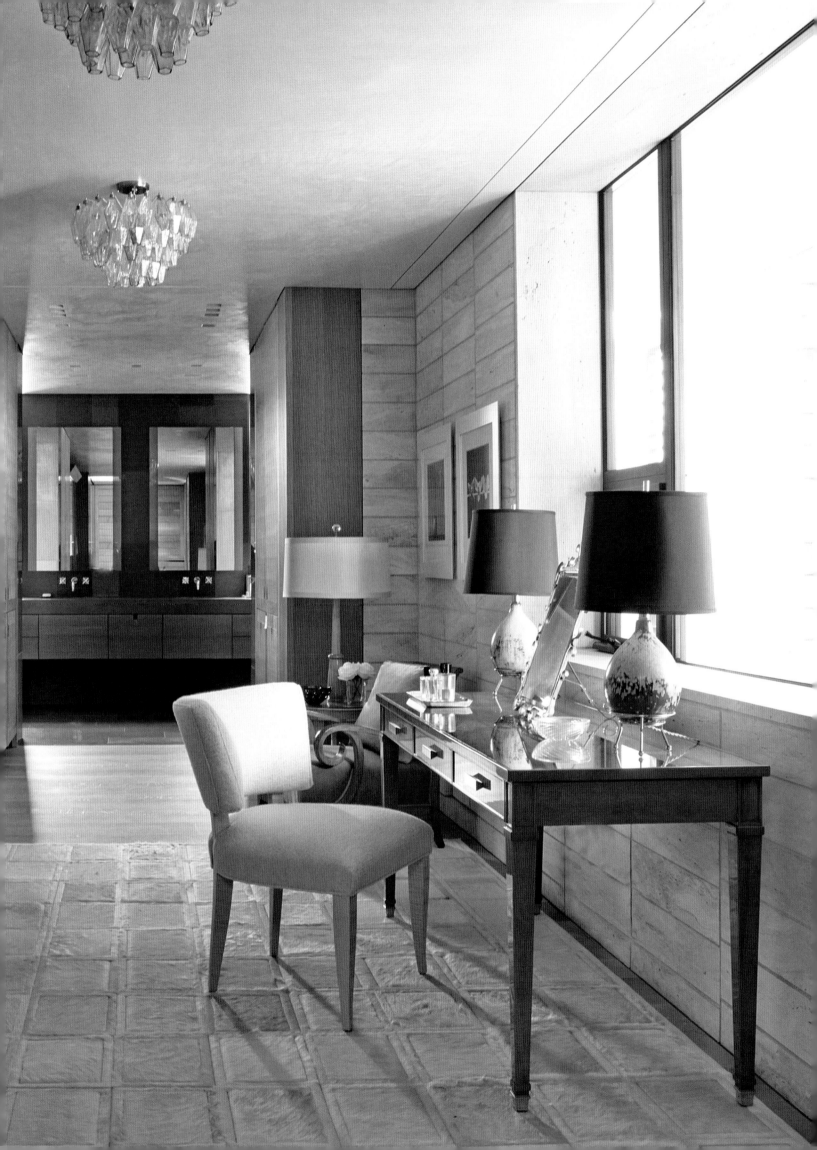

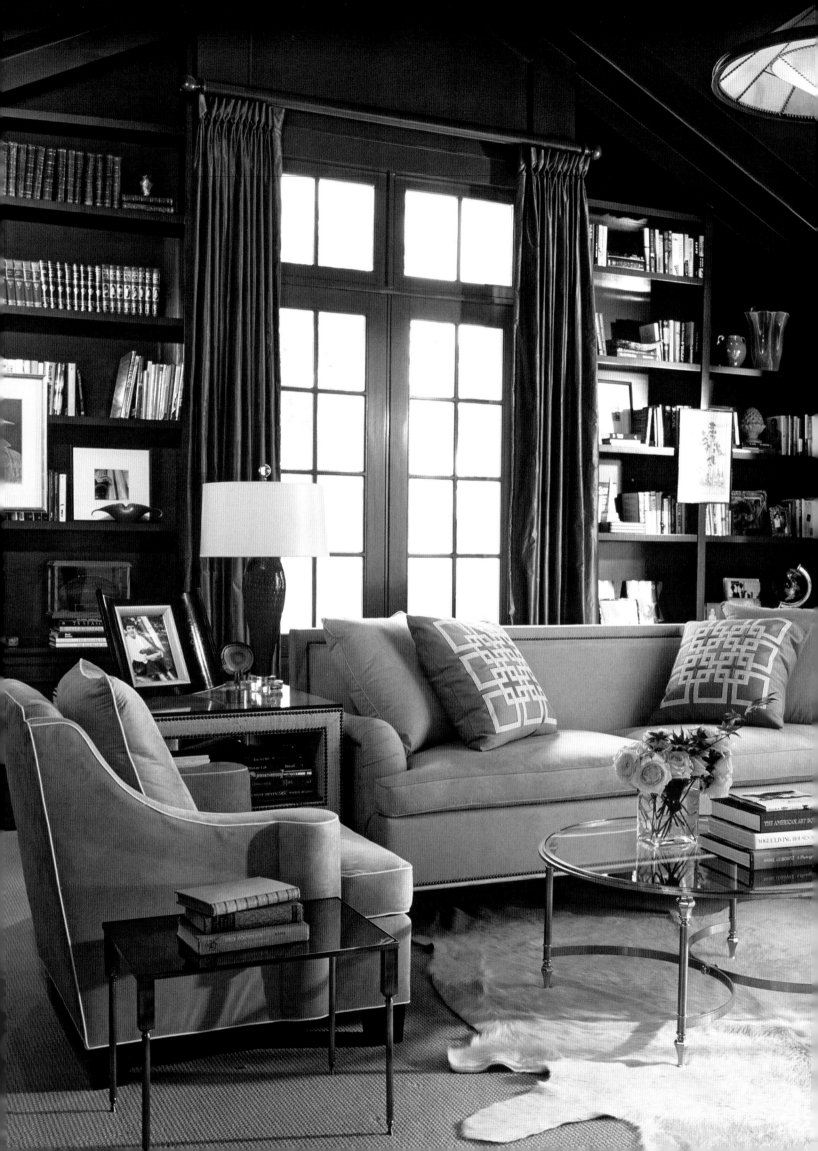

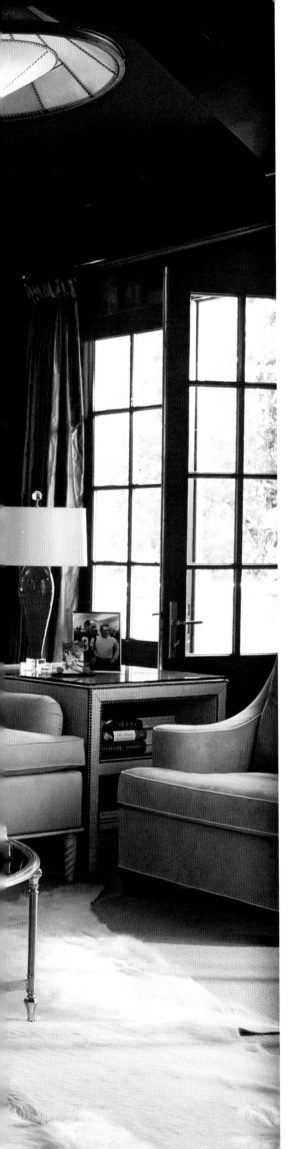

*"Bookshelves should
be filled with books and a few
objects, but always
books and more books."*

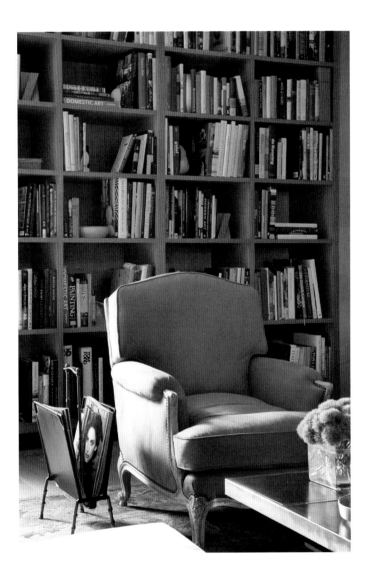

Opposite: A combination library and TV room with chocolate-brown
glazed walls is the favorite room in this Tulsa house. The Palm
Beach Sofa, Manhattan Side Tables, and Villa Chairs are all from the
Jan Showers Collection. The coffee table and opaline-and-brass
side tables are from France, c. 1950. The chandelier came from a French
countryside château. *Above*: An acid green suede Louis XV–style chair
with a vintage French magazine rack sits in front of a wall of bookcases.

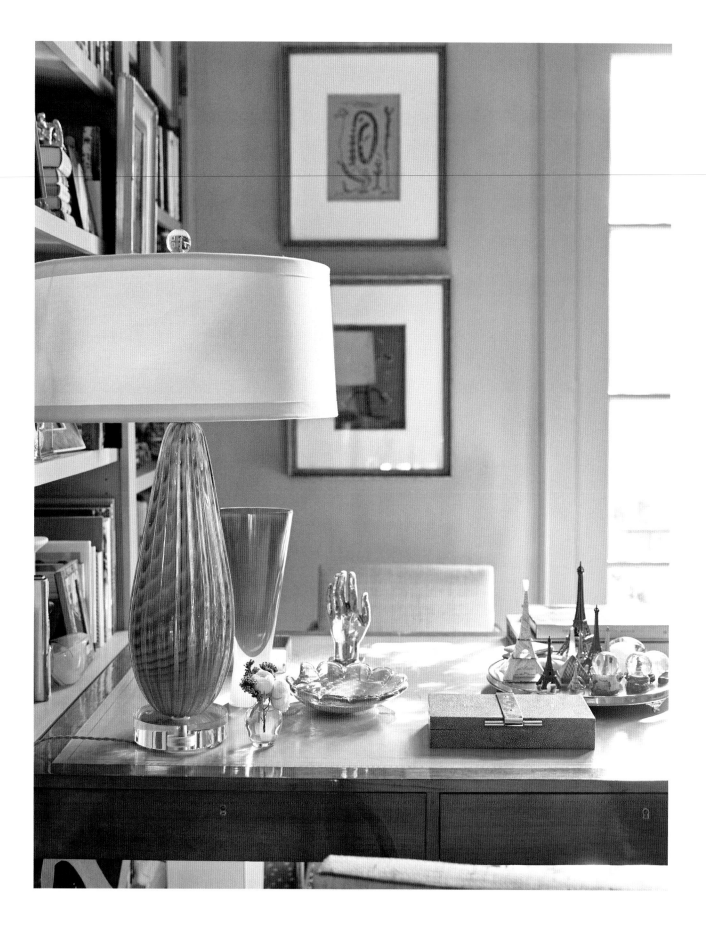

Above: An unusually colored Murano lamp, Murano vase, and bowl highlight the desk in my townhouse office in Dallas. The brass hand sculpture was cast from the hand of Judy Garland, and the Eiffel Towers are a collection of souvenirs from twenty-five years of buying trips to Paris for my showroom. Art by Karl Mohner. *Opposite:* A lady's study with an ivory lacquered Plaza Desk and an Audrey Chair from the Jan Showers Collection. The lamp and the chandelier are vintage Murano from the 1940s, and the drapery is Garden of Persia in Blush Conch by Mary McDonald for Schumacher.

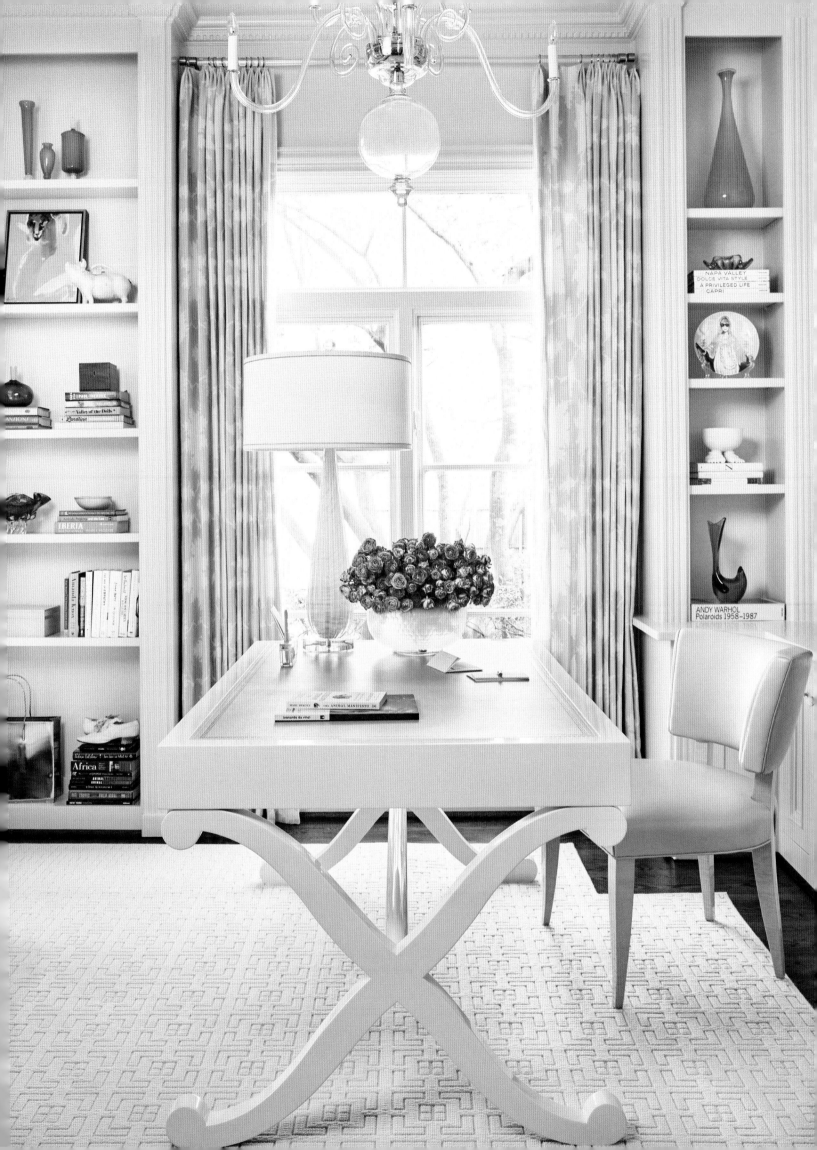

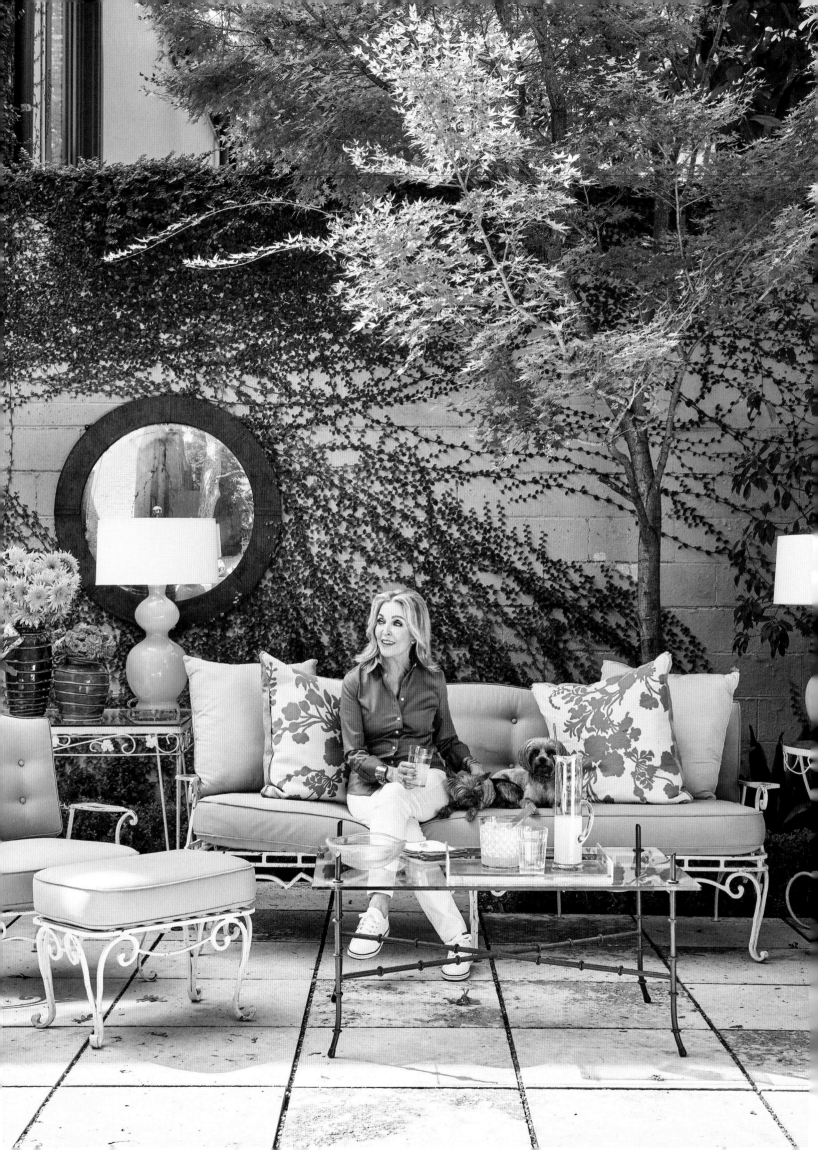

Glamour
OUTDOORS

Every time we entertain, whether at our town house in Dallas or our country house, I always do whatever possible to incorporate the outdoors. In Dallas, that means using the courtyard for cocktails before dinner then for coffee and after-dinner drinks when the meal is finished. In my country house I host almost all my family dinners on our terrace where I set vintage outdoor tables just as I would set my indoor dining room table, with more casual china and glassware, so we can dine al fresco in the European style. The feeling at such a dinner party, beneath the trees and in the open air, is unlike anything that could ever be replicated indoors, and though it requires no special effort on my part—quite the opposite in fact—my guests always tell me how glamorous it feels to dine outside.

I treat my outdoor spaces with the same consideration and care as my indoor rooms, with lamps, wonderful accessories, comfortable cushions and pillows, and magazines. Being outdoors draws out a different dimension in my guests and me. At our country house, I find myself increasingly drawn outdoors to watch the variety of birdlife that come to visit our feeders and birdbaths. There's nothing more soothing. I have some of my best ideas on my outdoor sofa, where inspiration strikes with uncommon frequency away from computers, televisions, and the constant drive to get things done.

As in any room, art must be a consideration outdoors. Sculpture in a garden adds so much. Its power cannot be overstated. That said, finding the right sculpture is absolutely essential. I've seen some that distract from the environment in an unpleasant way. Just as I do indoors, I try to take into account the views from every possible seating area. The eye should have a place to travel and travel again.

Pip and Sis enjoy a warm spring day in our Dallas townhouse courtyard with me. The vintage
French garden furniture from the 1940s and 1950s was found in Paris. Lamps are Venetian
Series #4 in Turquoise from the Jan Showers Collection. The rusticated convex mirror was
custom-made for this courtyard in steel.

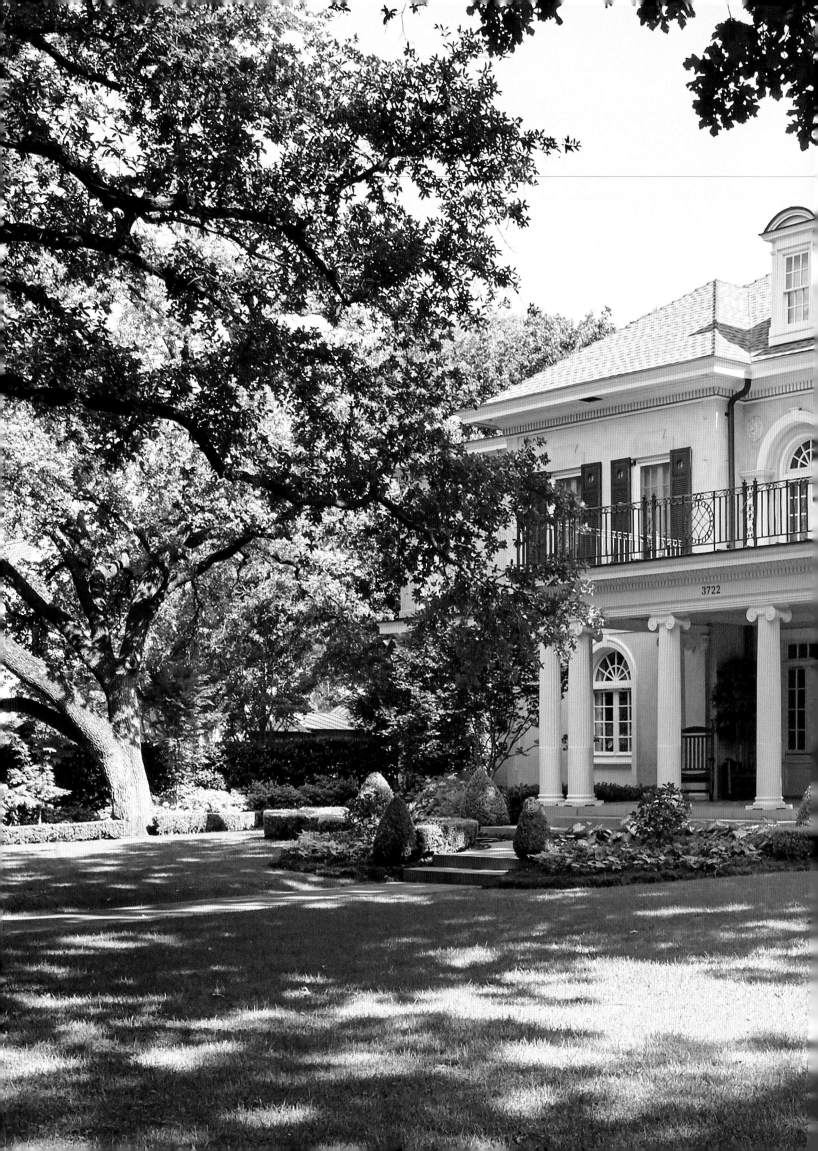

Previous spread: One of a small number of historic homes still in existence in Highland Park, Dallas, by Hal Thomson built in the early twentieth century. It has been described American Georgian.

✳

A pair of antique rocking chairs invite people to sit and relax on the front porch.

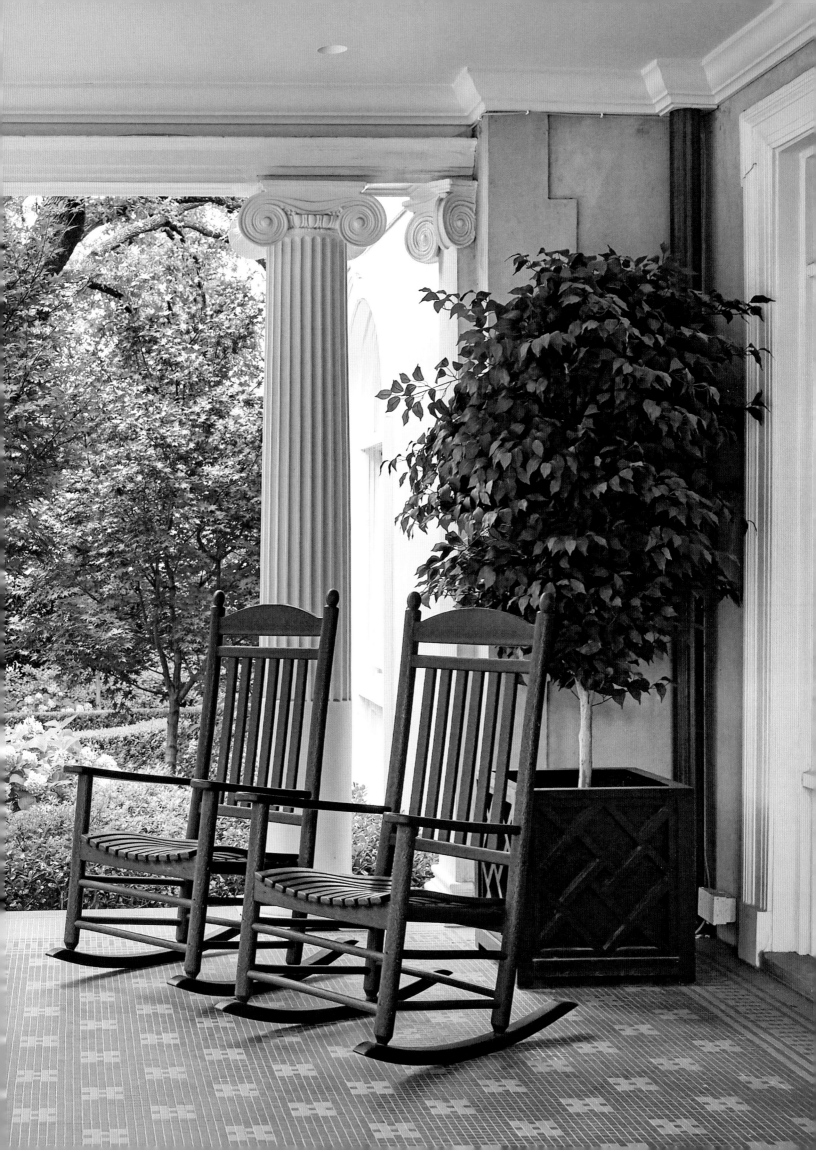

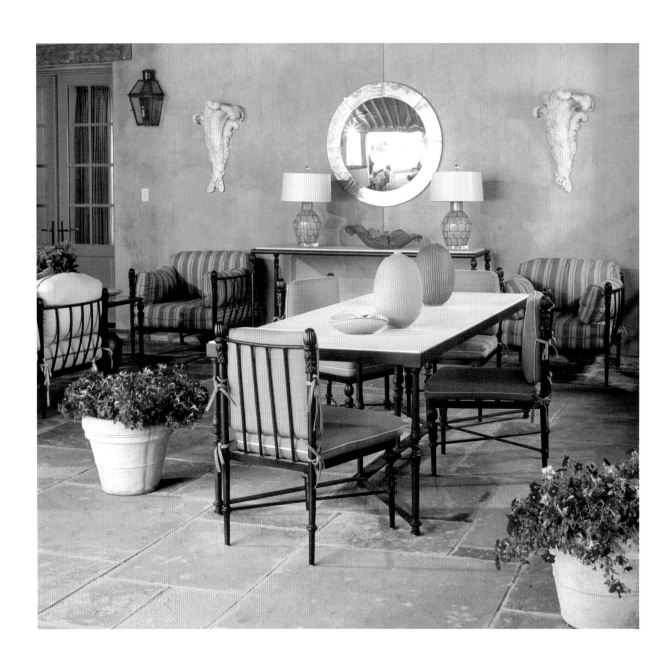

Above: A very large loggia has ample space for entertaining. All furniture is by Michael Taylor. I like to mix vintage with new so the Capiz shell lamps and the plaster plume-shaped sconces are from the 1960s and 1940s, respectively. A custom convex mirror completes the dining area. *Opposite*: A historic house in Pemberton Heights in Austin with vintage garden furniture upholstered in Perennials fabric overlooks the grounds in front of the house.

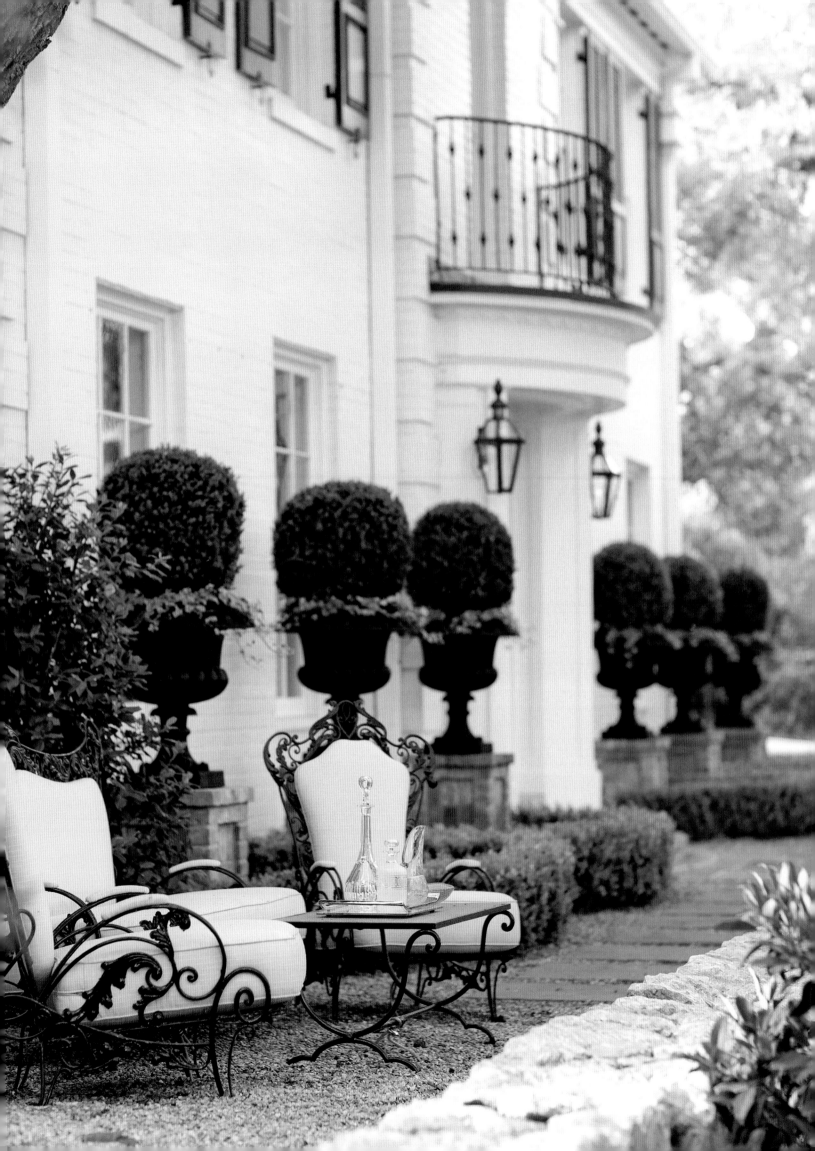

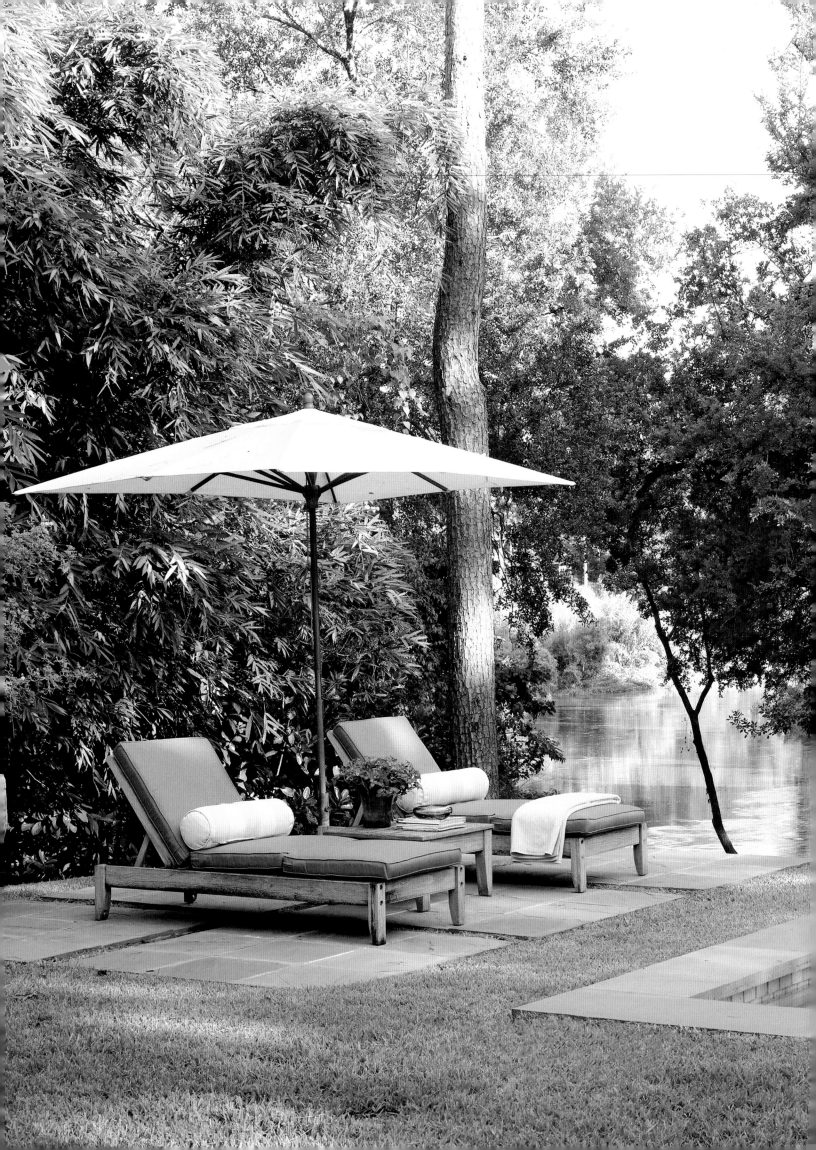

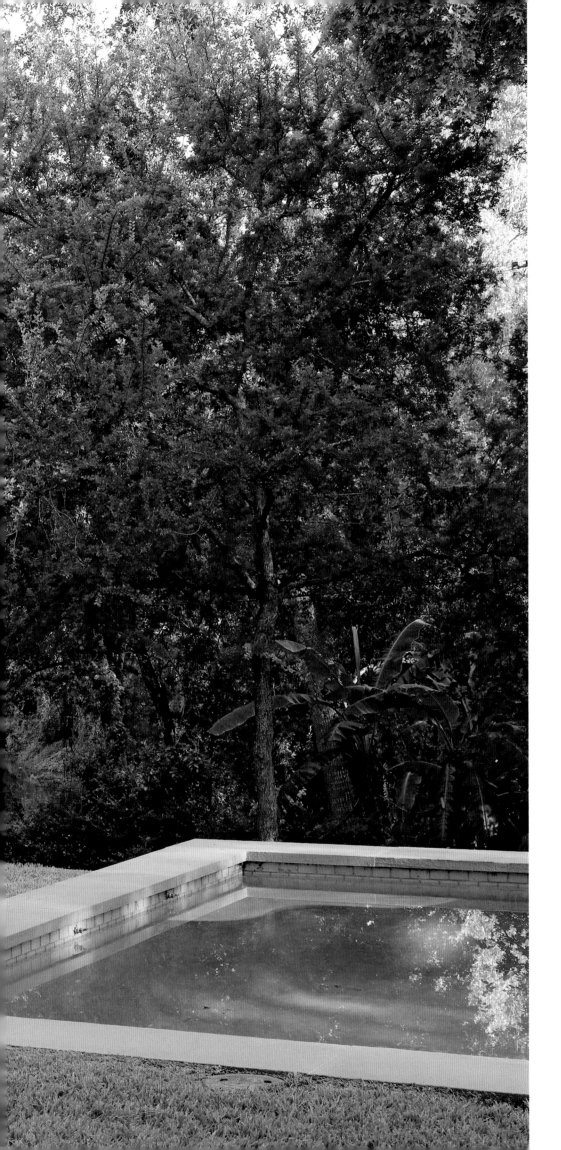

A cool corner of the pool area overlooking Buffalo Bayou in Houston.

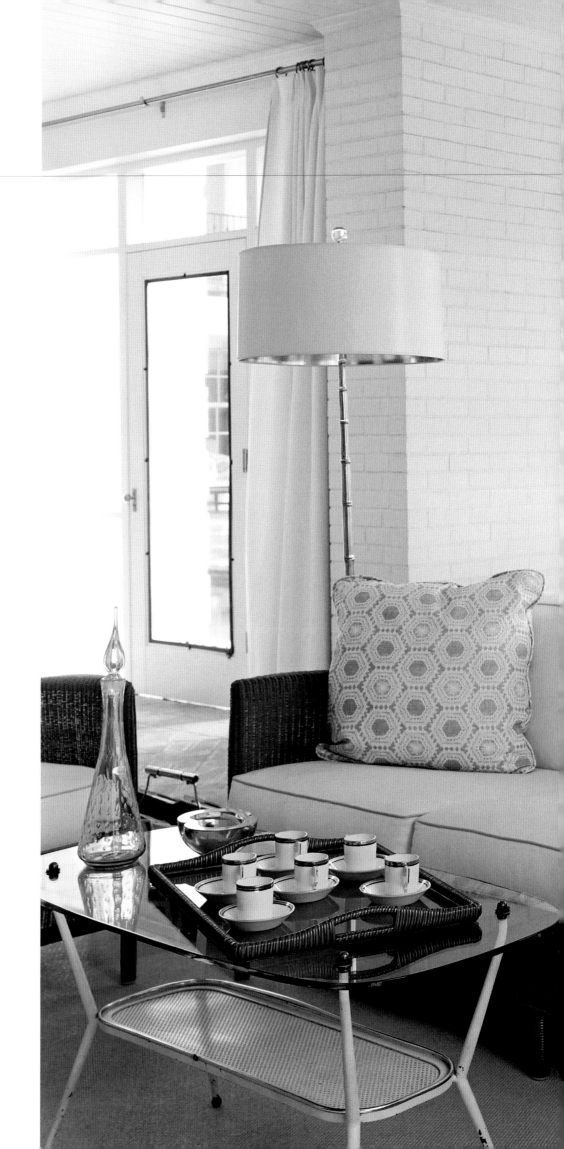

*"The eye
should have
a place to
travel and travel
again."*

This looks like an ordinary
room, but it is actually a
screened porch in an Austin
house with wicker furniture
from JANUS et Cie and a
vintage 1940s French painted
metal table by Mathieu
Matégot. The silver-plate French
chandelier and the pair of
brass faux-bamboo floor lamps
are from the 1940s. The dining
table is from Sutherland.

Following spread:
A spacious outdoor living
room in Houston with
new metal furniture and
vintage pieces mixed together
overlooking Buffalo Bayou.

180

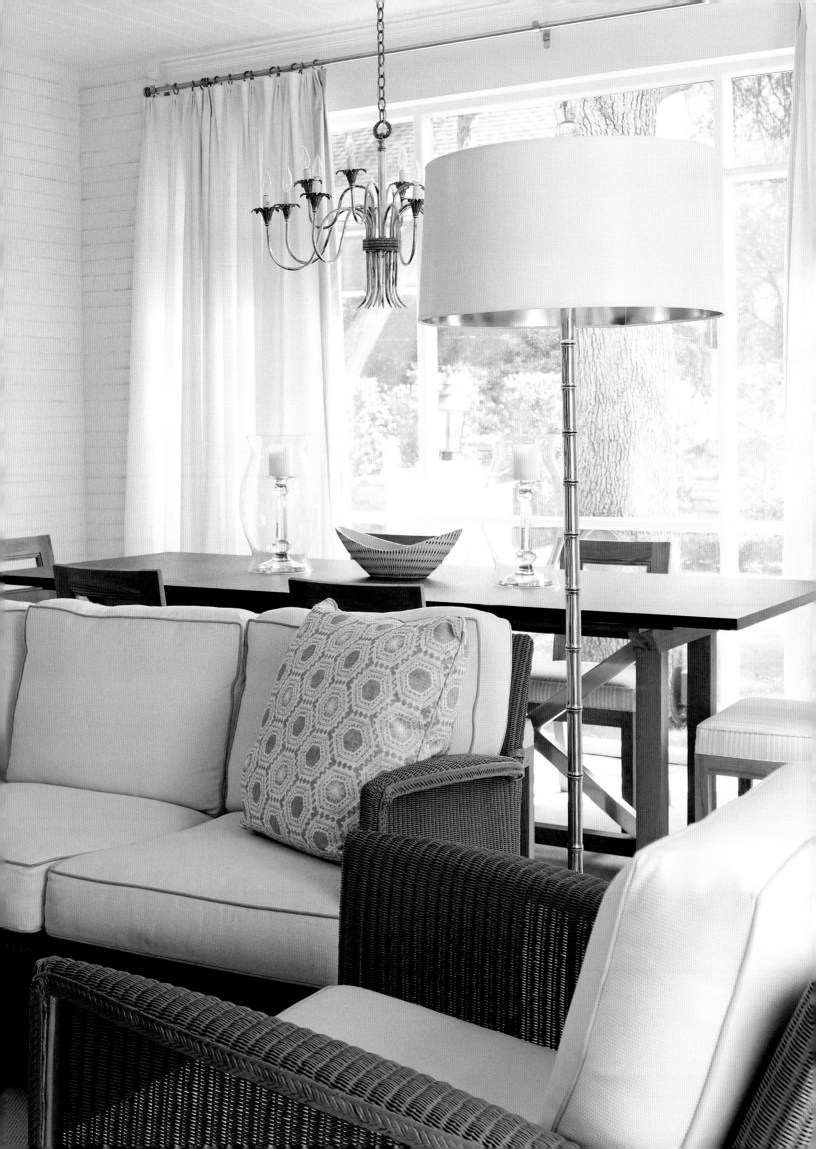

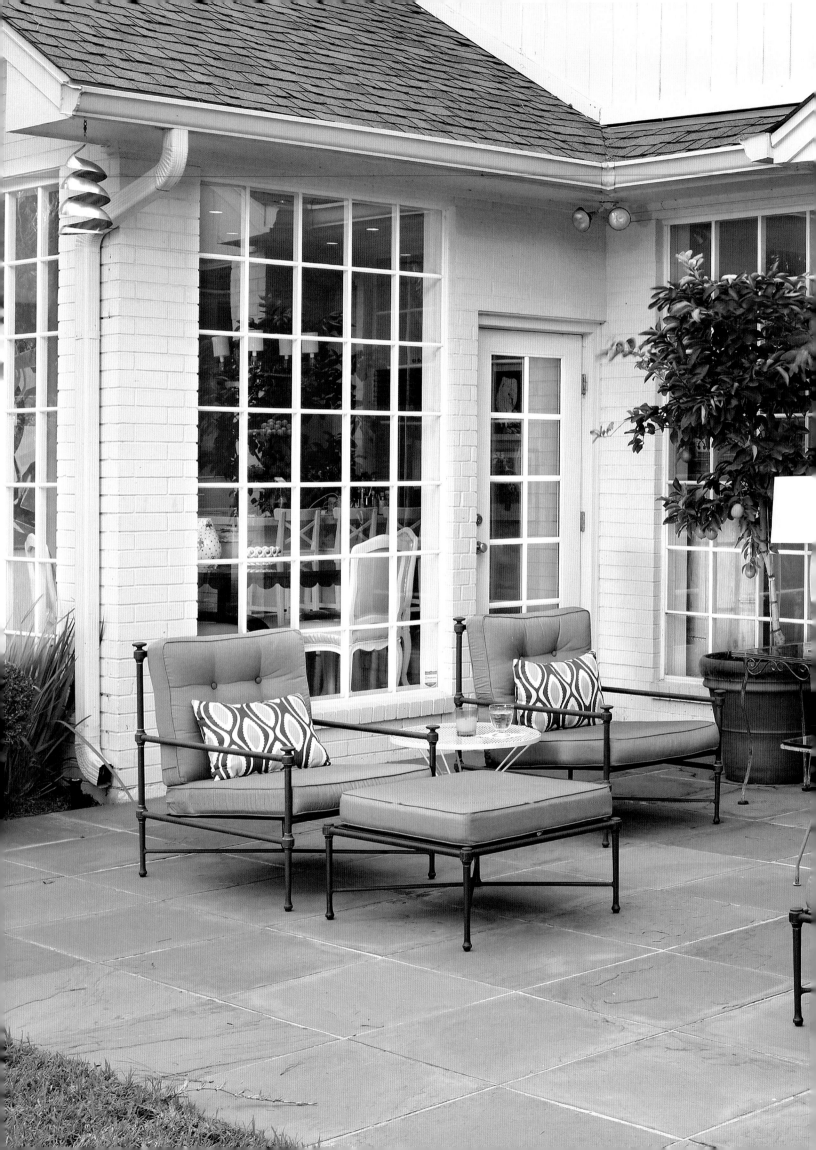

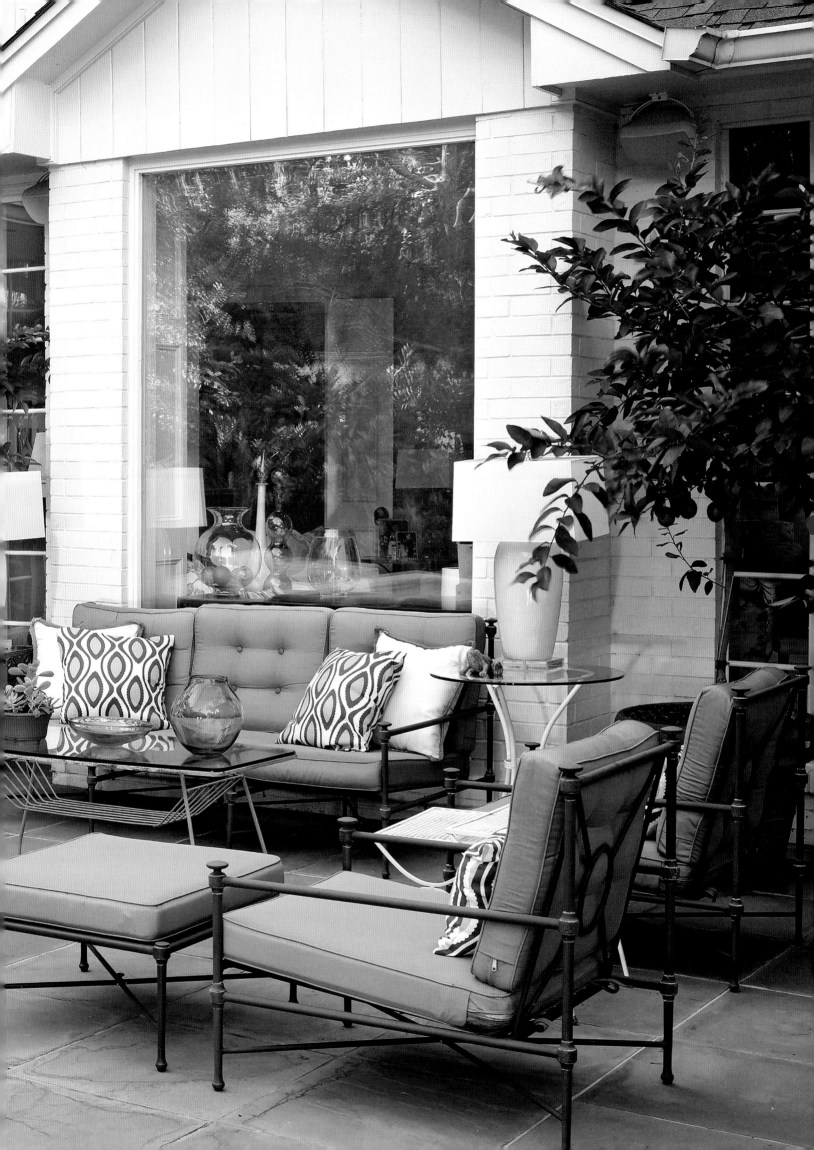

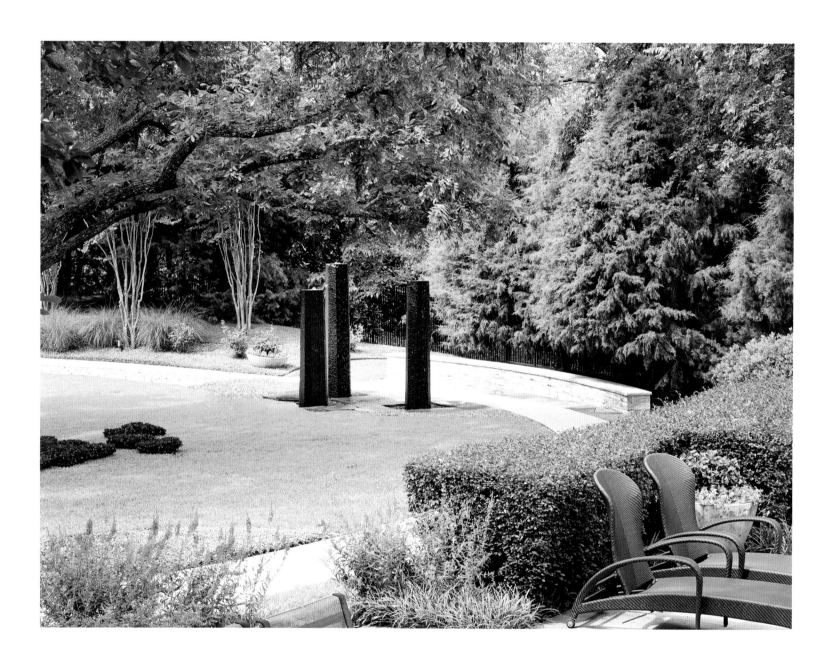

Above: A garden adjacent to the main house in a North Dallas neighborhood features interesting sculpture and landscaping. *Opposite*: A loggia overlooking a parklike setting at the Mansion Residences in Dallas. JANUS et Cie furniture.

Following spread: A giant pecan tree shelters the terrace of our country Georgian house with vintage garden furnishings for dining alfresco.

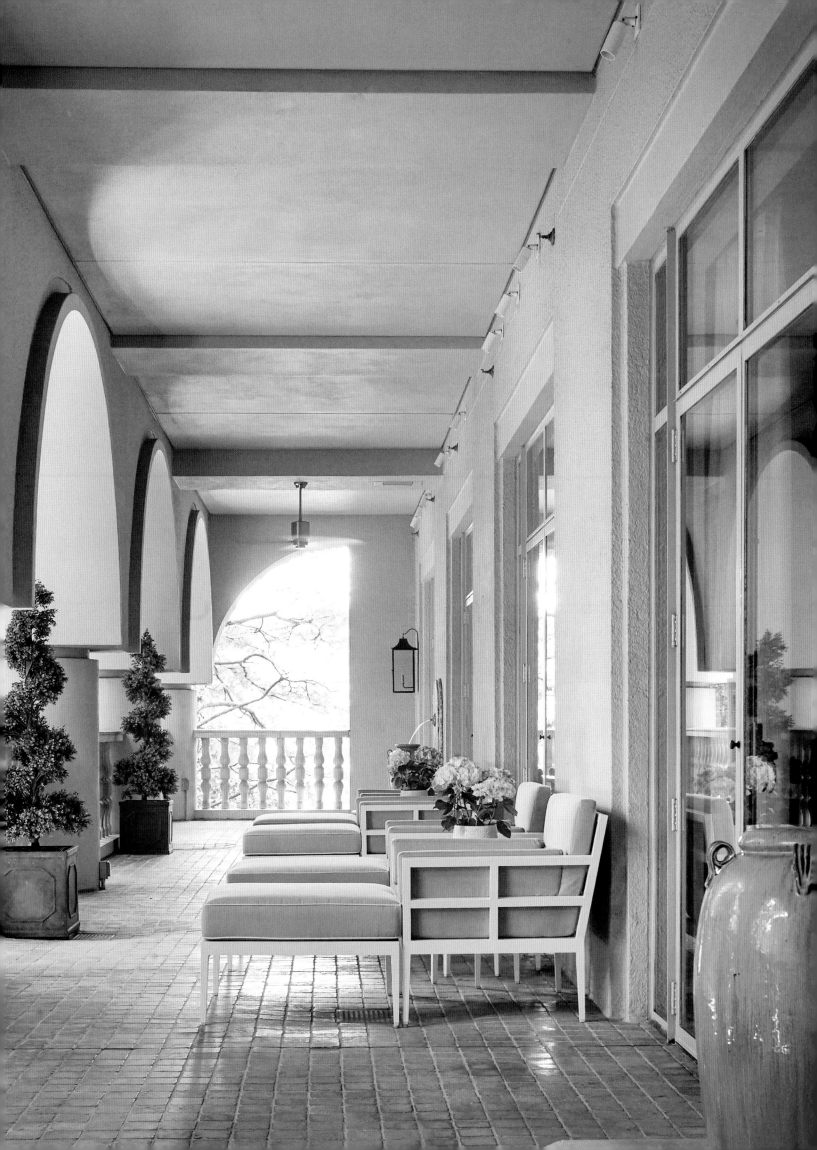

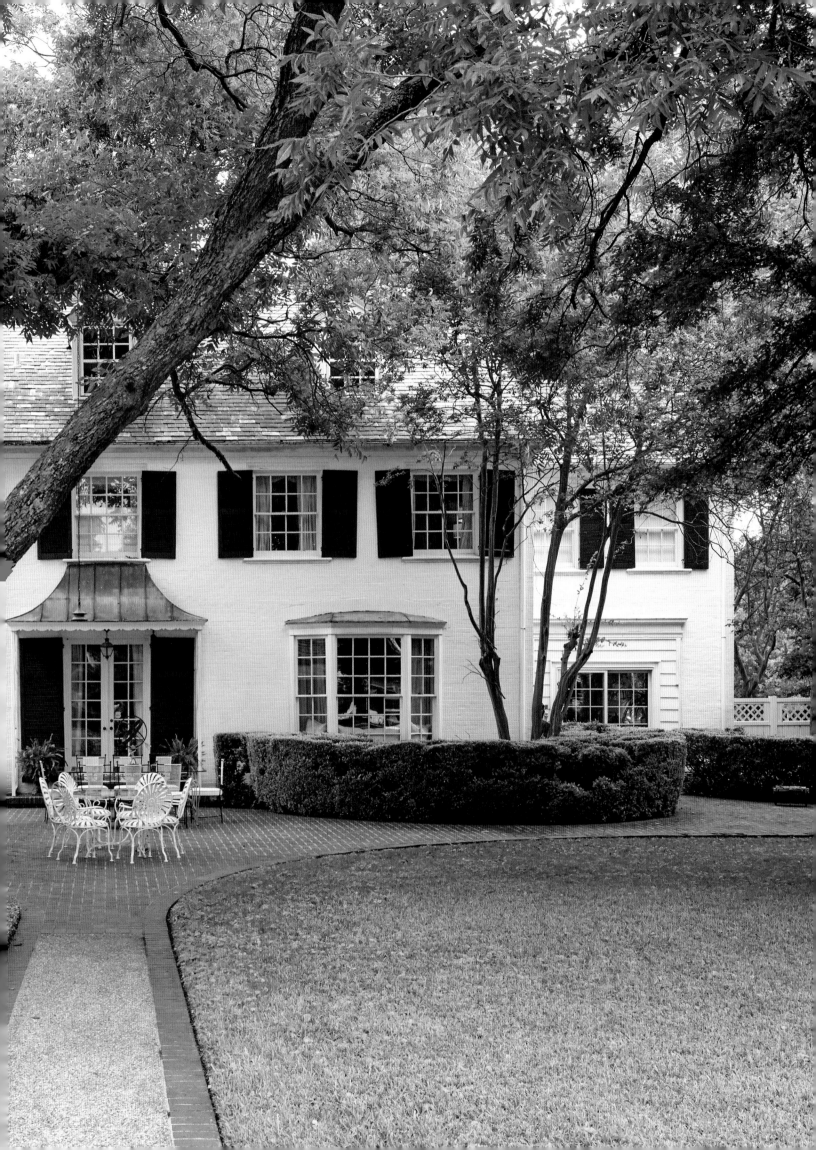

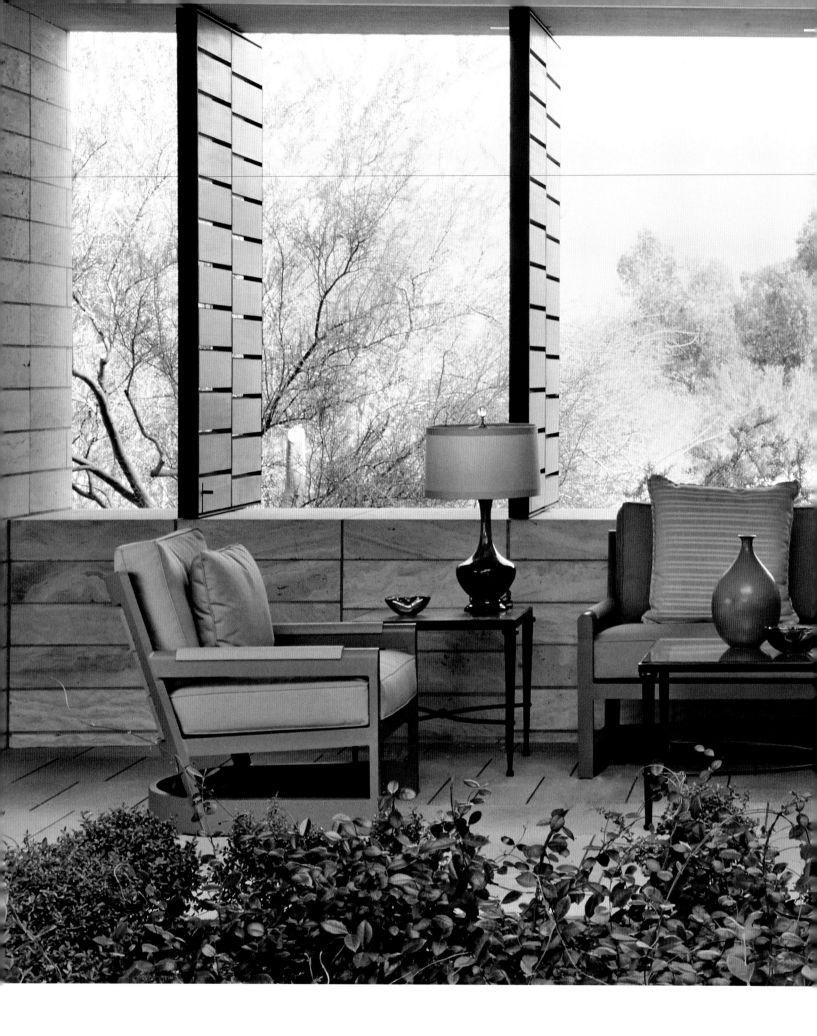

An outdoor living room in Paradise Valley, Arizona, with shutters that can completely close. Sofa and lounge chairs are by Sutherland. The vintage lamps are drip glaze ceramic, c. 1960.

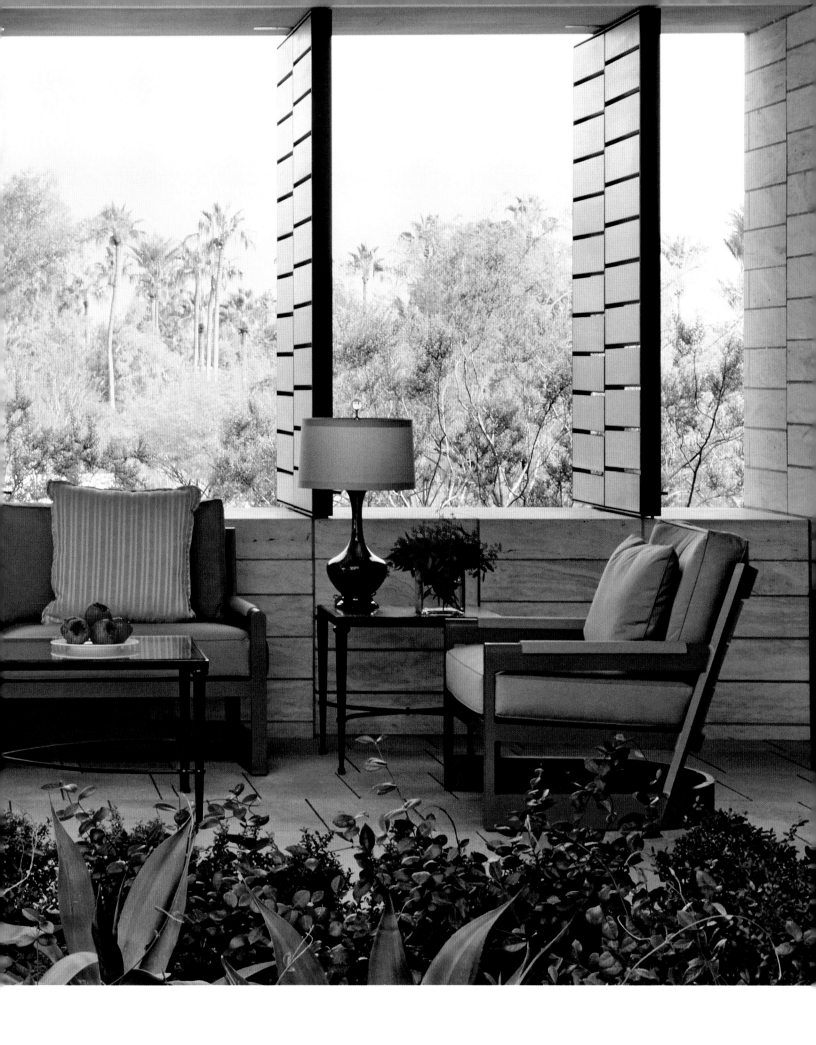

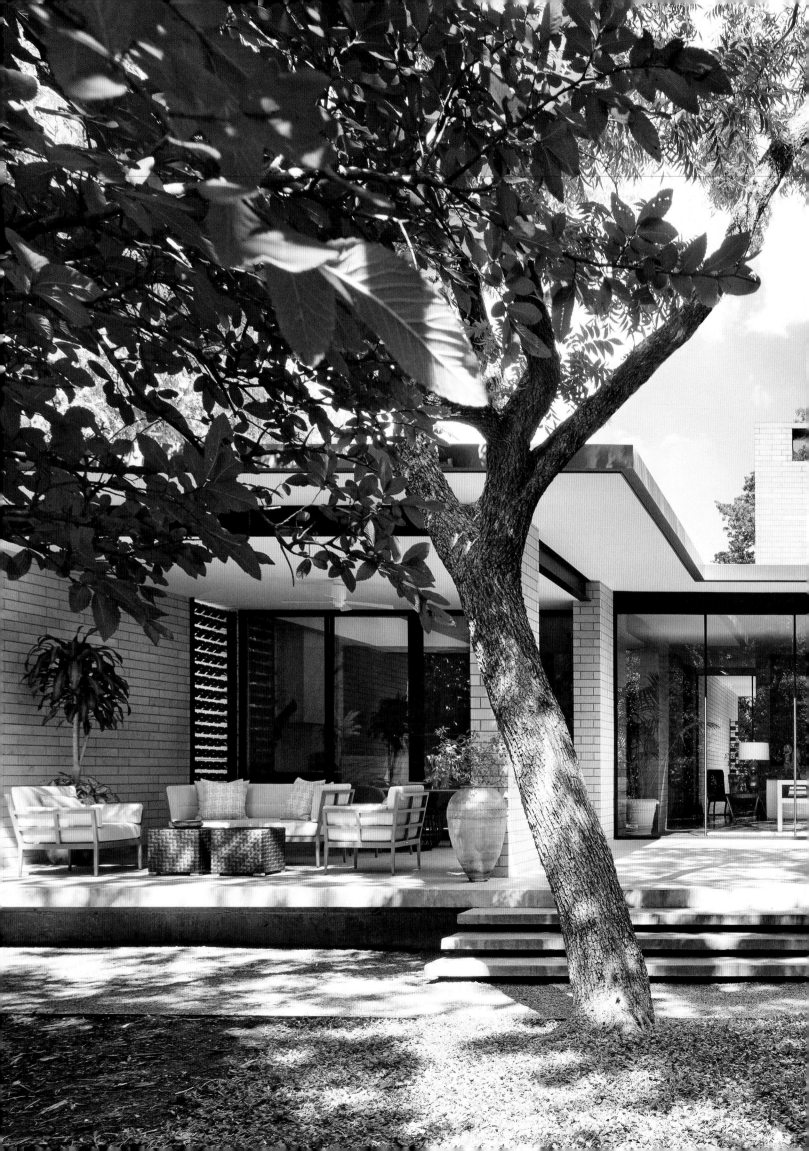

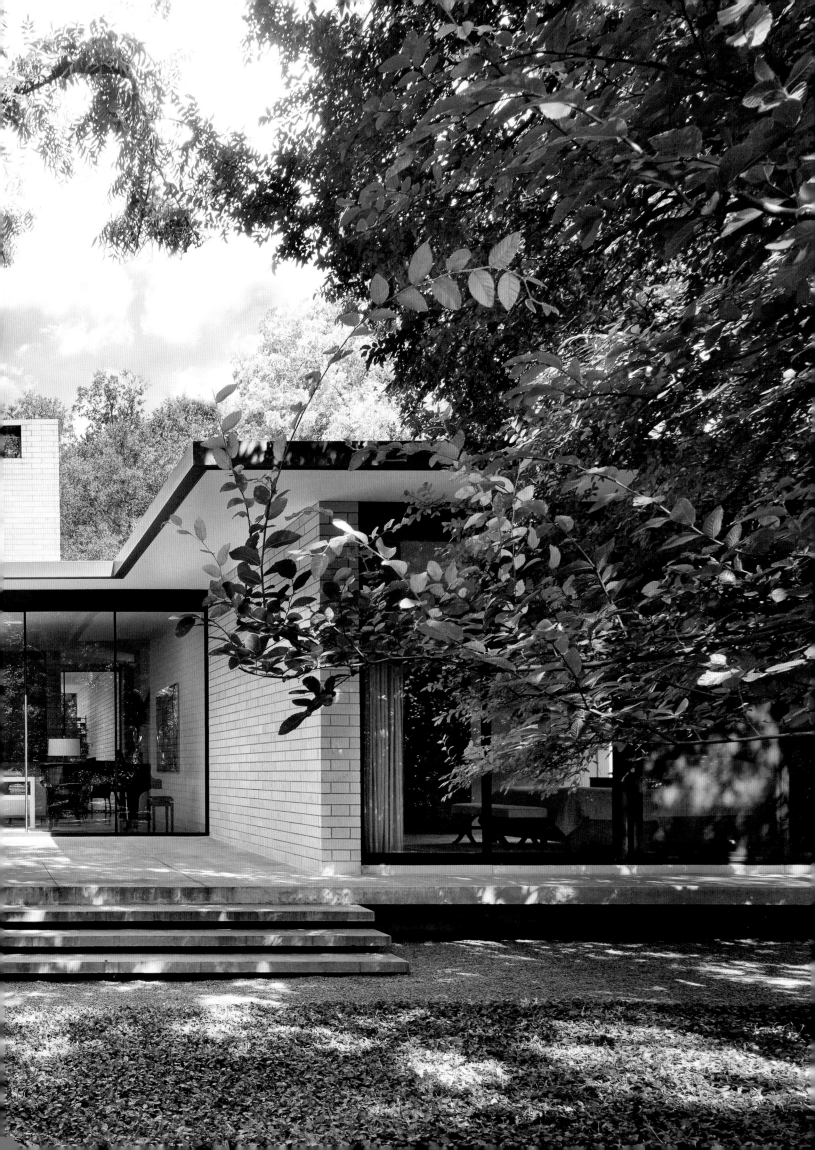

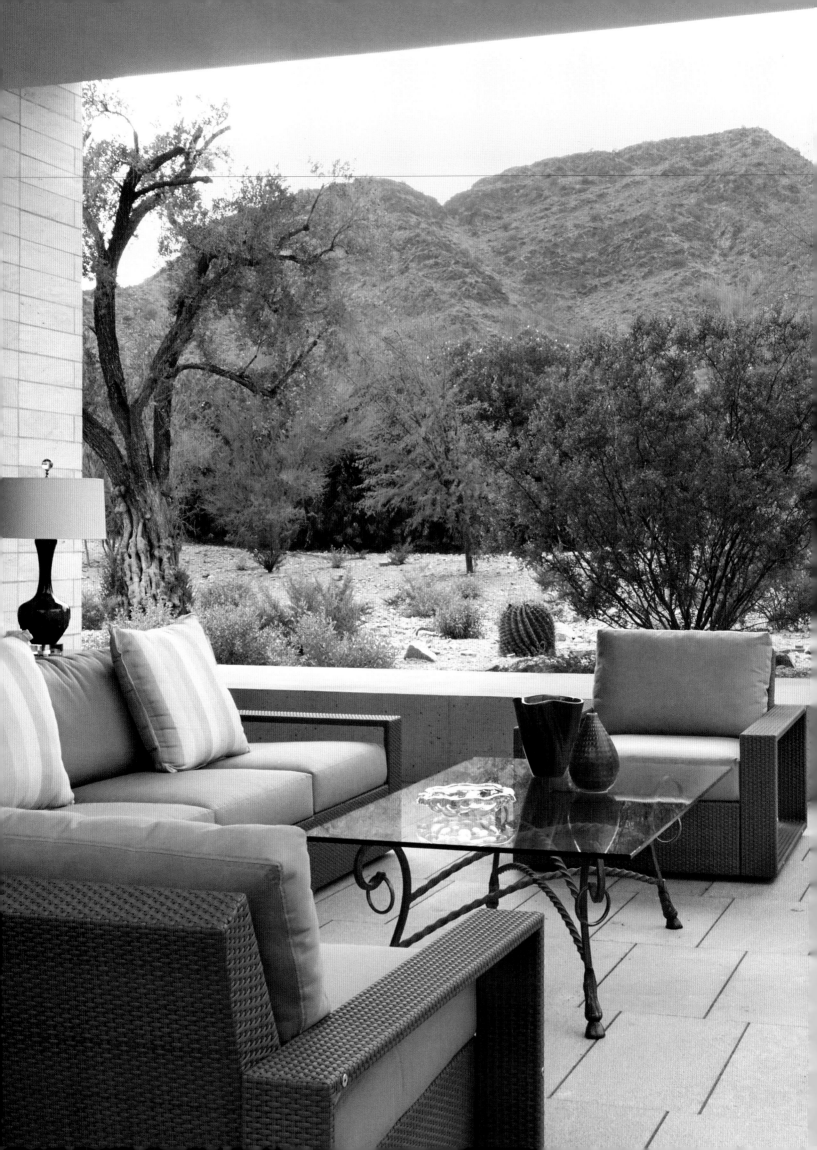

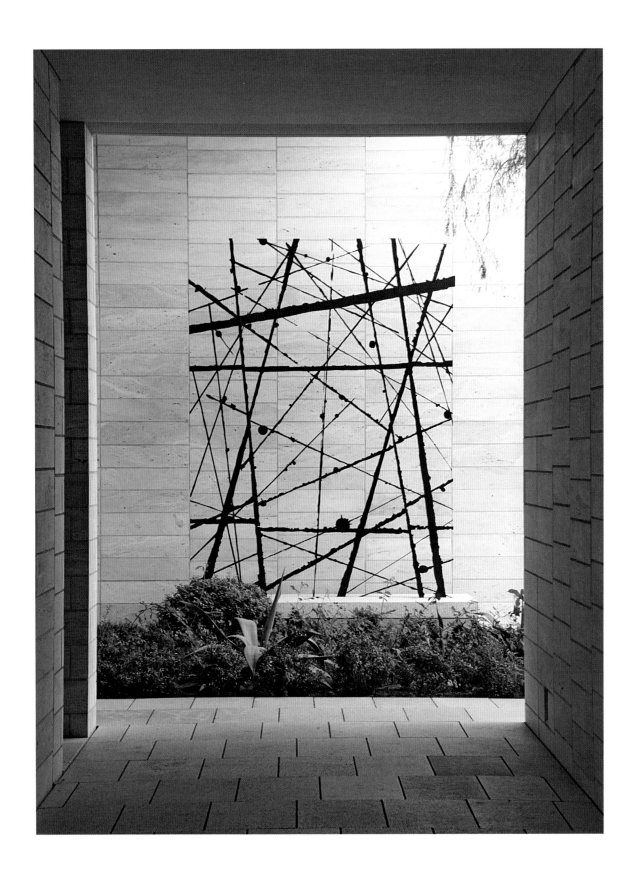

Previous spread: A back view of a house in Bluffview, Dallas, with JANUS et Cie
furnishings. Architecture by Bodron/Fruit, Dallas.

✳

Opposite: A cozy seating area with Sutherland furniture overlooking the mountains
behind the house in Paradise Valley, Arizona. *Above*: A sculpture by Anthony Pearson, *Untitled
(Transmission)*, 2012, one sees when walking from the main house to the guest house.

Finishing TOUCHES

Art collecting is one of the great passions of my life, and though I love paintings, lithographs, and photographs, I certainly don't limit myself to what can be displayed on a wall. On a buying trip years ago, I discovered a whimsical and unexpected foot sculpture, and I knew exactly where it would go the moment I saw it. I don't think most people would look at it and say, "That's a Jan Showers moment." Art is, so often, about one's first instincts and singular point of view.

Many of my clients gravitate toward art that is different than the architecture of their house would suggest, which is as it should be. Nothing is better in a traditional home, for instance, than contemporary works of art. In fact, incongruities of this type create an energy that you might never have anticipated.

It's a myth that you have to spend a lot of money on good art, but too often people overspend on art that is fundamentally decorative and has no lasting value. Whenever possible I recommend hiring an art consultant. It's not a matter of ceding your tastes to another person. The best art consultants will learn about your taste and guide you in terms of investment.

Anyone who has been to one of my houses knows that tabletops are an art form. The layering of collections and interesting objects is absolutely essential to create a warm, comfortable, and personal environment. Even with furniture, lighting, and rugs in place, without rich, thoughtful layering any room will feel incomplete and utterly lifeless.

I've seen firsthand on many occasions the pleasure on my clients' faces when a room finally takes shape with mirrors, artwork, and tableaux—snapshots in vintage frames, interesting boxes, books, and collections. That's the moment a room springs to life.

Placing objects on the table behind the sofa in our Dallas townhouse living room.

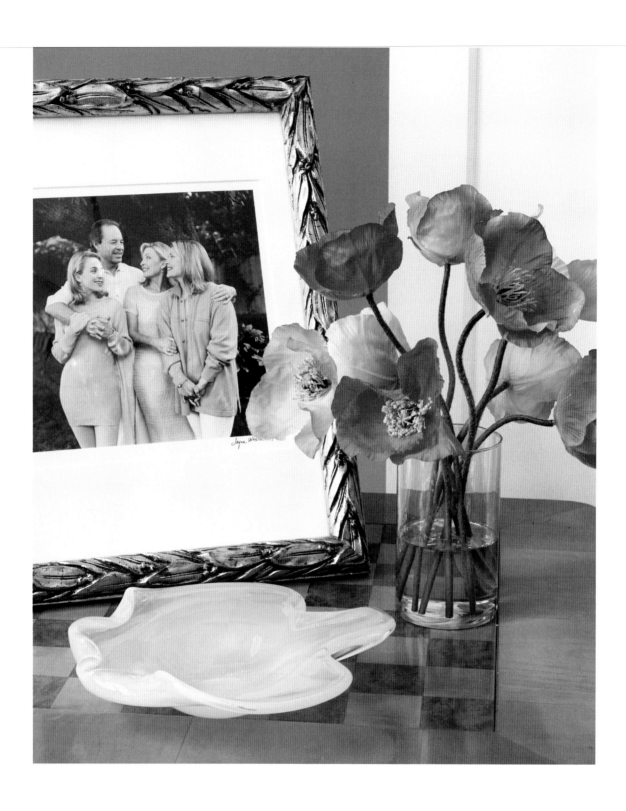

Above: A favorite family photograph, a beautiful glass bowl, and a sculptural arrangement of poppies create a simple but beautiful group of objects at the end of a sofa. *Opposite*: Art doesn't have to be a painting—this stunning mirrored sculpture by Christophe Gaignon of Paris creates the center of interest at this end of a large living room.

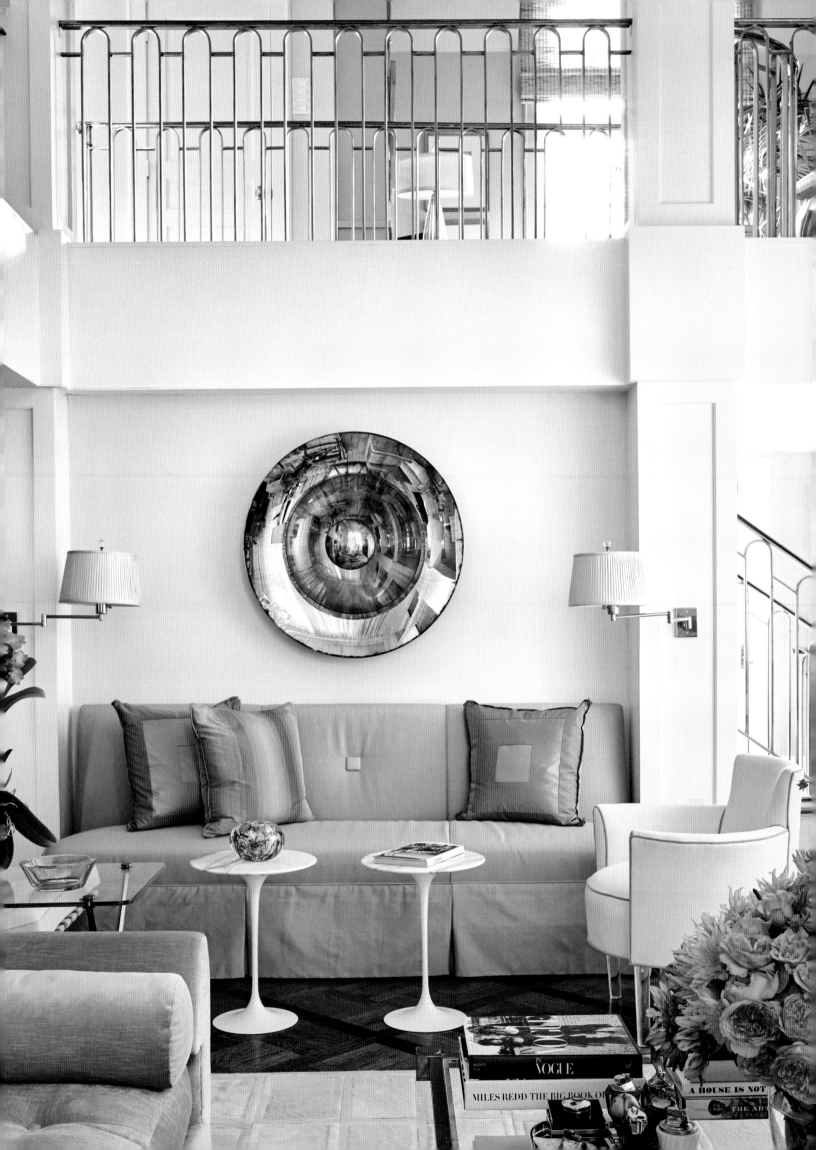

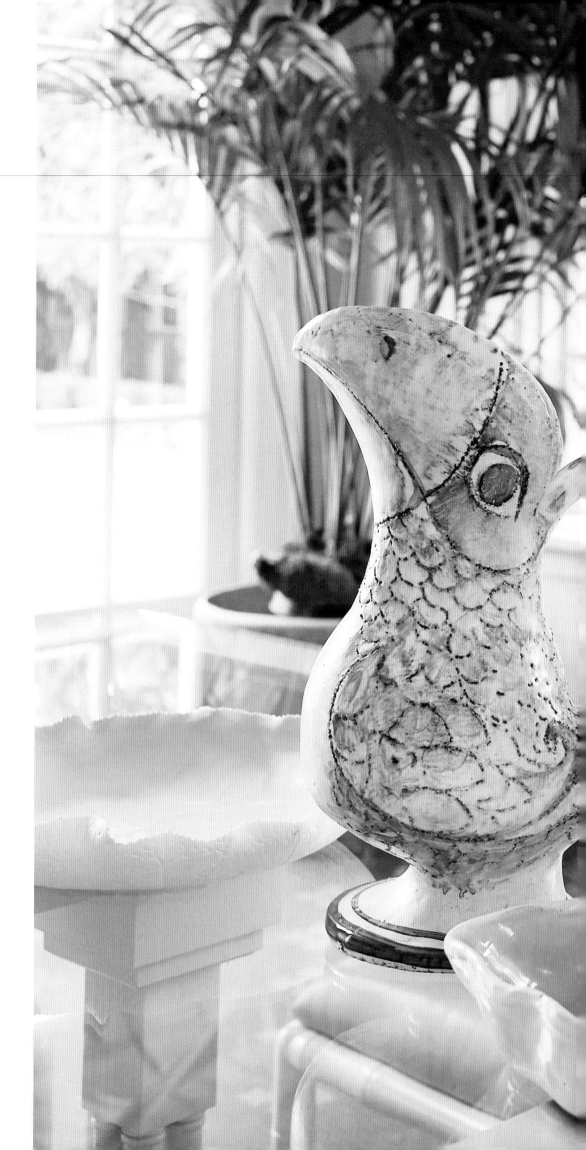

One of my favorite tableaux—
exceptional ceramic objects
from France in unusual colors
create interest and mood in
a morning room.

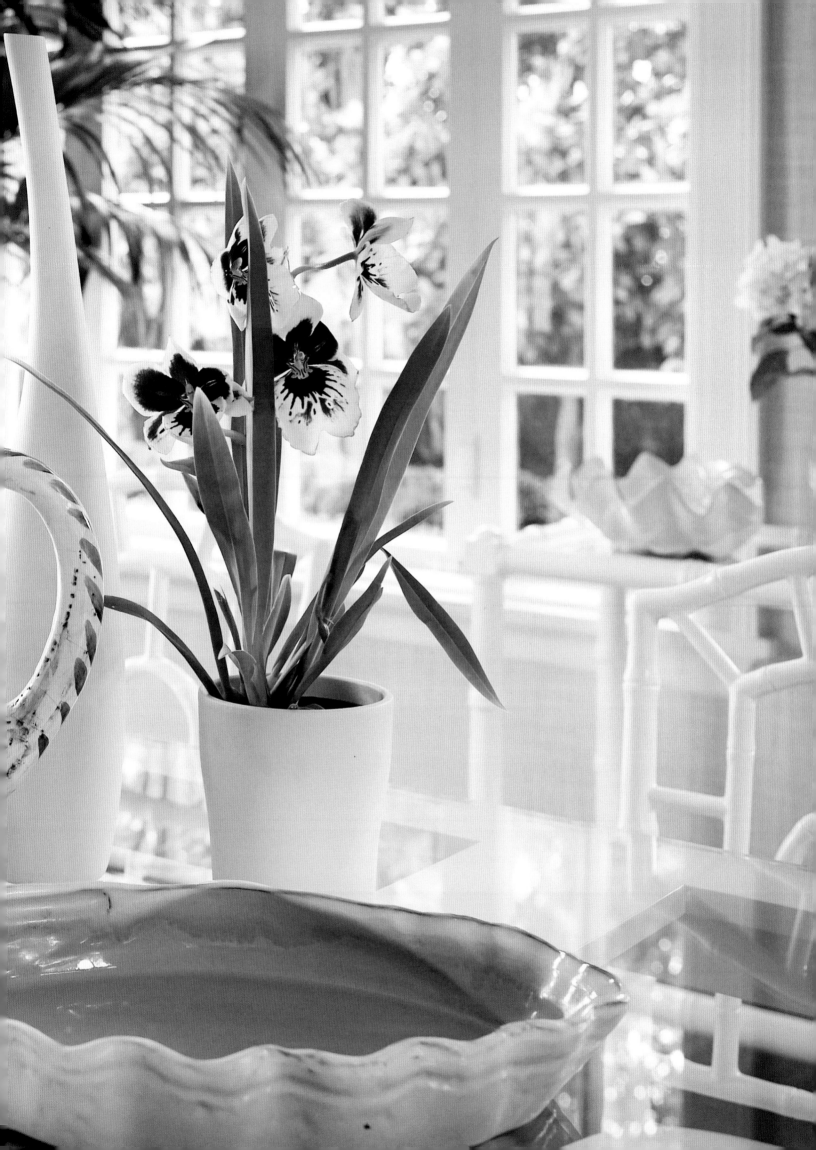

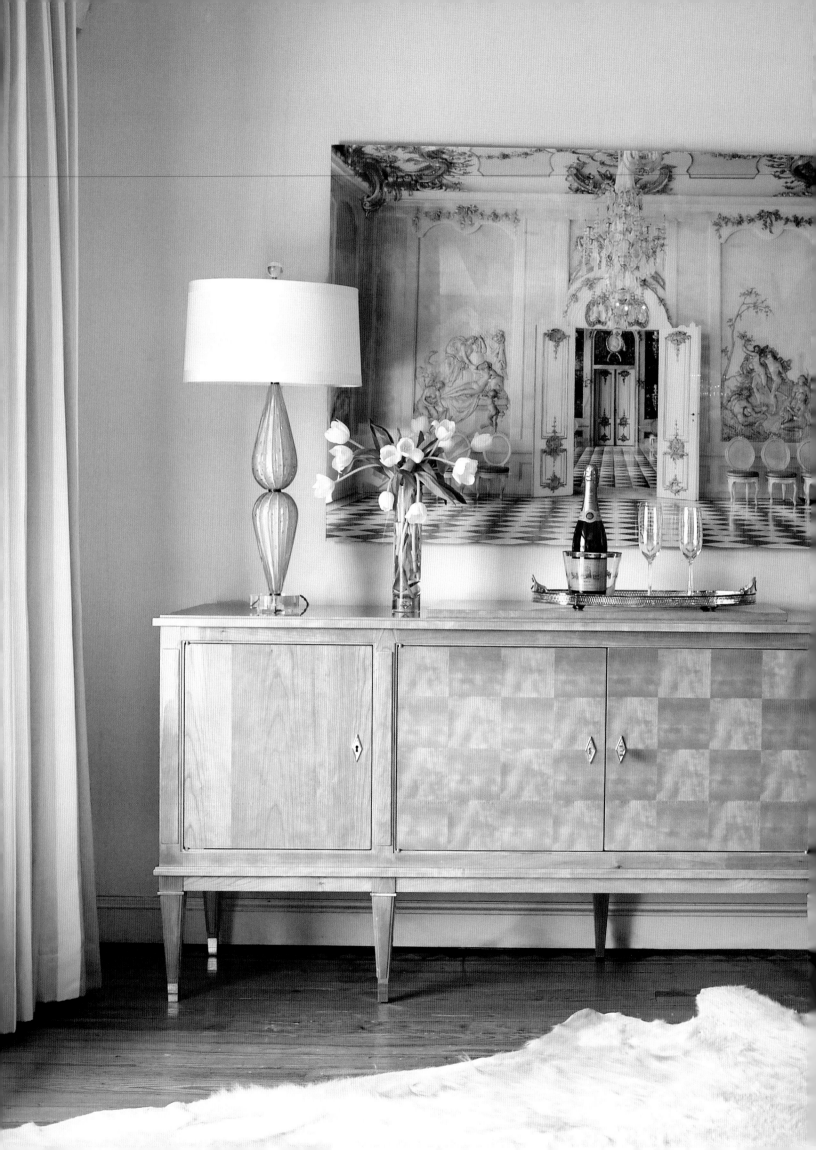

Neue Kammern Enfilade II, by Celia Rogge complements the Veronique Credenza—a part of the 1308 Collection in my Dallas showroom. The art is flanked by a stunning pair of turquoise Murano lamps from the 1950s. A painted Louis XVI vintage chair upholstered in Kravet Smart is nestled beside it.

"Art is, so often, about one's first instincts and singular point of view."

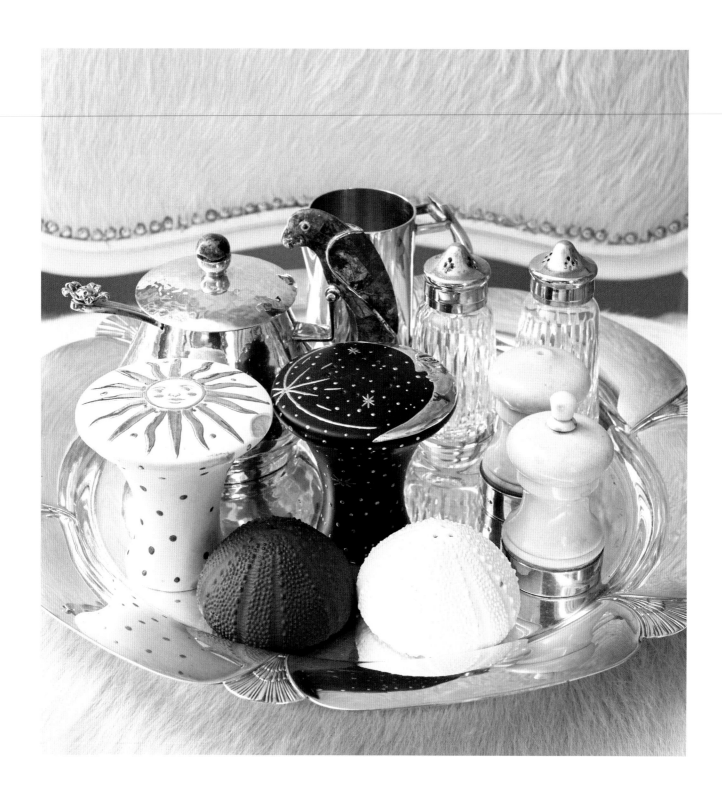

Above: A collection of salt and pepper shakers on an antique silver tray from the 1920s. Grouping like things together is always better than scattering them around, and it's definitely better than placing them in a cabinet. *Opposite*: A strong painting, *One Thousand Sofias*, 2007, by Jennifer Nehrbass, graces a hallway into a long china and crystal room.

Following spread: This tray of barware creates a festive air on this stainless steel kitchen wet bar.

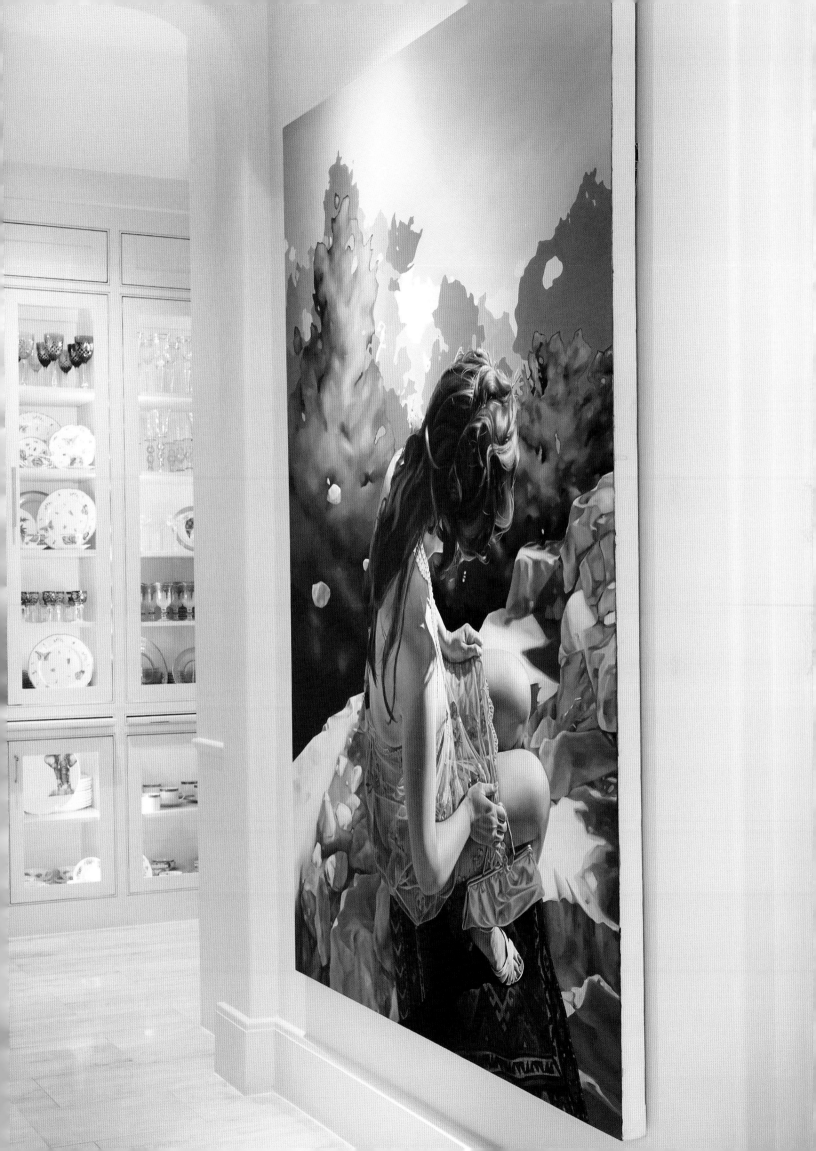

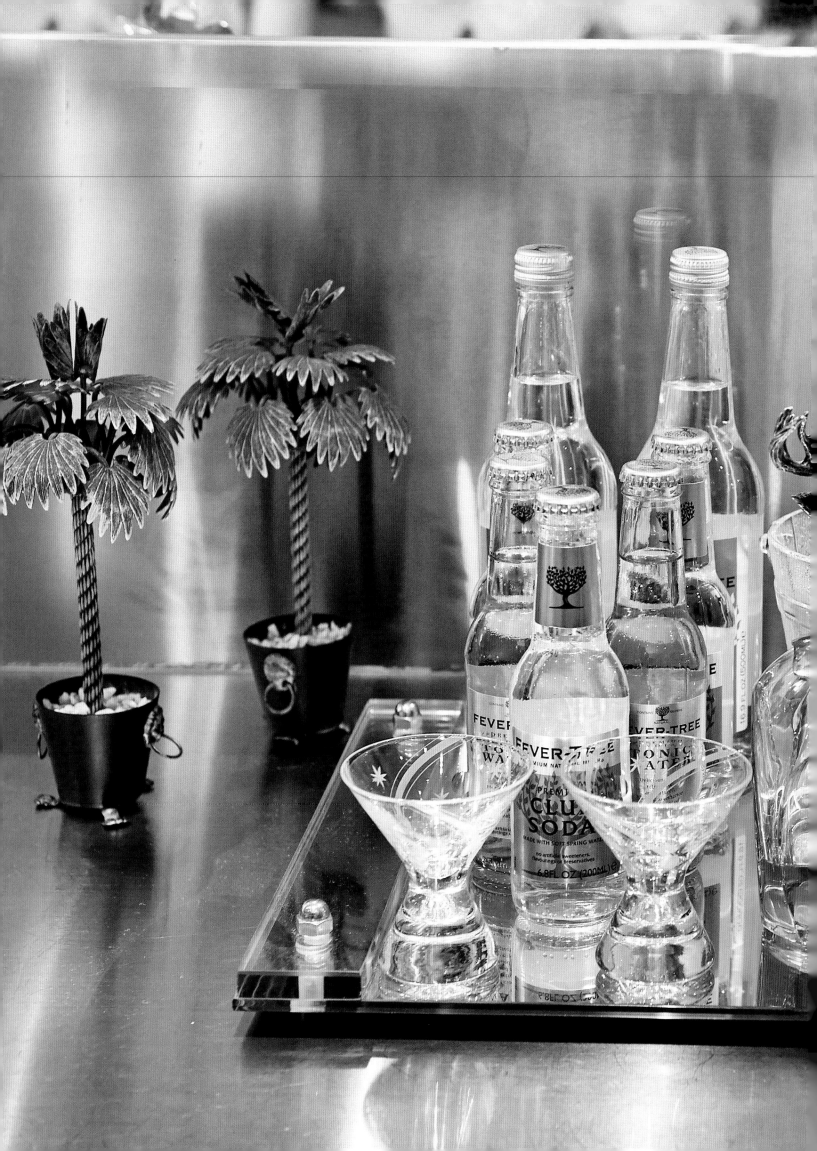

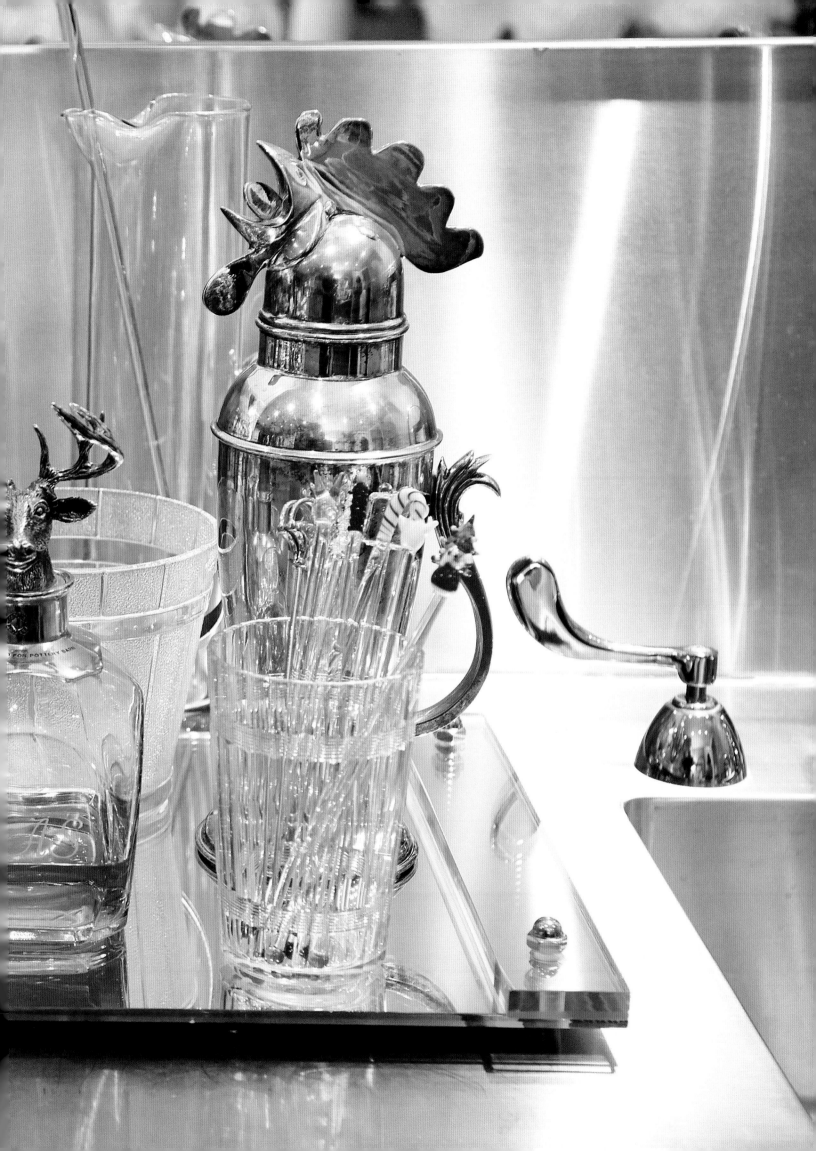

Above: A grouping I am fond of—a wonderful lamp, a stack of books, and similarly colored Murano glass objects reflect in the mirror that hangs above them. *Opposite*: This gold-leaf soleil mirror, flanked by French engravings framed in gold leaf, complements this Holden Credenza made of several different elements. An Elizabeth Chandelier in 22-karat gold adds sparkle and shine. The vintage ceramic pieces on the left of the credenza add a nice counterpoint to the sheen of the other pieces.

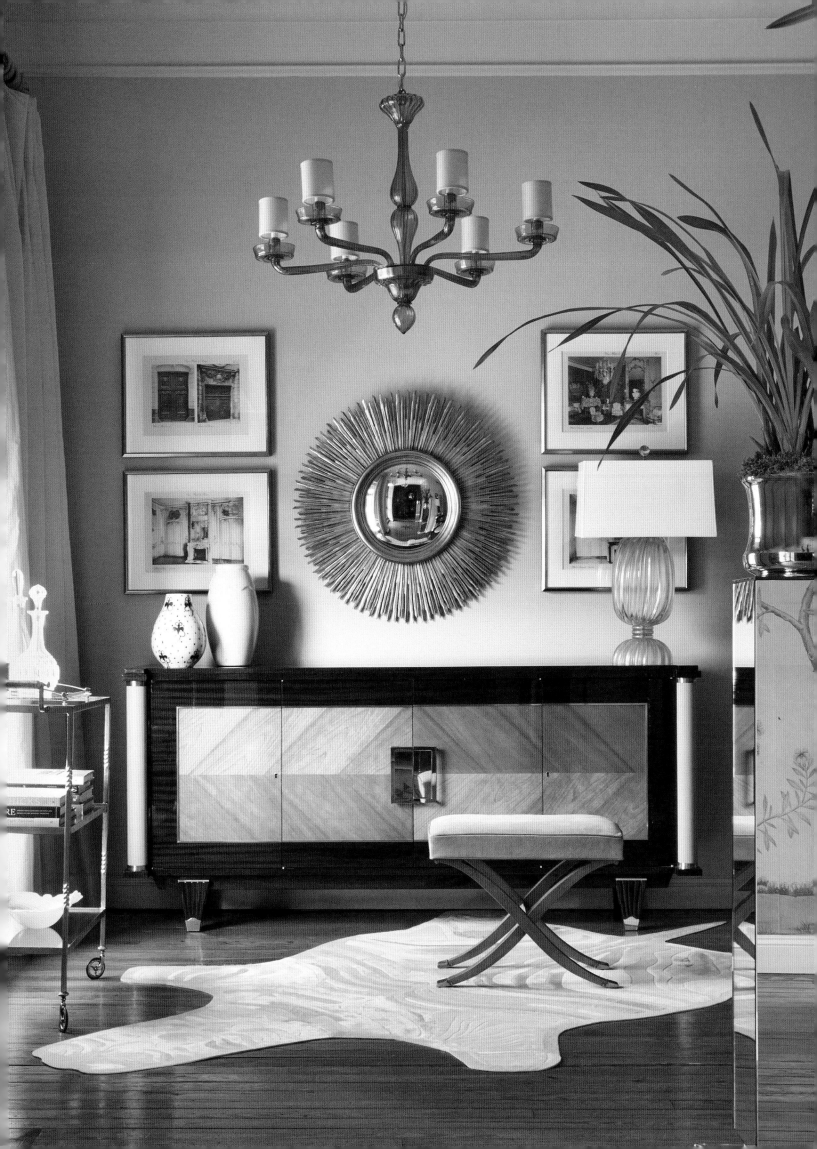

An impressive collection of green French majolica graces a vintage split-bamboo table in a solarium overlooking a pool.

Left: A simple orchid with two pieces of vintage Murano opalescent glass on a mirror-top table add glamour between two chairs in a master bedroom. *Opposite*: Some of my favorite personal things on my bedside table, which change from time to time: a treasured photo of my mother when she was in college, two very special signed pieces of Murano glass, a bronze star clock from the 1940s, a round gold-plated clock with a green face (both from my collection of French clocks), and two paperweights given to me by my daughter.

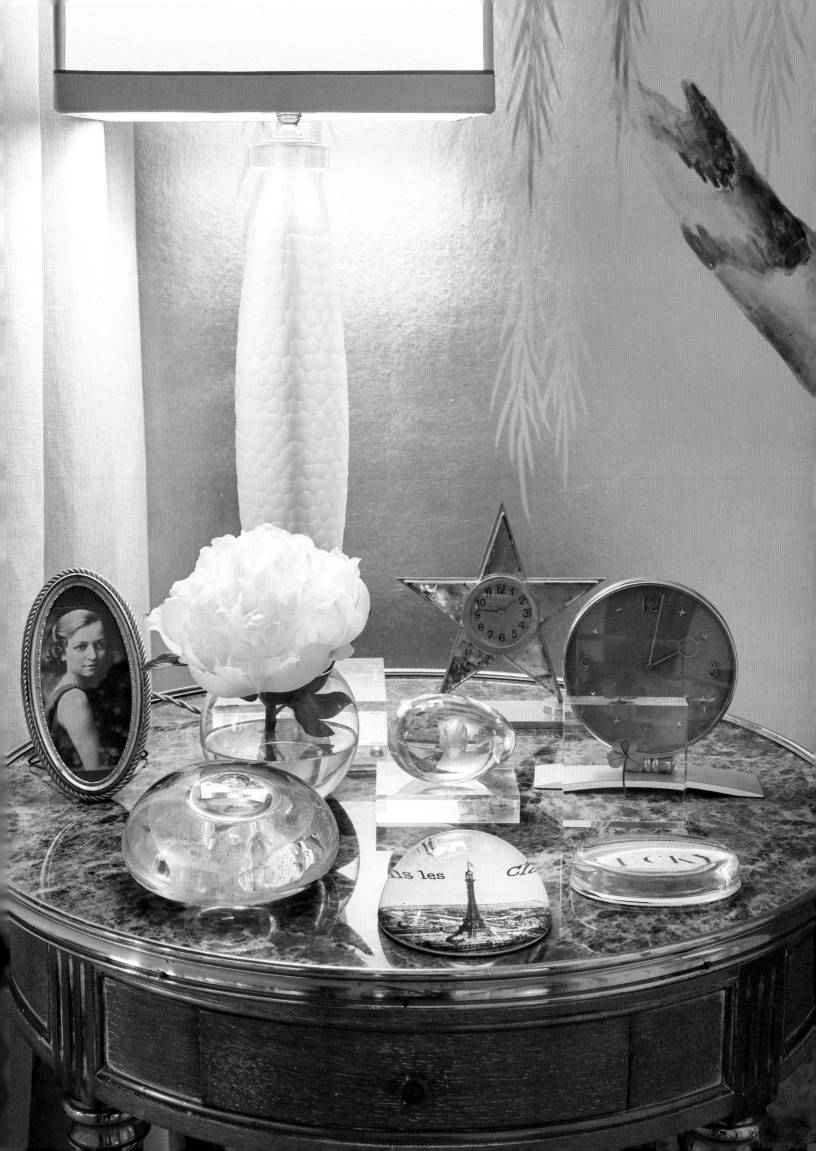

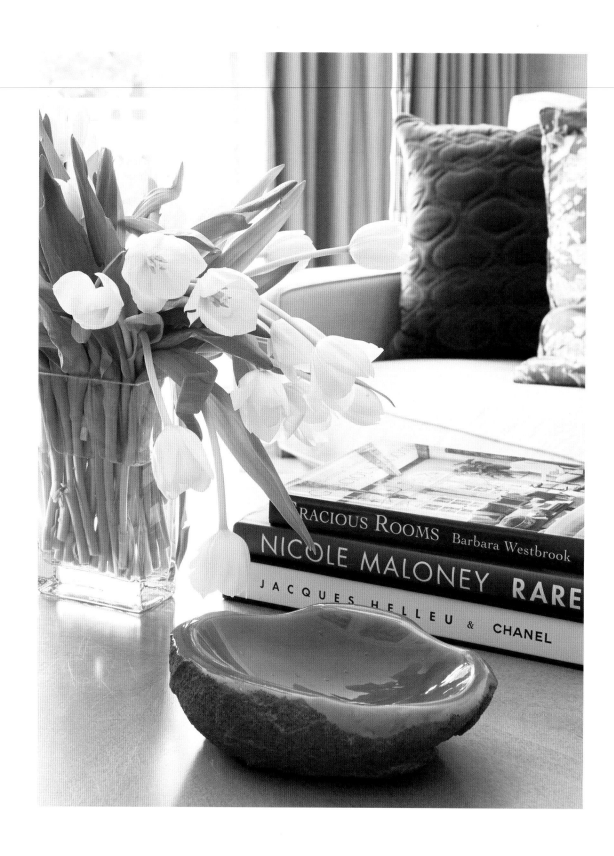

Above: Blues are the primary color with drapery, pillows, books, and a ceramic bowl
in this family room. *Opposite*: Cherished books, a much-treasured collection of
cigarette lighters—I do not smoke, but they are beautiful art objects—and a collection
of other favorite pieces of vintage glass and ceramics create one of my favorite
tableaux in our Dallas townhouse.

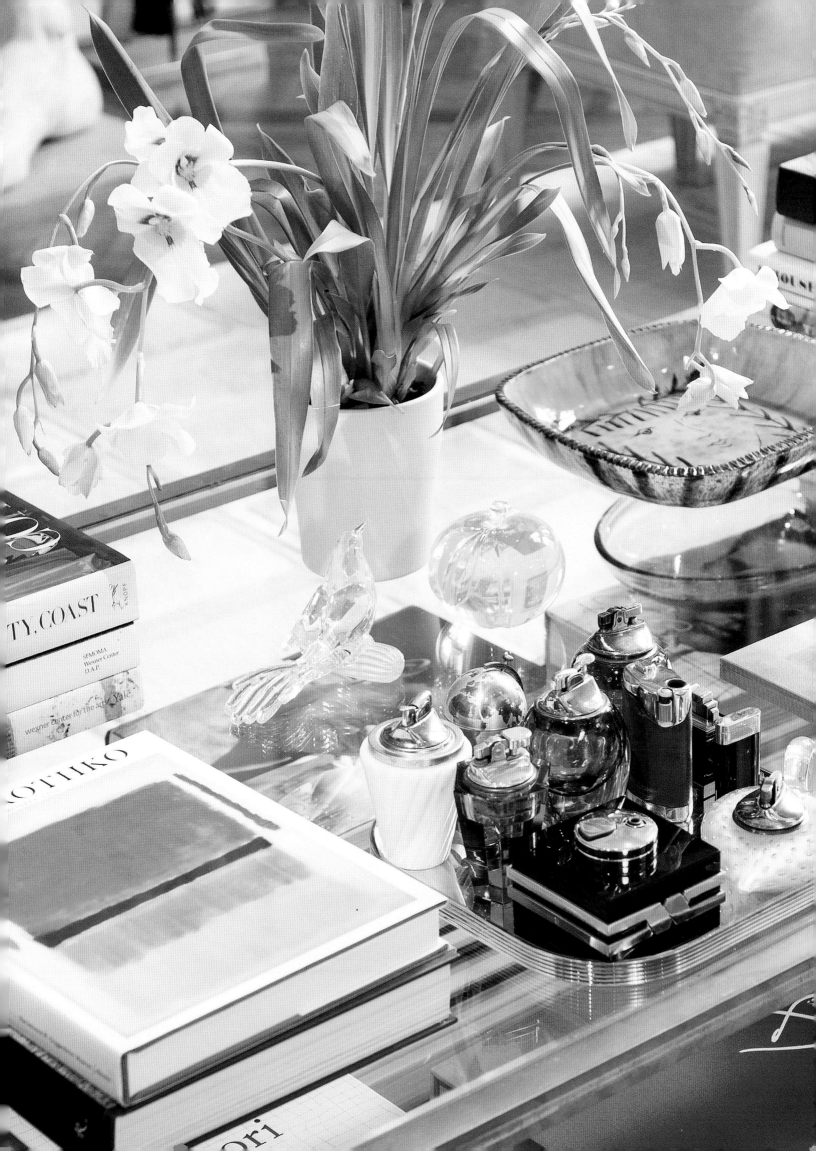

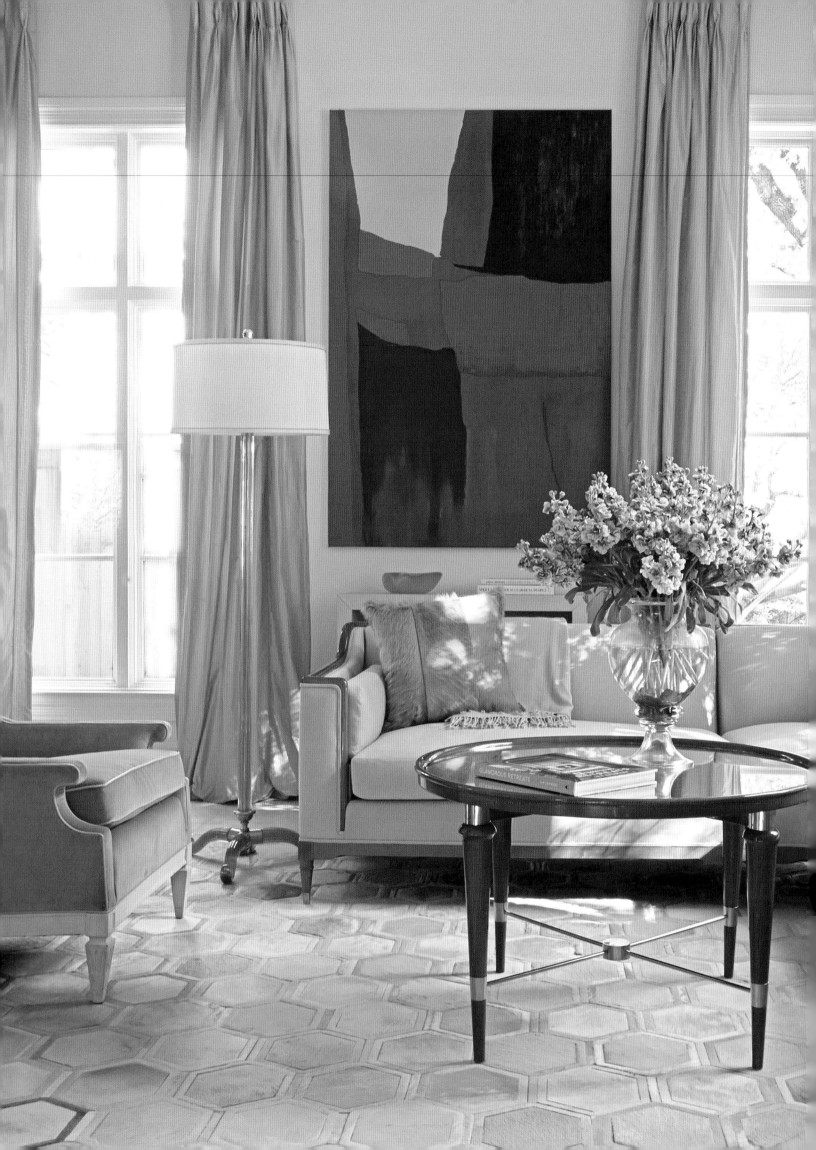

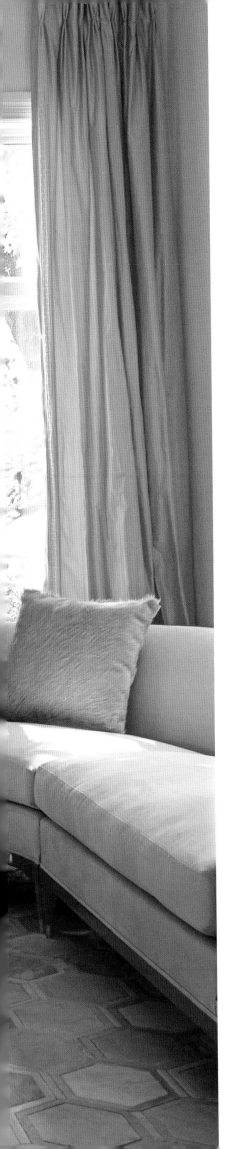

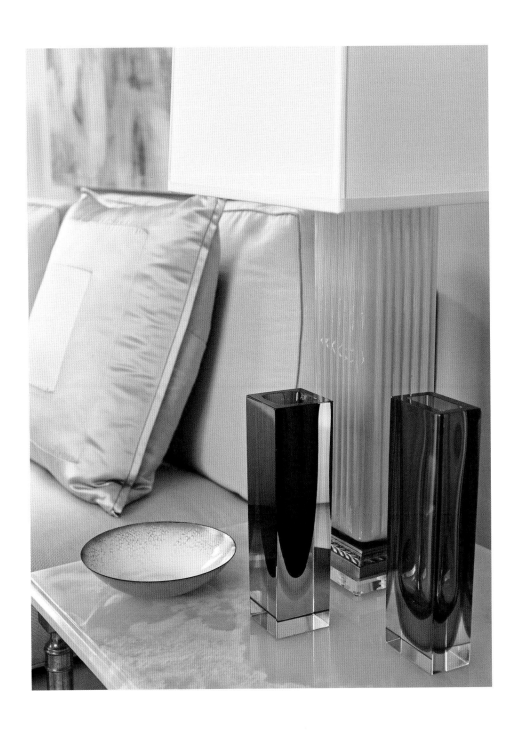

Opposite: A strong painting in dark colors works beautifully with the lighter colors in this living room. The Marilyn Sofa is from the Jan Showers Collection, as is the Baxter Coffee Table. *Above*: A pair of Murano cased-glass vintage vases sit next to one of a pair of unusual square Murano lamps from the 1950s in lavender.

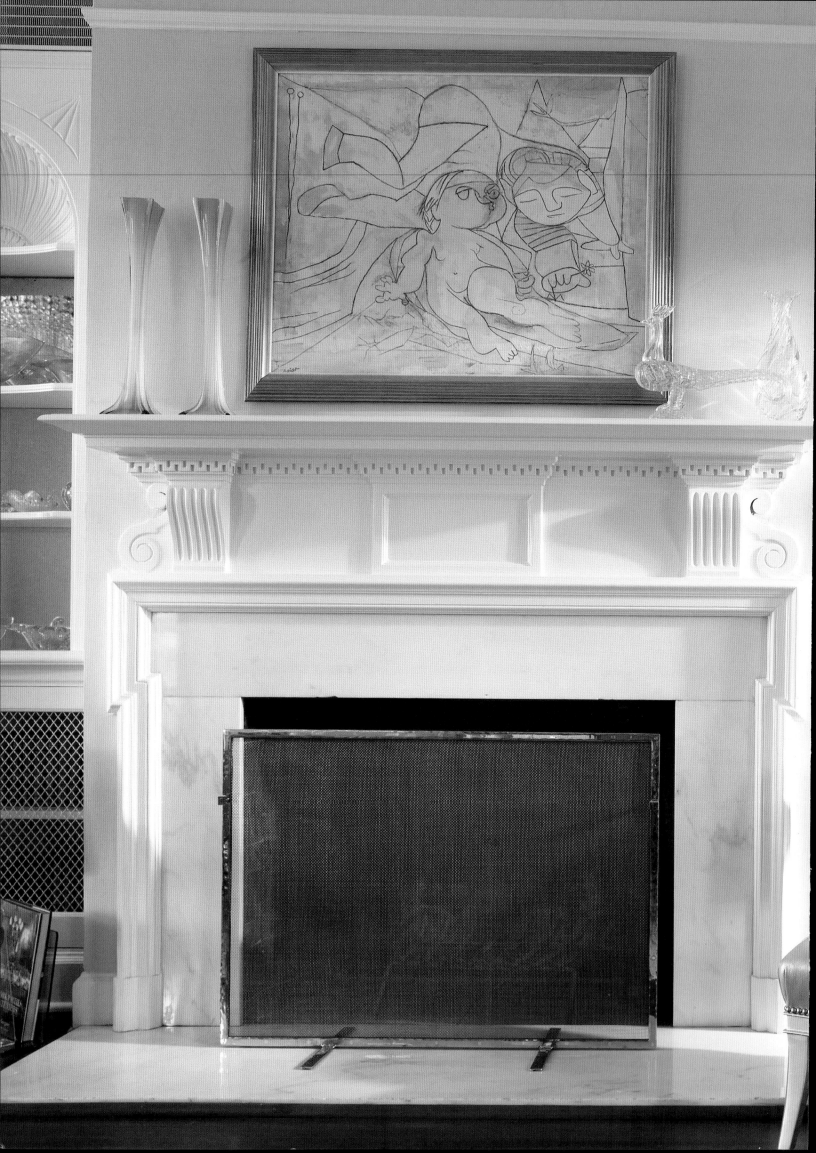

Wonderful bookcases with shell
detail flank the fireplace in
this historic Austin house. The
painting, by Françoise Gilot,
is a portrait of her two children,
Paloma and Claude. All glass
is vintage Murano in shades of
gold that sparkle even more
because of the distressed mirror
that was added to the cases.

PHOTOGRAPHY CREDITS

Stephen Karlisch: pages 3, 22, 24, 36–37, 48, 53, 72, 73, 86, 91, 93, 108, 133, 142, 143, 152, 170, 177, 180–181, 194, 197, 206, 216–217

Jeff McNamara: pages 4, 5, 12, 20–21, 28, 29, 30, 31, 34, 35, 38, 41, 42, 43, 45, 47, 54–55, 62, 63, 64–65, 66–67, 74, 76–77, 78–79, 80–81, 82, 94, 95, 97, 100, 105, 106–107, 118, 120–121, 122, 123, 126, 127, 129, 130–131, 134–135, 140–141, 150–151, 158, 160, 162–163, 164–165, 167, 172–173, 174–175, 184, 185, 188–189, 192, 193, 196, 198–199, 200–201, 202, 203, 204–205, 207, 210, 211, 212, 213, 214, 215

Lisa Petrole: cover, pages 6–7, 11, 26, 27, 32, 33, 52, 70–71, 83, 84–85, 102–103, 104, 114, 115, 116–117, 119, 136–137, 138, 148–149, 156, 157, 190–191, 222–223

Eric Piasecki/OTTO: pages 25, 75, 154–155, 219

Cody Ulrich: pages 44, 46, 50–51, 88–89, 92, 110, 111, 112–113, 146, 147, 169, 208–209

Nathan Schroder: pages 39, 186–187

Kate Martin: pages 40, 57, 58–59, 60–61

Brian McWeeney: pages 56, 90, 96, 166, 176

Michael Hunter: pages 68–69, 128, 139, 159

David Tsay/OTTO: pages 98–99, 124, 125, 161, 220

Tria Giovan: pages 101, 144–145, 178–179, 182–183

Victoria Pearson: page 168

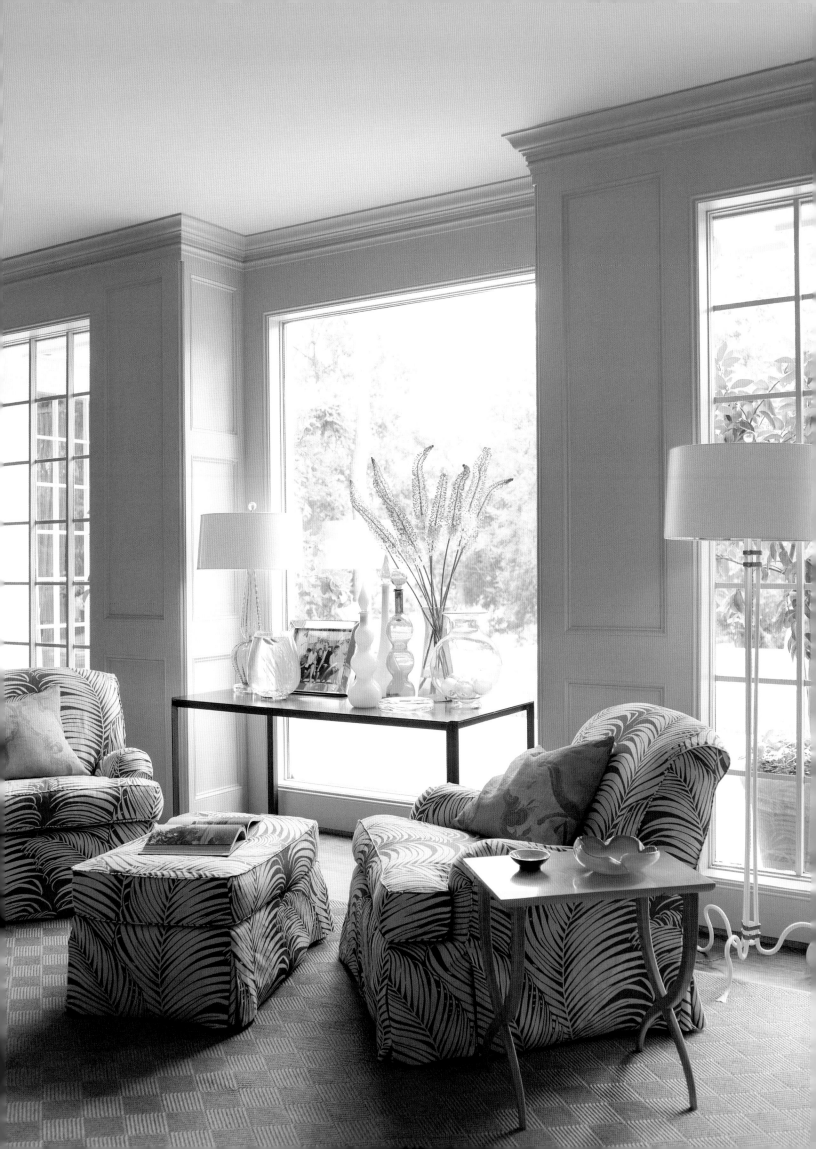

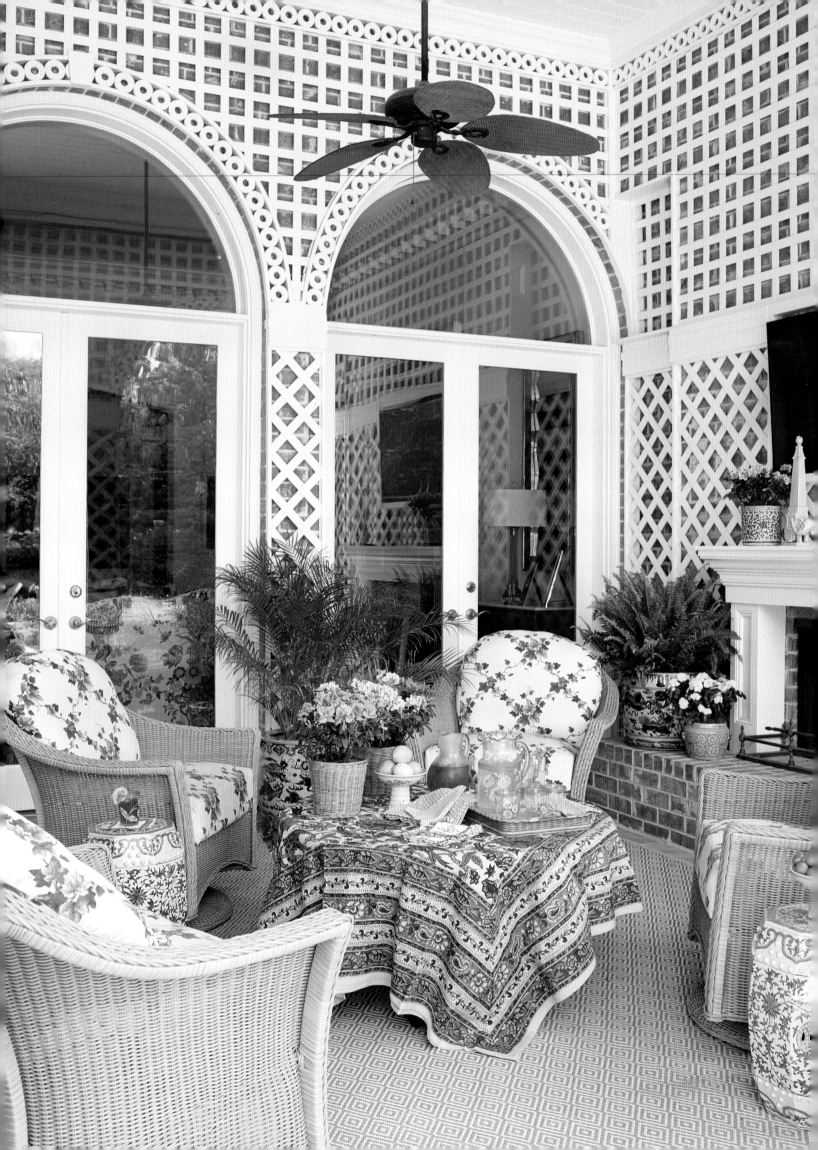

ACKNOWLEDGMENTS

Glamorous Living came into being thanks to the support and influence of my team at Abrams—Rebecca Kaplan, my editor; Emily Wardwell, my art director; and Jennifer Brunn, the head of publicity. Emily, with her background in fashion, got me from the very beginning. I feel tremendously fortunate that she was the creative spirit guiding me through this process.

Drew Smith, once again, wrote the book with me—our third together. I cannot imagine working with another writer who understands me as he does.

To my clients who let me invade and photograph their homes, this book could never exist without your generosity and patience. I am so grateful, first for your trust in asking us to design your homes, and second for allowing us to share them with the world.

Special thanks to Jeff McNamara and Steve Karlisch for the primary photography you see here. Jeff is a genius with interiors photography, with a rare eye for detail. In addition to contributing many stunning interiors images, Steve made me laugh, relax, and enjoy having my lifestyle shots done—not an easy task!

Several other interiors photographers, whose wonderful images can be seen in these pages, are named in the photography credits. Without their talents and contributions, *Glamorous Living* would not be what it is.

The lifestyle images were styled beautifully by Jimmie Henslee. Alejandro Guzman did an amazing job with my hair and makeup—he worked miracles!

I want to especially thank several members of my team at Jan Showers & Associates—Zara Taitt, senior designer and chief operating officer; Natalie Butler, my in-house public relations person who worked on the photography; and Mary Andres, my executive assistant who supports me in every way on a daily basis, and certainly did with this book.

Of course, I want to thank my family—my husband, Jim Showers, and my daughters, Elizabeth Showers and Susanna Moldawer. Without their love and support, I would not be able to accomplish half of everything I do.

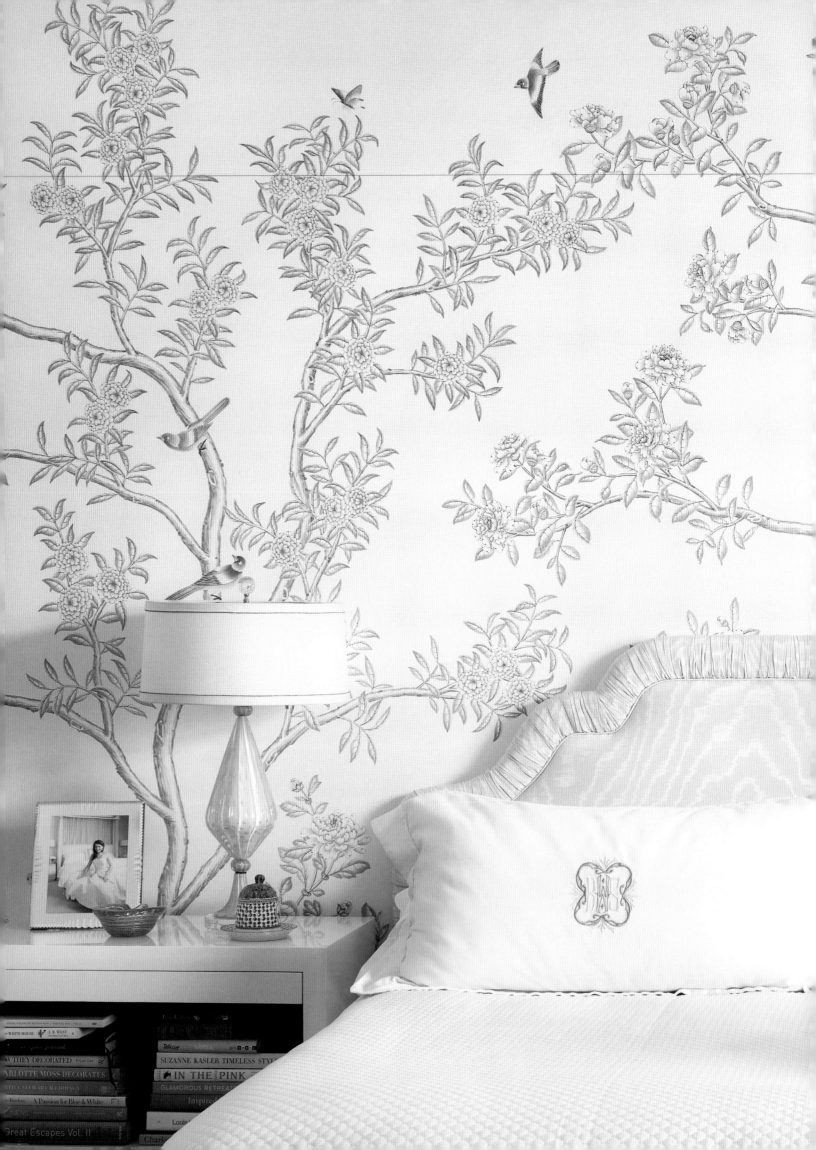

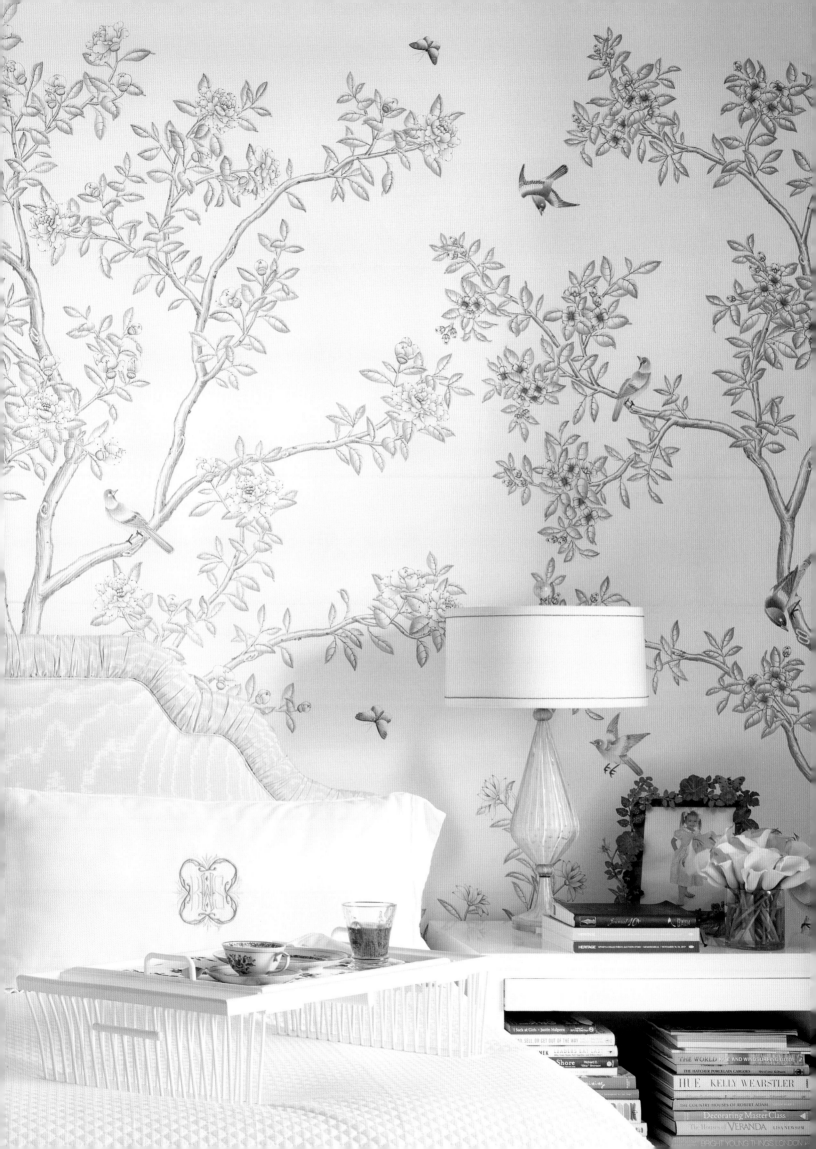

Editor: Rebecca Kaplan
Designer: Emily Wardwell
Production Manager: Anet Sirna-Bruder

Library of Congress Control Number: 2019939712

ISBN: 978-1-4197-4278-1
eISBN: 978-1-64700-177-3

Text copyright © 2020 Jan Showers
Photograph credits listed on page 218.

Jacket and cover © 2020 Abrams

Printed and bound in China
10 9 8 7 6 5 4 3

Abrams books are available at special discounts when
purchased in quantity for premiums and promotions as well
as fundraising or educational use. Special editions
can also be created to specification. For details, contact
specialsales@abramsbooks.com or the address below.

Abrams® is a registered trademark of Harry N. Abrams, Inc.

ABRAMS The Art of Books
195 Broadway, New York, NY 10007
abramsbooks.com